V/Ball/ESI/I 38

B Kontape

ERRATA

On page 30 (Figure 12) and on page 196
(Figure 81), the illustrations have been printed
upside down in error and will be corrected
in later printings.

CB

JACKSON POLLOCK

JACKSON POLLOCK

MEANING AND SIGNIFICANCE

CLAUDE CERNUSCHI

IconEditions
An Imprint of
HarperCollins*Publishers*

HarperCollins books may be purchased for educational, business, or sales promotional use. For information, please call or write: Special Markets Department, HarperCollins Publishers, 10 East 53rd Street, New York, NY 10022. Telephone: (212) 207-7528; Fax: (212) 207-7222.

FIRST EDITION

Designed by Abigail Sturges

Library of Congress Cataloging-in-Publication Data

Cernuschi, Claude, 1961–
 Jackson Pollock : meaning and significance / by Claude Cernuschi.
 —1st ed.
 p. cm.
 Includes bibliographical references and index.
 ISBN 0-06-430978-9/ISBN 0-06-430977-0 (pbk.)
 1. Pollock, Jackson, 1912–1956. 2. Painters—United States—
 Biography. 3. Abstract expressionism—United States. I. Pollock,
 Jackson, 1912–1956. II. Title.
 ND237.P73C47 1992 91-55131
 759.13—dc20

92 93 94 95 96 CC/CW 10 9 8 7 6 5 4 3 2 1
92 93 94 95 96 CC/CW 10 9 8 7 6 5 4 3 2 1 (pbk.)

CONTENTS

LIST OF ILLUSTRATIONS

*The letters CR followed by numbers refer to the O'Connor-Thaw
catalogue raisonné listings; the first number is the volume number,
the second the catalogue number.*

85. Lee Krasner, *Untitled* (1949). Museum of Modern Art, New York. Gift of Alfonso Ossorio.
86. Robert Motherwell, *Elegy to the Spanish Republic* (1961). Metropolitan Museum of Art, New York.
87. Adolph Gottlieb, *Thrust* (1959). Metropolitan Museum of Art, New York.
88. Mark Rothko, *Black and Grey* (1970). Museum of Modern Art, New York. Gift of the Mark Rothko Foundation.
89. Franz Kline, *Painting Number 2* (1954). Museum of Modern Art, New York. Mr. and Mrs. Joseph H. Hazen and Mr. and Mrs. Francis F. Rosenbaum Funds.
90. Willem de Kooning, *A Tree in Naples* (1960). Museum of Modern Art, New York. Sidney and Harriet Janis collection.
91. David Smith, *Untitled* (1964), black enamel on canvas, 23 ½ × 56″. Courtesy Knoedler Galleries, New York.
92. Larry Rivers, *Girl with Sad Eyes* (1951). Artist's collection.
93. Helen Frankenthaler, *Mountains and Sea* (1952). National Gallery, Washington, D.C.
94. Frank Stella, *Marriage of Reason and Squalor* (1959). Museum of Modern Art, New York. Larry Aldrich Foundation Fund.
95. Carl Andre, *Mönchengladbach Square* (1968), steel. Blum Helman Gallery, New York.
96. Roy Lichtenstein, *Composition III* (1965). Blum Helman Gallery, New York.
97. Roy Lichtenstein, *OK Hot Shot* (1963). Mr. and Mrs. S. I. Newhouse collection.
98. Richard Serra throwing lead (1969), Castelli Warehouse, New York. Photographed by Gianfranco Gorgoni.
99. Robert Smithson, *Glue Pour* (1969). Vancouver, British Columbia. Photographed by Nancy Holt.
100. Jackson Pollock's studio, photographed by Hans Namuth in 1951.

All works by Kandinsky, Miró, Picasso, Pollock, and Rothko are reproduced by permission from The Artists' Rights Society.

ACKNOWLEDGMENTS

I would like to thank professors Marion Burleigh-Motley, William Rubin, and Kirk Varnedoe of the Institute of Fine Arts, New York University, whose insights and understanding of modern art have contributed to my own. Particular gratitude, moreover, is due to Irving Sandler, Robert Rosenblum, and the late Gert Schiff, who have read the manuscript with great care and provided me with invaluable constructive criticism and encouragement. Special mention should also be given to William C. Lipke, now of the University of Vermont, under whom my early interest in the work of Pollock was allowed to develop.

I would also like to thank the Institute of Fine Arts Fellowship Committee and the Institute of Fine Arts Alumni Association for having assisted my research on Pollock. The staff of the art history department at Duke University, Mary Cash and Betty Rodgers, provided immeasurable assistance; the generous help and good humor of William Broom, without which the Duke art history department could never run with its customary efficiency, also deserves particular mention. I am further indebted to my friends and colleagues at the Institute of Fine Arts, New York University, and the Duke University art and art history department who have listened to my ideas and have, either directly or indirectly, suggested possibilities for improvement.

Particular gratitude is expressed to Cass Canfield, Jr., my editor at Harper-Collins, to his assistant Bronwen Crothers, to Francis V. O'Connor for his help and advice, and to L. Susan Forster, who also read the manuscript with great care and who helped with innumerable aspects of this project; and to my parents for their continual affection and support.

JACKSON POLLOCK

INTRODUCTION

In the current art historical literature, Jackson Pollock is perceived as a dominant, if not pivotal, figure in postwar art. If his radical technique of pouring paint first shocked the public, and earned the artist the derisive title of "Jack the Dripper," his works have since become highly visible and widely respected icons of American painting. In recent years scholars have recognized the seriousness of Pollock's artistic aims, the originality of his stylistic solutions, and his crucial role in the general development of contemporary art. Indeed, he has recently been called the "great artist of the second half of the 20th century, in the manner that Picasso dominated the first half."[1] Curiously, however, if a general critical consensus exists about the importance of Pollock's achievement, the nature and reasons for this importance are still unclear. In an article titled "To Interpret or Not to Interpret Jackson Pollock," for example, Donald B. Kuspit concluded that "the importance of Pollock's allover paintings has not yet been firmly established, for their general character has not yet been made clear."[2] Thus, although Pollock has received increasing public recognition and critical attention (he was the first member of his generation to be granted a catalogue raisonné), Kuspit argues that no convincing account of the "character" and "importance" of Pollock's paintings has emerged. He blames Pollock scholars for being too "fact-obsessed and not sufficiently general,"[3] for excavating minutiae, and for failing to account for Pollock's relevance. Information is revealed, but, in his view, no wider or broader conclusions are drawn.

Kuspit's comments notwithstanding, to be too general and ne-

glect the "facts" is no solution either. Indeed, to reach even the simplest of conclusions, scholars need the tangible evidence of hard facts: when and where artists lived, under what conditions, with whom they studied, who patronized them and why, what intellectual, artistic, or cultural currents they may have been exposed to, to what degree the historical or political situations affected their work, and so forth. Even if the accuracy of such "facts" are often open to question or debate, without them interpretation—however sound, however convincing—remains essentially tentative.

Kuspit's remarks about the state of Pollock scholarship, however, effectively draw attention to a basic conflict facing the methodology of modern art history. On the one hand is the fact-oriented—sometimes called old-fashioned—side of the discipline exemplified by Erwin Panofsky's recovery of intention in "The History of Art as a Humanistic Discipline." Art historical inquiry, according to Panofsky, can "only be characterized in a terminology which is re-constructive as the experience of the art historian is re-creative: it must describe the stylistic peculiarities . . . as that which bears witness to artistic 'intentions.' "[4] On the other hand, and in direct opposition to Panofsky's recovery of intention, is the new post-structuralist/deconstructionist approach, exemplified by, among others, Roland Barthes's methodological revolt against the "tyranny" of authorial intention as the standard of literary inquiry. In "The Death of the Author," he argues that a text is not a "line of words releasing a single 'theological' meaning (the 'message of the Author-God') but a multi-dimensional space in which a variety of writings, none of them original, blend and clash."[5] Barthes concentrates on the inherent complexity of literary texts. The author's intention, he argues, cannot be recuperated because meaning is always deferred: writings refer to other writings, signs refer to other signs, and so on indefinitely. A text cannot have a single, fixed meaning, and criticism should concentrate on the individual reader's idiosyncratic experience rather than on the author's intention. Barthes thus declares the death of the author and the birth of the reader.

The amplification of this critical debate in the Pollock literature (and, for that matter, in the literature on modern art as a whole) has been noted by Yve-Alain Bois in his review of Angelica Zander Ruden-

stine's catalog of the Peggy Guggenheim collection. Bois sees an irreconcilable conflict between the application of Panofsky's method of iconology to modern and particularly abstract art and a more cautious approach that considers authorial intentions to be largely indecipherable.[6] Of these two, seemingly antithetical, critical stances, Kuspit has written: "The rivalry between positions is too great, the contempt of one for the other too deep, and the fatal play of the will to power between them too injurious . . . to allow the nominal reconciliation, the appeasement, of eclecticism to exist."[7]

But such a reconciliation does exist. In *The Aims of Interpretation*, for example, E. D. Hirsch makes a crucial reconciliatory distinction between meaning and significance.[8] Instead of using the terms interchangeably, as is often done, Hirsch gives them an added dimension. If, as Barthes claims, readers should replace the author's meaning with their own, will there not be as many meanings as there are readers? In such a situation, Hirsch asks, by what criteria, and on what methodological grounds, can any critical distinctions be made? No interpretations may be accepted or rejected; on the contrary, all interpretations remain equally "valid" or equally "invalid." The logical implication of Barthes's "birth of the reader" philosophy is the creation of a democratic, utopian view of interpretation, where ostensibly no view dominates and all voices are heard. But despite the appearance of tolerance, partisans of Barthes's mode of criticism still validate and invalidate, accept and reject specific types of interpretations or specific modes of criticism. In Barthes's view, any attempt to recover an author's intention, regardless of its success or failure, regardless of its epistemological problems, is unqualifiably defined as "tyrannical." But on what grounds? If all interpretations are equally valid, equally permissible, why should the attempt to recover authorial intention be any less valid or any less permissible? If one accepts—as Barthes does—that all interpretations are incurably subjective, and contingent on the spectator's response, how can one reader, or one mode of interpretation, be given prominence over another? How, then, does one methodologically justify labeling one method "tyrannical" and the other not? By what prerogative? Under the guise of liberation, of releasing interpretation from the tyranny of authorial intention,

Barthes imposes another form of tyranny. It becomes increasingly clear that his implementation of a methodological system to gauge the validity of interpretation by labeling one form of interpretation "tyrannical" does not eliminate privileging one mode of interpretation or one ideological stance—whether these are openly acknowledged or not.

If all approaches inevitably privilege one method at the expense of another, the investigator's responsibility, then, is to declare his or her method, his or her standard of validation at the outset. At this point, of course, any evaluative standard could be chosen. There is nothing to compel a critic to choose one way of evaluating an interpretation as opposed to another—it is as much a matter of philosophy as of choice. But according to Hirsch, the most plausible critical standard that may be privileged in evaluating the validity of interpretation is authorial intention—what he calls *meaning*. Of course, authorial intention is as arbitrary a standard as any other, but, in his view, its critical effectiveness derives from its standard conventional use in interpreting everything from judicial codes to religious texts, from doctor's orders to traffic regulations, from last wills and testaments to everyday speech in ordinary conversation. No other standard of evaluation can approach this kind of applicability; to be sure, in all such instances, the function of readers and listeners is to recover the intention behind the text and utterance, not to interpret it according to their own fancy. And although no interpretation can ever be entirely objective, or completely accurate, in Hirsch's view authorial intention remains (because of its wide applicability) the most plausible and stable standard against which to evaluate the subjectivity of interpretation. Thus Hirsch outlines his method and mode of validation at the outset. Indeed, it is more intellectually honest to validate or invalidate a specific mode of inquiry on the grounds of its correspondence to an already established and openly declared standard (such as authorial intention) than to insist, on the one hand, that all modes of interpretation are equally valid and, on the other, to paradoxically proceed by invalidating selected interpretations on the dubious grounds of their being "tyrannical."

If, moreover, art cannot be precisely defined, or objectively dis-

tinguished from non-art (a distinction, incidentally, most deconstruc-
tionists labor to destroy), Hirsch questions the logic behind applying
one evaluative standard (authorial intention) to traffic regulations,
conversational language, and the like and another, totally different
standard, for works of art. Not only is this dichotomy completely
arbitrary, but it would inescapably reinforce the very elitist division
between "high culture" and "popular culture" that the deconstruc-
tionists themselves have been at pains to call into question.

Thus, if one mode of interpretation must be privileged, as is
inevitably the case in all forms of criticism, Hirsch sides with authorial
intention. Indeed, the use of authorial intention has a wider applica-
bility than other modes of interpretation and relocates works of art
within the general realm of cultural products. But, despite his empha-
sis on original intention as the gauge of validity in critical interpreta-
tion, Hirsch nonetheless recognizes that works of art are more complex
than traffic regulations or conversational language; their value often
transcends the function for which they were originally intended. Each
period of history, moreover, reinterprets the products of civilization
according to the issues prevalent in and pertinent to their own day and
age. In the process, each period of history contributes its own in-
sights—different, surely, from authorial intention, but no less valid.
Indeed, with historical distance, an artist's work may appear all the
more intelligible when placed in a broader context of which the artist
may have been unaware. Since this realm inevitably lies outside that
of authorial intention, the issues it covers are distinct from those of
meaning. But since such issues may enhance the comprehension of,
say, an artist's position in history, they are no less important; this
realm is what Hirsch calls *significance*. Significance is how a work of
art relates to a broader context, to any context, in fact, beyond itself.

The question, then, is not to attribute more importance to meaning
than to significance but to avoid confusing one with the other. The
connotations attached to a work of art in a later century, or a scholar's
personal interpretation, should not be confused with the author's
intentions, and vice versa. Again, this is not to claim that they are
unworthy of critical consideration, only that they constitute a separate
and distinct realm. Interpretive problems will inevitably arise, how-

ever, because meaning is so difficult to decipher. Indeed, on the practical rather than theoretical level, the two realms may be much harder to separate. For example, an artist's influence on a later generation may have been unknown to him or her (thus obviously belonging to the realm of significance rather than meaning), but whether an artist was directly aware of, or consciously borrowed from, this or that visual or literary source is sometimes far from obvious. Often, if little direct evidence survives, it may be impossible to determine where meaning leaves off and significance begins—whether artists were involved in direct borrowing or simply affected by the general intellectual climate of their time.

If no evidence of the artist's intentions exists, and if no hypothesis may be convincingly presented, then interpretation remains in the realm of significance rather than in that of meaning proper. But if an intermediate situation occurs, the two realms, in the interpreter's mind, tend to overlap. The attempt to recover an artist's intentions may lead to broader issues, and, conversely, the analysis of broader issues is more often than not predicated on a suspicion about the artist's intentions. Not surprisingly, therefore, interconnections between, superimpositions of, and transgressions between the two realms inevitably occur. But since the ends and methodology of both areas of investigation are somewhat different, the separation of meaning and significance—from which this book borrows its title—will be adopted for the sake of clarity.

This distinction, in addition, may have particularly fruitful results when applied to the work of Jackson Pollock. Meaning and significance, in fact, correspond almost exactly to the two aspects of Pollock's work Kuspit had declared unexplained in the literature: "the importance of Pollock's allover paintings has not yet been firmly established, for their general character has not yet been made clear." For "general character" one can read "meaning," and for "importance" one can read "significance." The object of this book, therefore, is to hypothesize about and consider the complexities of Pollock's intentions *and* to place his work within a larger context. To attempt to recover Pollock's intentions implies covering his work from the vantage point of both style and iconography (and the possible interrelationships between the two) and addressing other issues Pollock may have considered pertinent to

his work—most importantly, the compatibility of meaning and abstraction. To place Pollock in a larger context is to relate his work to that of his contemporaries, to broader intellectual currents, and to determine its place in history by assessing its influence on the second half of the twentieth century. The reader should know at the outset, however, that the intention here is not to trace Pollock's life or his relationship to his family with the detail and thoroughness of a biography. For this reason, the reader is referred to B. H. Friedman's *Jackson Pollock: Energy Made Visible*, to Jeffrey Potter's *To a Violent Grave: An Oral Biography of Jackson Pollock,* and to Deborah Solomon's *Jackson Pollock: A Biography.* It is, furthermore, impossible to cover his oeuvre with the thoroughness either of a painting-by-painting chronological survey[9] or of a detailed study of a single period. The intention, rather, is a more global account of Pollock's work and of the critical issues it raises.

NOTES

1. A. Wallach, "An Oversimplified Portrait of Jackson Pollock," Review of Deborah Solomon's *Jackson Pollock: A Biography* (New York, 1987), *Newsday,* 16 August 1987, pp. 13, 16. I would like to thank Doris Forster for bringing this reference to my attention.

2. D. B. Kuspit, "To Interpret or Not to Interpret Jackson Pollock," *Arts Magazine* 53 (March 1979): 127.

3. Ibid.

4. E. Panofsky, "The History of Art as a Humanistic Discipline," in *Meaning and the Visual Arts* (Garden City, New York, 1955), 20–21.

5. R. Barthes, "The Death of the Author," in *Image—Music—Text* (New York, 1977), 147.

6. Y. A. Bois, "[Review of] Angelica Zander Rudenstine, *Peggy Guggenheim Collection, Venice,*" *Art Bulletin* 69 (September 1987): 484.

7. D. B. Kuspit, "Conflicting Logics: Twentieth-Century Studies at the Crossroads," *Art Bulletin* 69 (March 1987): 120.

8. E. D. Hirsch, *The Aims of Interpretation* (Chicago, 1976). The Introduction to the present study is not the place to summarize the long and complex arguments that have led Hirsch to this conclusion. For this reason, the reader is referred to the book directly. See also Hirsch's earlier *Validity in Interpretation* (New Haven, 1967).

9. For additional information on the individual works discussed in this book, the reader is referred to Francis V. O'Connor and Eugene V. Thaw, *Jackson Pollock: A Catalogue Raisonné of Paintings, Drawings, and Other Works* (New Haven, 1978).

PART ONE
MEANING

1
FORMATIVE WORK

When reviewing the development of (and interrelationships between) an artist's life and work, particularly those of an important artist, it is tempting, with the hindsight of history, to see early experiences and experiments as anticipations of later achievements. But Pollock's beginnings were modest. He was born Paul Jackson Pollock on January 28, 1912, on a sheep ranch in Cody, Wyoming—the fifth and youngest son of a Presbyterian couple of Scotch-Irish descent.[1] His father, LeRoy Pollock, never led a financially secure existence. Shortly after Jackson's birth, he left Cody with his family, never to return. Looking for opportunity, they moved six times in ten years: from Cody to San Diego (California) to Phoenix (Arizona) to Chico (California) to Janesville (California) to Orland (California) and finally to Los Angeles. Jackson never saw his birthplace again.

Nothing in this itinerant life-style, nothing, indeed, in Pollock's parents' profession, interests, and education would explain why all five brothers chose careers in the arts: Charles Cecil Pollock (born 1902) was a painter and teacher, Marvin Jay Pollock (born 1904) was a rotogravure etcher, Frank Leslie Pollock (born 1907) was a writer and commercial rose grower, and Sanford LeRoy Pollock (born 1909) was involved in painting, graphic arts, and silk-screening. Young Jackson, therefore, grew up in an environment where his brothers, if not his parents, were directly involved with art and with the issue of creativity.

In 1922 the eldest brother, Charles, left home to enroll at the Otis Art Institute in Los Angeles. Four years later, in September of 1926,

Charles left again to study at the Art Students League in New York with one of the most prominent American artists of the day: Thomas Hart Benton. Jackson would later follow his older brother's footsteps by moving to New York in 1930, joining him at the League, and studying under the same man. But before acquiring formal training in art, Pollock, as a youth, was in constant trouble. In 1927 he enrolled at Riverside High School but left a year later as the result of an argument with an ROTC officer. When the Pollocks moved to Los Angeles in 1928, Jackson entered Manual Arts High School and met Frederick John de St. Vrain Schwankovsky, a teacher who introduced him to mysticism, theosophy, and modern art. But if Pollock found a sympathetic personality or a possible mentor in Schwankovsky, the discipline of school life and the stress on athletics proved too oppressive for him. During the 1928–29 academic year, Pollock was expelled for his part in writing and distributing a pamphlet attacking the faculty and the school's emphasis on sports.[2]

Out of school, in the summer of 1929, Jackson worked at land surveying and road construction with his father. Working outdoors in the vast expanse of the western landscape probably gave the young Pollock a sensitivity to the natural environment—a feeling he would later speak of and a quality that, arguably, he attempted to re-create in his mature work. In the fall Pollock managed to re-enroll at Manual Arts but was expelled again. On October 22, he wrote his brothers Charles and Frank about his personal problems and his ambition to be an artist:

> I have been ousted from school again. The head of the Physical Ed. Dept. and I came to blows the other day. We saw the principal about it but he was too thick to see my side. He told me to get out and find another school. I have a number of teachers backing me so there is some possibility of my getting back. . . .
>
> If I get back in school I will have to be very careful about my actions. The whole outfit think I am a rotten rebel from Russia. . . . Altho I am some better this year I am far from knowing the meaning of real work. I have subscribed for the "Creative Art," and "The Arts." From the Creative Art I am able to understand you better and it gives me a new outlook on life. . . . I am

doubtful of any talent, so whatever I choose to be, will be accomplished only by long study and work. I fear it will be forced and mechanical. . . . I became acquainted with [Diego] Rivera's work through a number of Communist meetings I attended after being ousted from school last year. He has a painting in the museum now. Perhaps you have seen it, Dia de Flores. . . . I certainly admire his work. . . .

 As to what I would like to be. It is difficult to say. An Artist of some kind. If nothing else I shall always study the Arts.[3]

This letter reveals the social and academic frustrations of a sensitive yet rebellious young man, whose ambition, at seventeen years of age, was to devote his life to art. His leftist political sympathies probably drew him to the art of the Mexican Muralists, whose work would later play an important role in American art of the 1930s—particularly Pollock's, as will be shown later. But since none of Pollock's work of this period survives, it is impossible to determine whether he was influenced by the Mexicans as early as 1929 or what the nature and degree of this influence may have been.

In the spring of 1930, Schwankovsky helped Pollock return to Manual Arts, if only at part-time status. He took drawing and modeling classes in the morning and worked at home in the afternoon. This flexible arrangement may have been more agreeable to a youth hostile to authority, but, writing to his brother Charles on January 31, Pollock expressed his continuing difficulties with art and with finding a philosophy of life:

school is still boresome but i have settled myself to its rules and the ringing bells so i have not been in trouble lately. this term . . i have started doing some thing with clay and have found a bit of encouragement from my teacher. my drawing i will tell you frankly is rotten it seems to lack freedom and rythem it is cold and lifeless. it isn't worth the postage to send it . . . the truthof it is i have never really gotten down to real work and finish a piece i usually get disgusted with it and lose interest . . . altho i feel i will make an artist of some kind i have never proven to myself nor any body else that i have it in me.

this
so called happy part of one's life youth to me is a bit of damnable
hell if i could come to some conclusion about myself and life
perhaps then i could see something to work for . . . the more i read
and the more i am thinking the darker things become. i am still
interested in theosophy and am studying a book light on the path
every thing it has to say seems to be contrary to the essence of
modern life but after it is understood and lived up to i think it is
a very helpful guide.[4]

Pollock's study of modern literature is reflected in the liberties he
takes with spelling, grammar, and punctuation. But more important
are the psychological implications of this letter. Nothing in the early
biographical information about Pollock suggests he would become one
of the most important artists of the later twentieth century. Unlike
Picasso, with whom he is often compared, he was no prodigy. He was
restless and bored and a slow learner. He found social intercourse
difficult and must have greatly missed his eldest brother's encourage-
ment during the latter's extended trips to New York.

That June Charles returned to Los Angeles for the summer. He
and Jackson took this opportunity to travel to Pomona College to see
José Clemente Orozco's fresco *Prometheus*. Charles's presence had a
positive impact on his troubled younger brother. Not only could he
encourage young Jackson, but, at that time, the two must have de-
cided that, to relieve Jackson's dissatisfaction with himself and his
work, he had to leave Manual Arts altogether. Thus when Charles
returned to New York in the fall, Jackson accompanied him. On Sep-
tember 29 Pollock registered at the Art Students League in Thomas
Hart Benton's class: "Life Drawing, Painting, and Composition."
Thomas Hart Benton, with John Steuart Curry and Grant Wood, were
among the most important practitioners of Regionalism—what may be
interpreted as an artistic equivalent to America's policy of isolationism
during the 1930s. Benton defined his intentions as the promotion of
"an indigenous art with its own aesthetics [as] a growing reality in
America."[5] He claimed that reality must be the artist's only inspira-
tion; and to Benton reality was specifically American. This is not to
imply that Benton was ignorant of European art. On the contrary, he

himself studied in Europe and returned in the 1910s deeply influenced by the American abstractionist Stanton McDonald Wright's paraphrases of Robert Delaunay's Orphism. But the experimental phase of Benton's career was short-lived; indeed, he later said of this period, "I wallowed in every cockeyed ism that came along and it took me ten years to get all that modernist dirt out of my system."[6] Typical of Benton's constant diatribes against modern art, moreover, was his condemnation of the Alfred Stieglitz circle as "an intellectually diseased lot, victims of sickly rationalization, psychic inversions, and God-awful self-cultivations."[7]

In place of European modernism, Benton offered a realistic art that celebrated the values of rural America. He urged his students to travel through the United States, and often did so himself, to discover the local color of native American subject matter. Pollock took his teacher's advice and made two such sketching trips in 1931.

Despite his rather dogmatic personality, Benton took to Pollock almost immediately. Perhaps Pollock, a boy from Wyoming, personified some of the very qualities Benton was striving to invest in his own work. And, in spite of Pollock's later embrace of abstraction and repudiation of his teacher's style, the two men remained friends and corresponded until Pollock's death in 1956. Benton's influence on Pollock's formative work was strong in both style and content. Pollock's early paintings [1] reveal his interest in Benton's curvilinear undulating rhythms and in rural American subject matter. It should be noted, if only parenthetically, that this specific stylistic and thematic combination is typical not only of Benton's work but of other American Regionalist artists as well. Indeed, although Benton, like Grant Wood and John Steuart Curry, rejected abstraction in favor of realism, their overall compositions and figural proportions are often deliberately distorted and elongated, creating a rather singular manneristic effect.

Benton, moreover, while repudiating abstraction to concentrate on the "primary reality of American life,"[8] actually taught his students to generate dynamic compositions through abstract means.[9] Benton intentionally structured his paintings to lead the spectator's eye naturally from one element to the other without interruption. In this endeavor he encouraged his students to compose patterns of arcs and half-circles in rhythmic sequences of shifts and countershifts—first

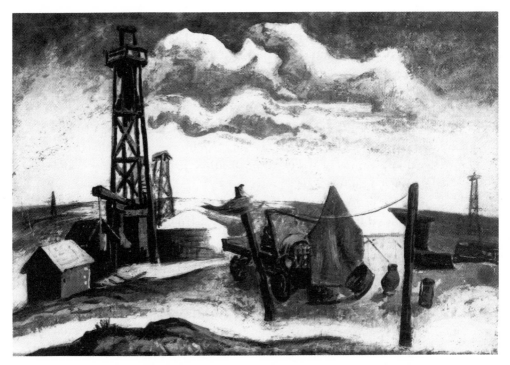

1. Jackson Pollock, *Camp with Oil Rig* (c. 1930–33). Mr. and Mrs. John W. Mecom Collection.

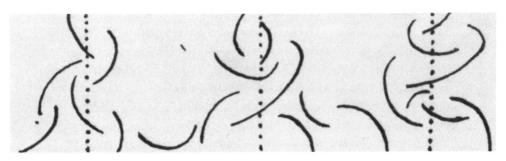

2. Thomas Hart Benton, *Compositional Diagram*, from *The Arts (1926)*.

revolving around an imaginary axis, or pole, then spreading across the entire picture space [2]. The spectator's natural predisposition, then, would be to complete the interrupted rhythms in imagination by following the curves from one side of the canvas surface to the other. Thus the anomalous distortions of Benton's paintings may be partially explained by the abstract rhythmic exercises he used as the core of his rather singular teaching methods—many of the diagrams for which he was simultaneously publishing in the periodical *The Arts*.[10] Not surprisingly, Pollock, who once accused his own drawing of lacking rhythm and being "cold and lifeless,"[11] absorbed a great deal from Benton's techniques. Under Benton's tutelage, he studied and made copies after old-master compositions such as those of El Greco and Rubens, particularly stressing rhythm and dynamic movement.

Benton later stated that although "Jack did not have a logical mind . . . he did catch on to the counterpuntal logic of occidental form construction quite quickly. In his analytical work he got things out of proportion but found the essential rhythms."[12] Pollock's obvious debt to Benton is evident in the *Composition with Figures and Banners* [3], a dynamic composition punctuated by Bentonian poles. Of course, Pollock was later to make dynamic rhythm the characteristic quality of his mature style. From *Mural* [33] of 1943 to *Autumn Rhythm* of 1950 [55], the Bentonian devices of shift and countershift are consistently maintained. Although Pollock would later call Benton's work "something against which to react very strongly"[13] and said Benton "drove his kind of realism at me so hard I bounced right into non-objective painting,"[14] the rhythmic qualities of Pollock's mature style are still visually and conceptually indebted to the pictorial devices of his teacher. Even more compelling, however, is the persistence, nearly twenty years after his apprenticeship with Benton, of the pole motif in Pollock's painting *Blue Poles* [4]. Referring to this work in a letter to Francis V. O'Connor, Benton thought it highly unlikely that anyone other than Pollock—or, more precisely, anyone who had not studied composition with him— would have used the device. He also explained that the poles were always erased, and sometimes imagined, but never made part of the final composition as Pollock did. And although Benton considered the inclusion of this preparatory device in a finished painting to be a "purely

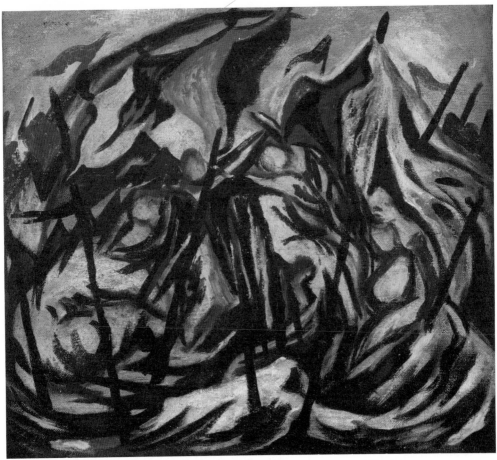

3. Jackson Pollock, *Composition with Figures and Banners* (c. 1934–38). Pollock/Krasner Foundation. Courtesy Jason McCoy Galleries, New York.

Pollock concept,"[15] he nonetheless concluded that the only possible precedents were his own teaching diagrams.[16]

For Pollock, however, the pictorial devices of shift and counter-shift may have meant more than the visual application of compositional dynamics to a two-dimensional picture plane. When applied to the study of human anatomy, moreover, the poles stood for the skeleton and the shifts and countershifts for the concavities and convexities of muscular undulations. Among Benton's students, these specifically became known as the "hollows" and the "bumps." Alex Horn, a classmate of Pollock's under Benton, recalled that "the 'hollow' and the 'bump' had a symbolic significance like 'yin' and 'yang.' It expressed for us the polarity from negative recessive softness to positive solid projecting forcefulness."[17] It thus appears that these mechanical models were far more significant than mere studio devices or compositional tricks. Indeed, Benton claimed a direct connection between pictorial rhythms and the biological rhythms of nature:

> Forms in plastic construction are never strictly created. They are taken from common experience, re-combined and re-oriented. This re-orientation follows lines of preference also having definite biological origin. Stability, equilibrium, connection, sequence movement, rhythm symbolizing the flux and energy are main factors in these lines. In the "feel" of our own bodies, in the sight of bodies of others, in the bodies of animals, in the shape of moving and growing things, in the forces of nature and in the engines of man the rhythmic principle of movement and counter-movement is made manifest.[18]

Hence Benton's compositional devices functioned as a metaphor as well as an infrastructure for his pictorial depictions of the pulse and dynamics of modern American life.

For Pollock, who later associated his mature abstractions with the "rhythms of nature,"[19] the intimate—and metaphorical—connection between pictorial and natural dynamics may have been particularly appealing. But however indebted his early and even mature works are to Benton, Pollock and his teacher were of different artistic temperaments. Even in his transcriptions of Bentonian depictions of the Amer-

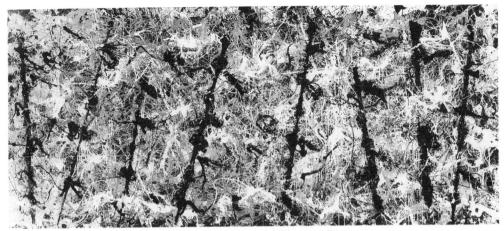

4. Jackson Pollock, *Blue Poles* (1952). Australian National Gallery, Canberra.

ican scene, such as *Camp with Oil Rig* [1], Pollock hardly celebrates the energy and vitality of rural existence. The predominantly somber palette and the strong contrasts of light and dark make Pollock's painting a scene of desolation and economic poverty—a view perhaps more sensitive to the actual condition of America during the depression than Benton's more optimistic attitude. Thus, although Pollock would identify with nature no less strongly than Benton, his vision is more romantic, more tragic. The depiction of experience would never satisfy him; nor would the depiction of the American Scene; art, he would later say, was not a question of illustration.[20] In the final analysis, it is perhaps not surprising that Benton's example—which Pollock, as he matured, described as something he reacted against vehemently—would be followed only in terms of compositional arrangements and rhythmic dynamics rather than in terms of subject matter. This does not imply, however, that the associations Benton attached to his pictorial devices—their suggestions of the organic, the biological, and the dynamic—would be lost on Pollock. On the contrary, even if Pollock reacted against his former teacher and decried illustration in favor of abstraction, he would speak of his own mature poured paintings in a manner not dissimilar to Benton's own specific references to flux, rhythm, energy, and so forth.

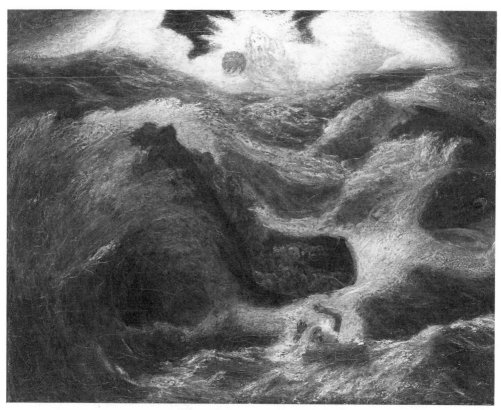

5. Albert Pinkham Ryder, *Jonah* (c. 1900). National Collection of Fine Arts, Smithsonian Institution, Washington, D.C.

6. Jackson Pollock, *Landscape with Rider* (1933). Lost.

7. Jackson Pollock, *Landscape with Rider II* (1933). Lost.

In December 1932 Benton left the League to execute mural commissions in Indiana, and as the 1930s progressed, Benton's influence on Pollock gave way to that of the romantic nineteenth-century painter Albert Pinkham Ryder [5],the only American artist Pollock later admitted being interested in.[21] In the two versions of *Landscape with Rider* of 1933 [6, 7]—the title of the works being a possible pun on the man who influenced him—Pollock takes up the theme of the human individual in nature. The composition is carefully constructed with an inverted pyramid in the center and the arching tree, on the left, and the rider, on the right, acting as closing parentheses. The rhythmical undulations are reminiscent of Benton, but the dark colors, the loose handling of paint, the thick impasto, and, above all, the evocation of death by the inclusion of the animal skeleton at the foot of the tree are reminiscent of Ryder. In counterdistinction to Benton, it seems that the evocation of nature includes an element of the tragic for the young Pollock.

In two later works, *Solitude* [8] and *Seascape* [9], both of around 1934, Pollock adapts the theme of the storm-tossed boat typical of Ryder and Romanticism in general.[22] Like Ryder, Pollock produced images of humanity, isolated and vulnerable, at the mercy rather than in control of the elements. Again, the theme of the individual's relationship to nature appears to be Pollock's main thematic preoccupation—one that will occupy him and recur in different guises throughout his artistic career. What is unusual and never to be repeated, however, is Pollock's execution, as in the rider and seascape paintings, of the same motif in two versions identical in every respect except style. One seems deliberately more controlled, the other more dynamic, one more linear, the other more painterly. Since only one of these paintings, *Seascape*, is dated and both Rider landscapes are lost, there is insufficient evidence to determine which version came first, whether one was intended as a preliminary sketch, or whether both versions were conceived as independent works of art. But since the mature Pollock never worked from sketches, and was apparently not in the habit of doing so, it may be more plausible to posit that Pollock's proclivity toward experimentation led him to create various versions of the same theme, if only to discover the style most appropriate to his

8. Jackson Pollock, *Solitude* (c. 1934–38). Courtesy Jason McCoy Galleries, New York.

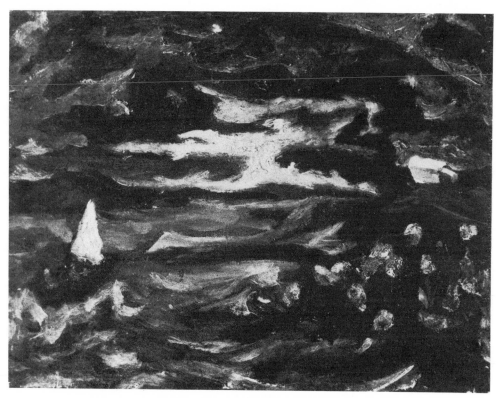

9. Jackson Pollock, *Seascape* (1934). Pollock/Krasner Foundation. Courtesy Jason McCoy Galleries, New York.

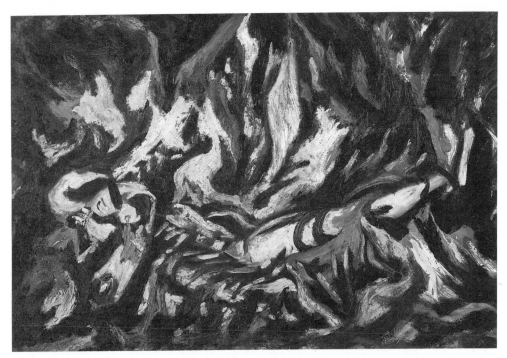

10. Jackson Pollock, *The Flame* (c. 1934–38). Museum of Modern Art, New York.
Enid A. Haupt Fund.

subject. As becomes progressively evident in his later works, he opted for the dynamic and the painterly.

His concern with the essentially negative or destructive side of nature continues in *The Flame* [10], unsigned and undated. The painting is reminiscent of Orozco, while the application of paint is reminiscent of Ryder. Pollock uses thick impasto and limits his color scheme to red, yellow, black, and white. He appears to paint impulsively, with even less refinement and care for finish than Ryder. The surface is rough and irregular; the effect is raw, even violent. This impression, moreover, is underscorded by the spectator's unusually close vantage point; indeed, not even given a safe distance from which to observe the scene, the spectator is almost inescapably immersed in the destructive side of nature's forces. In addition, the painting reveals Pollock's increasing propensity toward abstraction, his thematic interest in nature, and his stylistic concern for dynamic composition and the physical properties of paint.

Even more abstract and prophetic is *Composition* [11] of approximately 1934–38. Pollock again uses the same restricted color scheme but disregards representational content altogether. He even anticipates what Clement Greenberg was later to call the "allover"[23] quality of his mature style—a radical compositional format that dispenses with visual centers of attention. Even if its appearance is precocious and its ramifications not fully felt until the mid- to late 1940s, Pollock's tendency toward allover composition reveals his inclination to decentralize the focal points in his paintings and to work toward the increasingly non-narrative and anti-illusionistic.

Thus, by the middle of the 1930s, Pollock's experiments took him well beyond his early attraction to Benton and Ryder. But despite his sometimes rapid stylistic development, these were difficult years for Pollock. America was in the middle of the Great Depression, and employment, particularly as an artist, was in short supply. Pollock supported himself with odd jobs: cleaning Augustus Saint-Gaudens's statue of Peter Cooper in Cooper Square, working as a janitor, and even stealing. By 1935, however, the Roosevelt administration allocated sufficient funds to employ eligible artists in government programs. On August 1st of that year, Pollock was able to join the easel

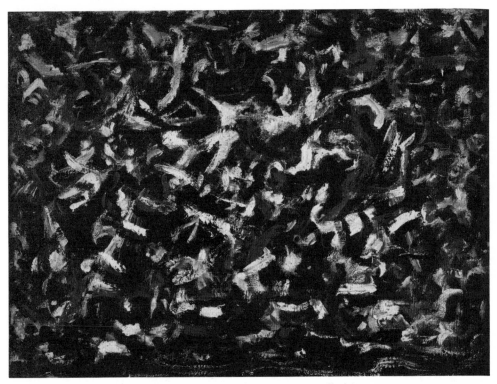

11. Jackson Pollock, [*Allover Composition*] (c. 1934–38). Pollock/Krasner Foundation. Courtesy Jason McCoy Galleries, New York.

division of the Federal Art Project of the Works Progress Administration (WPA). Pollock stayed on the WPA until its termination in 1943, with occasional and extended interruptions, mostly due to hospitalization for alcoholism.

Among the over five thousand artists employed at one point or other by the Project were, in addition to Pollock, many of the most important future Abstract Expressionists: Arshile Gorky, Willem de Kooning, Lee Krasner, William Baziotes, Adolph Gottlieb, Mark Rothko, and Philip Guston. Hitherto unemployed artists could earn a secure income and devote their time to their work by periodically submitting a preordained number of paintings, eventually to be allocated to public buildings. In addition to providing artists with greater financial security, the Project was meant, in the words of its director, Holger Cahill, to integrate "the arts with the daily life of the community."[24] Olin Dows, the chief of the Treasury Relief Art Project from 1935 to 1938, recalled that the inspirational model for the American Art Projects was the immensely popular mural program in Mexico, which employed artists at workmen's wages.[25] Mexican artists, the most prominent being Diego Rivera, José Clemente Orozco, and David Alfaro Siqueiros, frequently visited and even executed commissions in the United States. Pollock's first contact with the Mexican Muralists, as mentioned above, occurred when he was still in his teens. Reuben Kadish, a sculptor Pollock befriended during high school, recalled how "Siqueiros coming to L.A. meant as much then as the Surrealists coming to New York in the forties."[26] Pollock himself was an admirer of Orozco since the 1930s[27] and it is also likely that he saw Orozco at work, since both he and Benton—for whom Pollock was posing—were simultaneously executing frescoes at the New School for Social Research in the fall of 1930.

Orozco's influence is evidenced in Pollock's untitled work of around 1938–41 [12], which, in general effect and composition, echoes Orozco's fresco at Dartmouth College: *Gods of the Modern World* [13] of 1932–34.[28] In both works, a massive skeleton dominates the spectator's visual field. But if Pollock borrows motifs and compositional arrangements from Orozco, their artistic intentions have little in common. Mexican artists like Orozco created collective rather than

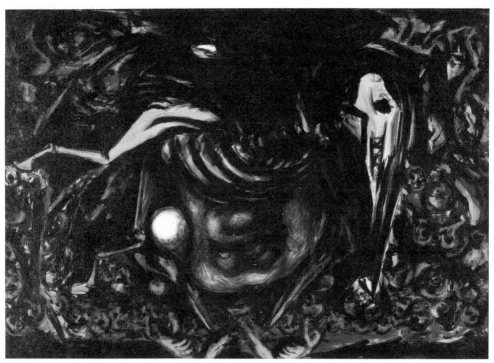

12. Jackson Pollock, *Bald Woman with Skeleton* (c. 1938–41). Pollock/Krasner Foundation. Courtesy Jason McCoy Galleries, New York.

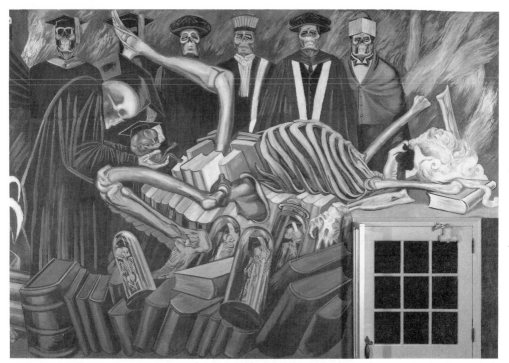

13. José Clemente Orozco, *Gods of the Modern World* (1932–34). Courtesy the Trustees of Dartmouth College, Hanover, New Hamsphire.

individual works and mostly thought of art as a direct means to trans-
mit a Marxist sociopolitical message. Orozco once stated that "the
highest most logical, the purest form of painting is the mural. It cannot
be a matter of private gain; it cannot be hidden away for the benefit
of a certain privileged few. It is for the people, it is for ALL."[29]
Indeed, Orozco's mural at Dartmouth is a violent and scathing attack
on academia and its role in the power structure of the United States.
The spectator is witness to a birth scene of a skeletal race of academi-
cians; the picture space is littered with books and homunculi, in aca-
demic regalia, encased and preserved in formaldehyde. But if the
Mexican Muralists' aim was to communicate a public, unambiguous,
and politically charged message comprehensible to the masses, Pol-
lock, in the end, was no more influenced by their leftist ideology than
by Benton's conservatism. Pollock's painting contains no discernible
trace of a political statement. His works are ambiguous, private rather
than public, psychological rather than sociological, vague rather than
specific. This is not to imply that Pollock, in the 1930s and 1940s, did
not have leftist political sympathies. On the contrary, all the evidence
seems to suggest that he did,[30] but it appears that for him art and
politics were always distinct and separable preoccupations.[31]

What Pollock did find in Mexican Muralism was powerful artistic,
rather than political, expression. Its visual and stylistic examples pro-
vided a way out of the parochial and prosaic qualities of Bentonian
Regionalism. Thus, when Siqueiros arrived in New York in February
of 1936 and opened an experimental workshop in April, "A Labora-
tory of Modern Techniques in Art,"[32] Pollock decided to join. In
working with Siqueiros, Pollock chose, whether consciously or not, the
most extremist of the three Mexicans. But his interest may have been
less in Siqueiros's political ideas than in his radical innovations in the
realm of technique. Indeed, one of his major visual preoccupations
was an artistic element with which Pollock already had a great deal
of experience: dynamic rhythm. Not surprisingly, the modern move-
ment Siqueiros was most attracted to was Futurism.[33] The emotional
pulse of the painting was, for Siqueiros, an extension of its visual
rhythm. He considered his murals to be forerunners of an art of the
future, an art that, in his words, "will be Baroque or, better still,

post-Baroque; for it will be dynamic, it will be morbid, passionate and impetuous."[34] His goal was to move spectators emotionally by moving them physically—the observer, he thought, had to be engaged by and interested in the entire structure. In his view, the entire space was critical; the composition should be generated by and arranged according to an anticipation of the spectator's movement across the picture plane. The mural would change appearance as the spectator changed position. For the effect to be successful, moreover, the work would have to be seen from a multiplicity of perspectives, and, as the result of the spectator's motion, the work would create, in Siqueiros's words, a "monumental dynamic . . . polyfaceted . . . in living action."[35]

Besides reinforcing concepts of rhythm with which he may have already been familiar from Benton, Pollock's participation in the workshop also exposed him to the use of new techniques of applying paint and to the exploitation of new industrial materials in the creation of works of art. New materials included the substitution of oil paint for plastic substances such as Pyroxiline[36] and nitrocellulous pigments.[37] New techniques, as Alex Horn, a colleague of Pollock's at the workshop, recalled, were numerous:

> Spurred on by Siqueiros, whose energy and torrential flow of ideas stimulated us to a high pitch of activity, everything became material for our investigation. For instance: lacquer opened up enormous possibilities in the application of color. We sprayed through stencils and friskets, embedded wood, metal, sand and paper. We used it in thin glazes or built it up into thick gobs. We poured it, dripped it, splattered it, hurled it at the picture surface. It dried quickly, almost instantly, and could be removed at will even though thoroughly dry and hard. What emerged was an endless variety of accidental effects. Siqueiros soon constructed a theory and system of "controlled accidents."[38]

Although Pollock participated in such free experimentation, there is no visual evidence of any direct appropriation of such methods in the paintings executed during or shortly after 1936. Even if it were possible to convincingly interpret the Workshop experiments as an anticipation of some of the hallmarks of Pollock's mature style—the use of

large scale, the poured technique, and the use of synthetic paints—one would nonetheless have to account for a ten-year hiatus between cause and effect.

This notable discrepancy between Pollock's radical experiments and his more conservative finished paintings (at least in the 1930s) may be largely due to Siqueiros's own attitude. Like Benton, he never considered his abstract works or dynamic compositional devices as artistic statements valuable in and of themselves. They were, quite simply, techniques utilized in the process of discovering new effects to be later included in his murals, whose ultimate purposes were to communicate a comprehensible but highly charged sociopolitical message. For Pollock, however, art was more of a private and personal rather than a public or political matter. Sharing neither Benton's conservative nor Siqueiros's radical ideas, he had no political ideology or cause at whose service he could put these innovations. His original contribution, although it came about a decade later, was to make explicit all of the possibilities implicit in these early experiments; to see them as artistic ends in themselves rather than as elements ostensibly subordinate to a political ideology.

Still on the issue of politics, it is surprising that the stylistically violent and socially critical art of the Mexican Muralists was not only being commissioned in the United States but that it successfully found its way into its corridors of power. In 1931, for example, Pollock wrote his brother Charles about his other brother Sanford's desire to see a Rivera mural in San Francisco, only to find it "impossible, it being in a private meeting room for the stock exchange members."[39] The Mexicans took every opportunity to exploit the situation by criticizing the very institutions that commissioned them. The Orozco murals at Dartmouth are a case in point. Another is Rivera's 1933 commission to paint a fresco at the entrance of the RCA Building in New York's Rockefeller Center. Nelson Rockefeller watched as Rivera painted a large portrait of Lenin, Marx, Trotsky, Stalin, and other revolutionaries. This time, however, Rivera had gone too far. No longer able to criticize his patrons with impunity, he was banned from the scaffold, and the mural was destroyed.[40]

During the course of the 1930s, the political motivations of the

Mexican Muralists were becoming increasingly evident. Moreover, it is ironic that those Mexican Muralists who originally provided the inspiration for the American Federal Art Projects ultimately caused their undoing. Their highly critical and politically charged art was eventually considered inflammatory and dangerous. The liberal mood was changing: Audrey McMahon, director of the New York section of the WPA from 1935 to 1943, remembered that

> the growing unease in the Congress concerning the size of the relief appropriations and the prevalent conviction that the WPA in general, and Federal Project No 1, in particular, were communist dominated, presaged our demise. The fact that some of our artists liked and emulated revolutionary Mexican painters including Diego Rivera, Orozco, and Siqueiros lent fuel to the flame.
>
> This was the period during which "Investigating Committees" and "Witch Hunts" flourished and the colonel [Brehon Somervell, a local administrative official on orders from Washington] had me on the carpet repeatedly, demanding to know the names of Communists on the Project, and requiring their summary dismissal.[41]

Such an account, although from a person in a position of authority, nonetheless coincides with the tone of a letter written by Sanford Pollock on May 22, 1940 describing his own and Jackson's condition on the Project: "We on the Project have been forced to sign a affidavit to the effect that we belong to neither the Communist or Nazi parties. A wholly illegal procedure. They are dropping people like flies on the pretense that they are Reds, for having signed a petition about a year ago to have the C. P. put on the ballot. We remember signing it so we are nervously awaiting the axe. They got 20 in my department in one day last week."[42]

But the Project was not only politically repressive, it was artistically regressive. Although a community of artists under Burgoyne Diller—the head of the WPA mural division—were devoted to abstract art, Olin Dows remembers that the subject matter requested for WPA competitions was supposed to deal with "local history, past and present, local industry, . . . or landscapes," and that paintings were

required to represent such institutions as the postal service, with "considerable human and dramatic significance as a concrete link between a community of individuals and the federal government."[43] Art was predominantly realistic and topical—like Benton's. Since its function was public, art had to be accessible to a large audience. Although some who have written about the WPA insist that no pressures were exerted on artists to work within any specified stylistic or thematic category,[44] Rosalind Bengelsdorf Browne, an artist employed by the WPA in New York from 1935 to 1939, recalled that "the majority of the membership . . . was engaged in illustrating social commentary about American Depression Scene—what they termed 'art for the proletariat.' They were really alien to an abstract art form that seemed remote from human problems."[45]

But the WPA was not only politically oppressive and generally opposed to abstract art. According to some, artists in general "were treated as beggars by the relief-oriented policies of the WPA, . . . their creative problems were not understood, and their work grossly undervalued."[46] These contemporary accounts are quoted not to paint a one-sided, negative picture of the Federal Art Projects—Pollock himself later acknowledged his gratitude to the WPA for "keeping me alive during the thirties"[47]—but to compensate for the predominantly uncritical appraisal of this period in the Abstract Expressionist literature. Dore Ashton, for example, in *The New York School: A Cultural Reckoning*, wrote that the WPA established an unprecedented community of artists and quoted the head of the Public Works of Art Project, Edward Bruce, as saying: "A check from the United States government meant much more than the amount to which it was drawn. It brought to the artist for the first time in America the realization that he was not a solitary worker. It symbolized a people's interest in his achievement. . . . No longer was he, so to speak, talking to himself."[48]

Although the WPA undoubtedly sustained many artists financially during the depression, the account just quoted neglects to mention the political harassment or limitations on artistic freedom imposed by the same institution. This is not to imply that all previous accounts of the effect of the WPA on the Abstract Expressionist generation are overly romanticized and, therefore, false. But it is evident that schol-

ars should not generalize about the WPA experience, particularly since comments like Edward Bruce's conflict with contemporary reminiscences such as this one:

> By 1940, quite a number of artists were ready to cut loose. Special meetings and seminars to discuss the esthetic quality of our work could have been arranged. Ideas could have been exchanged and we could all have profited by coming to grips with basic problems. As it was, we had an uncomfortable sense of working in isolation, despite our occasional meetings at the shop, and the feeling that the administration had an aloof attitude toward our production. In a real sense, we found ourselves working in a vacuum. We created our prints, and that was the end of it. We never received information about the allocation of our work, and to this day most artists don't know where their prints can be found. The artists needed encouragement, a little nudge now and then to stimulate them . . . but the administration gave no sign.[49]

The idea—pervasive in the literature on Abstract Expressionism—that the WPA experience was uniformly positive for the artist in general must be revised. Without a doubt, the financial support and security of employment did assist artists during an economically difficult period. But mere subsistence was not always enough. Many of the Abstract Expressionists in particular eventually defined their later artistic aims in direct opposition to the ones encouraged by the WPA. And although it would, again, be dangerous to generalize (since Pollock may have considered the experience positive), Robert Motherwell, in conversations with William Seitz, created a diagram representing "an impression of the true chronology and of the separate clusters that taken together are sometimes called Abstract Expressionism." At the very top of the diagram, Motherwell wrote, "Politics: None—Hatred of the WPA."[50] Thus, according to Motherwell, Abstract Expressionism was apolitical, and, by extension, its members hated WPA politics. This is an important and particularly revealing statement and requires further elucidation.

Since Motherwell was not on the Project, his statement may be more accurately interpreted as an example of the general Abstract Expressionist dislike of the politically charged realism of American

Scene painting championed by the WPA, rather than as a specific indictment of the WPA's financial support of artists. Because of its stylistic rejection of European modernism, American Scene depictions would prove unpopular among Abstract Expressionist artists. But particularly distasteful were the conscious conservative political connotations and implicit chauvinism associated with the rejection of abstraction in favor of the more accessible, realistic, and indigenous American Regionalist style. The nationalistic program of depicting something topical and typically American became, at best, a sign of chauvinism and, at worst, identified with the ideological excesses of Nazi Germany. Barnett Newman, in an unpublished essay entitled "What about Isolationist Art?" written in 1942, insisted that "isolationism, we have learned by now, is Hitlerism. Both are expressions of the same intense, vicious nationalism. . . . [Both use] the 'great lie,' the intensified nationalism, false patriotism, the appeal to race, the re-emphasis of the home and homey sentiment. . . . Art in America today stands at a point where anything that cannot fit the American Scene label is doomed to be completely ignored."[51]

Indeed, some typically nationalistic Regionalist work looked dangerously close to Nazi art. Pollock, in a somewhat milder version, reiterated the same point in 1944 by stating, "The idea of an isolated American painting, so popular in this country during the thirties, seems absurd to me, just as the idea of creating a purely American mathematics or physics would seem absurd."[52] Both Pollock and Newman's statements would explain the motivations behind the Abstract Expressionist rejection of the aesthetic and political agenda underlying Regionalist art. That such conservative ideologies proved unappealing to the members of the New York School is not altogether surprising; what remains perplexing, however, is Motherwell's other claim relating to the Abstract Expressionists' renunciation of any political involvement, since Pollock, for one, obviously harbored strong leftist sympathies in this period.

During the 1930s, disillusionment with leftist politics in general, and what caused many politically committed artists and intellectuals to renounce politics altogether, was directly related to the domestic and foreign policy of the Soviet Union. Communist parties in the West

were shocked by the Moscow Trials of 1936–38, where prominent intellectuals—Leon Trotsky among them—were accused of treason. By 1939, moreover, Stalin signed a nonaggression pact with Hitler and invaded Finland, a neutral country. Disillusioned by Stalin's betrayal of the revolution, artists left the Communist party and politics in general.[53] Edward Laning, an artist active during the period and a participant in the WPA, remembered: "The steam had gone out of the revolutionaries. What had made the change? It was the Hitler-Stalin pact of 1939. My old revolutionary friends had been left with nothing to paint. Stalin had pulled the rug from under their feet. With nothing to say, they decided to paint for painting's sake, merely to push and pull the paint on the picture surface."[54] The touch of irony notwithstanding, this statement accurately describes how the historical situation in the 1930s and 1940s led to the aesthetic depoliticization of American artists during the years leading up to World War II. After the Hitler-Stalin pact, artists like Mark Rothko and Adolph Gottlieb considered both communism and fascism examples of "totalitarianism of thought and action," which used the artist as a mere "craftsman who may be exploited."[55] By the 1940s, artists, hitherto socially conscious during and following the depression era, turned away from the realistic depiction of social problems and embraced European modernism. This attitude was not restricted to artists. It affected the American intelligentsia in general and leftist intellectuals such as the art historian Meyer Schapiro and the critic Clement Greenberg[56]— the latter exclaiming that "anti-Stalinism which started out more or less as Trotskyism turned into art for art's sake, and thereby cleared the way, heroically, for what was to come."[57] It was as if artists had become convinced that, to make an original and powerful statement, they had to declare their independence from political ideology and their refusal to be manipulated by politics. In their view, abstract art was the most plausible way to engender this position. Indeed, Pollock's wife, Lee Krasner, recalled that most of the artists she knew in this period

> were sympathetic to the Russian Revolution—the socialist idea against the facist idea, naturally. Then came complications like Stalinism being a betrayal of the revolution. I, for one, didn't feel

my art had to reflect my political point of view. I didn't feel like I was purifying the world at all. No, I was just going about my business and my business seemed to be in the direction of abstraction.[58]

But, of course, the attempt to engage a nonpolitical attitude is itself political. The stylistic and thematic strategies employed by the Abstract Expressionist generation could themselves be interpreted as their own political manifestos against what they saw as the repressive ideologies of the WPA. Art critics such as Clement Greenberg, for one, would attach ideologies and agendas to abstract art no less political in their ramifications than those attached to art produced by the WPA. In the final analysis, perhaps Motherwell's statement should read: "Politics: Hatred of the WPA" rather than "Politics: None—Hatred of the WPA." Indeed, in 1943, when the WPA was shut down, Pollock was already working within a modern idiom.

NOTES

1. F. V. O'Connor and E. V. Thaw, *Jackson Pollock: A Catalogue Raisonné* (New Haven, 1978), 4 vols. Vol. 4, p. 203 (hereinafter referred to as CR followed by a volume number). For additional biographical information on Pollock's life, see also B. H. Friedman, *Jackson Pollock: Energy Made Visible* (New York, 1970); J. Potter, *To a Violent Grave: An Oral Biography of Jackson Pollock* (New York, 1985); and D. Solomon, *Jackson Pollock: A Biography* (New York, 1987).

2. See CR4, pp. 206–7.

3. Ibid., pp. 207–8.

4. Ibid., p. 209.

5. T. H. Benton, *An Artist in America* (Kansas City, Mo., 1951), quoted in H. Rand, "The 1930's and Abstract Expressionism," in *The Genius of American Painting* (New York, 1973), 254.

6. Friedman, op. cit., 18.

7. Ibid.

8. Benton quoted in M. Baigell, "Thomas Hart Benton in the 1920's," *Art Journal* 29 (Summer 1970): 426.

9. For an excellent and more detailed discussion of this phenomenon, see S. Polcari, "Jackson Pollock and Thomas Hart Benton," *Arts Magazine* 53 (March 1979): 120–24.

10. T. H. Benton, "The Mechanics of Form Organization," *The Arts* 1 (November 1926): 285–89; 2 (December 1926): 340–42; 3 (January 1927): 43–44; 4 (February 1927): 95–96; 5 (March 1927): 145–58.

11. CR4, p. 209.

12. Benton, quoted in F. V. O'Connor, "The Genesis of Jackson Pollock," *Artforum* 5 (May 1967): 17.

13. J. Pollock, "Jackson Pollock: Answers to a Questionnaire," *Art and Architecture* 61 (February 1944): 14.

14. Pollock quoted in "Unframed Space," *New Yorker* 26 (5 August 1950): 16.

15. Polcari, op. cit., 124.

16. Ibid.

17. A. Horn, "Jackson Pollock: The Hollow and the Bump," *Carleton Miscellany* 7 (Summer 1966): 81.

18. Benton, quoted in Polcari, op. cit., 123.

19. Friedman, op. cit., 228.

20. See CR4, pp. 250, 253.

21. CR4, p. 232

22. L. Eitner, "The Open Window and the Storm-Tossed Boat," *Art Bulletin* (1953): 281–90.

23. C. Greenberg, "The Crisis of the Easel Picture," in *Art and Culture* (Boston, 1965), 155.

24. Quoted in F. V. O'Connor, *Federal Art Patronage 1933 to 1943* (University of Maryland Art Gallery, College Park, Md., 1966), 29.

25. O. Dows, "The New Deal's Treasury Art Program: A Memoir," in F. V. O'Connor, ed., *The New Deal Art Projects: An Anthology of Memoirs* (Washington, D.C., 1972), 14.

26. Friedman, op. cit., 12.

27. In the early 1930s, Pollock considered Orozco's *Prometheus* as the "most important twentieth century painting" (ibid., 29).

28. O'Connor, "The Genesis of Jackson Pollock," 23.

29. Quoted in D. Ashton, *The New York School: A Cultural Reckoning* (New York, 1972), 38. See also A. Reed, *The Mexican Muralists* (New York, 1960), 24.

30. CR4, p. 208: "I became acquainted with Rivera's work through a number of communist meetings I attended." See also p. 225 for Sanford's letter to Charles that he and Jackson had signed petitions to have the Communist party put on the ballot.

31. On this point, Lee Krasner, in an interview with Bruce Glaser, *Arts Magazine* 41 (April 1967): 37: "Many of us took part in demonstrations and sit down strikes. In fact, I was arrested many times myself. But as far as I can see this had no connection with my painting. My experience with Leftist movements in the late 1930's made me move as far away from them as possible because they were emphasizing the most banal provincial art. They weren't interested in an independent and experimental art, but rather linked it to their economic and political programs."

32. L. P. Hurlburt, "The Siqueiros Experimental Workshop: New York, 1936," *Art Journal* 35 (Spring 1976): 238.

33. A. Rodriguez, *A History of Mexican Mural Painting* (New York, 1969) 384.

34. S. M. Goldman, "Siqueiros and Three Early Murals in Los Angeles," *Art Journal* 23 (Summer 1974): 321–27.

35. Hurlburt, op. cit., 238.

36. Rodriguez, op. cit., 379.

37. Hurlburt, op. cit., 243.

38. Ibid., 241–42. In addition to Horn's recollections, Mervin Jules remembered Siqueiros's practice of preparing panels by splattering and dripping on them so that the abstractly patterned underpainting would stimulate the figurative imagery to follow. Quoted in Friedman, op. cit., 38.

39. CR1, p. 211.

40. Laning, E. "The New Deal Mural Projects," in O'Connor, ed., *The New Deal Art Projects*, 82–83.

41. A. McMahon, "A General View of the WPA Federal Art Project in New York City and State," in O'Connor, ed., *New Deal Art Projects*, 74.

42. CR4, p. 225.

43. Dows, op. cit., 36.

44. J. Kainen, "The Graphic Arts Division of the WPA Federal Art Project," in O'Connor, ed., *New Deal Art Projects*, 166.

45. R. Bengelsdorf-Browne, "The American Abstract Artists and the WPA Federal Art Project," in O'Connor, ed., *New Deal Art Projects*, 223–24.

46. Kainen, op. cit., 166.

47. CR4, p. 248.

48. Quoted in D. Ashton, *The New York School*, 46.

49. Kainen, op. cit., 173.

50. W. Seitz, *Abstract Expressionist Painting in America* (Cambridge, Mass., 1983), 168–69. A similar view was related by Jack Tworkov: "The project [WPA] itself had a depressing effect on me. I don't mean the people who administered [it], but the artists on the project were nearly all connected with organizations under the Artists Union and the Artists Congress. These things had a terribly depressing effect on me, although I participated in them. By the end of the thirties I was incredibly weary of the constant phoniness of the ideological life in New York." Quoted in Richard Armstrong's "Jack Tworkov's Faith in Painting," in *Jack Tworkov: Paintings 1928–1982* (Pennsylvania Academy of Fine Arts, Philadelphia, 1987), 19.

51. Quoted in T. B. Hess, *Barnett Newman* (Museum of Modern Art, New York, 1971), 35. See also note 31.

52. CR4, p. 232.

53. I. Sandler, *The Triumph of American Painting: A History of Abstract Expressionism* (New York, 1970), 12.

54. Laning, op. cit., 112.

55. M. Rothko and A. Gottlieb, "Statement of Principles," 1940. Federation of Modern Painters and Sculptors Papers, Archives of American Art, Smithsonian Institution, Washington, D.C.

56. See S. Guilbaut, *How New York Stole the Idea of Modern Art* (Chicago, 1983), esp. chap. 1.

57. C. Greenberg, "The Late 1930's in New York," in *Art and Culture*, 230.

58. B. Rose, *Lee Krasner* (Museum of Modern Art, New York, 1983), 37.

2
SURREALISM

During the late 1930s—the precise date is unknown, since many of Pollock's early works are undated, and insufficient evidence exists to date them—Pollock's stylistic and thematic interests shifted from the works of Benton, Ryder, and the Mexican Muralists toward those of Picasso and the Surrealists. Surrealism was unlike any artistic movement or aesthetic ideology Pollock had been exposed to in the past. Drawing inspiration from the psychoanalytic writings of Sigmund Freud, its members were as concerned with literary and psychological ideas as with pictorial ones. Particularly taken with the discovery of the unconscious—of a hidden, repressed layer of the human personality—the Surrealists attempted to make psychoanalytic findings central to both the creation and interpretation of works of art.

After World War I, opinion was gaining ground that the increasing industrialization and mechanization of Western society, which for many promised to improve the material and intellectual condition of humanity, had in actuality only brought about the unprecedented devastation of the Great War. Disillusioned by the very idea of human rationality and technical progress, the Surrealists sought to recover the primal, unconscious, and instinctual side of humanity by deliberately circumventing interference from and censorship by its socially acceptable rational side. Thus, like their psychoanalyst counterparts, the Surrealists attributed increasing importance to modes of behavior functioning outside the confines of social conventions: the inexplicable dream, the phobia, the fantasy, the slip of the tongue, the unexpected association, and so on. Indeed, whatever acted outside the repressive limits of reason or excessive socialization—however superficially

meaningless—ostensibly held the key to evaluating human behavior and understanding the human mind. In November 1922, in an attempt to define the aesthetic premises of Surrealism, André Breton, the founder and leader of the movement, wrote: "By [Surrealism], we mean a certain psychic automatism that corresponds rather closely to the state of dreaming, a state that is . . . extremely difficult to delimit."[1] By 1924 Breton wrote an official Surrealist manifesto, defining automatism as the expression of "the real functioning of the mind . . . in absence of any control exercised by reason."[2] But, as in psychoanalysis, the free and unrestricted play of the unconscious was not enough. The psychic health of human individuals, and their effective functioning within social institutions, are predicated on a successful integration of the pleasure-seeking drives of the unconscious, on the one hand, and the rational and pragmatic orientation of the conscious mind, on the other. "I believe," Breton added, "in the future resolution of the states of dream and reality, in appearance so contradictory, in a sort of absolute reality, or *surréalité.*"[3] On the practical level, however, the artistic implementation of the Surrealists' desire to reintegrate the conscious and unconscious mind would bifurcate along two distinct stylistic lines: automatism, the random improvisation or wandering of the hand without conscious control on the canvas or paper surface, of which Joan Miró and André Masson are prominent examples; and the realistic depiction but irrational juxtaposition of images in dreamlike situations, of which Salvador Dali and René Magritte are prominent examples—while other artists, such as Max Ernst and Yves Tanguy, vacillated between the two styles.

With its iconographical emphasis on broader psychological rather than exclusively political issues,[4] and on a poetic, imaginary "superior reality" rather than on the banality of everyday experience, Surrealism catalyzed young American artists to circumvent what they saw as the banal and prosaic stylistic solutions and thematic interests of Regionalism or Social Realism. In addition to setting a significant artistic example in the form of paintings, sculptures, manifestos, and so forth, many important modern European and Latin American artists fled war-torn Europe and settled in the United States. Among them were Matta, Yves Tanguy, Kurt Seligmann, Max Ernst, Pavel Tchelitchew,

Marc Chagall, André Breton, and André Masson. The immediate presence of such already respected masters of modern art in New York could only have encouraged the younger Americans to familiarize themselves with Surrealist doctrines and engage in stylistic experiments of their own. Indeed, in 1944, when asked about the importance and possible implications of this new proximity between European and American artists, Pollock replied:

> I accept the fact that the important painting of the last hundred years was done in France. American painters have generally missed the point of modern painting from beginning to end. . . . Thus the fact that good European moderns are now here is very important, for they bring with them an understanding of the problems of modern painting. I am particularly impressed with their concept of the source of art being the unconscious. This idea interests me more than these specific painters do, for the two artists I admire most, Picasso and Miró, are still abroad.[5]

This quote reveals not only Pollock's appreciation of modern art and his familiarity with Surrealist ideas concerning art and the unconscious but his general admiration for Picasso—the most pervasive influence on his early career.

Picasso, particularly in *Guernica* and its studies (exhibited at the Valentine Gallery in New York in 1939), demonstrated how the language of modern art and the subject of myth could be applied to, and were not incompatible with—as the Regionalists had claimed—making a powerful statement on the nature of things. In addition, Picasso's rather idiosyncratic eclecticism encouraged a broader and less restrictive pictorial and iconographical approach than the topical depictions of Benton and the Mexican Muralists. An awareness of Picasso, in turn, specifically led to, and went hand in hand with, an awareness of non-Western art. In 1937, moreover, Pollock read an article entitled "Primitive Art and Picasso" in the April issue of the *Magazine of Art*. He was so taken with the piece that he uncharacteristically decided to seek out its author, John Graham, a man who would later befriend the artist and exercise an important influence upon him. A Russian-born aristocrat, intellectual, artist, collector, and theoretician, Graham re-

inforced the Surrealist fascination with the unconscious and particularly praised Picasso for emulating and sustaining a visual dialogue with "primitive" art. In his article, Graham argued that "primitive races and primitive genius have readier access to their unconscious mind than so-called civilized people. It should be understood that the unconscious mind is the creative factor and the source and storehouse of power and of all knowledge, past and future."[6] And "Picasso's painting," in Graham's opinion, "has the same ease of access to the unconscious as have primitive artists—plus a conscious intelligence."[7] Thus, if modern artists wanted to elicit the unconscious, no better inspiration could be found than in artistic forms created by non-Western cultures, since, according to Graham, their relationship to the unconscious was already manifest.

But Graham's knowledge of modern and non-Western art (and his ideas concerning the possible interrelationships between the two) may not have impressed Pollock as much as his mastery of psychological ideas, particularly those of Jung and Freud. The importance of Freud's writings to the Surrealists has already been mentioned. Automatism, free association, and accidents were among the many devices used to elicit repressed unconscious imagery, quite often of a sexual nature. But Graham's references to "primitive" art and to the unconscious as a "storehouse of power and of all knowledge, past and future" are conceptually closer to Jung than they are to Freud. Even if Freud saw ancient myths as examples of psychological and sexual fixations—the tale of Oedipus, for instance—it was really Jung who understood them as archetypal manifestations of what he called the collective unconscious. In Jung's view, that all myths, regardless of geographical origin or chronological period, display striking thematic similarities could not be mere coincidence; on the contrary, these similarities supplied enough evidence to posit the existence of a universally inherited level of the psyche, a collective unconscious common to humanity as a whole. Thus, although according to both Jung and Freud, children and primitives have readier access to the unconscious than "civilized" and excessively conditioned adults, the symbolic character of the collective unconscious emerges in and is accessible through archaic myths and dreams.

For artists increasingly disillusioned by right- and left-wing poli-
tics—and suspicious of the reactionary political connotations attached
to realism in the years leading up to the Second World War—Jungian
ideas, Surrealism, and primitivism converged to establish a different
worldview and an alternative aesthetic. As a result, evocations of the
unconscious and references to the mythical gradually replaced Ameri-
can Scene painting as the central subject of early Abstract Expression-
ism. The intellectual impact of Jungian ideas on New York School
artists, moreover, is nowhere better expressed than in a collective
statement made by Mark Rothko and Adolph Gottlieb, with possible
collaboration from Barnett Newman:

> If our titles recall the known myths of antiquity, we have used them
> again because they are the eternal symbols upon which we must
> fall back to express basic psychological ideas. They are the symbols
> of man's primitive fears and motivations, no matter in which land
> or what time, changing in detail but never in substance, be they
> Greek, Aztec, Icelandic, or Egyptian. And modern psychology
> finds them persisting in our dreams, our vernacular, and our art, for
> all the changes in the outward conditions of life. . . . The myth holds
> us . . . because it expresses to us something real and existing in
> ourselves.[8]

Because of its purported universality and timelessness, ostensibly re-
vealing psychological truths common to humanity as a whole, myth
became one of the quintessential Abstract Expressionist subjects of
the 1940s.

Pollock's work was no exception. A clear derivation from Picasso[9]
and Masson,[10] Pollock's *Head* of 1941 [14], for example, is a thematic
reference to the mythical figure popular among the Surrealists and the
title of their most important periodical: *Minotaure*. Residing in the
labyrinth (symbolic of the recesses of the unconscious mind), the off-
spring of human and animal sexual relations and the devourer of
young virgins, the Minotaur was the perfect Surrealist symbol. Half-
man, half-beast, the Minotaur could represent the instinctual, bestial,
and primal side of the human personality—the Freudian id unchecked
and unrestrained by the civilized and rational ego. But in spite of these

14. Jackson Pollock, *Head* (c. 1938–41). Pollock/Krasner Foundation. Courtesy Jason McCoy Galleries, New York.

connotations, it is difficult to generalize about, or impose a single meaning on, the figure of the Minotaur. For Picasso the Minotaur was also a private symbol. Not only symbolic of the inner conflicts of the human mind, the Minotaur could stand for the artist's own alter ego. Not only some psychological principle in the abstract, or direct evidence of the collective unconscious, but something he knew to be part of his individual personality. In addition, by including the Minotaur (and bull) in the context of the bullfight, Picasso inevitably connected them to a heritage characteristically Spanish in theme and origin.[11]

Pollock's use of the Minotaur, however, is iconographically less specific; no suggestion of either a spatial or narrative context is even provided. Pollock also makes his image more brutal than either Picasso's or Masson's. He emphasizes the texture of the pigment by painting loosely, almost violently—even leaving scratches and marks visible on the canvas surface. In addition, he restricts his color scheme to a dark monochrome, with just a few touches of red, yellow, and blue, and pushes the bull's head right up to the picture plane in direct confrontation with the spectator. The color scheme, the articulation of the features, and the general appearance of this work are also somewhat reminiscent of Northwest Coast Indian masks [15]. In fact, Pollock was known to have a great appreciation of non-Western art and owned a vast library on the subject.[12] In a 1944 interview, moreover, Pollock acknowledged being impressed by the plastic qualities of American Indian art. "The Indians," he said, "have the true painter's approach in their capacity to get hold of appropriate images, and in their understanding of what constitutes painterly subject matter. Their color is essentially Western, their vision has the basic universality of all art."[13] But if Pollock admired American Indian art, and never denied its general influence on his work, he warned, in the same interview, that the references to American Indian art and calligraphy some people found in parts of his pictures weren't "intentional"; they probably were "the result of early memories and enthusiasms."[14] But even if direct quotations from non-Western art are rare in Pollock's work, certain visual similarities do exist. The curved mouth and row of teeth in the Eskimo mask (which was also reproduced by Graham in "Primitive Art and Picasso") may well have influenced the repeated

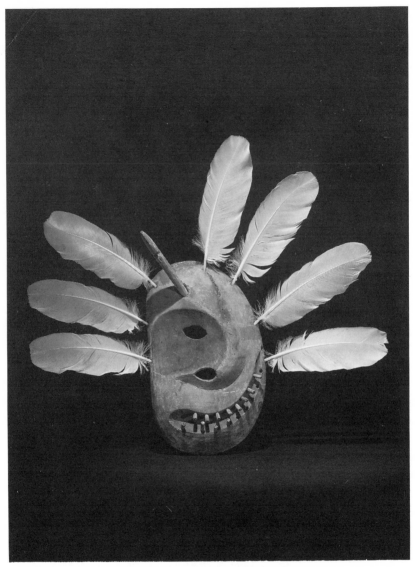

15. *Eskimo Mask* (c. 1900). University Museum, University of Pennsylvania, Philadelphia.

16. Jackson Pollock, *Birth* (c. 1938–41). Tate Gallery, London.

teethlike strokes in *Head*, as well as the central forms in another painting, *Birth* [16].

The conflation of man and beast, and suggestions of the mythical and the primitive, evidenced in *Head* are not isolated incidents. They are Pollock's most consistent thematic preoccupations in his surrealist period. Indeed, both concerns reemerge in the 1943 painting *The She-Wolf* [17], a conscious or unconscious echo in pose and content of the Etruscan sculpture of the same subject [18]. Pollock evokes a myth where the human—the baby is barely discernible at the extreme left of the composition—is protected, nurtured, and mothered by the animal. But even if the thematic assimilation of human and animal may have appealed to Pollock, and reengendered iconographical concerns already evident in *Head*, *She-Wolf* can hardly be said to function as an illustration of a specific scene or psychological concept. Pollock's impulsive manner of painting obstructs clarity; the many layers of paint obscure the forms, and specific iconographical exegesis becomes impossible. The artist himself, even when this painting was chosen to be illustrated in Sidney Janis's book *Abstract and Surrealist Art in America*, refused to comment on this work, claiming, "*She-Wolf* came into existence because I had to paint it. Any attempt on my part to say something about it, to attempt explanation of the inexplicable, could only destroy it."[15]

However reluctant the artist may have been to explain his work, an attitude common to the Abstract Expressionists in general, his overall thematic concerns increasingly alternate between suggesting intimate relationships between human and animal and aggressive ones. Indeed, this iconographic interest recurs in *Wounded Animal* of 1943 [19], a rare instance of a direct borrowing from a prehistoric source. Although initially difficult to decipher, as with the majority of Pollock's work of this period, the painting depicts an undefined animal wounded by arrows or spears—a motif directly traceable to a book in Pollock's possession:[16] Baldwin Brown's *The Art of the Cave Dweller*, which included illustrations of prehistoric paintings such as the *Wounded Bison* from the caves at Niaux, France [20].[17] Although Pollock's work is a clear instance of assimilating a specific motif from a non-Western source, artists of his generation generally believed that

quotations from "primitive" art were hardly sufficient to suit their aesthetic purposes. Rothko and Gottlieb, in the statement previously mentioned, wrote that while modern art was first inspired by the "forms of primitive art, we feel that its true significance lies not merely in formal arrangements, but in the spiritual meaning underlying all archaic works. . . . the fancies, the superstitions, the fables, . . . strange beliefs, . . . of primitive man."[18] To the Abstract Expressionists, it was thus conceptually insufficient, if not intellectually inept, simply to borrow or to quote stylistic characteristics from non-Western proto-types—perhaps what they mistakenly thought Picasso was doing.[19] Indeed, they frequently sought and ascribed increasing importance to understanding the aesthetic decisions and intellectual motivations *behind* the very shapes and forms they were assimilating.

What importance, beyond the stylistic connection, Pollock may have ascribed to his specific appropriation of the Bison image is, of course, largely conjectural. But if Rothko and Gottlieb's statement was symptomatic of concerns shared by the Abstract Expressionists as a whole, one may hypothesize that Pollock's interest was more than simply formal. If Pollock had taken the trouble to read the passages accompanying the illustration of the Bison image, he would have learned that in his book Brown describes the painting as an example of what he considers a widely practiced phenomenon in non-Western cultures: sympathetic magic. In his view, the primal mind perceives no intrinsic difference between real objects and their corresponding images or representations. So strong are these connections, Brown argues, that object and image are often confused. Progressively the idea evolved that acting upon one could simultaneously affect the other: magic by imitation—a practice, incidently, also explained in two other books in Pollock's possession, Frazer's *Golden Bough*[20] and an anthology entitled *The Making of Man: An Outline of Anthropology*.[21] In the specific example of the Bison, for instance, it was believed that a hunter's chances of success would be vastly improved if the particular prey desired was depicted in advance and its image subsequently "killed"—the target would ostensibly be hit as easily as the wounds were inflicted on the painting.

If Rothko and Gottlieb's statement about the anthropological

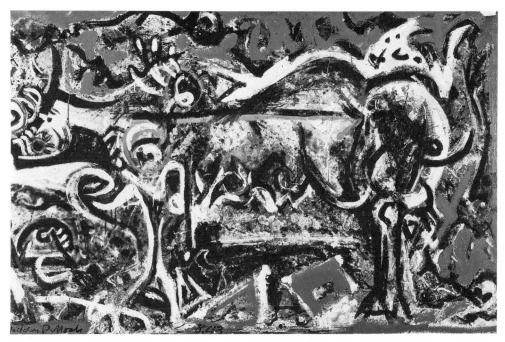

17. Jackson Pollock, *The She-Wolf* (1943). Museum of Modern Art, New York. Purchase.

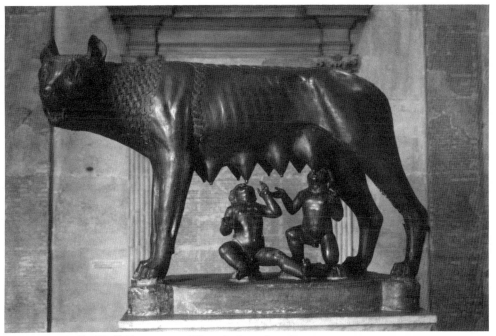

18. *She-Wolf* (Etruscan, c. 500 B.C.). Capitoline, Rome.

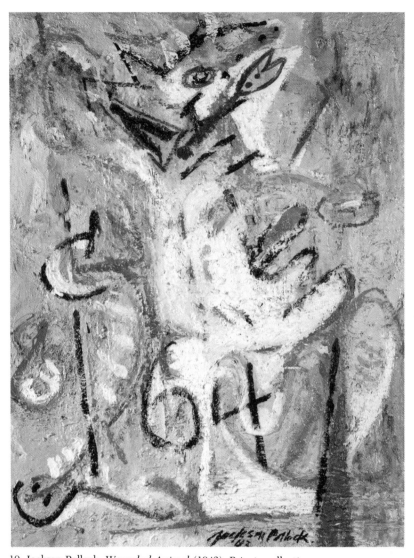

19. Jackson Pollock, *Wounded Animal* (1943). Private collection.

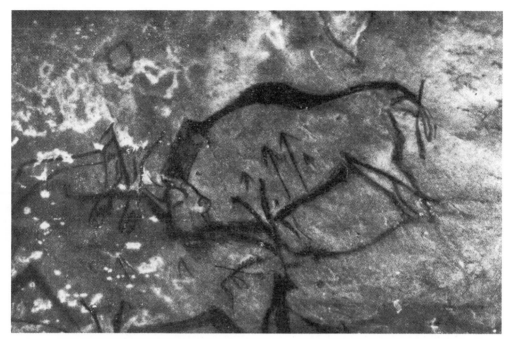

20. *Wounded Bison* (prehistoric, c. 10,000 B.C.). Niaux, France.

interests of New York School artists is to be interpreted at face value, Pollock, then, did not simply borrow a "primitive" motif. He may have integrated an idea considered central to prehistoric thought into his work: that art is magical rather than decorative, that its ritualistic purpose underscores how art in preindustrial society was not marginal to but functioned as an integral part of ordinary existence—and, ultimately, that art is a force effectively capable of altering reality in some preconceived and precalculated way. Yet even if this example exemplifies Pollock's interest in non-Western mentality as well as in non-Western art—a tendency consistent with Rothko and Gottlieb's statement—the absence of commentary on Pollock's part regarding the relationship between art and reality prevents any direct connection between the philosophy described above and Pollock's paintings in general. Any such connection, therefore, must remain purely speculative.

The theme of animals in conflicting situations, however, recurs frequently in Pollock's drawings of the period, where, even more than in his paintings, Pollock reveals his artistic debt to Picasso. An undated and untitled drawing [21], for example, quotes almost literally from Picasso's images of animal brutality [22]. Although the iconography of the horse and bull was extrapolated from the specifically Spanish context of the bullfight, Picasso often abstracted them from this situation, as in the *Minotauromachy* and *Guernica*. Represented together, these animals act out a tense dialectic between aggressor and victim, brutality and innocence, violence and submission. And even when Picasso's intentions were (either generally or specifically) political—as in *The Dream and Lie of Franco* or *Guernica*—his concern was always with the antagonistic nature, rather than the external trappings, of political conflict. What may have appealed to Pollock was not only Picasso's capacity to transfer meanings to animal protagonists but his tendency to make conflicts metaphorical rather than literal, implicit rather than explicit.

But even less specific than Picasso's oblique references to the Spanish civil war, the meanings of Pollock's drawings are personal, never political. They were, in fact, made to serve a rather unorthodox function. Pollock was a violent alcoholic and was frequently hospital-

ized for treatment. As a result, early in 1939 he entered psychoanalysis with Dr. Joseph Henderson, a follower and analysand of Jung's. Considering his previous exposure to Jungian thought through John Graham, it is very likely that Pollock was positively predisposed toward this kind of therapy. But despite Pollock's general sympathy with Jungian ideas, Henderson found it difficult to communicate with the normally quiet and taciturn Pollock. As a solution, it was later decided that the artist would bring in his drawings to encourage discussion and facilitate therapy. This does not necessarily imply, of course, that Pollock drew especially for his analytic sessions. On the contrary, it is more likely that Pollock simply brought Henderson examples from what would otherwise have been his normal production. In a letter to Pollock's biographer, B. H. Friedman, dated November 11, 1969, Henderson recalled the situation:

> It sounded as if I had set Pollock the task of portraying the unconscious in these drawings. This was not the case. He was already drawing them, and when I found it out, I asked for them. He brought me a few of the drawings each time in the first year of treatment, and I commented on them spontaneously, without establishing any therapeutic rules. He did not have free associations, nor did he wish to discuss his own reactions to my comments. He was much too close to the symbolism of the drawings to tolerate any real objectivity towards them. I had to be content with saying only what he could assimilate at any given time, and that was not much. There were long silences. Most of my comments centered around the nature of the archetypal symbolism in his drawings. I never could get onto a more personal level with him, until after he stopped bringing the drawings. So you see my role was mainly to empathize with his feeling about the drawings and share his experience without trying to "interpret" them in the ordinary sense. They provided a bridge to communication, and it gave him the assurance that at least one other person understood something of their abstruse language.[22]

Henderson makes several important points besides describing Pollock's reluctance to talk. The most significant is that the drawings

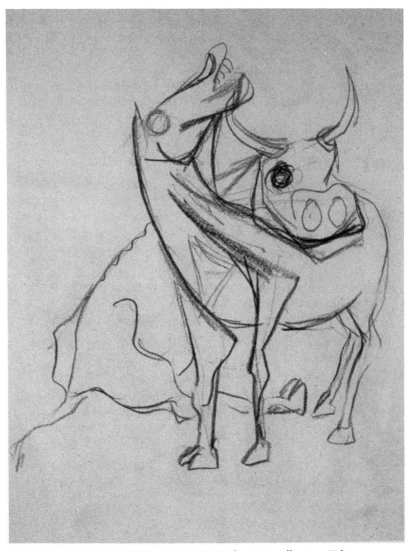

21. Jackson Pollock, *Untitled* (c. 1939–40). Noriko Togo collection, Tokyo.

22. Pablo Picasso, *Bullfight* (1934). Private collection.

used during analysis are not, and should not be considered, a distinct category in Pollock's work. Henderson later added that "all of Pollock's work was highly subjective. The drawings in my collection are no more revealing or more subjectively colored than any of his paintings or other drawings done during the three or four years following his work with me."[23] In other words, the drawings used in analysis are no different from, and display the same stylistic and thematic concerns as, Pollock's other paintings and drawings of the same period.

The second of Henderson's important points is that most of his comments "centered around the nature of the archetypal symbolism" of the drawings. Such a statement, and the very fact of Pollock's undergoing Jungian psychoanalysis, have made these wrongly called "psychoanalytic drawings" central to the recent investigations of a psychologically oriented group of art historians, whose exegetical objective has been to elucidate the specifically Jungian content of Pollock's early iconography. Implicit in their methodology is the belief, articulated most succinctly by Elizabeth Langhorne, that "the imagery in Jackson Pollock's early work is not only remarkably specific, but lends itself to quite precise interpretation in light of Jungian psychology."[24] A typical example of the interpretive strategy of Pollock's Jungian critics is the use of numerological symbolism. Elizabeth Langhorne, for instance, interprets the following markings from Pollock's 1942 painting *Stenographic Figure* [23] as the numerical equation $66 = 42$. She explains further that

> Jung notes that the number 6 traditionally represents the hermaphrodite, or fusion of male and female [Jung, C. G. *The Practice of Psychotherapy*, Collected Works 16, Princeton, N.J., 1966, p. 238, no. 8]. The number 4 traditionally represents the totality of the self [Jung, C. G. *The Integration of the Personality*, New York, 1939, pp. 40–41; Jung, C. G. *Psychology and Alchemy*, New York, 1953, p. 26]. For Pollock the totality of the self is achieved by the union of two. Thus the numerical formula $66 = 42$ can be seen as yet another statement of Pollock's desire for a union of opposites.[25]

But to elucidate paintings, or specific forms within paintings, by

23. Jackson Pollock, *Stenographic Figure* (c. 1942). Detail. Museum of Modern Art, New York.

referring to obscure passages in Jung's writings (some of which were published only after Pollock's death in 1956) is, first, incompatible with Langhorne's own admission that Pollock most likely did not read Jung.[26] And, second, a close analysis of the painting in question reveals that the marks were created by squeezing pure pigment directly from the tube and by applying paint in a highly rapid and spontaneous manner, somewhat akin to Surrealist automatism, rather than in the highly deliberate manner one would expect from a learned allusion to an obscure psychological text. Furthermore, Langhorne isolates one set of marks out of context; the rest of the strokes on the painting, those perhaps unsusceptible to Jungian exegesis, are left paradoxically unexplained.

William Rubin, commenting critically on the tendency to interpret Pollock's paintings in a Jungian mode, noted that an artist who was deeply influenced by Surrealist ideas, who spent four years (1938–42) in Jungian analysis, and who incorporated references to primitive art and to mythology in his work must have been aware, if only generally, of Jung's theory of the collective unconscious. After all, Pollock himself stated: "I've been a Jungian for a long time."[27] But, although Rubin does not dispute the general influence of the psychologist, he objects to Langhorne's assumption, without adequate evidence, of Pollock's familiarity with Jungian principles, to her references to Jungian texts Pollock most likely never read, and to her assuming Pollock's "saturation in Jungian thought while under Jungian analysis"[28] without knowledge of what actually occurred during those sessions.

Donald Gordon, however, did ask Pollock's therapists about the analytic sessions. Henderson, who saw Pollock from early 1939 to mid-1940, replied: "My treatment was supportive and I did not consciously discuss Jung or Jungian theories with him," while Violet Staub de Lazlo, who saw Pollock from the fall of 1940 to the winter of 1942–43, said: "We rarely discussed abstract concepts, nor do I recollect discussing archetypes since I wished to avoid intellectualization."[29] These remarks appear to substantiate Rubin's thesis. But, curiously enough, Henderson's remark in 1980—"I did not consciously discuss Jung"—blatantly contradicts his previously quoted 1969 letter

to B. H. Friedman, where he wrote that the majority of his comments "centered around the nature of the archetypal symbolism in his drawings."[30] What, then, accounts for this rather obvious reversal?

It is perplexing that the heated debate about Pollock's possible Jungian symbolism has not included any mention of the lawsuit between Lee Krasner, Pollock's widow, and Joseph Henderson. During the late 1960s, as Pollock's fame spread, Henderson decided to sell the drawings that had accumulated in his files. He first contacted the Pollock estate, which, after deliberation, decided not to purchase the drawings. Henderson finally sold them in 1969 to the Maxwell galleries in San Francisco, which in 1970 organized an exhibition and published a catalog entitled *Jackson Pollock: Psychoanalytic Drawings*. The show later traveled to the Whitney Museum of American Art in New York, at which point Lee Krasner sued Henderson for violating the privacy of his patient by revealing confidential information about the analysis. Henderson eventually won the case, but in the process he had to prove the irrelevance of the drawings to the analytic sessions, their autonomy as "art" rather than their validity as psychological material, and their general lack of Jungian content. He argued all this even though two years earlier, in 1968, he had delivered a lecture, "Jackson Pollock: A Psychological Commentary," using these very drawings as the basis for his psychological diagnosis. It may be argued, therefore, that Henderson's need to disassociate the drawings from the analysis after the lawsuit explains the inconsistency between his 1968–69 statements and those of 1980. His statements prior to 1970 ("Most of my comments centered around the archetypal symbolism in his drawings"), unaffected by the legal issues that would be raised at the trial, might therefore be closer to what actually transpired between analyst and patient.

This is not to imply an unjust trial. After all, in the 1967 Pollock retrospective at the Museum of Modern Art, two of Henderson's drawings were exhibited—presumably with Lee Krasner's consent, if not her direct approval. Nor is this to imply that Langhorne's assumptions about Pollock's specific Jungian iconography are still methodologically tenable. But if the drawings were used in therapy, they had to serve some psychological purpose. Henderson, at least, seems to

have considered them symbolic, judging by his 1968 lecture, in which he said:

> I am astonished to realize how little I troubled to find out, study, or analyze his [Pollock's] personal problems in the first year of his work with me, and especially do I wonder why I did not seem to try and cure his alcoholism, which remained such a problem all his life. I have decided that it is because his symbolic drawings brought me strongly into a state of counter-transference to the archetypal material he produced. Thus I was compelled to follow the movement of his symbolism as inevitably as he was motivated to produce it.[31]

The point at issue, however, is the specific nature of this symbolism. In Pollock's oeuvre the only drawing known to illustrate specifically a Jungian principle is a small pencil sketch [24], where Pollock associated yellow with intuition, blue with thinking, green with sensation, and red with emotion and feeling. Although Pollock made these colors coincide with the four functions described by Jung, scholars have generally paid little attention to this sketch.[32] Yet its significance may lie in Pollock's use of this drawing as the basis for a near-identical, but larger and colored, gouache [25], which Pollock decided to give Henderson as a going-away present when the doctor left for California. Henderson quite possibly suggested these meanings directly to his patient; in this case, the doctor, so Pollock must have thought, would understand the painting's general significance.

Even if such a direct illustration of a Jungian principle is a rather isolated example in Pollock's work, it suggests that the artist was not altogether psychologically innocent. When he flirted with Surrealism in the early 1940s, moreover, Pollock and Lee Krasner met with Motherwell, William Baziotes, Matta, and their wives to engage in games of automatic drawing and poetry. The group played the game of *Cadavre exquis*—or Exquisite Corpse, the sequential creation of a drawing by several artists, each unaware of the previous contributions—and executed and interpreted automatic drawings.[33] In conversation with David Rubin, Lee Krasner recalled that despite being the least talkative of the group, Pollock was the one who interpreted many

24. Jackson Pollock, *Untitled* (c. 1939–40). Private collection.

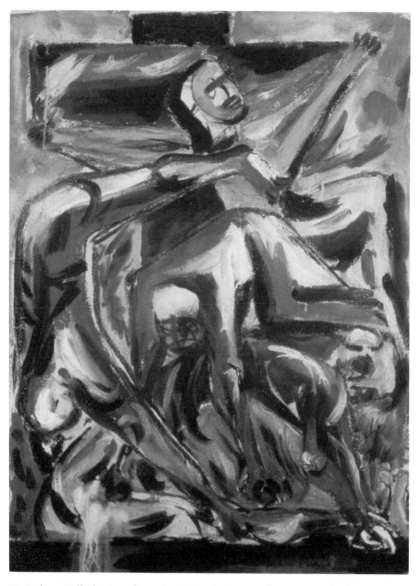

25. Jackson Pollock, *Crucifixion* (c. 1939–40). Craig and Mary Wood collection, Tampa, Florida.

of the male and female images.[34] And Pollock's friend Alfonso Ossorio commented that "the few art criticisms he made were couched in psychoanalytic terms rather than in esthetic ones. . . . The psychiatrist's vocabulary was the only trained, technical vocabulary he had."[35]

Certain visual similarities, moreover, have been traced between some of Pollock's drawings [26] and illustrations in Esther Harding's book *Woman's Mysteries* [27], a Jungian study subtitled *A Psychological Interpretation of the Feminine Principle in Myth, Story and Dreams*.[36] Not only do some of these illustrations serve as convincing sources for motifs in Pollock's drawings of the period—the crescent moon in particular—but Pollock must have been aware, at the very least, of the association of the moon with the female principle, since three of his paintings are titled *The Moon Woman, The Mad Moon Woman*, and *The Moon Woman Cuts the Circle* (CR1:86, 84, 90). Again, this is not to imply that every motif in Pollock's work is an illustration of a psychological principle or part of a specific Jungian iconographical program. But even if Pollock did not read Jung, the evidence does suggest that he, like Henderson, must have considered his works symbolic and susceptible to psychoanalytic exegesis. On this point Donald Gordon has made an important contribution to the discussion by stating that one can still interpret Pollock's

> symbolism as Jungian because it is archetypal, and archetypal because it is the unconscious product of psychic fragmentation. Such symbolism is explainable . . . not by the artist but by the informed observer [i.e., the trained therapist]. Indeed what Langhorne . . . [has] done is to discover not the *iconography* but, erratically and with several false starts, the *psychology* of Pollock's art. Though a task well worth doing, such psychological investigation is not, strictly speaking, art history.[37]

Gordon thus makes the crucial point that manifestations of symbols from the collective unconscious are by definition unconscious. Hence Pollock could have created images he did not consciously understand but whose nature he knew was symbolic and whose meanings were amenable to elucidation during therapy.

26. Jackson Pollock, *Untitled* (c. 1939–40). Mrs. Leonard Granoff collection, Providence, Rhode Island.

27. *Transformations of the Moon Deity.* Drawing from Esther Harding's book *Woman's Mysteries.* (1935).

Such an interpretation of Pollock's procedure as an attempt to elicit unconscious and therefore unpredictable imagery—as in Surrealism—is not only more plausible than the conscious illustration of highly erudite psychological principles suggested by Langhorne but corresponds to the visual evidence of the drawings themselves. Close analysis of unfinished drawings (or of drawings in different states of finish) reveals that Pollock often worked in two stages. First, he drew rapidly, in a quasi-automatist, agitated, and spontaneous manner— mostly in pencil. Second, he added color in a more controlled and premeditated fashion [28]. Such working methods can hardly be consistent with Langhorne's assumptions about a complex, highly intricate, and planned iconography. Indeed, Langhorne and Pollock's Jungian critics, by assuming Jungian symbolism to be conscious, have in a sense misunderstood Jung. They have confused unconscious psychology with deliberate iconography, or, in psychoanalytic terms, latent content with manifest content. As Gordon rightly stated, "It was not Jung after all who invented the mythic image in the first place, it was instead the autonomous *unconscious* of practicing artists."[38]

Even if psychoanalytically-minded art historians would disagree with Gordon's assertion that such inquiry belongs exclusively to psychiatry rather than to art history, they would agree with his assessment of the unconscious nature of psychological symbolism. To illustrate this point, the relevant passages from Richard Kuhns's book *Psychoanalytic Theory of Art* should be quoted at length:

> In the person . . . feelings, beliefs, . . . dreams and fantasies are repressed. That is to say, interpretation, when exercised upon human products, discovers an unconscious domain which is an . . . inevitable accompaniment of a conscious domain. For Freud . . . repression refers to individual unconscious aspects of psychic life. The emphasis in psychoanalytic theory is upon conflict which prevents unconscious material from reaching consciousness. . . . Repression is a force within the self that turns an idea away from consciousness. And that force, operating in artists, is . . . expressed in art. . . . Therefore psychoanalytic theory of art recognizes the force and success of repression in every aspect of art making and use. . . . The distinction between

28. Jackson Pollock, *Untitled* (c. 1939–40). Mr. and Mrs. Haven collection,
Brookline, Massachusetts.

"thought processes that have become conscious" and "conscious thought" provides the ground [for a] distinction between latent content and manifest content. . . . Works of art have the power to transport certain thoughts from the unconscious to the preconscious through their having been, as it were "aestheticized." The whole complex activity of art making . . . can be understood as a cultural loosening of the ordinary rigid boundaries of the unconscious and the conscious. However, in general, when psychoanalytic theory asserts that the content of a . . . work of art expresses unconscious material, it is assumed that the unconscious or latent content is not accessible without interpretation.[39]

Thus, unknown to the patient, the ego represses all undesirable and threatening thoughts in the unconscious. These thoughts, nonetheless, reemerge (when the defenses of repression are lifted or weakened) in the form of dreams, fantasies, phobias, or works of art. The meaning of these dreams or works of art can later be interpreted to the patient, or artist, by a trained psychoanalyst in order to reintegrate the personality. But one must reiterate that the latent psychological content of dreams and works of art is unknown even to the patient, or artist, who produced them. This was undoubtedly Pollock's situation. Imagery was therefore elicited without a preconceived program. Pollock himself once said, "The source of my painting is the unconscious."[40] Any interpretation suggested by Henderson, such as this one of an untitled drawing [29], should not, therefore, be confused with Pollock's own intentions: "The oval-shaped area in the center with its plant symbol suggests that the principle of psychic growth or development is the central meaning of the pole which is therefore not only a sexual symbol (if at all) but represents the primitive conception of the *axis mundi* which stands for the strength of tribal identity and by analogy is the new ego-strength the patient is hoping to obtain."[41]

But if we qualify psychoanalytically relevant meaning as unintentional or unconscious, what then can be said of Pollock's iconography, of his intended rather than unintended meanings? Many characteristics of Pollock's paintings and drawings may not have been anticipated at the outset, but we cannot assume that his stylistic decisions and

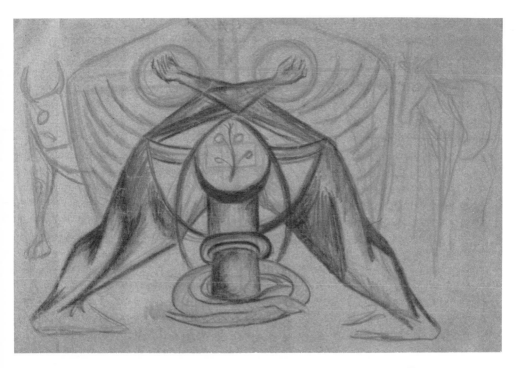

29. Jackson Pollock, *Untitled* (c. 1939–40). Phyllis and David Adelson Collection, Brookline, Massachusetts. Courtesy Nielsen Gallery, Boston.

thematic concerns in this period were entirely unconscious. Most conspicuous and not accidental in the works discussed hitherto is Pollock's consistent struggle with Picasso. In the drawing he attempts to analyze, Henderson fails to discern the presence of Picasso's horse and bull motifs at the extreme left and right. Although Pollock's combination of disparate sources and images almost defies iconographical interpretation, the horse and bull may be for Pollock, as for Picasso from whom he borrowed them, visual manifestations of an internal conflict. Pollock may well have associated a particular character to each: the two animals symbolizing, as was suggested above, the polarity between active and passive, submission and aggression, or the psychological extremes of his own personality. But however ambiguous and personal Pollock's thematic interests may be, his iconographical debt to Picasso reveals an artist still restlessly searching for a meaning to express and visual means by which to express it. At this juncture Pollock is still speaking Picasso's language.

In another untitled drawing [30], however, also executed during psychoanalysis, Pollock appears to be breaking new ground. The work is initially difficult to decipher, but one may eventually discern a human head in the center, another at the bottom left, several horses' heads at the periphery of the central cluster, and an embryolike form. The strong debt to Picasso notwithstanding—the human head at the bottom left is conspicuously derived from the wounded warrior at the bottom of *Guernica*, and the horses' heads and limbs are borrowed from related studies—Pollock does manage to create an unprecedented fusion of human and animal forms.

This fusion may, again, be directly related to and inspired by contemporary ideas on non-Western thought and religion found in books in Pollock's library. In *The Making of Man*, an anthropological anthology in Pollock's possession, Edward Tylor devotes a chapter to a phenomenon he considers almost universally present in preindustrial cultures: animism.[42] He defines this concept—an idea similar to anthropomorphism—as the attribution of human characteristics to animals, plants, or inanimate objects. "The sense of absolute psychical distinction between man and beast," he writes, "so prevalent in the civilized world, is hardly to be found in the lower races."[43] Not only

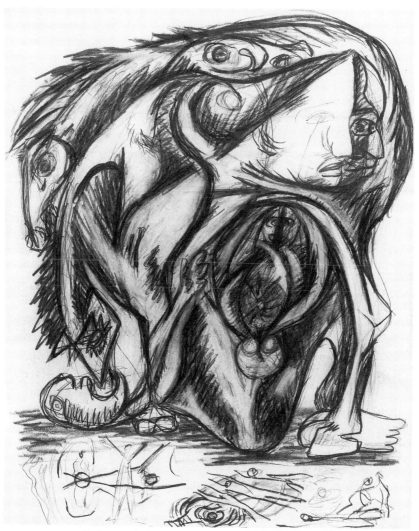

30. Jackson Pollock, *Untitled* (c. 1939–40). Leonard Nathanson collection, Nashville, Tennessee.

do the groups in question regard animals as their equals, but, Tylor adds, they believe "that an animal may have a soul, but that soul may have inhabited a human being, and thus the creature may in fact be their own ancestor or once familiar friend."[44] The predisposition of the "primitive," then, is to integrate rather than separate human and animal. This strong identification is also suggested, if only vaguely, in Pollock's paintings *Totem I* (CR1:121) and *Totem II* (CR1:122) of 1944 and 1945 respectively. The concept of totemism, like that of animism, is also widely referred to and explained in the literature Pollock had at his disposal.[45] A word borrowed from the Indians of North America, *totem* refers to a specific kind of social organization, where a clan identifies a specific animal or plant as its protector. Each member of the clan worships and identifies with the totem animal— often to such an extent that, in most cases, injury or death befalls any member of the clan who harms or kills the totem animal.

The conflation of man and beast found in Pollock's drawings and inspiring the imagery of his paintings may also be due to the artist's personal interest in American Indian folklore. Although little is known of Pollock's specific knowledge of mythology, Peter Busa, an artist friend, remembered that "Jack had a feeling for the transformation that the mythology of the Northwest Indians have—a bird turns into a man or something."[46] But however idiosyncratic or unprecedented Pollock's visual solutions and integration of man and animal may be, his interest in archaic myth and religion was not unique. In fact, a fascination with primitive ways of thinking and with humanity's relation to the natural dimension was a common thematic concern in early Abstract Expressionism. Occasional references to the idea of the totemic are found in such titles as Rothko's *Totem Sign* of 1945–46, David Smith's *Tanktotems*, and Frederick Kiesler's 1947 *Totem for All Religions*.[47] Mixtures of man and animal are found in Mark Rothko's *Omen of the Eagle* of 1942, where human heads and feet are interrupted by birdlike forms; and Barnett Newman, in an introductory essay in the catalog of a Theodoros Stamos exhibition, declared that the latter's *Sounds in the Rock* of 1946 revealed "an attitude towards nature that is close to true communion. His ideographs capture the moment of totemic affinity with the rock and the mushroom." The

artist, according to Newman, "is on the same fundamental ground as the primitive artist who portrayed the phenomenon . . . always as an expression of the original noumenistic mystery in which man and rock are equal."[48] Newman's connection of Abstract Expressionism with non-Western art and of non-Western art and the natural dimension was equally reinforced by Robert Motherwell. In his opinion, art was "one's desire to wed one's self to the universe," and "primitive art" expressed a feeling of "*already* being at one with the world."[49] This does not imply that Pollock and the other Abstract Expressionists believed in totemism and animism but that, if their art was to express the union of man and nature, they could emulate no better idiom than non-Western art, a creative form they believed already possessed this quality.

Thus Pollock's and other Abstract Expressionists' emulations of the primitive—unprecedented fusion of human and animal and suggestions of the totemic—reflect a general Abstract Expressionist tendency to break down the rigid distinctions between human beings and nature. To understand how and to what degree this solution was original, different from, say, what was done in Surrealism, it may be instructive at this point to extend beyond the realm of meaning into that of significance by locating Pollock's specific place in the context of animal imagery in modern art.

Humanity's perception and understanding of animals (and, by extension, the relationship between human and animal) have undergone several transformations since the eighteenth century. Inevitably these transformations have been directly or indirectly reflected in art. In the second half of the eighteenth century, for example, as in the early paintings by George Stubbs, animals were depicted as soulless automatons (the way Descartes understood them), as mere symbols of social standing, property, and wealth. By the late eighteenth century, however, as in Stubbs's own later work—which, by now, can be labeled Romantic—the artist began to project human emotions onto the actions of animals.[50] This romantic concern with or empathy for the thoughts and emotions of irrational creatures continues in the twentieth century, particularly in the art of Franz Marc, where the artist, it seems, attempts to penetrate the very psyche of the animal he

represents. This tendency toward empathy for subhuman forms of intelligence is far stronger in the late nineteenth and twentieth centuries than in preceding periods. Indeed, in a post-Darwinian age, human beings are no longer conceived as separate from animals by virtue of their God-given reason; they become instead yet another link in the long and impersonal chain of evolution. Moreover, in a post-Freudian age (Freud, incidentally, was greatly influenced by Darwin), the attempt to recover the unconscious—the hidden, irrational side of the human personality—put the emphasis not on seeking the human in the animal but on seeking the animal in the human.

In early twentieth-century art, the most evident breakdown of distinctions between human and beast is in Surrealism: in the mythical figure of the Minotaur[51] or in Max Ernst's close identification with the bird Loplop.[52] Pollock's work is simply another step in this process. Dependent on Surrealism, but mixing man and beast in an even more violent and complete way, he transcends the mythical into the totemic. For an even more complete integration of human and animal than Pollock's hybrid forms, one would need to look to the later introduction of real animals (sometimes living, sometimes dead) in the performance pieces of Mark Thompson, Carolee Schneemann, Hans Haacke, and Joseph Beuys. This is not the place for a thorough analysis of the history of animal representation in modern art, but to understand Pollock's singularity and the importance of his contribution, it is useful to place him in the context of this history. Pollock's totemic images, then, may be said to stand halfway between Surrealism on the one hand and performance art on the other.

But the totemic encompasses more than identifications or relationships with animals, however complex they may be. Suggestions of the totemic abound in Pollock's mythic work of this period and intersect a wide range of iconographical concerns. In 1946, for example, Pollock acquired the catalog of a South Seas art exhibition at the Museum of Modern Art. The author described totemic initiation rites as including circumcision,[53] which, the same year, Pollock adopted as the title of one of his paintings (CR1:142). Because of the painting's lack of visual clarity, and considering Lee Krasner's recollection that the painting was titled only after completion,[54] it would be unwise to

draw too specific a relationship between the work and the concept alluded to in the title. Pollock often titled his works after completion, sometimes at the suggestion of friends. Occasionally Pollock even changed his titles.[55] But even if they remain poetic rather than explicit, suggestive rather than illustrative, titles were never meaningless for Pollock; they always had, Lee Krasner remembered, to coincide, however vaguely, with the artist's general intention.[56]

An example of a title referring directly to the image depicted is *Male and Female* [31], which, like the title of *Circumcision*, may also allude to totemic initiation. The importance of the circumcision rite, a concept widely mentioned in the literature Pollock owned, is its practice at puberty.[57] Performed during sexual maturity, the ceremonies not only introduce youths to the totem clans and prepare them for adult life but allow them to take a wife. Totemic organization thus directly relates to the ancestry of the marriage system, and because initiation through circumcision may anticipate a wedding ceremony, totems are also closely associated with the union of the sexes.

Pollock's use of forms resembling totem poles for his two protagonists in *Male and Female* may thus betray a familiarity with the tribal assimilation of the totem and wedding rites. The painting may be interpreted as the female figure at left, distinguished by her eyelashes and curvilinear form, and the male at right, strictly vertical and exposing an erect phallus at the moment of ejaculation. But the sexual identity of the figures implied in the title is far from clear. In fact, some Pollock scholars even disagree as to which figure is male and which is female. This ambiguity, however, may itself be revealing, since totem poles are intentionally sexually ambiguous. For example, in an article titled "Totem Art" in *Dyn* magazine, Wolfgang Paalen wrote that the "ancestral post was originally bisexual, that by its very erection it expresses the male principle, and by its material the female principle (wood symbolizes the maternal element). This corresponds to the archaic *complementary concept* . . . which in many religions is expressed through divinities morally ambivalent and physically hermaphrodite."[58]

There is no evidence to suggest, however, that Pollock was familiar with this article, but Pollock read *Dyn* and could have been aware

31. Jackson Pollock, *Male and Female* (1942). Philadelphia Museum of Art.

of Paalen's ideas through Robert Motherwell, a mutual friend and close associate of Paalen during the publication of *Dyn*.[59] A painting by Pollock, moreover, was illustrated in the following volume of the magazine.[60] But Pollock could also have been familiar with this concept from other sources. In a book in his library on the vestiges of ancient civilizations, the complementary concept is also explained. The author mentions certain ancient legends that describe the first human being as both male and female, a belief that survives, he maintains, in Western civilization: the figure of the hermaphrodite from Greek mythology and the biblical text of Genesis, where Eve is created from Adam's body.[61] In *Male and Female*, therefore, the union of the sexes and the loss of identity through lack of sexual differentiation suggest Pollock's attempt to reflect an archaic and primal state of being where contraries are reconciled. As in his depictions of the relationship between humanity and animals, Pollock's thematic tendency is to rethink conventional divisions by reintegrating and recombining the traditionally separate.

The theme of sexual confrontation and imminent union occurs frequently in his work: *Two* (CR1:123), *The Child Proceeds* (CR1:145), and an untitled drawing (CR3:635) are examples. The encounters are ritualistic and primal—sometimes similar to non-Western renderings of the same subject, where figures of both sexes stand motionless, side by side. Hardly a celebration of physical pleasure, Pollock's works are sexual but never erotic. The theme of union is even occasionally represented as something frightening, as in the untitled drawing [32] where an attenuated and frail skeletal male, on the left, confronts a massive and threatening half-organic, half-mechanical female, on the right. One should not automatically assume, therefore, that the union of the sexes, or, for that matter, of psychological opposites, was necessarily positive in the artist's mind; it could just as easily represent anxiety as sexual desire, or an autobiographical event as much as an abstract suggestion of a primal union of opposites.

Whether negative or not, the representation of the primal couple is not unique to Pollock. It belongs to a broader context including both the Surrealist images of Giacometti and Miró and several early Abstract Expressionist images of Rothko and Gottlieb. As with his inter-

32. Jackson Pollock, *Untitled* (c. 1938–39). Pollock/Krasner Foundation.

est in ancient myths, in animals, and in the totemic, Pollock appears to be a child of his age, sharing a common set of stylistic and iconographical concerns with both the Surrealists and the emerging avant-garde group in New York. And despite several idiosyncracies—violent handling of paint, thick, textural accumulations of pigment, obscuring of imagery, and dissonant color relationships—Pollock's work of this period, as that of his New York colleagues, still lies within the general orbit of Surrealism.

By the early and mid-1940s, however, the previously unknown young Americans began to attract critical attention. Through his friend John Graham, Pollock was given several invitations to exhibit. In 1942 he was invited to participate in an exhibition Graham was organizing at the McMillen Gallery, where the unknown Pollock, Lee Krasner, and Willem de Kooning had the opportunity to hang alongside already established modernists such as Matisse, Picasso, and Braque. Through William Baziotes, whom he knew from the WPA, Pollock met Motherwell, who later introduced him to Peggy Guggenheim. The niece of Solomon R. Guggenheim, she established a major gallery, Art of This Century, where emergent American artists could see works by and meet European Surrealists in New York. She would eventually give Pollock and many artists of the New York School their first one-man shows. Pollock contributed *Stenographic Figure* to her 1942 exhibition "Spring Salon for Young Artists." Excited by the exhibition of the painting and about his newly found patron, Pollock wrote his brother Charles:

> Things really broke with the showing of that painting. . . . I have a year's contract with The Art of This Century and a large painting to do for Peggy Guggenheim's house 8' 11½" × 19' 9". With no strings as to what or how I paint it. . . . They are giving me a show November 16 and I want to have the painting finished for the show. I've had to tear out the partition between the front and middle room to get the damned thing up. . . . It looks pretty big, but exciting as all hell.[62]

But Pollock did not finish the painting in time for the November 1943 show. Regardless, the Art of This Century exhibition was a success—

even if none of the paintings sold—if only for bringing Pollock to the attention of a man who was to become one of the most important and influential American art critics and theoreticians of his generation: Clement Greenberg.

Although John Graham is usually credited for "discovering" Pollock,[63] it was Greenberg who championed Pollock in print. Not only did he provide friendship and encouragement, but his writings would make Pollock's place central to the development of Abstract Expressionism, if not to American art as a whole. On November 17 Greenberg wrote in *The Nation:*

> There are both surprise and fulfillment in Jackson Pollock's not so abstract abstractions. He is the first painter I know to have got something positive from the muddiness of color that so profoundly characterizes a great deal of American painting . . . by Blakelock and Ryder. . . . "Male and Female" (Pollock's titles are ambitious) zigzags between the intensity of the easel picture and the blandness of the mural. . . . "Wounded Animal," with its chalky incrustation, [is] among the strongest abstract paintings I have yet seen by an American.[64]

In addition to greater praise than Pollock could have anticipated or even hoped for, Greenberg had, this early in Pollock's career, made significant points: connecting Pollock with Ryder and stressing the issue of scale. In describing Pollock's work as midway between the easel and the mural, Greenberg anticipates Pollock's later propensity for using large formats. In fact, when he unsuccessfully applied for a Guggenheim Fellowship in 1947, he almost repeated Greenberg's words verbatim. And even if his largest paintings reached heroic proportions—as large as nine by twenty feet—they always remained separate and detachable from the wall, suggestions of, but never, murals in the strict sense of the term.

Perhaps appropriately, when the large canvas for Peggy Guggenheim was finally finished, Pollock called it *Mural* [33]. In addition to its scale, the painting also anticipates Pollock's mature work in its dynamic rhythm, a quality still maintained from Benton, and in what Greenberg was soon to call allover composition. It was as if Pollock

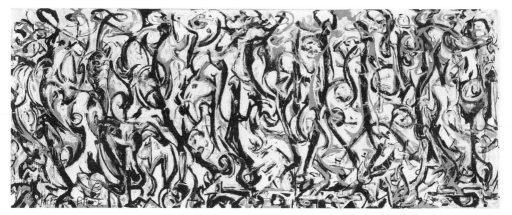

33. Jackson Pollock, *Mural* (1943). Museum of Art, University of Iowa, Iowa City.

had attempted to solve a particular visual problem: how to organize a composition of diverse and multiple elements into a unified and harmonious whole. An examination of *Mural* at close range [34] reveals that the artist used a great variety of strokes—changing his gesture, his touch, the quantity of pigment, and the method of applying paint—but at a distance all of these separate effects are neutralized and blend together in a cohesive homogeneous structure. Rather than using devices to lead the spectator's eyes to the most important visual part or psychological center of the painting, as in many old-master compositions, Pollock diffuses the center of attention across the entire canvas. Peggy Guggenheim approved of the painting, and, after looking at it, Greenberg acknowledged being convinced more than ever of the young Pollock's "greatness."[65] Besides the Guggenheim contract, Pollock received additional recognition when, after long deliberation and at Alfred H. Barr's request, the Museum of Modern Art decided to purchase *The She-Wolf.*

On March 19, 1945 Pollock's second one-man show opened at Art of This Century. It included *Gothic* (CR1:103) and *Totem I* and *Totem II*. Pollock continued the emphatic painterly handling and strident color combinations evident in his previous work, but the overwhelming tendency was toward greater abstraction. The exhibition could not have been reviewed more favorably by Greenberg:

34. Jackson Pollock, *Mural* (1943). Detail. Museum of Art, University of Iowa, Iowa City.

Jackson Pollock's second one-man show . . . establishes him, in my opinion, as the strongest painter of his generation and perhaps the greatest one to appear since Miró. . . . There has been a certain amount of self-deception in School of Paris art since the exit of Cubism. In Pollock there is absolutely none, and he is not afraid to look ugly—all profoundly original art looks ugly at first. . . . Among [the oils] are two—both called *Totem Lessons* [*Totem I* and *Totem II*]—for which I cannot find strong enough words of praise.[66]

But Pollock's visual violence, his indifference to looking "ugly," did not draw unanimous praise. His very thick, often crude, textural handling of paint made the *New York Times* critic, Howard Devree, compare Pollock to "baked macaroni."[67] On the other hand, it also drew perceptive comments from Robert Coates in the *New Yorker*, who understood that the new painting of Pollock, and of other artists of his generation, was combining two hitherto incompatible artistic trends, Abstraction and Expressionism, into a new idiom. According to Coates, the new style "is neither Abstract nor Surrealist, though it has suggestions of both, while the way the paint is applied—usually in a pretty free-swinging, spattery fashion, with only vague hints at subject matter—is suggestive of Expressionism. I feel that some new name will have to be coined for it, but at the moment, I can't think of any. Jackson Pollock . . . and William Baziotes are of this school."[68]

Coates, the critic later credited for coining and popularizing the term *Abstract Expressionism*, understood that the new style was synthetic in nature. Indeed, in his formative years, Pollock had assimilated a wide range of sources, including rhythmic patterns from Benton, themes and motifs from Picasso, automatism from Masson, masks from native American art, and even figures from Miró [35, 36], doodles from Klee [37, 38], and compositional formats from Kandinsky [39, 40].[69] Trying to find himself artistically, Pollock experimented with widely different artistic modes. If some works are brightly, even dissonantly colored, others are nearly monochromatic. If some are thickly painted, dense, and labored, others are spontaneous and automatic—in some cases, as in *Mural*, Pollock used diverse methods of applying paint in the same painting. Some are clearly figurative,

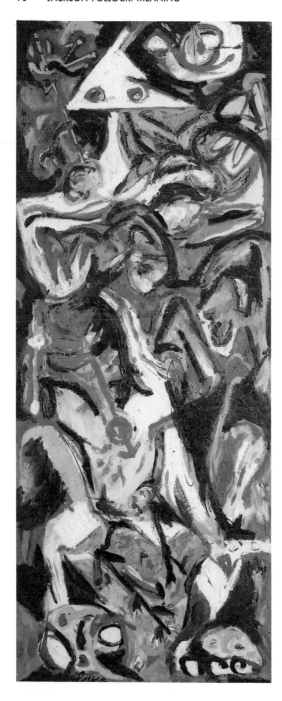

35. Jackson Pollock,
Water Figure (1945).
Hirshhorn Museum and
Sculpture Garden,
Smithsonian Institution,
Washington, D.C. Gift of
Joseph H. Hirshhorn,
1966.

36. Joan Miró, *The Hunter* (1938). Detail. Museum of Modern Art, New York.

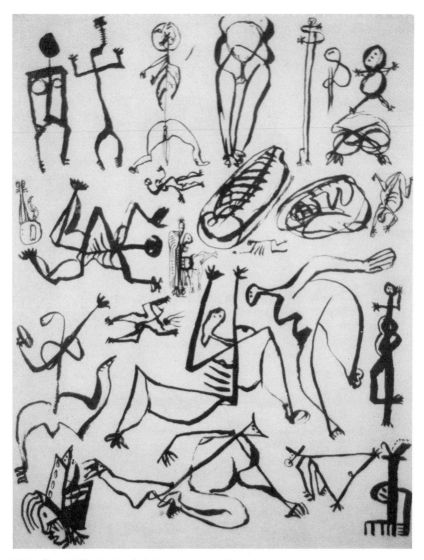

37. Jackson Pollock, *Untitled* (c. 1939–42). Whitney Museum of American Art, New York.

38. Paul Klee, *Handbill for Comedians* (1938). Metropolitan Museum of Art, New York.

39. Jackson Pollock, *Untitled* (1946). Planet Corporation, New York.

40. Wassily Kandinsky, *Kleine Welten* (1922). Private collection.

others are ambiguously so, and still others are totally abstract. In *The She-Wolf* [17], moreover, Pollock not only used different ways of applying paint, but close scrutiny of the canvas reveals that the figurative reference was quite possibly a late addition in the creative process. Pollock, like the Surrealists, may have applied the pigment in a random, automatic manner; then, when the marks suggested a specific image, he may have superimposed the shape suggestive of the wolf. In effect, careful perusal of *The She-Wolf*'s surface reveals the plurality of effects Pollock used not only in this given period but within the stricter confines of a single painting.

As a result, it is difficult to generalize about the nature of his achievement in these years. Pollock's exploitation of a plurality of styles and effects even led him to experiment with a technique of pouring paint that, after 1947, would make him famous. Precocious experiments in this vein are found in the upper sections of *Male and Female* and in several abstract compositions of 1943, such as *Composition with Pouring* [41]. But these are isolated rather than paradigmatic examples; the pourings, moreover, are either marginal to the overall effect or mere additions to canvases already covered in conventional ways.

From the point of view of style, it seems that Pollock tried, as yet not always successfully, to transcend his sources in Picasso and Surrealism. Working in a variety of modes, he was thus far unable to make a unified and consistent artistic statement. His diverse experiments have in common, however, a respect for the integrity of the picture plane, a concern with visual dynamics, and a tendency toward abstraction. From the point of view of iconography, his interest in myths, in the unconscious, and in the primitive all led to related but distinct thematic concerns with animals, totemic imagery, and the union of the sexes. If a common denominator can be found here, it is in Pollock's fascination with the natural side of the human personality and, conversely, with the human personality's relationship to the natural—thematic preoccupations that will become all the more significant in the stylistic, technical, and iconographical development of Pollock's mature style.

Of course, art does not necessarily require stylistic and thematic

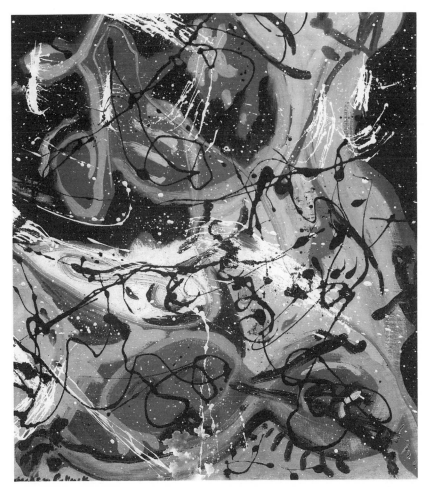

41. Jackson Pollock, *Composition with Pouring* (1943). Hirshhorn Museum and Sculpture Garden, Smithsonian Institution, Washington, D.C. Gift of Joseph H. Hirshhorn.

consistency to be successful. But for Pollock this very consistency occurred in the next phase of his career (1947–50), culminating in what are generally acknowledged to be his best and most original works. Before turning to this next phase, however, certain particulars of Pollock's biography should be related. By all accounts, Pollock's life in New York, aggravated by the pressures of the art world and by his drinking problem, was full of unrest. In the summer of 1945, however, Pollock and Lee Krasner visited Long Island and eventually decided to move there permanently in early fall. They found a house on Fireplace Road, in The Springs, East Hampton, with five acres of land and a large barn (Pollock's future studio). Peggy Guggenheim lent them enough money for the down payment in return for a new contract: Pollock was to receive three hundred dollars a month, and Guggenheim had rights to Pollock's total production, save one painting a year. Before their move to Long Island, Pollock and Lee Krasner married on October 25, 1945. This change of location, taking Pollock from the city to the country and providing him with a larger area in which to work, would, both stylistically and thematically, have a dramatic impact on the general appearance and character of Pollock's work. As B. H. Friedman correctly observed, if Pollock had died then and there, he would not have his "place in history."[70] To this point, his work had shown a propensity toward abstraction and experimentation as well as a dramatic and emotional intensity. But even at his most original, Pollock's work was, relatively speaking, still derivative. Within several years, however, Pollock would rise from relative obscurity to a pinnacle of fame few living American artists had achieved before him. As a result, his paintings would help shift the center of artistic attention away from Europe to the United States in general, and to New York in particular.

NOTES

1. Quoted in W. Rubin, *Dada, Surrealism, and Their Heritage* (Museum of Modern Art, New York, 1968), 63–64.

2. A. Breton, *Manifeste du Surréalisme* (Paris, 1924), 42.

3. Ibid., 23–24.

4. This is not to imply that the Surrealists were not interested in political issues. On the contrary, many, and Breton in particular, were members of the Communist party. On the whole, however, the art of the Surrealists only rarely possessed any conspicuously overt political significance.

5. CR4, p. 232.

6. J. D. Graham, "Primitive Art and Picasso," *Magazine of Art* 30 (April 1937): 237.

7. Ibid., 238.

8. A. Gottlieb and M. Rothko, "The Portrait and the Modern Artist," typescript of a broadcast on "Art in New York," radio WNYC, 13 October 1943.

9. W. Rubin, "Pollock as Jungian Illustrator: The Limits of Psychological Criticism, Part I," *Art in America* 67 (November 1979): 108ff.

10. See W. Rubin, "Notes on Masson and Pollock," *Arts Magazine* 34 (November 1959): 38ff.

11. See Rubin, "Pollock as Jungian Illustrator," and for the Spanish signification of the bullfight, see V. Marrero, *Picasso and the Bull* (Chicago, 1956). See also L. Gasman, "Mystery, Magic, and Love in Picasso, 1925–1938" (Ph.D. diss., Columbia University, 1981).

12. His friend Alfonso Ossorio, in F. du Plessix and C. Gray, "Who Was Jackson Pollock?" *Art in America* 55 (May 1967): 58, wrote: "He had an enormously catholic appreciation of the art of the past: Indian Sand painting, Eskimo art. . . . He certainly knew the anthropological collection at the Museum of Natural History very well. And he knew the art of the American Indian because he had lived part of his life in the South West. He had fifteen volumes published by the Smithsonian on American Anthropology—he once pulled it out from under his bed to show me."

13. CR4, p. 232.

14. Ibid.

15. Ibid., p. 234.

16. The books in Pollock's library have been compiled and cataloged in the Catalogue Raisonné, see "Pollock's Library" in CR4, p. 188.

17. Illustrated in B. Brown, *The Art of the Cave Dweller* (New York, 1931), ill. p. 146, fig. 99. I first suggested this relationship in an unpublished qualifying paper titled "Primitive Sources in Jackson Pollock" (Institute of Fine Arts, New York University, 1982) and in my doctoral dissertation, "Jackson Pollock: Meaning and Significance" (Institute of Fine Arts, New York University, 1988).

18. Gottlieb and Rothko, "The Portrait and the Modern Artist."

19. For a corrective on the traditional view that Picasso's use of African masks in the *Demoiselles d'Avignon* was purely formalistically motivated, see William

Rubin's essay on Picasso in *"Primitivism" in 20th Century Art: Affinities Between the Tribal and the Modern*, vol. 1 (Museum of Modern Art, New York, 1984), 240ff.

20. J. Frazer, *The Golden Bough* (New York, 1926), 12–13. (See CR4, "Pollock's Library," 195.)

21. J. Déchelette, "The Art of the Reindeer Epoch," in V. F. Calverton, ed., *The Making of Man: An Outline of Anthropology* (New York, 1931), hereinafter referred to as *The Making of Man* (see CR4, "Pollock's Library," 188), 101. In the following pages, Déchelette mentions the wounded bisons at Niaux, the illustrations found in Brown's book.

22. Friedman, op. cit., 41.

23. Quoted in "How a Disturbed Genius Talked to His Analyst with Art," *Medical World News* (5 February 1971), 18.

24. E. Langhorne, "Jackson Pollock's 'The Moon Woman Cuts the Circle,'" *Arts Magazine* 53 (March 1979): 128.

25. Ibid., 131.

26. Ibid.

27. Rubin, "Pollock as Jungian Illustrator," 106–7.

28. Langhorne, op. cit., 131.

29. D. E. Gordon, "Pollock's 'Bird,' or How Jung Did Not Offer Much Help in Myth-Making," *Art in America* (October 1980): 44.

30. Friedman, op. cit., 41.

31. "How a Disturbed Genius," 28, and C. L. Wysuph, *Jackson Pollock: Psychoanalytic Drawings* (New York, 1970), 14.

32. See CR1, p. xiv: "It would be wrong to place too much emphasis on this minor document done for a specific purpose and quoting the Jungian 'Four Functions.'" And E. Frank, *Jackson Pollock* (New York, 1983), 31, said the drawing's "specificity is unusual." For the four functions, see C. G. Jung, *Psychology and Alchemy* (Princeton, 1968), 107.

33. Lee Krasner in conversation with David Rubin, quoted in D. Rubin, "A Case for Content: Jackson Pollock's Subject Was the Automatic Gesture," *Arts Magazine* 53 (March 1979): 105.

34. Ibid.

35. Ossorio in du Plessix and Gray, op. cit., 58.

36. This relationship was drawn by Philip Leider in "Surrealist and Not Surrealist in the Art of Jackson Pollock and His Contemporaries" in *The Interpretive Link: Abstract Surrealism into Abstract Expressionism* (Newport Harbor Art Museum, California, 1986).

37. Gordon, op. cit., 43.

38. Ibid., 45.

39. R. Kuhns, *Psychoanalytic Theory of Art* (New York, 1983), 7–8, 16, 18.

40. CR4, p. 241.

41. Wysuph, op. cit., 16.

42. E. Tylor, "Animism," in *The Making of Man*, 640ff.

43. Ibid., 647.

44. Ibid., 648.

45. See Déchelette, op. cit., 100ff.; A. Goldenweiser, "Totemism: An Essay on Religion and Society," in *The Making of Man*, 378ff.; and Frazer, op. cit., 473ff.

46. J. Potter, *To a Violent Grave: An Oral Biography of Jackson Pollock* (New York, 1985), 88.

47. See K. Varnedoe, "Abstract Expressionism," in W. Rubin, ed., *"Primitivism" in Twentieth Century Art*, vol. 2, 625ff.

48. C. Hobbs, "Early Abstract Expressionism: A Concern with the Unknown Within," in *Abstract Expressionism: The Formative Years* (Whitney Museum of American Art, New York, 1978), 26, note 5.

49. Motherwell quoted in F. O'Hara, *Robert Motherwell* (New York, 1965), 45.

50. Robert Rosenblum, lectures on late eighteenth-century English painting (Institute of Fine Arts, New York University, Fall 1982).

51. For Picasso's symbolism, see Rubin, "Pollock as Jungian Illustrator" (Part I), 110ff.

52. See W. Spies, *Max Ernst: LopLop* (New York, 1983).

53. R. Linton, *Art of the South Seas* (Museum of Modern Art, New York, 1946), 129.

54. A. Z. Rudenstine, *Peggy Guggenheim Collection, Venice* (New York, 1985), 634.

55. *Pasiphae*, for example, was originally titled *Moby Dick* and later changed at the suggestion of James Johnson Sweeney; see Rubin, "Pollock as Jungian Illustrator" (Part II), 73ff.

56. E. Johnson, "Pollock and Nature," in *Modern Art and the Object* (London, 1976), 114: "Although Pollock sometimes got help from others in the difficult task of naming paintings, Lee Pollock says that even so he never accepted a suggestion unless it fitted in with his own ideas." Many of the titles, she continues, were Pollock's own.

57. B. Spencer and F. J. Gillen, "Initiation Ceremonies," in *The Making of Man*, 281–82; and Frazer, op. cit., 700ff.

58. W. Paalen, "Totem Art," *Dyn* 4–5 (1943): 28.

59. For a discussion of Paalen's ideas in relation to modern painters, see D. Ashton, *The New York School* (New York, 1979), 124ff., and on page 126, she writes: "When Paalen founded his magazine *Dyn* . . . in 1942, Motherwell's work was frequently reproduced and he later contributed one of its most important articles. When Motherwell returned to New York he continued discussions with Baziotes, and sometimes with Pollock, on the emergent post-surrealist ideas."

60. *Moon Woman Cuts the Circle* (CR1:90) was illustrated in *Dyn* 6 (1944), n.p.; see CR1, p. 80.

61. J. Churchward, *The Lost Continent of Mu* (New York, 1932), 41–43.

62. CR4, p. 228.

63. When Willem de Kooning was once asked if John Graham discovered Pollock, he replied: "Of course he did. Who the hell picked him out? The other critics came later—much later. Graham was a painter as well as a critic. It was

hard for other artists to see what Pollock was doing—their work was so different from his. . . . But Graham could see it." Quoted in J. Valliere, "De Kooning on Pollock," *Partisan Review* 34 (Fall 1967): 603–5.

64. Friedman, op. cit., 61–62.

65. Ibid., 63.

66. Ibid., 76.

67. Ibid.

68. *New Yorker* (23 December 1944), quoted in ibid., 78.

69. See G. Levin, "Miró, Kandinsky, and the Genesis of Abstract Expressionism," in *Abstract Expressionism: The Formative Years*, 30–31, 36–37. For Klee, see also A. Kagan, "Paul Klee's Influence on American Painting: New York School," *Arts Magazine* 49 (June 1975): 54–59.

70. Friedman, op. cit., 85.

3
THE POURED PAINTINGS

Before closing her gallery and returning to Europe permanently, Peggy Guggenheim agreed to give Pollock a final show at Art of This Century in the spring of 1947, where he exhibited paintings finished in the second half of 1946—the first full year he spent on Long Island. A case could easily be made that the change of environment had a conspicuous, if not dramatic, impact on Pollock's style. Although he maintained the pictorial congestion and density typical of his earlier work, his color scheme was radically different. As Clement Greenberg, who reviewed the exhibition in the February 1st issue of *The Nation*, noticed, Pollock "has now largely abandoned his customary black-and-whitish or gum metal chiaroscuro for the higher scales, for alizarins, cream whites, cerulean blues, pinks, and sharp greens."[1] But in addition to the general heightening of the palette, Greenberg noticed in three transitional but highly important works—*Croaking Movement* (CR1:161), *Eyes in the Heat* (CR1:162), and *Shimmering Substance* [42]—Pollock's tendency "to handle his canvas with an over-all evenness."[2] During 1947 to 1950 Pollock consistently exploited the possibilities inherent in such a compositional format—a quality anticipated in earlier works and continued, though not fully realized, in these three paintings.

Although closer to abstraction than the majority of Pollock's preceding work, these paintings do not in fact qualify as completely allover: *Shimmering Substance* is composed around a central yellow circular form, *Croaking Movement* is interrupted by irregular geometric markings, and organic shapes are visible throughout *Eyes in the Heat*. However difficult to identify with any degree of precision, these

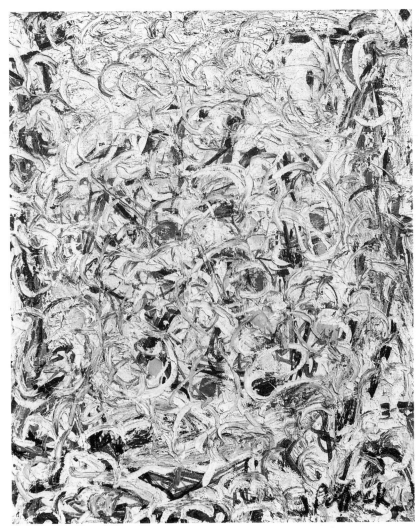

42. Jackson Pollock, *Shimmering Substance* (1946). Museum of Modern Art, New York. Mr. and Mrs. Albert Lewin and Mrs. Sam A. Lewisohn Funds.

vestiges of representation cause enough centers of attention to pre-
vent the full impact of allover composition from taking effect. But
whether or not Pollock's compositions are fully nonhierarchical by
1946 is of course less important than his growing tendency to work in
this direction. Another conspicuous development is Pollock's increas-
ing propensity to endow his work with greater energy and dynamic
rhythm without abandoning his interest in the textural properties of
paint. His gestures are freer, more impulsive than, say, the labored
encrustations of *Birth* and *Male and Female*.

Such stylistic shifts may be directly related to Pollock's move to
Long Island. "Living in Springs," Lee Krasner recalled, "allowed
Jackson to work. He needed the peace of country life."[3] Pollock was
not only in the midst of nature, to which his titles obviously refer, but
found himself in a more conducive place to paint. He decided to move
his studio from the small bedroom in the farmhouse to the nearby
barn. With greater privacy and in a larger area, Pollock could set his
stylistic and technical experiments in motion; during the years
1947–50 Pollock created his large-scale abstractions and developed
the poured technique. Abandoning the tradition of easel painting,
Pollock began to lay the bare canvas on the floor [43], and, abandon-
ing traditional tools such as brushes and palette knife, he used sticks
and trowels to pour—a preferable term to the inaccurate and pejora-
tive "drip"—paint directly on the canvas surface.

In the winter of 1947–48 Pollock published a commentary on his
newly developed painting method in the first and only issue of *Possi-
bilities*, an avant-garde periodical edited by Robert Motherwell and
Harold Rosenberg:

> My painting does not come from the easel. I hardly ever stretch
> my canvas before painting. I prefer to tack the unstretched can-
> vas to the hard wall or the floor. I need the resistance of a hard
> surface. On the floor I am more at ease. I feel nearer, more part
> of the painting, since this way I can walk around it, work from the
> four sides and literally be *in* the painting. This is akin to the
> method of the Indian sand painters of the West.
>
> I continue to get further away from the usual painter's tools

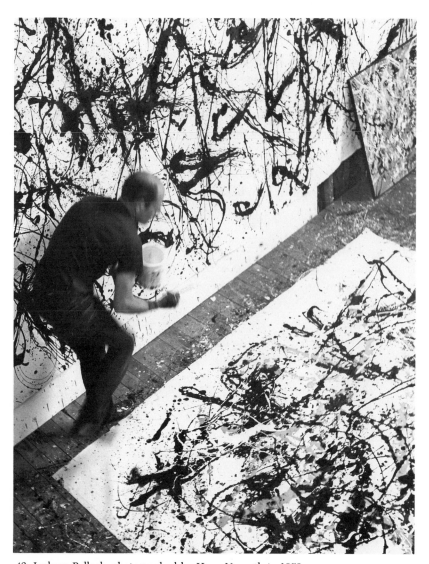

43. Jackson Pollock, photographed by Hans Namuth in 1950.

such as easel, palette, brushes, etc. I prefer sticks, trowels, knives and dripping fluid paint or a heavy impasto with sand, broken glass and other foreign matter added.

When I am *in* my painting, I'm not aware of what I'm doing. It is only after a sort of "get acquainted" period that I see what I have been about. I have no fear of making changes, destroying the image, etc., because the painting has a life of its own. I try to let it come through. It is only when I lose contact with the painting that the result is a mess. Otherwise there is pure harmony, an easy give and take, and the painting comes out well.[4]

Of course, no single prototype can account for the development and complexity of the poured technique; most likely, Pollock's exposure to Surrealist automatism[5] and his experiences in the Siqueiros experimental workshop were prototypes seminal enough for Pollock to recombine them in a more synthetic and comprehensive style in 1947. But, however influential these prototypes may have been, in his few recorded statements on technique Pollock accorded them little importance. Indeed, when describing his painting method, Pollock chose to mention only its physical kinship to that of Indian sand painters.[6]

Whether Pollock actually witnessed Indian sand-painting ceremonies during his frequent trips to the West remains undocumented and has therefore caused critical disagreement in the Pollock literature.[7] It has been documented, however, that Pollock did observe an Indian sand-painting demonstration at the Museum of Modern Art in the 1940s and—as his analyst, Violet Staub de Laszlo, remembered—was quite taken with the ritual.[8] In addition, when specifically questioned about possible precedents for the poured technique, Lee Krasner recalled Pollock mentioning having seen Indian sand painters working on the ground.[9] Indian sand painting was not, of course, the only viable prototype for Pollock's painting method after 1947. As already discussed, Surrealist automatism and Mexican Muralism anticipated certain visual effects and technical innovations specific to the poured paintings—even if Pollock later chose not to mention them. Moreover, if Pollock was technically inspired by Indian sand painting, one should not categorically dismiss his previous statement—made in

1944—that any visual similarity between his work and American Indian art was "unintentional."[10] Indeed, when compared, Indian sand paintings and Pollock's poured canvases look nothing alike. It is in the method—on the technical rather than on the visual level—that the kinship exists. Like his Native American precursors, Pollock worked on the floor and dropped pigment, sand, and other foreign matter onto the canvas surface, thus incorporating both the force of gravity and the intermediary element of air in the artistic process.

In addition, although technically akin to that of Indian sand painters, Pollock's technique was not restricted by the preconceived visual format of the Indian design; Pollock could be physically freer, more impulsive, and conceptually less premeditated, as is evidenced in the only surviving accounts of Pollock's method: the verbal recollections, films, and still photographs of Hans Namuth. A young photography student in 1950, Namuth was intrigued by what he called the "difficulty" of Pollock's allover abstractions. He eventually sought out the artist and asked if he could photograph him while painting. Pollock was first reluctant but eventually agreed. He invited Namuth to his studio, promising to start a new painting especially for the photographic session. When Namuth arrived, however, Pollock apologized and told him the painting was finished. Cautiously Namuth suggested they go into the studio:

> A dripping wet canvas covered the entire floor. . . . There was complete silence. . . . Pollock looked at the painting. Then, unexpectedly, he picked up can and paint brush and started to move around the canvas. It was as if he suddenly realized the painting was not finished. His movements, slow at first, gradually became faster and more dancelike as he flung black, white, and rust colored paint onto the canvas. He completely forgot that Lee and I were there; he did not seem to hear the click of the camera shutter. . . . My photography session lasted as long as he kept painting, perhaps half an hour. In all that time, Pollock did not stop. How long could one keep up that level of activity? Finally, he said "This is it." Later, Lee told me that until that moment, she had been the only one to watch him paint.[11]

Namuth's account describes, and his photographs show, a man oblivious to the outside world, utterly and completely absorbed in the act of creation. With the canvas on the floor, painting now required unprecedented physical participation on the part of the artist. Before Pollock, painters—however spontaneously they worked—traditionally placed canvases on easels or fixed them vertically; the pigment was applied directly by means of brushes and by touches whose general orientation was perpendicular to the picture plane. By placing the canvas on the floor, Pollock not only reversed the horizontal/vertical orientation of painting but amplified the amount of physical space where creation takes place. Unrestricted by format—by a working situation dictating an up-and-down position—Pollock could attack the canvas from all directions, occasionally even stepping inside the painting.

The immediate consequence of this unprecedented spontaneity was the liberation of the artist's gesture. A crucially important aspect of his work, Pollock's gesture engaged not only the hand or wrist but the entire body. By eliminating physical contact with the canvas, moreover, and by being dependent on the force of gravity, Pollock ran the risk of having the most minute inflection of his wrist alter the quality of his line. Pollock's technique thus required a certain apprenticeship with the way paint is affected by its own viscosity, by the speed of the gesture, by the height of the fall, and so on. It also required a certain dexterity, a capacity to associate a gesture with its effect and to reproduce that effect at will. By manipulating these variables, Pollock could produce a great variety of effects with a seemingly limited and highly restricted technique. As the critic Frank O'Hara perceptively noted: "There has never been enough said about Pollock's draftsmanship, that amazing ability to quicken a line by thinning it, to slow it down by flooding, to elaborate that simplest of elements, the line—to change, to reinvigorate, to extend, to build up an embarrassment of riches in the mass by drawing alone."[12]

But although O'Hara is essentially correct in stating that the varying thickness of a line can affect its visual quality—making it appear "faster" or "slower" [51]—it is important to remember that Pollock was pouring paint. In manipulating the pigment, Pollock had

to learn to use, if not control, the force of gravity. While working, he asserted, the brush did not touch the canvas but hovered above.[13] Thus, to "quicken a line by thinning it" or to "slow it down by flooding" Pollock simply accelerated or decelerated his movements so that the marks on the canvas became direct traces of the artist's sequential movements in space. To a greater extent than in painting prior to Pollock, the process of creation remains visible in and becomes part of the final product. So close is the relationship between certain strokes on the canvas and Pollock's "choreography" that, in imagination, spectators can almost feel themselves reconstructing the artist's physical movements in space.

O'Hara also points out—as Clement Greenberg did before him[14]—that Pollock's strength lies in his draftsmanship. In fact, the poured line continues and elaborates stylistic concerns already evident in Pollock's earlier paintings. Several strokes in *Stenographic Figure* [23], for example, were not applied with a brush but squeezed directly from the tube. Most likely, Pollock wanted a continuous, calligraphic line, unbroken and uninterrupted by the inconvenient necessity of reloading the brush. What Pollock wanted, in effect, was to draw with paint. With the poured technique, he could carry far more paint on a stick than on the tip of a brush, thus solving his practical problem and achieving one of the most complete integrations of drawing and painting in the history of art.[15]

But if the poured technique permitted greater spontaneity, physical freedom, and uninterrupted continuity in the application of paint, it also divorced Pollock from what was hitherto consistently maintained by artists for centuries: the physical *contact* between the canvas and the artist's hand by the intermediary of the brush. By drawing or painting in the air, Pollock lost this essential contact and, as a result, was somewhat alienated from his medium. Whether Pollock regretted losing this sense of touch or not, he seems to have compensated for it by including his own handprints in two of the poured paintings: *Number 1A* of 1948 [44] and *Lavender Mist* of 1950 (CR2:264). For Pollock, who spoke of the proximity he felt toward his work ("On the floor I am more at ease. I feel nearer, more a part of the painting. . . . It is only when I lose contact with the painting that the result is a mess"),

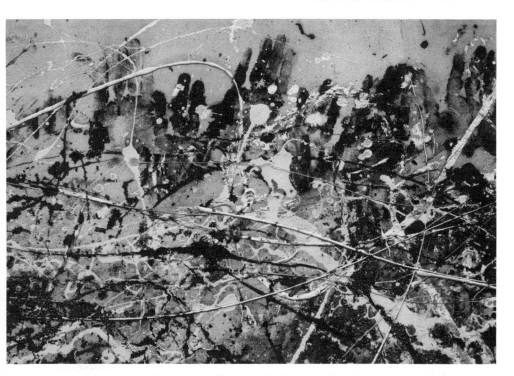

44. Jackson Pollock, *Number 1A, 1948*. Detail. Museum of Modern Art, New York. Purchase.

the absence of this contact may have required some form of compensation. It may be worth mentioning, if only parenthetically, that an analogous situation occurred to the photorealist painter Chuck Close, who, after years of painting with the impersonal instrument of the airbrush, reverted to applying pigment on canvas by using his own fingerprints. Like Pollock, Close may have lamented the absence of touch, the distance, between himself and his work. In *Number 1A*, then, as if it symbolized a basic and primal kind of signature, Pollock affirmed and reaffirmed, by a repeated, almost incremental, progression of handprints, the sense of touch he had lost with the poured technique.

There appears, moreover, to be a primal, or primitive, quality to these handprints. Although certain precedents for this inclusion exist in the history of modern art,[16] the most likely source is an illustration included in Baldwin Brown's *Art of the Cave Dweller* (the previously mentioned book in Pollock's possession, which included the wounded-animal paintings). Reproduced in this book are the stenciled hands [45] from the caves of Castillo in Spain.[17] The accompanying text explains how the prints were made, where other such prints were found, and describes other methods resulting in positive renditions of the hand—a result closer to Pollock's solutions than the negative stenciling. In terms of iconography, however, Brown surmised, despite the general lack of evidence, that the prints possibly referred to a primal system of ownership.[18] A year after completing *Number 1A*, Pollock was given Leonard Adam's book *Primitive Art*, which also included an illustration of handprints and may thus have influenced Pollock to reintroduce the motif in *Lavender Mist* of 1950. Unlike Adam, however, Brown did not propose an interpretive explanation of the hands.[19]

Although Pollock most likely borrowed the motif from illustrations in his library, these specific sources provide little basis for interpretation. In another book in Pollock's possession, however, Ralph Linton's *Art of the South Seas*, the author describes how certain Australian tribes represent animals not in their entirety but simply by their tracks, which the hunters nonetheless considered "part of the animals' total reality."[20] For Pollock, who, in his own words, spoke

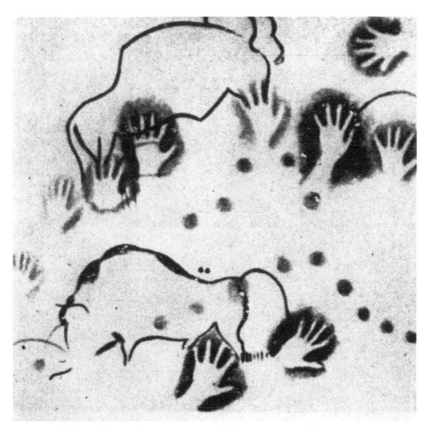

45. Stenciled hands from the caves in Castillo, Spain, from Baldwin Brown's *Art of the Cave Dweller* (1931).

about "being in" or "being part of" his paintings, these handprints become not only his compensation for losing his sense of touch through the poured technique but a private signature: the evidence of his physical role in the creative process and his continual presence in the final product—the specific traces of an animate being in an otherwise abstract composition. As if he were himself engaged in some form of animistic projection, Pollock once remarked, "Every good artist paints what he is."[21] Thus, by allowing Pollock to participate in the creative process in a physically unprecedented way (stepping inside the canvas, leaving handprints), the development of the poured technique, whereby every mark on the painting becomes a trace of the artist's movements in space, seems to have generated a feeling of co-identity between the artist and his work.

Although the expressive quality Pollock wished to invest in his work was not immediately apparent to most critics, its revolutionary quality was; indeed, the critical responses to the new paintings were predominantly negative. The Italian critic Bruno Alfieri, for example, in a piece entitled "Piccolo discorso sui quadri di Jackson Pollock," wrote: "Jackson Pollock's paintings represent absolutely nothing: no facts, no ideas, no geometrical forms. Do not therefore be deceived by suggestive titles. . . . [They] are phony titles, invented merely to distinguish the canvases and identify them rapidly." Further in the article, Alfieri enumerated what he considered the major characteristics of Pollock's art:

- chaos
- absolute lack of harmony
- complete lack of structural organization
- total absence of technique, however rudimentary
- once again, chaos[22]

In their general antipathy to Pollock's work, hostile critics normally focused on the poured technique, which earned Pollock the nickname "Jack the Dripper,"[23] and on the device of allover composition, which earned derogatory comparison with impersonal and mechanically reproduced wallpaper patterns.[24]

But critical responses were not all negative. First, even if Pollock

was somewhat isolated by living in Long Island, a particular bond and solidarity, as well as rivalry, was strengthening among Abstract Expressionist artists.[25] Above all was the friendship and criticism of "Pollock's champion," Clement Greenberg. In the 24 January 1948 issue of *The Nation*, Greenberg wrote his most laudatory and daring comments to date. He stated that "Pollock will in time be able to compete [with John Marin] for recognition as the greatest American painter of the twentieth century."[26]

While other critics saw a violent artist doing violence to art history, a man recklessly flinging paint on canvas without rhyme or reason, Greenberg was faithfully, if not obsessively, committed to Pollock's work. So much so that both names are often inseparably conjoined in art historical accounts. Yet what exactly did Greenberg see in Pollock that other critics did not? For Greenberg, criticism was not the pure exercise of aesthetic judgment, making arbitrary and intellectually unjustifiable qualitative decisions of good and bad. Greenberg was keenly interested in history and in the progression of history. This specific interest, this intellectual predisposition, made him far more responsive to the specific characteristics within Pollock's work that he considered extrapolations from historical precedents. The revolutionary aspect of Pollock's art, the break with tradition, was apparent to most; except for Greenberg, the structural aspect, the continuity with tradition, was not. As early as 1946, Greenberg sensed that "Pollock's superiority to his contemporaries in this country lies in his ability to create a genuinely violent and extravagant art without losing stylistic control."[27]

Thus, to describe the radical nature of Pollock's procedures—placing the canvas on the floor, pouring the pigment, exploiting the force of gravity, and expending great physical energy in the act of creation—is not to imply that the poured paintings were the haphazard product of an irrational system. On the contrary, Pollock's early apprenticeship with Benton (see chap. 1) included intensive training in composition, particularly in rhythmic dynamics. William Rubin, moreover, expanding on a thesis first suggested by Greenberg—that Pollock's work was not *sui generis* but intimately rooted in the most respected of modern artistic styles: Cubism[28]—argued that the

poured paintings did not emerge from nowhere, nor did they create an artistic tabula rasa, eliminating all sources and references to older art. Reacting against critics who either admired or accused Pollock for being exceedingly unconventional, Rubin specifically interpreted the poured paintings as the product of a gradual and logical, if not to say predictable, evolution in late nineteenth- and early twentieth-century art.

Rubin noticed, quite correctly, that allover composition and the poured technique, though not identical, appear to coincide in the 1947–50 paintings. Rubin then went on to trace the development and progression of both through the history of modern painting. Pollock, as already discussed, experimented with allover composition in various sketches and paintings as early as the 1930s. Yet this seemingly radical innovation, which often drew comparisons with wallpaper patterns, did not emerge like Athena, fully clad from the head of Zeus. On the contrary, as Rubin argues, allover composition may be interpreted as the culmination of a modernist tradition beginning with Impressionism, running through Cubism, the 1913–14 paintings by Piet Mondrian, and abstract Surrealism.[29] Rubin also mentions that Mark Tobey independently arrived at allover composition—most likely through the influence of Paul Klee and oriental calligraphy—but argues that his paintings are an unlikely source for Pollock, since there is no evidence he saw Tobey's exhibition at the Willard Gallery in 1943.[30] Another, more probable, source is the work of Janet Sobel [46], a self-taught Russian-born artist, which was exhibited at Peggy Guggenheim's Art of This Century in 1944. Greenberg recalled that "Pollock (and I myself) admired these pictures rather furtively. . . . The effect—and it was the first really 'allover' one that I had ever seen, since Tobey's show came months later—was strangely pleasing. Later on, Pollock admitted that these pictures had made an impression on him."[31]

Allover composition was thus not Pollock's invention, however much he exploited it and was criticized for it. On the contrary, the product of an artistic evolution Pollock and his contemporaries were undoubtedly very conscious of, this pictorial device became quite common among artists of the New York School. So common, in fact,

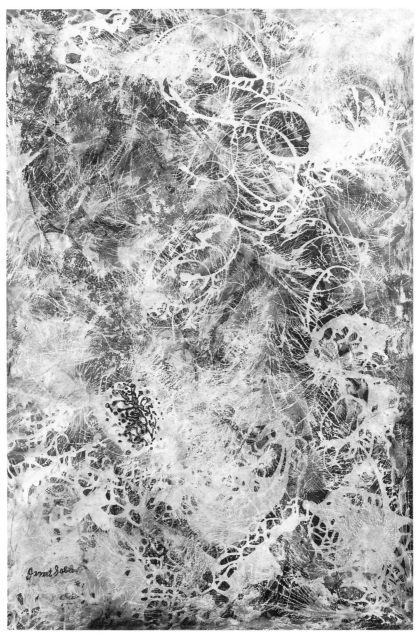

46. Janet Sobel, *Milky Way* (1945). Museum of Modern Art, New York. Gift of the artist's family.

that Greenberg codified the term in a 1948 essay titled "The Crisis of the Easel Picture." Citing parallels in literature and music, Greenberg wrote that "the 'allover' may answer the feeling that all hierarchical distinctions have been literally exhausted and invalidated; that no area or order of experience is intrinsically superior, on any final scale of values, than any other area or order of experience."[32] Although the claim that the allover compositional strategy destroys any visual center of attention is essentially persuasive, Greenberg, using both Pollock and Tobey as examples, also posits that allover painting "relies on a surface knit together of identical or closely similar elements which repeat themselves without marked variation from one edge of the painting to the other. It is a kind of picture which dispenses, apparently, with beginning, middle, end."[33]

Greenberg's remark may convincingly describe the obviously smaller, Klee-inspired work of Tobey, who maintained a more regular and consistent calligraphic style with a relatively limited repertory of strokes.[34] But it hardly serves as a convincing stylistic analysis of the mature Pollocks, particularly if one tests his descriptions against the visual evidence of the large paintings, about which it is far more difficult to generalize. The plurality and variety of incident particular to the Pollockian web, moreover, are evident in *Number 32* [54]. At first glance the painting appears allover in Greenberg's sense; Pollock's reliance on a single color and the absence of a visual center of attention are consistent with Greenberg's remarks on the homogeneous nature of allover composition. Indeed, the spectator's attention tends to be directed to the entire field of energy rather than to any particular mark or set of marks. And although a contrast does exist between painted and unpainted areas (the black versus the tan of bare canvas), the two are balanced so evenly that the dominant effect is one of totality rather than particularity, of an organic whole rather than the sum of individual parts.

If the paintings are seen at close range, however, Greenberg's thesis is far from persuasive. Three details from *Number 32* [47–49], taken from approximately the same distance, reveal a heterogeneous and extremely varied surface. Pollock may have used a single technique and a single color, but he obtained an almost inexhaustible

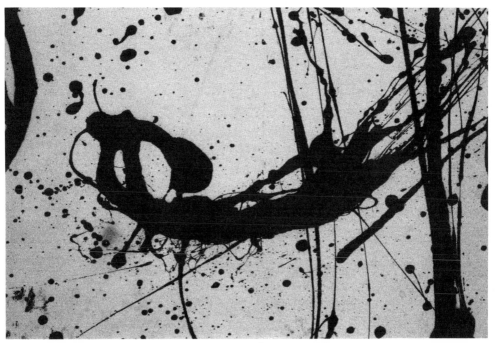

47. Jackson Pollock, *Number 32, 1950*. Detail. Kunstsammlung
Nordrhein-Westfalen, Düsseldorf.

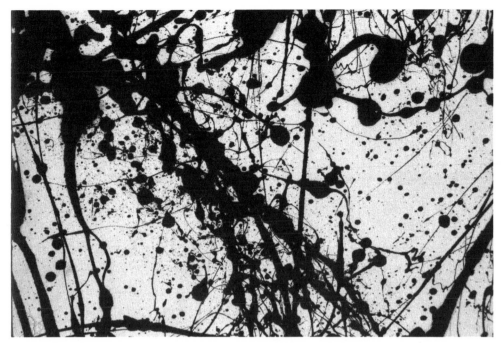

48. Jackson Pollock, *Number 32, 1950*. Detail. Kunstsammlung
Nordrhein-Westfalen, Düsseldorf.

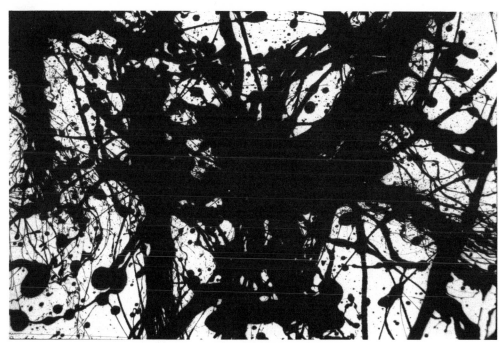

49. Jackson Pollock, *Number 32, 1950*. Detail. Kunstsammlung
Nordrhein-Westfalen, Düsseldorf.

variety of effects. One cannot convincingly argue, as Greenberg does, that the three details illustrated here represent "identical or closely similar elements which repeat themselves without marked variation from one edge of the painting to the other." Moreover, the clusters, as they are formed by a plurality of lines converging toward a center, create areas more visually engaging than those occupied by bare canvas.

But in all fairness to Greenberg, the three details illustrated here do comprise a kind of visual repertoire or vocabulary of forms upon which the artist consistently draws to organize his paintings. Close scrutiny of the canvas also shows that the cleflike shape at the bottom [47] is, with slight variation, repeated upward [51], creating a structured and repetitive arrangement of related but not identical parts. And although there are areas of greater and lesser density in *Number 32*, the distribution of the clusters, or denser areas, is such that the eye is led from one area of the canvas to the next without resting on any particular spot [54]. The painting, then, would remain allover if the term would be defined not as the repetition of identical, interchangeable parts but as a type of composition that permits stylistic variation but distributes pictorial incidents so evenly as to permit no visual center of attention.

In Pollock's work, however, variation applies as much to the relative consistency or thickness of the paint as it does to the types of marks left on the canvas. In some works, like *Number 32*, the thickness of the pigment is maintained at relatively equal density throughout the painting, while in others, like *Number 1A*, the paint is sometimes diluted, sometimes poured in a thick impasto [50]. A change in consistency inevitably creates a change in effect: if the paint is thick, it rests on the canvas and creates a strong textural and irregular surface, which sometimes casts shadows on the painting; if the paint is thin, it is absorbed in or stains the canvas, causing little, if any, textural effect. There are, in addition, a plurality of contrasts between painted areas and those where the bare canvas is left conspicuously visible. In the final analysis, one cannot and should not overgeneralize, as Greenberg does, about the regularity of pictorial incidents in Pollock's paintings.

But however many visual and textural effects Pollock had at his

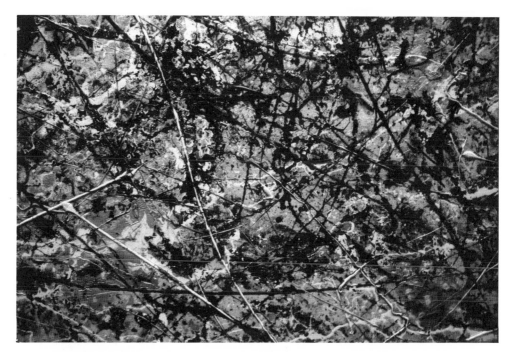

50. Jackson Pollock, *Number 1A, 1948*. Detail. Museum of Modern Art, New York. Purchase.

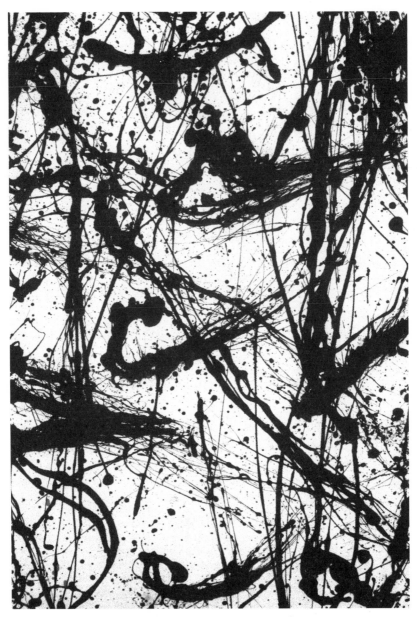

51. Jackson Pollock, *Number 32, 1950*. Detail. Kunstsammlung
Nordrhein-Westfalen, Düsseldorf.

disposition, one must agree with Greenberg that Pollock composed his canvases in such a way as to create no center of attention. And, despite not having defined allover composition with as much precision as possible, Greenberg was not wrong in asserting that gestural painting did not "rely on ungoverned spontaneity and haphazard effects," as most of its critics maintained, but was "subject to a discipline as strict as any that art obeyed in the past."[35] If the last part of that statement seems somewhat exaggerated, one should consider the context in which it was made. Greenberg was most likely simultaneously reacting against critics who either accused or admired Pollock for being an untrained and undisciplined artist who unthinkingly splashed out paintings by the dozen. To redress the critical balance, however, he may have gone too far in the opposite direction. His misreading of allover composition as the visual repetition of similar and identical elements without marked variation was quite possibly the direct result of his overzealous attempt to characterize effects in Pollock's paintings as the results of a disciplined formula.

Be that as it may, Greenberg's claim that "major art is impossible, or almost so, without a thorough assimilation of the art of the preceding period or periods," and that Abstract Expressionism "makes no more a break with the past than anything before it in modernist art has,"[36] is still valid. The claim is made even more convincing by William Rubin, who argues that Pollock's 1947–50 paintings represent the logical culmination of the modern tradition, rather than the deliberate attempt to destroy the nature of painting of which he was often accused. Indeed, in Rubin's view, not only is allover composition tied to the modern tradition, so is the poured technique.

Pollock's method, Rubin asserts, "descends from a line within the modern tradition bent on increasingly loosening the fabric of the picture surface in a 'painterly' way."[37] The most pertinent exponents of this tradition for the subject at hand were the attempts to circumvent the role of the brush as intermediary between the artist's hand and the canvas. Rubin cites Picabia's experiments with spilled ink in *La Sainte Vierge* of 1917 and the related Surrealist experiments in Miró's *Birth of the World* (1925) and in Max Ernst's *A Young Man Intrigued by the Flight of a Non-Euclidian Fly* of 1942–47. Although

the Picabia was an unrepeatable Dadaist gesture of spilling ink or pigment on a picture surface, the Miró exemplifies the common Surrealist practice of using chance procedures, such as automatism, staining, and accidents, to generate subconscious imagery. Ernst's experiment, however, consisted of swinging a punctured paint can like a pendulum to obtain relatively symmetrical elipses of poured paint on canvas.

Pollock probably saw similar paintings in the early 1940s, but, as Rubin claims, their influence has been overrated.[38] Indeed, Motherwell said he and Pollock knew of Ernst's experiment but had little interest in it.[39] Ultimately Ernst's geometrical and rather limited, predictable patterns have little in common with the pulsating and dynamic energy of the poured paintings. Closer to, but an unconfirmed source for, Pollock's technique is Hans Hofmann's own experiments with pouring from around 1940 to 1945 [52]. Hofmann's use of pouring was limited to a handful of examples and loosely coincides with Pollock's own anticipations of his later poured technique as early as 1943 [41]. There is no conclusive evidence, however, of influence in either direction.[40] Hofmann superimposed poured passages on conventionally painted backgrounds, much like Pollock's first attempts in this direction and unlike the completely poured Pollocks of 1947–50. Thus, although it is often debated as to which artist did what first, Rubin concluded that "these arguments are beside the point since it was not the dripping, pouring or spattering *per se,* but what Pollock *did* with them that counted."[41]

In the final analysis, Rubin's placement of Pollock within the context of the modern tradition does not take away from Pollock's achievement or belittle his originality. On the contrary, Greenberg's and Rubin's contributions to scholarship have done much to redress the hostility and misconceptions with which Pollock's art was first received. Of course, it would be impossible to confirm whether Pollock was as historically conscious as Greenberg and Rubin claim. They have convincingly argued, however, that the poured technique was not an irrational or illogical system but a skill to be acquired. Pollock's own statements reveal that practice and experience made the poured technique easier to control. In 1947, when Pollock first started pouring

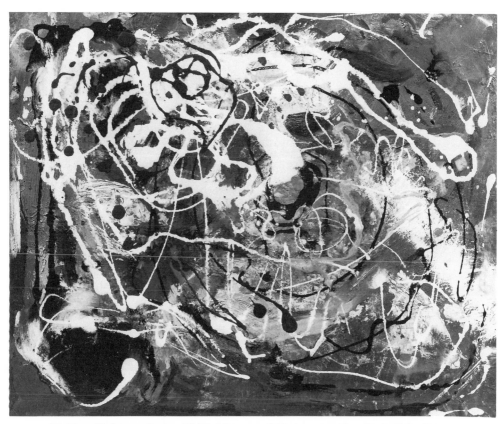

52. Hans Hofmann, *Spring* (1940). Museum of Modern Art, New York. Gift of Mr. and Mrs. Peter A. Rubel.

paint consistently, he stated, "When I am *in* my painting, I'm not aware of what I'm doing."[42] When he first experimented with pouring, Pollock apparently worked without preconceived ideas. In 1950, however, when asked by an interviewer whether he had a preconceived image in mind as he worked, Pollock, after three years of working with the technique, replied: "Well not exactly—no—because it hasn't been created, you see . . . it's quite different from working, say, from a still life where you set up objects and work directly from them. I do have a general notion of what I'm about and what the results will be."[43]

This quote reveals two things. First, Pollock's statements should be interpreted carefully, not in the abstract but in relation to the paintings Pollock was creating at the time. Second, the changes in Pollock's comments from 1947 to 1950 suggest that his method became progressively less accidental. His decisions, though often spontaneous, were not completely impulsive. Pollock in fact spent long hours contemplating the untouched canvas and studying works in progress.[44] In the same 1950 interview, when asked if his technique implied a loss of control, he answered: "No, I don't think so . . . with experience—it seems to be possible to control the flow of paint to a great extent, and I don't use . . . I deny the accident."[45] This idea of a controlled gesture was no less emphasized by Lee Krasner, who, describing Pollock's working methods to B. H. Friedman, remarked, "His control was amazing."[46] It is also reinforced by the visual evidence of the paintings themselves, as in the sequential upward repetition of a particular gesture at the bottom of *Number 32* [51]—also suggesting that Pollock was conscious of the orientation of his works (i.e., top versus bottom) and composed his canvases accordingly.

But although greater evidence of technical control can be detected in Pollock's mature paintings, his statement "I deny the accident" cannot be accepted uncritically. As William Rubin remarked, one cannot assume that every spot, stain, or mark on a Pollock painting is the direct result of a conscious decision. Once made, however, Pollock had the choice of either hiding, altering, or retaining any unanticipated effect.[47] Only in this sense did he deny the accident; in fact, it may be more appropriate to say that Pollock accepts, manipu-

lates, and incorporates rather than denies the accident. Unlike the Surrealists, Pollock had no use for the accident per se. His originality lies in reenergizing the latent potential of automatism by placing the canvas on the floor and fully exploiting the physical possibilities of gestural painting; in the process Pollock redefined the technical parameters of his own medium.

By all accounts, the poured paintings are Pollock's most complex and original works. They not only exploit a new technique of applying paint but achieve one of the seminal characteristics of Abstract Expressionism: a rather singular combination of painting and drawing, improvisation and composition, and tradition and modernity. But thus far the issues covered have dealt exclusively with the formal character, with the stylistic sources and innovations, of the poured paintings. A more problematic issue—not only in Pollock's work but in that of the whole Abstract Expressionist generation—is that of subject matter and interpretation. Pollock's poured paintings, with a few exceptions that will be discussed later, are devoid of visual references to the external world; in other words, they are abstract. Indeed, on this point Lee Krasner commented: "Jackson used to give his pictures conventional titles . . . but now he simply numbers them. Numbers are neutral. They make people look at a picture for what it is—pure painting."[48] Pollock himself on the issue of numerical titles added: "I decided to stop adding to the confusion . . . Abstract painting is abstract."[49]

This "confusion" probably arose when the public was baffled at confronting nonfigurative images with conventional titles. The spectator's natural tendency may have been primarily to scan the canvas for a visual confirmation of a given work's title. To prevent the spectator from searching for corresponding figural or representational images, which were nonexistent from the outset, Pollock decided to abandon titles and number the paintings. When asked how to appreciate modern art, Pollock, no doubt with his own paintings in mind, replied that the spectator "should not look for, but look passively—and try to receive what the painting has to offer and not bring a subject matter or preconceived idea of what they are to be looking for."[50] But simply because Pollock discouraged his audience from approaching his art

with preconceived ideas does not necessarily imply that his work is devoid of meaning. Nor does the use of numerical titles. After all, in 1951–53, when Pollock returned to figuration, he consistently designated figurative paintings by numerical titles. Even in 1950, when his work was consistently abstract, Pollock nonetheless hinted that his work contained some kind of meaning: "It doesn't make much difference," he insisted, "how the paint is put on as long as something is being said. Technique is just a means at arriving at a statement."[51] Pollock did not, of course, articulate what that "statement" was; he most likely wanted to avoid the problem described above—having the audience come to the works with preconceived ideas rather than experiencing the works on their own terms. The question thus is whether this "statement" can be expressed through or is compatible with an essentially abstract pictorial idiom.

The Abstract Expressionists, moreover, although committed to abstraction, continuously made remarks emphasizing the content of their works. Pollock himself, in a 1956 interview, expressed his dislike of the term *Abstract Expressionism* because, in his opinion, the movement was neither "non-objective" nor "non-representational."[52] From the context of the remark, Pollock appears to have considered himself included in Abstract Expressionism (however much he disliked the term). By implication, therefore, "non-objective" and "non-representational" do not apply to him. It should be interjected parenthetically that the last remark was made in 1956, shortly before Pollock's death. In that year Pollock did not paint, but the few paintings of the previous years (c. 1953–55) are, like the poured paintings of 1947–50, visibly abstract. Pollock thus appears to react against the idea that abstract art has no meaning as much as he reacts against the idea that abstract art copies the world. This paradox is still a point of contention in Abstract Expressionist scholarship. A major impediment to the resolution of the issue is the prevalent view of abstract art found, for instance, in Susan Sontag's book *Against Interpretation:* "Abstract painting is the attempt to have, in the ordinary sense, no content; since there is no content, there can be no interpretation."[53] Because this critical view is so pervasive (and still permeates much art historical scholarship to this day), the public's reaction was to see the

paintings either as pure form—causing Pollock to insist his paintings were not nonobjective—or to seek hidden images in the poured webs of paint—causing Pollock to insist that abstract painting was abstract. These seemingly contradictory remarks can be reconciled only if one abandons, as the Abstract Expressionists apparently did, the idea that abstraction cannot accommodate subject matter. Indeed, art historians have too readily assumed that systems of signification are necessarily (if not exclusively) predicated on visual resemblance. As a result, artists' statements on the congruity of meaning and abstraction have not been given the critical attention they deserve, and no attempt to formulate an alternative account of signification has emerged. These artists were in effect striving precisely for what Sontag claimed was impossible: *the compatibility of meaning and abstraction.*

This compatibility, moreover, already existed in another artistic medium to which Pollock and other Abstract Expressionists frequently referred: music. Pollock said abstract art "should be enjoyed as music is enjoyed,"[54] and Mark Rothko claimed to be an artist attempting to "raise painting to the level of music."[55] In addition, as early as the 1940s, Clement Greenberg, while formulating his views on modernism, was claiming that one of the aims of modern painting was to "purify" its medium of foreign references. Music was admired because, not having to illustrate observable phenomena like visual or literary arts, it was inherently abstract. In "Towards a Newer Laocoon," Greenberg wrote that "only when the avant-garde's interest in music led it to consider music as a method of art rather than as a kind of effect did the avant-garde find what it was looking for. It was then that it discovered that the advantage of music lay chiefly in the fact that it was an 'abstract art.' "[56] But music meant more than being purely abstract or inherently self-referential. Its importance was precisely in its capacity to reconcile the seemingly irreconcilable: to express a wide range of emotions while simultaneously being an abstract art.

The writings of Friedrich Nietzsche, which artists of Pollock's generation read with great interest,[57] provided added impetus. In *The Birth of Tragedy* (whose complete title, incidentally, is *The Birth of Tragedy Out of the Spirit of Music*), Nietzsche praises music above the other arts, since, in his view, it expresses the essence rather than

copies the appearance of phenomena.[58] Thus Nietzsche puts music on a higher level of achievement than either painting or literature. Freed from mere representation and the slavish need to copy appearances, music can concentrate on what Nietzsche termed the "metaphysical." Although there is no evidence to suggest Pollock read Nietzsche, his interest in music most likely drew him to artists that did. Mark Rothko, Barnett Newman, and Clyfford Still were strongly influenced by Nietzsche's writings,[59] and since the Abstract Expressionists established what Robert Motherwell called an "underlying network of awareness in which everyone knew who was painting what and why,"[60] it could be surmised that Pollock—who himself equated modern painting and music—could have been generally familiar with such ideas.[61] His own statement that "the modern artist is expressing his feelings rather than illustrating"[62] suggests that if Pollock was not aware of these ideas directly, he was nonetheless thinking along parallel lines. The relationship the Abstract Expressionists saw between painting and music, therefore, was not simply an attempt to "purify" the medium of painting. It was also the perfect precedent for and justification of the compatibility of meaning and abstraction.

Although Pollock could never be accused of being an illustrator— even his earlier references to myth were always abstracted, implicit rather than explicit—his work prior to 1947 could nevertheless have given the spectator a suggestion, a hint, however subtle, of recognizable subject matter. In the 1947–50 paintings, however, Pollock severed all perceptual references to a human subject in time, place, or scale, or, for that matter, to visual reality itself. The risk the artist, and by extension the interpreter, takes is that the more abstract the work, the more obscure and ambiguous the message. As Robert O'Rorke correctly pointed out, the more Pollock "pushed his imagery toward abstraction, the wider became the range of possible interpretations and the greater the risk of misinterpretation."[63] On this point, Edward Lucie-Smith added: "Communication in art is in its essentials a matter of the recognition of certain fixed symbols and conventions, rather than the direct transfer of emotions."[64] But, paradoxically, what Pollock and other artists of his generation attempted was precisely to reject "fixed symbols and conventions." They invented in effect their

own symbols, their own language—for which, of course, no dictionary exists.

But without common means of communication between artist and spectator, how do Pollock's paintings acquire meaning? A possible answer to this question appears to be closely related to what Ferdinand de Saussure called the arbitrary nature of the sign. In his *Course in General Linguistics*, Saussure argued that the relationship between a word and the concept or object that word refers to is completely arbitrary. "Tree" is no better sign than "arbre" or "baum" to suggest the object usually defined by that denomination; we recognize that the word "tree" refers to a certain object in the external world because the word "tree" has consistently been used to refer to that same object—and has been so defined by our linguistic convention—not because it describes or imitates that object. Therefore Saussure argues that the association of a linguistic sign to a specific object, or that the very process of signification, may function abstractly rather than imitatively: what he understands by the arbitrary nature of the sign.[65]

The nature of an abstract visual sign may be identical to that of a linguistic sign. For example, the meanings attached to the various crosses used among world cultures are independent of any visual associations with the external world. As Robert O'Rorke has stated: "Some symbols are so highly abstracted and unrelated to any figurative convention that their meaning is not apparent in the image itself and is therefore dependent on its functional context. Hitler's manipulation of the swastika is a typical example of the powerlessness of the symbol, for the word 'swastika' literally means 'fortunate' in Sanskrit."[66] The abstract sign, therefore, acquires meaning not through imitation but through (1) consistent usage or repetition and (2) the communal agreement of or codification by the individuals that employ the sign.

That many Abstract Expressionists consistently repeated an identical or near-identical format throughout certain periods of their careers suggests that these artists were precisely engaged in a kind of private sign making. This does not mean, however, that artists like Pollock were out to illustrate ideas or were always fully conscious of the meaning of their work. Pollock himself confessed that during the

creative process he was not always fully aware of what he was doing. Only after what he called a "get acquainted period" did he begin to see "what he was about." In other words, although intentions may not have been clearly defined at the outset, the artist upon later reflection would discern a meaning from the general character of the painting.

As Saussure has convincingly demonstrated, signification may function independently of imitation and may, as in the case of Pollock, actually occur after the process of creation. The paintings, therefore, *are no less meaningful abstract than figurative*, but because the artist has refrained from explaining his work—preferring the paintings to speak for themselves—their codification has remained private. As the spectator detects neither recognizable images nor conventions in the work, the artist and his public are, so to say, speaking a different language. This does not imply, however, that any attempt to recover this language is necessarily doomed to failure, that the poured paintings are ineffable, and that interpretations are hopelessly open, without the slightest possibility of being substantiated. This does imply that the meaning(s) of the poured paintings are noncodified; they cannot be looked up in a handbook or dictionary of symbols the way one does an unidentified object in a religious painting; there is no narrative for which a descriptive explanation may be sought in a literary source. In Pollock's case, the possibility of interpretation is contingent on whether a sufficient body of evidence exists to present a convincing hypothesis. Detractors of modern art often criticize the need to find evidence external to the works themselves. But although external evidence is an integral part of any interpretation, its ultimate test, its capacity to persuade, is in conjunction with the object it seeks to interpret. Since the response to paintings in general, and to abstract paintings in particular, may be incurably subjective, to review external evidence is an attempt not only to recover the artist's intentions but to make interpretation more convincing. To look outside the work for evidence is no less valid than, say, Panofsky's use of a passage in Ovid to explain a painting by Titian.

The question then is whether enough evidence exists even to attempt an interpretation of the poured paintings. There does. For example, clues may first be found in particular events in Pollock's

biography. Ellen Johnson remarked that as Pollock moved from New York City to Long Island, his titles began to change. For example, the titles in Pollock's April 1946 exhibition at Peggy Guggenheim's Art of This Century were *Circumcision, Troubled Queen, An Ace in the Hole,* and *High Priestess.* Several months after his stay in Long Island, however, evocations of the mythical were replaced by evocations of the natural; titles such as *Sounds in the Grass, Croaking Movement, Shimmering Substance,* and *Earth Worms* began to appear.[67] But this same phenomenon is equally applicable to the 1947–50 poured paintings as a whole, the titles of which suggest references to nature: *Galaxy, Watery Paths, Magic Lantern, Enchanted Forest, The Nest, Reflections of the Big Dipper, Sea Change, Vortex, Full Fathom Five, Prism, Alchemy, Comet, Shooting Star, Phosphorescence, Summer Time, Out of the Web, Lavender Mist,* and *Autumn Rhythm.* Since Pollock hated titling, sometimes declining to choose titles, changing them, or substituting numbers, the use of titles as explanations of paintings has caused controversy in the Pollock literature.[68] And although one cannot deduce a convincing hypothesis from a single title, the change, coinciding with the move to Long Island, of most of Pollock's titles to evocations of nature cannot be mere coincidence.

Evidence for Pollock's thematic interest in nature may also be discernible in statements by Pollock himself and those around him. According to those individuals closest to him, Pollock's own dialogue with the natural environment was quite intense. Lee Krasner, for example, recalled that Pollock "identified very strongly with nature,"[69] and his friend Tony Smith emphasized Pollock's "feeling for the land. . . . I think it had something to do with his painting canvases on the floor. . . . I don't think Jackson painted on the floor just for its hard surface, or for its large area. . . . There was something else, a strong bond with the elements. The earth was always there."[70] Pollock himself told B. H. Friedman, "My concern is with the rhythms of nature, the way the ocean moves, I work inside out like nature."[71] Hence, like Turner, to whom Robert Rosenblum astutely compares him,[72] Pollock translates the dynamic energy of nature into the medium of paint. But unlike Turner, Pollock never illustrates or even refers to the specifics and particulars of empirical experience.[73] In his

statement Pollock proclaimed interest not in the optical qualities of the landscape but in its rhythm—not in nature per se but in the effect of nature. In transcending the visual appearance of the environment, Pollock gives, instead, a visual *equivalent* (Pollock's own word),[74] a metaphor, of its underlying energy. In notes preserved in the Pollock archive, Pollock wrote, "States of order—Organic Intensity—Energy and Motion made visible."[75]

It is no surprise, therefore, that following the completion of *Number 29* (CR4:1036)—a painting executed on glass for Namuth's film of Pollock at work—Pollock installed the work in front of the Long Island landscape.[76] This way he could study the correspondence between art and nature, between his work and the environment it was meant to capture.[77] Thus, without depicting a representational landscape yet expressing the perpetual motion and dynamic rhythms of nature, Pollock's poured paintings reconcile and affirm the possible compatibility of meaning and abstraction. Yet for Pollock abstraction's potential to accommodate meaning may not have been a problematic issue at all. Abstraction was, arguably, the most appropriate stylistic avenue open to him. How else could he have expressed an incorporeal principle such as energy without resorting to allegorical representation? Abstraction was the only way to render "energy made visible." An energy filtered not through the eye but through Pollock's unprecedented physicality in the act of painting.

Even Pollock's technique—his placement of the canvas on the floor near the earth, as Tony Smith noticed, his manipulation of the elemental force of gravity, and his inspiration from Indian sand painters—may be related to the evocation of nature. As quoted earlier, Robert Motherwell considered art to be the "desire to wed one's self to the universe" and that "primitive art" expressed a feeling of "already being at one with the world."[78] Indian sand painting, therefore, should not be considered a mere precedent for painting on the floor. Its proximity to the earth could be interpreted as thematically as well as technically paramount. And, like all non-Western art, if one accepts Motherwell's reading, it already possessed the very qualities Pollock was trying to express. If Pollock wanted to evoke the dynamism of the natural environment, his adoption of a technique akin to or inspired

by that of a non-Western culture becomes perfectly appropriate. In 1944 Motherwell believed that Pollock's principal problem was "to discover what his true subject is," but Motherwell nonetheless accurately predicted that "since painting is his thought's medium, the resolution must grow out of the process of painting itself."[79] In fact, from 1946 onward, Pollock's interest in nature *and* in the poured technique developed simultaneously as Pollock started living on Long Island. In addition, Lee Krasner's recollection that Pollock painted on the floor only after living in Springs[80]—the period when the titles changed to evocations of nature—suggests that Pollock may have associated, at least during 1947–50, the poured technique with the thematic reference to nature.

Pollock, it seems, did not consider form and meaning to be distinct and separable entities. On the contrary, the poured paintings may have a specific iconography, but this iconography is intimately, if not inseparably, rooted in Pollock's painting method. Only through the combination of stylistic and iconographical analysis can the general character of these works be interpreted with any kind of persuasiveness. It should therefore be instructive at this point to return to issues of style and to determine how and to what degree they reinforce issues of content. Iconographical interpretations should always be tested against the visual evidence of the works they seek to interpret.

Pollock, like all artists, had a plurality of formal elements at his disposal: line, color, composition, relative density of the paint, and so on. Yet the specific ways in which he consciously decided to manipulate these elements is particularly revealing. In effect, what Pollock achieved was a reduction of the autonomous properties of line, color, composition, and density of pigment into an almost unprecedented synthesis. Michael Fried described Pollock's line, for example, as working independently of description; no shapes, either abstract or representational, are suggested. "There is," he concludes, "only a pictorial field so homogeneous, overall and devoid both of recognizable objects and of abstract shapes that I wish to call it 'optical,' . . . the materiality of his pigment is rendered sheerly visual."[81] Even if Pollock used a variety of effects in the poured paintings—changing, for example, the relative thickness of lines or the relative density of the

pigment—these oppositions, according to Fried, cancel each other out in the textural fabric of a web that appears, although in reality is not, homogeneous. The multiplicity of foci and the decentralized quality of allover composition distribute pictorial effects so evenly that differences tend to be visually eliminated.

Predictably, the same may be said of Pollock's use of color. Although he uses different hues, often in different superimposed layers, the general effect is not of colors but of color.[82] The occasional use of silver paint, moreover, which alternatively absorbs and reflects light as one moves before the canvas, tends to neutralize various colors in favor of a unified field. Again, as in the case of material density or compositional emphasis, Pollock tends to neutralize visual differences. His formal tendency is to subordinate the part to the whole and make heterogeneous elements conform to a homogeneous image. Therein lies one of the paradoxes of Pollock's rather singular method of art making: on the one hand, a direct application of paint, an undisguised emphasis on the materiality of the pigment for its own sake, independent of its descriptive function, and on the other, the neutralization of this quality in favor of the immateriality of the allover optical field. The result is analogous to a musical composition where the listener would be aware only of sound rather than of the combination of separate instruments.

But to return to issues of meaning, or, rather, to the concordance between meaning and form, it is reasonable to assume that the visual neutralization of difference achieved by Pollock's allover field is a pictorial quality warranted by the subject. If the goal is to render the pulse and energy of nature in pictorial but abstract form, the effect would be less successful if the composition was fragmented, compartmentalized, or sequentially arranged part to part. Pollock's holistic and dynamic image prevents any part of the painting from conspicuously assuming too much importance. As a result, the spectator's attention does not rest on any particular spot but ceaselessly races from one to the other, creating the very effect of "energy made visible."

In the poured paintings, everything comes together for Pollock. The propensity toward allover composition, the physicality of the

poured technique, and the thematic reference to nature are not only interrelated but mutually reinforcing. And despite Pollock's consistent iconography and formal strategy of neutralizing differences within the frame of a single painting, the poured paintings are diverse enough to generate infinite variety. Artists as diverse as Claude Lorrain, Jacob van Ruisdael, Constable, Turner, and Georgia O'Keeffe may all have painted landscapes, but the subject of nature elicits different responses in each. Similarly, the poured paintings may collectively suggest the energy of nature, but they display an exceptional variety of expression. Each work is different. The slightest shift in scale, in tonality, in texture, or in the properties of line can dramatically alter the visual effect of any given work. Indeed, the poured paintings have been called everything from violent and anguished to lyrical and rococo.

Of course, such qualifications are subjective. They lie somewhat outside the realm of art historical analysis, and it is the individual spectator's prerogative to make such judgments when in direct confrontation with the work. The subjective nature of public reactions, however, is complicated by an artist's use of abstraction. Through the elimination of recognizable imagery, the paintings have indeed become more subjective. And this subjectivity applies as much to the artist's intentions as it does to the public's reception.

Pollock may have spoken of "energy made visible," but this energy is filtered through the artist himself—his bodily movements, his psychology. Pollock may have mentioned "the rhythms of nature," but he also spoke of modern artists communicating an "inner world—in other words—expressing the energy, the motion, and other inner forces."[83] The content of the poured paintings thus alludes not only to the force of the physical environment but, perhaps more importantly, to the artist's interiorization of this force. Pollock's identification with nature allowed his introverted character a means of expression. In the landscape he could have found the same energy and violence, conflicts and contradictions that ruled his own personality, a personality he would then project onto his own work.

When Pollock described his technique as allowing him to be in or part of his painting, he spoke as if his works were an extension of

himself: "Every good artist," he asserted, "paints what he is."[84] The paintings, thus, are not so much an evocation of nature as a unification of the self with nature—an effort, as Motherwell put it, to "wed one's self to the universe." Hence, when Hans Hofmann reproached him for not working from nature, Pollock appropriately replied, "I am nature."[85]

Yet this apparent equation of the self with nature, of the painter with the paintings, leads to a rather problematic, if not controversial, question in the Pollock literature. If Pollock drew such an intimate connection between himself and his work, could obscured figural references be detected within the poured paintings? The controversy began with a statement Pollock made to his wife, Lee Krasner. When interviewed by B. H. Friedman, she recalled: "I saw his paintings evolve. Many of them, many of the most abstract began with more or less recognizable imagery—heads, parts of the body, fantastic creatures. Once I asked Jackson why he didn't stop the painting when a given image was exposed. He said, 'I chose to veil the imagery.' "[86] This recollection would imply that Pollock's method was actually the reverse of Surrealist automatism. Instead of beginning with random and spontaneous hand movements to elicit unconscious imagery, Pollock would have obscured or veiled preexisting imagery by means of the abstract web. The idea that the poured paintings possibly covered hidden layers of figurative—and thus legible—images became a popular one in the Pollock literature; some scholars even adapted it as a general rule.[87] Lee Krasner, however, later clarified what she meant in conversation with William Rubin. She related that "veiling the imagery" referred only to *There Were Seven in Eight*, a painting of 1945 (CR1:124). It was an exception, she then asserted, and should not be applied to the poured paintings.

Although this seems the most plausible of the two hypotheses—indeed, there is no direct visual evidence to suggest the poured paintings cover initial layers of figurative imagery—a few exceptions to this rule should be mentioned. Several drawings and paintings of this period are, in fact, conspicuously figurative. The question then is whether these are isolated instances or possible paradigmatic examples of the first stage of any number of paintings during 1947–50. A

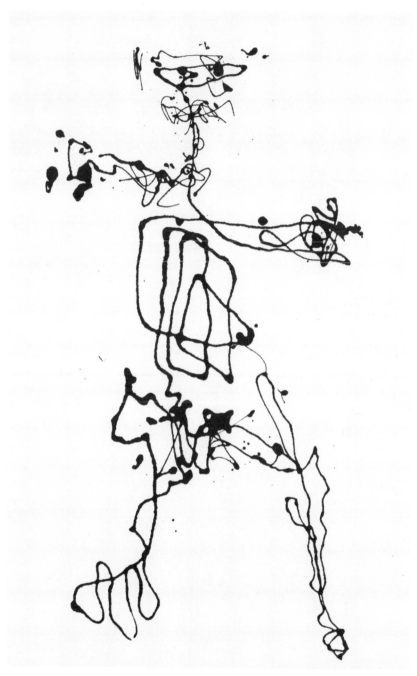

53. Jackson Pollock, *Untitled* (c. 1948–49). Mr. and Mrs. Herbert Matter collection.

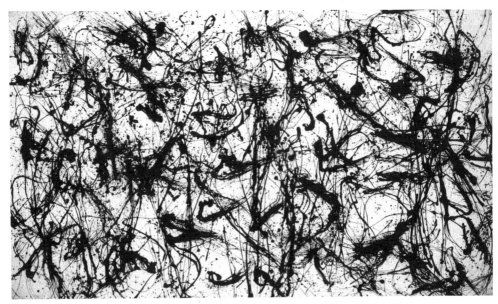

54. Jackson Pollock, *Number 32, 1950*. Kunstsammlung Nordrhein-Westfalen, Düsseldorf.

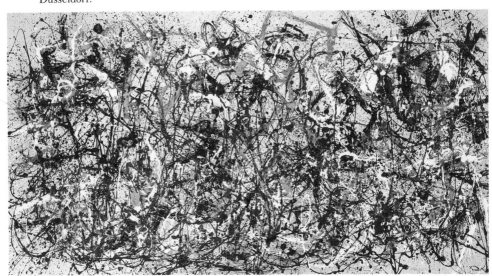

55. Jackson Pollock, *Autumn Rhythm* (1950). Metropolitan Museum of Art, New York.

small apparently poured drawing of 1948–49, moreover, clearly outlines the shape of a human figure [53]. But to change its orientation (to place it upside down or on its side) and to add several additional layers of pigment would, in all likelihood, completely obscure all suggestions of a figurative reference. Indeed, Pollock worked "contrapuntally," that is, one layer above another. *Number 32* [54], *Autumn Rhythm* [55], and *One* [56], although they were not painted in that order (it was actually *Number 32, One,* and then *Autumn Rhythm*), could easily be read as the three stages, or layers, of the same painting.[88] And although figural imagery is not perceptible in *Number 32,* it is clearly present in an untitled drawing of 1948–49 [57]. As it is, the figural reference is hardly visible in black-and-white photographs. But in color the drawing reveals two layers. The first, in black, is clearly figurative, while the second, in red and thicker in density, covers and partially obscures the imagery. Were the two color layers of identical or close-valued hues, the figural images would be barely visible. It would require very little, it seems, for Pollock to obliterate any representational layer, if such was his intention.

Another possible indication that the poured paintings may hide a latent figural presence is that Pollock occasionally mounted his pictures on board and proceeded to cut shapes directly from them. The most notable example is *Out of the Web* of 1949 [58]. Although the shapes created in this painting can only loosely be called figural, the shapes removed from *Cut Out* [59] and *Rhythmical Dance* [60] are more obviously so. But Pollock not only removed those shapes, he remounted them on either board or masonite and poured paint on them as he would on any other painting [61, 62]. This is not to suggest that Pollock associated all of the poured webs with hidden figuration. On the contrary, as far as the evidence suggests, the examples mentioned here are exceptions rather than symptomatic of the paintings as a whole. In the majority of cases where the skeins of paint are more transparent, the paintings reveal no figures in the initial or subsequent layers.

This does suggest, however, that the poured paintings are connected to humanity as much as to nature. After all, the poured paintings were not painted mechanically or impersonally but by the move-

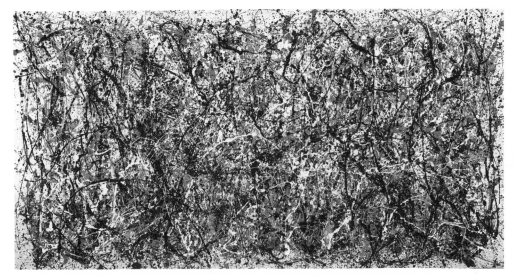

56. Jackson Pollock, *One: Number 31, 1950*. Museum of Modern Art, New York. Sidney and Harriet Janis collection.

ments and gestures through space of a human subject. The gesture of the human body, its capacity for lateral expansion, dictates the scale and the character of the movement, which in turn dictates the character of the line. Thus, although he moved around the canvas as he worked, Pollock was restricted by, and could not expand beyond, his own—human—capacity for lateral movement. This is perhaps why he called his studio "the arena."[89] It is also why one cannot compare Pollock's paintings with wallpaper—and all of the pejorative connotations implicit in that term: an impersonal, mechanically reproduced fabric that can expand indefinitely.[90] On the contrary, the marks in Pollock's paintings are intimately tied to the proportions and scale of a human body—his own.

With the rhythms of his own body Pollock suggests the rhythms of nature, as if he was attempting to break down the distinctions that segregate the self from the environment, the internal from the external. Again his retort to Hans Hofmann comes to mind: "I am nature." Such an equation of the self with the natural dimension may draw further allusions to or parallels with Lucien Lévy-Bruhl's concept of

57. Jackson Pollock, *Untitled* (c. 1948–49). Metropolitan Museum of Art, New York.

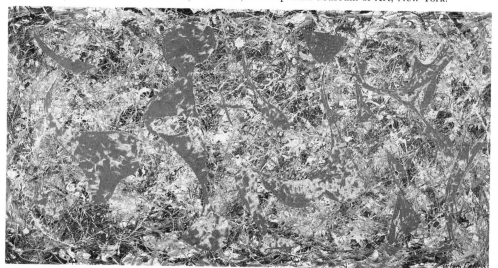

58. Jackson Pollock, *Out of the Web: Number 7, 1949*. Staatsgalerie, Stuttgart.

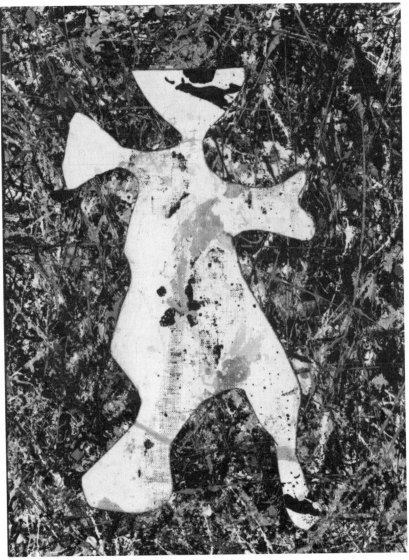

59. Jackson Pollock, [*Cut Out*] (c. 1948–50). Ohara Museum of Art, Kurashiki, Japan.

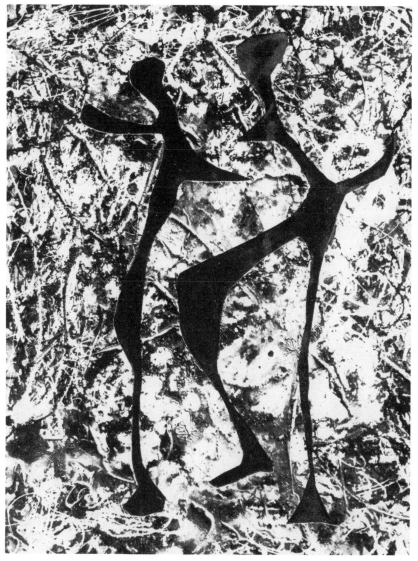

60. Jackson Pollock, [*Rhythmical Dance*] (1948). Private collection, London.

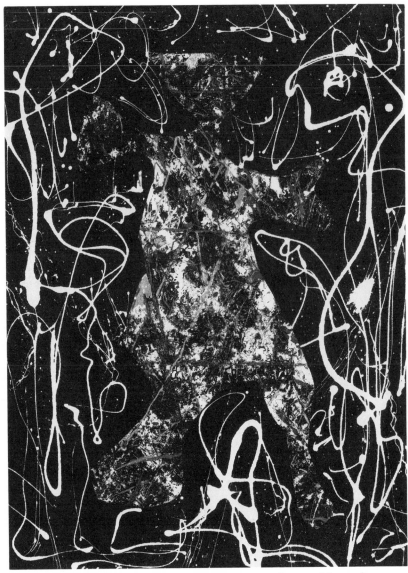

61. Jackson Pollock, [*Cut-Out Figure*] (1948). Private collection, Montreal.

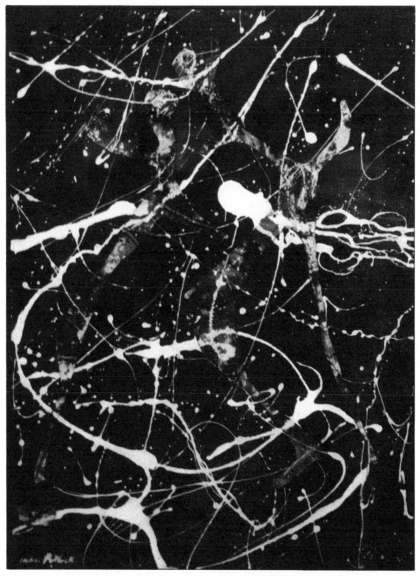

62. Jackson Pollock, [*Rhythmical Dance*] (1948). Jason McCoy Galleries, New York.

the primal mind. But since this connection is rather speculative, it is presented here as an affinity rather than as a direct influence. Pollock's allover compositions and lack of hierarchy of imagery are indeed analogous to certain anthropological definitions of primitive thought.[91] Included in the anthropological anthology in Pollock's possession is Lucien Lévy-Bruhl's essay "The Solidarity of the Individual with His Group." Explaining the collective nature of the "primitive" mind, Lévy-Bruhl writes: "The primitive mind tends to confuse the individual and the species, . . . individuality is but relative, . . . only a multiple and transient expression of a single and imperishable homogeneous essence."[92] This is not to imply that the "primitive" does not make distinctions; on the contrary, in certain cases, as in his comprehension of the natural world, the "primitive" can be quite categorical. But unlike Western individuals, the "primitive" does not feel divorced from the natural environment. This close proximity with nature makes the "primitive" aware of an underlying energy behind a world that, according to Frazer in *The Golden Bough* (also in Pollock's possession), is "viewed as a great democracy; all beings in it, whether natural or supernatural, are supposed to stand on a footing of equality."[93]

This view of the world as a "homogeneous essence," as a "great democracy," where all aspects of life are equal and interrelated, parallels what Pollock was trying to achieve stylistically (allover composition) and iconographically (the union of the self and nature). What Pollock felt intuitively, that humanity is connected to rather than separate from nature, and the way he depicted this feeling in art, translating the rhythms of nature and of man in a single field of energy, also anticipate modern ideas about the origins of the universe. Although Pollock could never have predicted the achievements of theoretical physics thirty years after his death, scientists now also believe that, on the atomic scale, all things are connected. Every atomic particle in a human body was once part of a star, itself a residue of the Big Bang. And, furthermore, although scientists see the universe as guided by four essential forces—the strong force (which binds atomic particles together), the weak force (by which atomic particles disintegrate), gravity, and electromagnetism—they nonetheless believe that these four forces are the exponents of, and originally acted

as, a single force. Paradoxically, the most modern and the most basic meet at this level; the concept of the universe—whether in the intuitive feelings of the primitive mind or in the advanced theories of twentieth-century astrophysics—is the same. And Pollock, who was always interested in and sensitive to his relationship to nature, must have, like the primitive, sensed something of the order of things.

Despite the new stylistic and iconographical issues raised by the poured paintings, a strong continuity does exist between the sometimes awkward and provincial work of the early 1930s and the mature and fully realized work of 1947–50. Pollock's obsession with the theme of humanity's connection with nature was apparent in his early landscapes of the 1930s, his interest in rhythmic dynamics can be traced back to his work with Benton, and his concern with primitivism was anticipated in the totemic imagery of the 1940s. But although they should not be entirely divorced from Pollock's earlier work, the poured paintings do constitute a category apart. To most critics and art historians, they represent his best and most original works. They typify Pollock's most successful marriage of modernity and tradition, of form and content, and of meaning and abstraction. In addition, not only are they his most powerful stylistic statements, but they mark the full development and implementation of the poured technique—his most original and innovative contribution to art history. In many ways the poured paintings are the culmination of Pollock's career. They represent his maturity as an artist, his importance on a world scale, and, ultimately, even signal the shift of the avant-garde from Paris to New York. It may in fact be no exaggeration to see Pollock's position in history resting primarily, if not exclusively, upon his achievement during 1947–50.

NOTES

1. C. Greenberg, in *The Nation*, 1 February 1947. Also quoted in Friedman, op. cit., 95.

2. Ibid.

3. F. du Plessix and C. Gray, "Who Was Jackson Pollock?" *Art in America* 55 (May–June 1967): 48, 59.

4. J. Pollock, "My Painting," *Possibilities* 1 (Winter 1947–48), quoted in CR4, p. 241.

5. See W. Rubin, "Jackson Pollock and the Modern Tradition, Part IV," *Artforum* 5 (May 1967): 28–33, and D. Rubin, "A Case for Content: Jackson Pollock's Subject Was the Automatic Gesture," *Arts Magazine* 53 (March 1979): 103–9.

6. In the *Possibilities* statement (note 4) and in the narration for the documentary film by Hans Namuth and Paul Falkenberg in 1951, quoted in B. Rose, ed., *Pollock Painting* (New York, 1980), n.p.

7. In "Jackson Pollock and the Modern Tradition," *Artforum* 5 (February 1967): 22, note 9, W. Rubin, quoting the artist's brother, does not believe Pollock ever saw such ceremonies. Jackson Rushing, in "Ritual and Myth: Native American Culture and Abstract Expressionism," in *The Spiritual in Art: Abstract Painting 1890–1985* (Los Angeles County Museum of Art, 1986), 272ff., is of another opinion. According to Rushing, Pollock saw demonstrations of Indian sand paintings at the Museum of Modern Art during an exhibition entitled *Indian Art of the United States* in 1941. Violet Staub de Laszlo, Pollock's analyst, related how fascinated Pollock was with this process (see Rushing, 282).

8. See Rushing, op. cit.

9. Krasner quoted in *Pollock Painting*, n.p. Pollock, in addition, owned numerous volumes of the *Publications of the American Bureau of Ethnology*, describing these ceremonies in great detail as well as including multiple illustrations of Indian sand paintings.

10. CR4, p. 232.

11. H. Namuth, "Photographing Pollock," in *Pollock Painting*, n.p.

12. F. O'Hara, *Jackson Pollock* (New York, 1959), 26.

13. CR4, p. 251.

14. In the 1 February 1947 review in *The Nation*, Greenberg wrote: "Pollock remains essentially a draftsman in black and white who must as a rule rely on these colors to maintain the consistency and power of surface of his pictures."

15. See B. Rose, *Jackson Pollock: Drawing into Painting* (Museum of Modern Art, New York, 1980).

16. Although examples of handprints can be found in the works of modern artists such as Picasso, Man Ray, Miró, Hofmann, and Gottlieb, only the prehistoric source provides a precedent for the lateral repetition of the prints in such a manner.

17. Brown, op. cit., 75, fig. 39. I first suggested this relationship in an unpublished qualifying paper, "Primitive Sources in Jackson Pollock" (Institute of Fine Arts, New York University, 1982), 8.

18. Brown, op. cit., 75; see also R. Hobbs, "Early Abstract Expressionism: A Concern with the Unknown Within," in *Abstract Expressionism: The Formative Years*, 9–10; C. Stuckey, "Another Side of Jackson Pollock," *Art in America* 65 (November–December 1977): 82ff.; A. Elsen, in *Purposes of Art* (London, 1967), 3–5, compared prehistoric handprints with those in *Number 1A*, implying a similarity of intention bridging modern and prehistoric art. He did not, however, suggest the former as a source for the latter.

19. L. Adam, *Primitive Art* (London, 1949), 87. See "Pollock's Library," CR4, p. 188.

20. Linton, op. cit., 191–93.

21. Quoted in S. Rodman, *Conversations with Artists* (New York, 1957), 82.

22. B. Alfieri, in *L'Arte Moderna* (undated) quoted in F. V. O'Connor, *Jackson Pollock* (Museum of Modern Art, New York, 1967), 54–55.

23. P. Restany, "Jackson Pollock, l'eclabousseur," *Prisme des arts*, quoted in Rubin, "Jackson Pollock and the Modern Tradition," Part I, 16.

24. In "A Life Round Table on Modern Art" (*Life*, 11 October 1948), Aldous Huxley spoke of *Cathedral* (CR1:184): "It raises the question of why it stops when it does. The artist could go on forever. . . . It seems to me like a panel for a wallpaper which is repeated indefinitely around a wall." Quoted in O'Connor, op. cit., 44. Pollock, of course, was quite conscious of and deliberately exploited the effect of allover composition. In O'Connor (51) he is quoted as saying: "There was a reviewer a while back who wrote that my pictures didn't have any beginning or any end. He didn't mean it as a compliment, but it was. It was a fine compliment."

25. Lee Krasner, in an interview with B. H. Freidman in a 1969 catalog *Jackson Pollock: Black and White* at the Marlborough Gallery in New York, stated: "In the late 1930's the 'art scene' consisted of a rather intimate group of painters and their friends. I don't mean that we saw each other steadily, but one knew who was painting and what their work was about" (37).

26. Quoted in O'Connor, op. cit., 43.

27. Quoted in J. O'Brian, ed., *Clement Greenberg: The Collected Essays and Criticism*, vol. 2 (Chicago, 1986), 75.

28. *Art and Culture*, 218–19: "By means of his interlaced trickles and spatters, Pollock created an oscillation between an emphatic surface—and an illusion of indeterminate but shallow depth that reminds me of what Picasso and Braque arrived at thirty-odd years before, with the facet planes of their Analytical Cubism. I do not think it exaggerated to say that Pollock's 1946–50 manner really took up Analytical Cubism from the point at which Picasso and Braque had left it when, in their collages of 1912 and 1913, they drew back from the utter abstractness to which Analytical Cubism seemed headed. There is a curious logic in the fact that it was only at this same point in his own stylistic evolution that Pollock himself became consistently and utterly abstract."

29. See W. Rubin, "Jackson Pollock and the Modern Tradition," *Artforum* 5 (February 1967): 14–22; "Part II" (March 1967): 28–37; "Part III" (April 1967): 18–31; "Part IV" (May 1967): 28–33.

30. Ibid., Part III, 27.

31. Greenberg, " 'American-Type' Painting," 218.

32. Greenberg, "The Crisis of the Easel Picture," in *Art and Culture*, 157.

33. Ibid., 155.

34. See Rubin, "Jackson Pollock and the Modern Tradition," Part III, 28–29.

35. Greenberg, " 'American-Type' Painting," 216.

36. Ibid., 210.

37. Rubin, "Jackson Pollock and the Modern Tradition," Part IV, 28.

38. Ibid., 30, quotes Patrick Waldberg, the author of a major monograph on

Ernst: "The *Mad Planet* and the *Non-Euclidian Fly* had, historically, unexpected repercussions. . . . When these canvases were exhibited late in 1942, the painters Motherwell and Jackson Pollock were astounded by the delicacy of their structures and begged Max Ernst to tell them their secret. It was a simple one (i.e. the string and can mechanism) and Jackson Pollock later used this technique called 'dripping,' most systematically. Later he was credited with its invention" *(Max Ernst* [Paris, 1958], 386).

39. Rubin, "Jackson Pollock and the Modern Tradition," Part IV, 30.

40. Ibid., 31.

41. Ibid., 28.

42. Pollock, "My Painting," CR4, p. 241.

43. Pollock interviewed by William Wright for station WERI in Westerly, R.I. Quoted in CR4, p. 251. This change in Pollock's statements was noticed by E. A. Carmean in "Jackson Pollock: Classic Paintings of 1950," *American Art at Mid-Century: The Subjects of the Artist* (National Gallery of Art, Washington, D.C., 1978), 136–37.

44. In conversation with E. A. Carmean, Lee Krasner confirmed Pollock's frequent study of the canvas while the work was in progress: "How well I remember when Pollock would want to study one of those big canvases on the wall. He'd attach the top edge to a long piece of 2 × 4, and together we'd lift it up" (Carmean, op. cit., 133).

45. CR4, p. 251.

46. Krasner interviewed by Friedman in *Pollock Painting*, n.p.

47. See Rubin, "Jackson Pollock and the Modern Tradition," Part II, 31.

48. Lee Krasner interviewed by Friedman in *Pollock Painting*, n.p.

49. CR4, p. 247.

50. CR4, p. 249.

51. CR4, p. 251.

52. Quoted in Rodman, op. cit., 82.

53. S. Sontag, *Against Interpretation and Other Essays* (New York, 1966), 10.

54. CR4, p. 249.

55. Rothko quoted in B. O'Doherty, *American Masters: The Voice and the Myth* (New York, 1973), 153. On this point, S. Buettner, *American Art Theory 1945–1970* (Ann Arbor, Mich., 1981), 71–73: "American painters and sculptors of the 1940's, like their German Expressionist counterparts tended to justify abstraction on the basis of the musical analogy. These never developed into theoretical postures like those of Kandinsky, but took the form of casual observation. . . . David Smith saw abstraction as an advancement over representational art simply because it was like music or mathematics." (D. Smith, undated speech, United American Artists' Forum, Smith Papers, Archives of American Art), Smithsonian Institution, Washington, D.C.

56. *Partisan Review* 7 (July–August 1940): 304. For a compendium of Greenberg's sources, see S. Foster, *The Critics of Abstract Expressionism* (Ann Arbor, Mich., 1980), 13–22.

57. See D. Ashton, *The New York School* (New York, 1972), 86.

58. F. Nietzsche, *The Birth of Tragedy and The Case of Wagner*, trans.

Walter Kaufmann (New York, 1967), 101–2. Seitz, in a conversation with Rothko, recalls the artist's familiarity with this work in *Abstract Expressionist Painting in America* (Cambridge, Mass., 1983), 8.

59. See S. Polcari, "The Intellectual Roots of Abstract Expressionism: Mark Rothko," *Arts Magazine* 54 (September 1979): 131; Ashton, op. cit., 131; E. Firestone, "Color in Abstract Expressionism: Sources and Background for Meaning," *Arts Magazine* 55 (March 1981): 140–43; and A. Gibson, "Regression and Color in Abstract Expressionism: Barnett Newman, Mark Rothko, and Clyfford Still," ibid., 144–53.

60. I. Sandler, *The Triumph of American Painting: A History of Abstract Expressionism* (New York, 1970), 30.

61. CR4, p. 250.

62. Ibid.

63. R. O'Rorke, "Malevich and Pollock," *Art and Artists* 6 (April 1971): 25.

64. Quoted in ibid., 24.

65. See F. de Saussure, *Course in General Linguistics*, trans. W. Baskin (New York, 1966), 65ff.

66. O'Rorke, op. cit., 24; On the independence of imitation from signification, see also N. Goodman, *Languages of Art* (Indianapolis, Ind., 1976).

67. E. Johnson, "Jackson Pollock and Nature," *Studio* 185 (June 1973): 259.

68. Friedman, op. cit., 94: "Pollock frequently encouraged the people close to him, those whose sensitivity he trusted, to free associate verbally around the completed work. From their responses, from key words and phrases, he often, though not always, chose his titles—typically vague, metaphorical, or poetic. He thought of each title as a convenience in identifying the work rather than in any sense a verbal equivalent of its subject matter. To Pollock the meaninglessness of titles (as compared with the work) is evident . . . in his having . . . retitled *Moby-Dick* of 1943 to *Pasiphae* at the suggestion of Sweeney." See also Rubin, "Pollock as Jungian Illustrator," *Art in America* 67 (December 1979): 72ff. Carmean, op. cit., 148, however, rightly concludes that "the important point is not that Pollock named or accepted the name for any particular work, but rather that the preponderance of 'abstractly' worded titles do refer to natural phenomena. Any single title—by itself—will not lead to sure analysis; but that there is such a large proportion of titles does suggest that Pollock viewed the allover works as connected with nature in some manner." Even Friedman, concerning the poured paintings, admits: "Most of the titles group easily around the . . . elements" (op. cit., 120).

69. Lee Krasner quoted in *Pollock Painting*, n.p.

70. T. Smith quoted in "Who Was Jackson Pollock?" op. cit., 52–53.

71. Freidman, op. cit., 228.

72. R. Rosenblum, "The Abstract Sublime," *Art News* 59 (February 1961): 38–41, and *Modern Painting and the Northern Romantic Tradition* (New York, 1975).

73. Pollock did not paint with nature in front of him. Lee Krasner recalled that, to avoid visual distractions, Pollock secluded his studio by having no windows on ground level. See *Pollock Painting*.

74. CR4, p. 253.

75. Ibid.

76. E. A. Carmean, "The Church Project: Pollock's Passion Themes," *Art in America* 76 (Summer 1982): 114.

77. This interest in art's visual proximity or juxtaposition to the natural environment was not unique to Pollock. David Smith, for example, not only carefully placed his sculptured landscapes in the fields at Bolton Landing but also photographed his work deliberately silhouetted against the environment so that the landscape would echo or emphasize the lines of the sculpture.

78. Quoted in F. O'Hara, *Robert Motherwell* (New York, 1965), 45.

79. Ibid., 36.

80. Lee Krasner quoted in *Pollock Painting*, n.p.

81. M. Fried, "Jackson Pollock," *Artforum* 4 (September 1965): 15.

82. Rubin, "Jackson Pollock and the Modern Tradition," Part II, 33: "Though it is not essentially monochromatic like that of the late Monet or the Analytic Cubists, the Pollockian structure is fundamentally a light-dark one, as is perfectly natural for an art that grows out of drawing. Individual colors fuse in an allover tonality; the color is applied, as Robert Goodnough observed, 'so that one is not concerned with separate areas: the browns, blacks, silver and white [*Autumn Rhythm*] move within one another to achieve an integrated whole in which *one is aware of color not colors.*' " The quote from Goodnough comes from "Pollock Paints a Picture," *Art News* 50 (May 1951).

83. CR4, p. 250

84. Rodman, op. cit., 82.

85. Friedman, op. cit., 99.

86. Krasner in *Pollock Painting*, n.p.

87. See O'Hara, op. cit., and Stuckey, op. cit.

88. Carmean, op. cit., 139–40.

89. Lee Krasner interviewed by Friedman in *Pollock Painting*, n.p.

90. Greenberg, "The Crisis of the Easel Picture," in *Art and Culture*, 155: "Though the 'all-over' picture will, when successful, still hang dramatically on a wall, it comes very close to decoration—to the kind seen in wallpaper patterns that can be repeated indefinitely—and insofar as the 'all-over' picture remains an easel picture, which somehow it does, it infects the notion of the genre with a fatal ambiguity." Although Greenberg's comparison is positive, Rosenberg made it even more pejorative when he coined the term *Apocalyptic Wallpaper*.

91. E. Levine, "Mythical Overtones in the Work of Jackson Pollock," *Art Journal* 26 (Summer 1967): 368.

92. L. Lévy-Bruhl, "The Solidarity of the Individual with His Group," *The Making of Man*, 251.

93. Frazer, op. cit., 91.

4
THE BLACK POURINGS AND AFTER

In 1950 Pollock was ostensibly at the apex of his artistic career. He had created what are now widely acknowledged as his best and most important works. The focus of a dozen one-man shows, championed by Clement Greenberg, photographed and filmed by Hans Namuth, he gained extensive public exposure and drew increasing critical attention from the press. His work was even featured in an article entitled "Jackson Pollock: Is He the Greatest Living Painter in the United States?" in the 8 August 1949 issue of *Life* magazine. Although the title was somewhat ironic, and the article hardly laudatory, Pollock surmounted the neglect and indifference with which the contemporary public customarily received advanced and particularly abstract art: in Willem de Kooning's words, Pollock "broke the ice."[1] And if Peggy Guggenheim's departure for Europe in 1947 left him without a dealer or a place to exhibit, Betty Parsons took up his contract (albeit at a lower rate). On a personal level, moreover, with the help of an East Hampton physician, Pollock managed, if only intermittently, to stop drinking. During the years 1948–50, when Pollock created what are generally recognized as his finest works, he abstained from alcohol almost entirely.

But late in 1950, immediately after the completion of Namuth's film, Pollock returned again, violently, to drink. What led him to alcohol after almost two years of near-complete abstinence—and after his most productive artistic period—is all the more perplexing since Pollock's sudden relapse precisely coincides with a radical stylistic and iconographical shift in his artistic development. Not surprisingly, this coincidence invites speculation as to whether the two events are in any

way connected. But since the potential effects of alcoholism on artistic creation (either generally or in Pollock's case) remain largely conjectural, the issue inevitably takes on a purely speculative character. Indeed, instead of directly relating Pollock's sudden stylistic mutations to his equally sudden return to drink, it may be more reasonable to see both not necessarily as cause and effect but as independent effects of an altogether different cause. Perhaps both were brought on by a combination of external and self-imposed pressure. In 1950 Pollock may have felt a critical impasse in his work. He had arrived—perhaps prematurely—at the culmination of his career; the question now, as Lee Krasner commented on Pollock's situation in 1951, was "What do you do next?"[2] Unlike other Abstract Expressionists (Rothko, Gottlieb, Newman, and, to a lesser extent, Motherwell), whose work is often based on the consistent variation of a single characteristic motif, Pollock had an avowed fear of "repeating himself."[3] Perhaps he saw no stylistic or technical way of surmounting the poured paintings, perhaps he needed another challenge, but in 1951, suddenly and unexpectedly, his art began to change. Although he did not relinquish the poured technique, he abandoned allover composition, restricted his color scheme almost exclusively to black, and, most significantly, returned to figuration.

In June of 1951 Pollock wrote his friend Alfonso Ossorio: "I've had a period of drawing on canvas in black—with some of my early images coming thru—think the non-objectivists will find them disturbing—and the kids who think it simple to splash a Pollock out."[4] The term "Black Pourings," it should be interjected, is not Pollock's. It was coined by Francis V. O'Connor when "Black and White" (the title of an exhibition of these works in 1969 at the Marlborough Gallery) and "Black Paintings" were both found inadequate on stylistic and visual grounds. The opposition implicit in the title "Black and White" suggests that Pollock either painted exclusively with two colors—as Franz Kline did for some time—or with black on a uniformly white ground. In fact, Pollock poured paint on unprimed raw canvas. The effect is not black on white—as overexposed illustrations often appear—but black on beige or light tan.

This incongruity between the title "Black and White" and the

process and appearance of the paintings was first noticed by Lawrence Alloway. In a review of the 1961 Marlborough exhibition, he wrote:

> Pollock poured black Duco, thinned with turpentine, onto raw canvas, not onto dead white canvas. The tools were either sticks or old brushes or, according to Lee Krasner, basting syringes. The paint though subject to exceptional control was not applied by touch; the paint impressions we see were formed by the fall and flow of liquid paint in the grip of gravity [in this sense the technique is identical to that used during 1947–50] onto a surface that was not hard and firm, like a primed canvas, but soft and receptive as sized and unprimed duck. Thus the black, even when applied in a continuous stream, does not produce a strongly visual reading. It burrs at the edges as it leaks out onto the canvas. . . . The black lines tend to dilate as a mark rather than converge upon enclosed areas. Thus what looks like drawing, is in fact, a restrained but pervasive way of painting; the black paintings are concerned with the fusion of color and surface, of paint and field.[5]

But if the term "Black and White" is found objectionable, O'Connor also considers the term "Black Paintings," used by Elizabeth Frank in her 1983 monograph on Pollock,[6] to be "too dark, both literally and figuratively, to describe the linear quality of even the most formally dense and iconographically ominous works of these years."[7] To be sure, although the pervasive tone of these paintings is black, Pollock occasionally included touches of other hues—primarily silver, yellow, and red (e.g., CR2:318, 354, 341). Indeed, "Black Paintings" would more accurately describe the late works of Ad Reinhardt or Robert Rauschenberg's monochromatic fields of color than the 1951–53 paintings by Pollock. O'Connor's term "Black Pourings," then, by eliminating the mistaken suggestion that Pollock used both black and white and denoting the use of black rather than uniformly black canvases, seems the more appropriate term.

Although the term "Black Pourings" may conveniently encapsulate a distinct and separable stylistic category—comparable, say, to the 1947–50 poured paintings—the reduction of the color scheme to black should not by itself be interpreted as a radical break with Pol-

lock's previous work. As early as 1947 Greenberg claimed that Pollock was "essentially a draftsman in black and white."[8] Not only does Pollock often rely on line at the expense of color, but several of the 1947–50 paintings are executed exclusively in black. Notable examples are *Number 26A, 1948: Black and White* (CR2:187), and *Number 32, 1950* [54]. E. A. Carmean, moreover, has argued that many of the polychrome poured paintings have an initial black layer; this is also implicit in Carmean's previously mentioned hypothesis that *Number 32, Autumn Rhythm,* and *One* can be seen as the three stages of a single painting, as if Pollock first painted a unifying black infrastructure for the other colors to follow.[9]

Thus, the predominance of black in 1951–53 should not, in and of itself, be interpreted as denoting a radical break from the general character of the 1947–50 poured paintings. Nor should Pollock's technique; as Alloway, basing his description on remarks made by Lee Krasner, explained: Pollock's working process (the placing of the unprepared canvas on the floor, the use of sticks or dried brushes, and the pouring of the paint with little if any physical contact between artist and canvas) hardly differs from the technique used in 1947–50.

What distinguishes the Black Pourings from the poured paintings, however, is Pollock's propensity in 1951–53 toward greater dilution of the pigment. There are several exceptions to this tendency, such as *Number 11, 1951* [63], where the paint is thickly applied, both with a brush and the poured technique. But, despite the exceptions, the dilution of paint provoked the most prominent and influential effect of Pollock's later work: staining. Diluted, the pigment loses its viscosity, its material texture. As it lands, it stains, it is absorbed into the canvas rather than resting on top of it. Not only an unprecedented flatness but an intimate association, if not co-identity, between paint and support also ensues.

In a diluted state, moreover, the pigment was both susceptible to physical manipulation and capable of producing a wide range of effects. Pollock's lines vary in thickness, size, and proportion [64], and the viscosity of enamel industrial paint produces various visual effects as the paint lands on and is absorbed into the canvas.[10] Francis V. O'Connor noticed that "the center of each line, where the poured

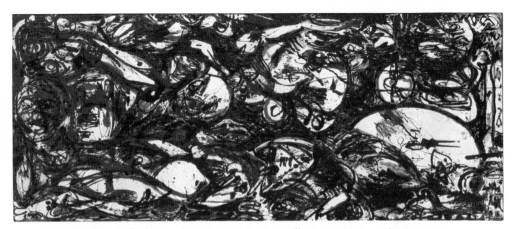

63. Jackson Pollock, *Number 11, 1951*. Private collection. Courtesy Thomas Ammann Fine Art, Zurich.

enamel first landed, is saturated and sparkles softly as light hits the texture of the canvas weave. To each side is an area where the paint has bled into the soft material. These lines, then, though consisting of no particular bulk of pigment . . . offer the eye a subtle dimensionality in their simultaneous fusion of matte, gloss, and *repoussoir* effects."[11]

Thus, in addition to the ways in which Pollock manipulates a wide range of effects—thinness versus thickness of pigment, larger versus smaller forms, straight versus curved lines, and so on—he uses pigments, like the aluminum paint occasionally used in 1947–50, that may alternately absorb or reflect light as the spectator moves before the canvas. The relative saturation of pigment creates a contrast between glossy and mat areas, causing specific parts to look wet and others to appear dry. Even before 1951, in the 1947–50 poured paintings, Pollock had used dilution and staining to produce an equally varied range of effects. But in the Black Pourings he manipulated the stylistic potential of these particular devices on a far more consistent basis.

In considering Pollock's greater propensity toward dilution of the pigment and staining, the formal and material properties of Pollock's works in 1951–53 have thus far been discussed as if his use of line were

64. Jackson Pollock, *Echo* (1951). Detail. Museum of Modern Art, New York.
Lillie P. Bliss Bequest and the Mr. and Mrs. David Rockefeller Fund.

no different from the 1947–50 paintings—that is, as if his line had remained essentially abstract. But Pollock's shifts in iconography inevitably accompanied a shift in style. Michael Fried asserted that while painting the large abstractions, Pollock had "managed to free line from its function of representing objects in the world, but also from its task of describing or bounding shapes or figures, whether abstract or representational."[12] Thus, if figural imagery reemerged in Pollock's work—as it does in 1951—the general character and visual properties of his linear designs, because of the new need to describe or bound shapes, would be expected to change. Predictably, during 1951–53 lines are less likely to span large areas; they are more controlled, they curve in on themselves and create comparatively smaller marks. But curiously enough, even if many of the Black Pourings are generally figurative, the lines retain an abstract character.

This may sound contradictory, but Pollock, having experimented for years with the stylistic effects and possibilities of a nonfigurative and nondescriptive line, was not about to abandon the technical freedom he had obtained. The works may qualify as figurative, but line rarely binds or consistently outlines any object or form. A paradigmatic example is *Number 3, 1951/Image of Man* [65]. The work betrays an obvious figural reference: a single layer of black enamel on raw canvas suggests the general shape of a human figure. But Pollock understood, like any modern artist, that line is an abstraction rather than a fact of nature. However abstract, line recalls the empirical facts of nature as much through the power of suggestion as through description—what Sir Ernst Gombrich calls the problem of abbreviation and information.[13] In this abbreviated manner, the Carracci could convincingly suggest a Capuchin preacher asleep at his pulpit with a mere five strokes [66]; nothing in those few minimal lines themselves creates this illusion. The illusion is not so much in the drawing as in the spectator's mind. Similarly, by manipulating line's abstract but visually suggestive character, the Surrealists (particularly Masson) could exploit line independently of any predetermined aesthetic system of representation other than the artist's own process of decision. This very capacity of line to shift its representational orientation—to be initially abstract and then to outline a breast, the length of a thigh,

65. Jackson Pollock,
*Number 3, 1951/Image
of Man*. Robert U.
Ossorio collection,
New York.

66. Diagram after Annibale Carracci's *Trick Drawing* (c. 1600).

and then to return to abstraction—is a frequent device of automatic writing. In the Black Pourings, Pollock works in a similar if not identical way. He must have understood that the power of line as a suggestive tool lies precisely in its capacity to be both abstract and figurative.

Yet compared with Masson's line, Pollock's is richer, fuller, and generates greater variety, not only in direction but in density and materiality. Pollock thus adapted the line of the 1947–50 paintings, with all of its plurality of effects and nonfigurative character, to the problem of figuration. But if Pollock's line has as much variety in 1951–53 as it does in 1947–50, why do the paintings differ so much in appearance? It would be tempting to attribute the formal differences to the progressive restriction of the color scheme after 1950, yet, as previously mentioned, Pollock executed monochromatic canvases well before the advent of the Black Pourings. The difference, rather, lies not so much in linear drawing or color schemes as in compositional emphasis.

For example, the 1947–50 poured paintings look strikingly different at close range than at a distance. The plurality of effects visible up close—of line, color, and texture—is, at a distance, neutralized by the even distribution of parts typical of the allover field (see chap. 3).

The spectator is less conscious of the relative thinness or thickness of lines, of various colors, of changes in textural density and is engaged, rather, not by minor details but by the dynamic energy of the picture's totality. In counterdistinction, the neutralizing effect of the allover field is rarely found in the Black Pourings. As a result, the different effects relative to the spectator's proximity or distance from the work are hardly as dramatic: the technique may be identical, but the effect is different. Although Pollock exploits the different visual and physical properties of liquid paint no more than in 1947–50, these properties are no longer neutralized by the structural homogeneity of allover composition. The full effect of the poured technique—manipulating the behavior of pigment under the law of gravity—implicit in the earlier period becomes all the more explicit. Less restricted by compositional formulas, the *process* and *materials* of painting take on unprecedented visual importance. This dual emphasis on the force of gravity and on the way it affects the materiality of pigment naturally, independent of a preconceived compositional plan, was to be particularly influential in postwar art—especially among the Post-Minimalists. For example, Philip Leider commented on Richard Serra's splashings of silver paint along the bottom of gallery walls [67] by stressing how "the material—the silver paint—had assumed no form other than that entirely natural to its own fluid, formless properties."[14] Serra's desire to let the material create shapes inherent or proper to its own properties under the laws of gravity is, as he himself admitted, clearly indebted to Pollock.[15]

Ironically enough, Pollock's new emphasis on the inherent material properties of paint under gravity arose through—or rather because of—a return to figuration. The need to suggest images forced him first to restrict the density of the layering to expose the imagery and second to work outside the stricter confines of allover composition, which, as stated before, tended at a distance to neutralize the material properties of the pigment in the allover field. The differences between the 1947–50 and the 1951–53 paintings are thus not only iconographical but compositional. One has the pictorial unity of the earlier non-hierarchical poured paintings versus the fragmentation of foci, the greater variety of effects, and the more pronounced opposition of

67. Richard Serra, *Splashing* (1968). Installed at Castelli Warehouse, New York.
Photographed by Harry Shunk.

painted and unpainted canvas left visible in the Black Pourings. Yet Pollock never worked within closed systems; even if the poured paintings and the Black Pourings are interpreted as distinct chronological and stylistic periods, excessive generalizations will only call exceptions to mind. In fact, the quality of line achieved in the Black Pourings was anticipated in the 1947–50 period—in several paintings where Pollock neglected allover composition, such as *Number 26, 1949* [68], and in a number of drawings [e.g., 53]. These works, both abstract and figurative, have properties far closer to the Black Pourings than to the 1947–50 poured paintings.

To detect compositional anticipations of the Black Pourings in several paintings and drawings of an earlier period, however, is not to undermine indiscriminately the validity of designating stylistic or chronological categories. It is, rather, to suggest that such categories are hardly as strictly circumscribed as art historians would often like to believe, and to point to a continuity in Pollock's work that may otherwise have been overlooked.

This continuity, moreover, between the Black Pourings and some of Pollock's drawings from 1947–50 raises another issue brought to the fore in the Pollock literature: the proximity of and relationship between painting and drawing. Indeed, one of Pollock's most appreciated qualities is his draftsmanship. For Frank O'Hara, "each change in [Pollock's] individual line is what every draftsman has always dreamed of: color."[16] William Rubin, in distinguishing Pollock's poured paintings from the inductive Surrealist devices of *coulage* (pouring) and frottage, called the former a "wilful, actively directed drawing with paint."[17] Bernice Rose, in a study of Pollock's drawings, also saw a connection between painting and drawing:

> For months in 1947 he seems to have given up working on paper entirely. By 1948 he had adapted the drip technique to work on paper as well as work on canvas, using the sheet of paper, like the canvas, as a horizontal surface to facilitate the dripping and pouring of the linear skeins and puddles of paint which generate the specific qualities of the style. The salient characteristic that emerged at this time . . . was the translation of drawing into

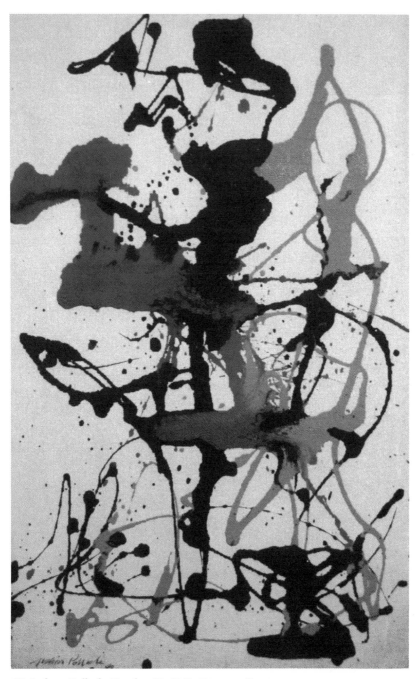

68. Jackson Pollock, *Number 26, 1949*. Private collection.

painting by the fusion of draftsmanship, paint, and color in a technique radically graphic in execution, achieving for the first time a homogeneous style.[18]

But although Pollock scholars seem to agree that during 1947–50 Pollock successfully fused line and color, painting and drawing, no such agreement exists concerning the Black Pourings. The only two scholars to have discussed these paintings at length, Lawrence Alloway and Francis V. O'Connor, disagree as to whether the Black Pourings should be called drawings or paintings or whether Pollock actually combines the two idioms. Because changing the relative viscosity of the paint creates different effects, and, more important, because Pollock's dilution of the pigment creates stains of color that expand as they are absorbed into the canvas, Alloway affirms that what "looks like drawing is, in fact, a restrained but pervasive way of painting."[19] Thus Alloway seems to claim that after combining drawing and painting in 1947–50, Pollock returned to painting.

O'Connor, on the other hand, following the artist's statements—such as "I've had a period of drawing on canvas in black—with some of my early images coming thru"—suggests that they are in fact drawings. Yet surprisingly, for O'Connor the distinction between painting and drawing is not a question of medium but of iconography. He noticed that in 1951 Pollock's works on paper were abstract, and his works on canvas were figurative. He therefore concluded that "Pollock called his works [on canvas] of 1951 'drawings' not because he saw these huge paintings literally as drawings, but because he felt them serving the same purpose as his earlier drawings and sketchbooks had served: they let his imagery 'come thru.' "[20] Thus, according to O'Connor, "drawing" is not a specific medium (works on paper) for Pollock but the generation of imagery. "The human implications," O'Connor continues, "of these images [the Black Pourings] can be deduced, in general, from Pollock's 'early images' which they re-engender."[21] The generation of imagery, therefore, an imagery specifically connected with the pre-1947 paintings and drawings, is what makes O'Connor consider the Black Pourings drawings.

But one must reiterate that in 1951 Pollock changed his color

scheme, his compositional format, and his iconography, but not his technique. There is no substantive reason, therefore, to suspect that the combination of painting and drawing particular to the poured paintings was discontinued in 1951–53. In another sense Alloway's and O'Connor's distinctions are hardly necessary, since Pollock himself, eliminating primary sketches, refrained from thinking of painting and drawing as mutually exclusive. On the contrary, in 1950 he stated: "I approach painting in the same sense as one approaches drawing; that is, it's direct."[22] Such problems of definition (painting or drawing) thus appear to have been of little technical or thematic consequence to Pollock, an artist who apparently considered the two mediums as virtually interchangeable. What is perhaps more important, however, and O'Connor does raise this issue, is the possible relationship or connections between the return of figuration in the Black Pourings and Pollock's earlier, pre–1947 imagery. But before an evaluation of the potential interrelationships between Pollock's works prior to and following the poured paintings may be made, the first question to address is the general implication of Pollock's return to figuration itself (independently of what this figuration may represent or reengage).

Pollock and other artists of his generation are best known for, and were even labeled "Abstract Expressionists" as an homage to, their abstract paintings. Yet Pollock's oeuvre is not only far from being predominantly abstract, the Black Pourings reversed the expected teleological progression from figuration to abstraction that most New York School artists and Pollock himself appeared to follow.

There was, however, another notable exception to this ostensible rule of progression: Willem de Kooning. Like Pollock, de Kooning had become famous for his abstractions of the late 1940s. But in 1950, contemporaneously with Pollock's Black Pourings, de Kooning reverted to figuration in his *Women* series. Violent criticism ensued, and the artist was accused of betraying abstraction.[23] Feeling increasing pressure to justify his thematic shift, de Kooning complained, "Certain artists and critics attacked me for painting the *Women*, but I felt this was their problem not mine. I don't really feel like a non-objective painter at all."[24] The same happened to Pollock. Even if criticism was not entirely negative, Greenberg, in " 'American-Type' Painting,"

wrote that, departing from the elimination of value contrasts in the 1947–50 poured paintings, "in 1951 Pollock had turned to the other extreme, as if in violent repentance, and had done a series of paintings, in linear blacks alone, that took back almost everything he had said in the three previous years."[25] Michael Fried—following the critical line implicit in Greenberg's argument—stated that, although some of these paintings anticipate the works of Morris Louis and color field painting in their staining, the return to "traditional drawing [in others] . . . probably mark[s] Pollock's decline as a major artist."[26]

Yet for Pollock—as well as for de Kooning, Guston, and the other Abstract Expressionists—the qualitative and thematic distinction between abstract and figurative was as historically inconsequential as that between, say, painting and drawing. The issue was, in de Kooning's words, one of artistic "freedom." Indeed, it is symptomatic of Abstract Expressionism that all its members, if one can even use such a reductive term, retain their own artistic autonomy. No manifesto was written, no unified group statement was made; and, perhaps as a result, no single prescriptive aesthetic ideology and no consistent style or technique have emerged.[27] When Pollock and de Kooning reverted to figuration, it never occurred to them that they were betraying the cause of abstraction, since, to their minds, there was no such cause to betray in the first place. If figuration served their aesthetic or thematic needs more successfully than abstraction, Pollock and de Kooning saw no contradiction, no betrayal, in alternating between different stylistic modes.

Yet, as already discussed, a strong stylistic continuity does exist between the Black Pourings and Pollock's previous period; his line, contrary to Greenberg's and Fried's assertions, retained many of its abstract characteristics. Indeed, unhampered by allover composition, some of these characteristics were made all the more apparent. It may be argued, consequently, that the specific distinction between what Fried retrospectively terms Pollock's "traditional" drawing and what would as a matter of course have to be labeled "untraditional" drawing glosses over many formal similarities and imposes too strict a stylistic division between the two.

Ultimately, critical and historical questions regarding whether his

change fulfilled preordained expectations as to what constitutes "progression" or "regression" may, as was argued above, have been of little consequence to Pollock (and may thus belong more appropriately to the realm of significance than meaning). For the artist the question of change may not have been as interesting an issue as the *nature* of the change. Indeed, if during 1947–50 Pollock saw style and content to be mutually reinforcing or conceptually interdependent, then a change in style should predictably coincide with a change in content. The questions to address, then, are: What do the shifts in Pollock's iconography represent? Is the return to figuration purely regressive, as the statement about "early images coming thru" seems to suggest, and, if so, what is the relationship between the Black Pourings and Pollock's pre-1947 work?

General questions about the iconography of the Black Pourings are difficult to answer. This is primarily because these works, like the 1947–50 poured paintings, are painted with varying degrees of density. Although the progressive accumulation of layers may have affected the visual appearance of a 1947–50 poured painting, the general subject, the rhythms of nature, remained relatively unaffected. But with figurative imagery, as in 1951–53, the relative density of the layering could either reveal or obscure the iconography underneath. Some Black Pourings are clearly figural, others are less so. Even where figuration is obviously present, some are so obscure that the identification of figural references—let alone elucidation of subject matter— is entirely conjectural. Others still are purely abstract. Questions of iconography are therefore problematic, and interpretation must necessarily be speculative. But certain themes are identifiable in the Black Pourings, the most conspicuous being that of the female figure (creating yet another coincidence with de Kooning's work of the same period). Two examples of 1951 are *Number 3/Image of Man* [65] and *Number 23/Frogman* [69]. In this particular instance, both titles are deceptive. *Frogman*, according to Francis V. O'Connor, was thus titled by a former owner,[28] and *Image of Man* was attached to *Number 3* after its inclusion in a Museum of Modern Art exhibition titled "New Images of Man." Prior to that, the painting was referred to only by its numerical title. It may be argued, therefore, that both figures

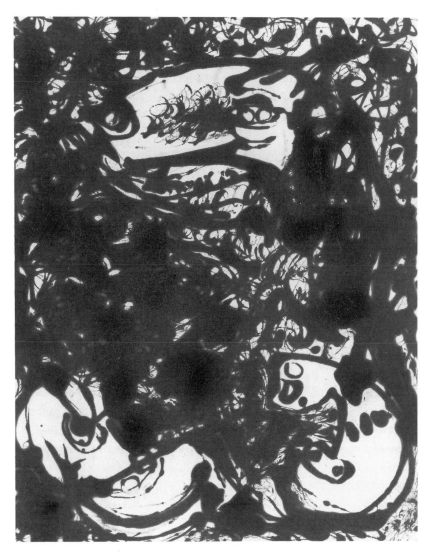

69. Jackson Pollock, *Number 23, 1951/Frogman*. Chrysler Museum, Norfolk, Virginia.

are in fact female, their sexuality emphasized by the importance and exaggeration of the breasts.

This identification would be reinforced by the recurrence of the theme of woman in many of the Black Pourings. Other examples are *Number 5, 1952* (CR2:353), in the left side of *Portrait and a Dream* [75], and in *Number 11, 1951* [63]. The subject is hardly a new one in Pollock's career. And since the artist himself identified "early images coming thru," one can trace a certain thematic continuity between these later paintings and Pollock's formative work: The essentially dark colors and threatening character attributed to women in the Black Pourings (particularly in *Number 23* and *Number 11*) directly relate to an earlier Pollock of the 1930s called *Woman* [70],[29] further strengthening Pollock's already strong ties with prehistoric art. Indeed, likely precedents and visual sources for Pollock's representations of women are found in prehistoric goddess figures such as the *Venus de Laussel* and *Venus of Willendorf* [71], illustrated in several of Pollock's books on prehistoric art.[30]

If Pollock had looked not just at the illustrations but at some of the texts, he would have read the anthropological theories that ascribed the inaccuracies of anatomy and proportion not to either ignorance or grotesque distortion but to a deliberate attempt to associate sexuality with the element of survival and fertility.[31] The central and dominating presence of the female in Pollock's *Woman* may allude, moreover, to the familial structure of certain preindustrial societies. In *The Making of Man*, the anthropological anthology in Pollock's possession, two essays were devoted to Mother Right,[32] a concept defined as the placement of the female at the center of the social structure. In such instances, privileges as significant as financial inheritance and possession of children, among others, belong exclusively to the female. Likewise, the central placement of the woman in Pollock's painting, as well as her disproportionately large scale, causes an analogous effect by physically—and psychologically—subordinating the surrounding figures. But even in such a remarkably non-Western social structure, Pollock may have recognized something personal. Scholars often relate *Woman* to Pollock's own family situation.[33] According to Pollock's friend Alfonso Ossorio, "All of his [personal] problems stemmed from

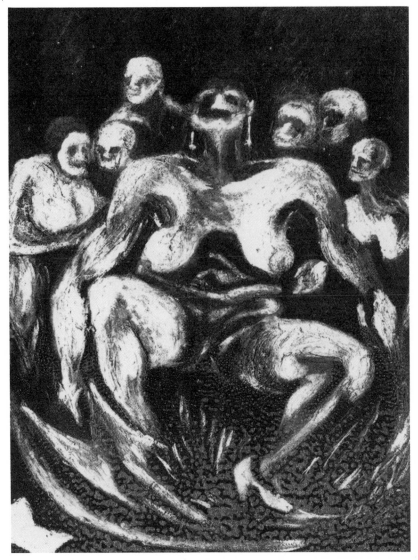

70. Jackson Pollock, *Woman* (c. 1930). Gerald Peters Gallery, Santa Fe.

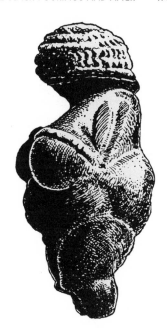

71. *Venus of Willendorf* (prehistoric, c. 20,000
B.C.). Illustrated in Leonard Adam's book
Primitive Art (1949).

his family, which centered around his mother—a large, firm, substantial matriarch, a dominating woman."[34] Lee Krasner, recalling how Pollock's drinking coincided with his mother's visits, said: "It took a long time for me to realize why there was a problem between Jackson and his mother . . . at that time I never connected the episode of Jackson's drinking with his mother's arrival. . . . I hadn't yet seen anything of the dominating mother."[35] His analyst, Joseph Henderson, partly basing his diagnosis on Pollock's drawings, mentioned "a problem left unsolved and perhaps insoluble, a frustrated longing for the all-giving mother. He had suffered from isolation and extreme emotional deprivation in early childhood and this had not yet been adequately compensated."[36]

Having such drawings at his disposal [72], it is no surprise Henderson came to this conclusion. In this work, a child, apparently wanting to nurse at his mother's breast, is unambiguously threatened, if not

about to be violently struck, by a menacing and physically overwhelming woman.[37] The drawing not only completely reverses traditional expectations about the relationship between mother and son but may be interpreted as a direct subversion of its traditional representations in art for centuries in the theme of the Madonna and Child. Abstracted from the context of biblical narrative, the theme's popularity must be partly due, in addition to its religious purpose, to its psychologically reassuring depiction of the link between mother and son. Pollock's drawing, by contrast, reveals that the artist considered this link anything but psychologically reassuring. This is not to psychoanalyze Pollock but to attempt to understand the iconography of what scholars have called his most "difficult" paintings.[38] The Black Pourings' thematic reprise of material in early drawings (the interest in female figures in particular) pinpoints a thematic continuity between Pollock's work before and after the 1947–50 poured paintings and partially explains what Pollock meant by "early images" coming through.

Significant for our purposes, however, is not so much that Pollock had emotional problems with women in general and with his mother in particular, but the way he expressed these problems in art. Indeed, Pollock's place within the context of depictions of women—or the nude—in art is hardly orthodox. One of the most enduring themes in the history of art, the nude, according to Kenneth Clark, is "not the subject of art, but a form of art."[39] The subject of this "form of art" is the human body, an entity that, as Clark continues, is "rich in associations, and when it is turned into art these associations are not entirely lost."[40] These associations, Clark argues, are often sexual:

> It is necessary to labor the obvious and say that no nude, however abstract, should fail to arouse in the spectator some vestige of erotic feeling, even though it be only the faintest shadow—and if it does not do so, it is bad art and false morals. The desire to grasp and be united with another body is so fundamental a part of our nature that our judgement of what is known as "pure form" is inevitably influenced by it; and some of the difficulties with the nude as a subject for art is that these instincts cannot lie hidden.[41]

72. Jackson Pollock, *Untitled* (c. 1939–40). Private collection.

But the idea of the nude as object of desire occurs only when the associations attached to the human body are generally positive. Even Clark acknowledges the existence of what he calls an "Alternative Tradition" in the representation of the nude—when the associations attached to the human body (because of morality or religion, for instance) are primarily negative, and when figural representations stress lack of idealization or even deliberate ugliness. But these polarities between the classical and the anticlassical, or between the real and the ideal, are still methodologically inadequate for understanding what Pollock is doing. Since he is working within a style only remotely correspondent to empirical reality, issues of beauty versus ugliness, of physical attraction versus vanitas, are less than interpretationally effective.

Although Pollock rejects the idea of the nude as sexually desirable, he does not embrace Clark's alternative vanitas tradition either—with its associations of pity, decay, and death. The tendency to which he does belong is not a common one in the history of art; in it women are not represented as objects of desire, unidealized reality, or evil or death. In it women become the deliberate objects of aggression. In these paintings Pollock seems to have expressed all the negativity he associated with women (according to Betty Parsons, Pollock connected the "female with the negative principle").[42] The most important precedent for such depictions is Picasso, but the most obvious parallel is de Kooning. Not only do both artists simultaneously return to figuration after a period of abstraction, but the subject of this figuration is the same: women. De Kooning, moreover, also acknowledged the influence of prehistoric goddess figures on the *Women* series: He spoke of the "idols" and "goddesses" of art, and specifically named the *Venus of Willendorf* as a visual prototype.[43] But in addition to being inspired by the same sources and returning to figuration at the same time, Pollock and de Kooning share the same violent treatment of their subject. "Women irritate me sometimes," confessed de Kooning. "I painted that irritation in the *Women* series."[44]

For Pollock and de Kooning, the use of archaic sources was not only a method by which to achieve a "tragic and timeless"[45] subject matter, as it was for Rothko and Gottlieb (see chap. 2). It was also a

way of rendering a very specific, but highly personal and private, symbolism more general. Pollock and de Kooning abstract their female figures, render them anonymous, preventing the clear legibility of their all-too-private meaning. But even if one could call Pollock's or de Kooning's images of women "archetypes . . . anonymous . . . images of women in general, not portraits but conceptions,"[46] their sexual identity, defined if only by the emphasis on female breasts, does give them a particular specificity. In addition, unlike de Kooning or Kline's large abstractions—where the aggression is unrelated to a figural reference and is thus made successfully general—the aggression in the women paintings are specifically directed toward what their titles indicate: women. Hence, even if Pollock and de Kooning have reversed the representations by men for men of women as sexually desirable objects, they still adhere to an essentially male-oriented artistic mode. The only difference is that the emotion projected is no longer desire but fear and aggression.

This poses a number of problems for interpretation. Most notably (although in general one can never assume that all members of an audience will interpret or react to an artist's intentions in the same way), Pollock's and de Kooning's presentations, if not impositions, of their negative feelings toward women may tend to affect a woman spectator differently than a man. Women might be more inclined to empathize with the victims of the artist's aggression. Feminist literary critics have addressed the corresponding problem of women readers' responses to literature produced by men. They argue that the reader (female) inevitably assumes the ideological point of view of the author (male). "Reading," writes Annette Kolodny "is a *learned* activity which, like many other learned interpretive strategies in our society, is inevitably sex-coded and gender inflected."[47] Judith Fetterly adds that while "the majority of fiction insists on its universality, at the same time it defines that universality in specifically male terms," and that "the female reader is co-opted into participating in an experience from which she is explicitly excluded; she is asked to identify with a selfhood that defines itself in opposition to her; she is required to identify against herself."[48]

Ultimately, however, the responses to works of art are individual,

73. Jackson Pollock, *Number 7, 1952*. Metropolitan Museum of Art, New York.

and whether one finds Pollock's or de Kooning's images of women offensive—or whether they force women to adopt the painter's own negative feelings against their sex—is a question to be resolved by spectators themselves in direct confrontation with the work. This plurality of possible readings was probably not part of the artists' intentions. But the works' very open-endedness affects and becomes part of interpretation. The issues raised by feminist critics in this context clarify how the seemingly universal qualities de Kooning and Pollock normally associated with borrowings from a non-Western culture are, as Fetterly suggests, anything but universal. Used to mask a highly private and psychologically charged content, this content is not only specific to the artists who created it but may affect spectators in different ways—namely, according to their gender.

Pollock and de Kooning's images of women thus belong to a specific tendency (*tradition* would not be the right word) to represent women outside the specific categories outlined by Kenneth Clark. Other notable examples of this tendency to use women not as symbols of desire but as objects of aggression are Dubuffet, whose work Pollock admired,[49] and, of course, Picasso, whose borrowings from African art in the right side of the *Demoiselles d'Avignon* also disguise the artist's often ambivalent and negative feelings toward women.[50] Not all of Pollock's images of women or motherhood are depicted in a malevolent way, however. *Number 3* [65], for example, although a representation of a woman, is, if anything, psychologically neutral and generally devoid of the negative associations so evident in Pollock's other depictions of the same subject.[51]

Besides the representation of women, the only other predominant theme consistently discernible in the Black Pourings is the representation of the human head. It appears in isolation [73] or in combination with another image, as in *Portrait and a Dream* [75] and *Number 27, 1951* [76]. Stylistically the heads often appear to combine the frontal and profile views—a juxtaposition extrapolated from Picasso, which Pollock employed no less frequently. Particular to Pollock, however, is the proclivity to surround the heads with circular forms,[52] the meanings of which are difficult to decipher without the example of a more legible precedent. One such precedent is an earlier

74. Jackson Pollock, *Untitled* (c. 1941–42). Location unknown.

1941–42 drawing [74], where a similar profile-frontal face, also sepa-
rated from a corresponding body and seemingly floating in a void,
again appears to be surrounded by circular shapes. The greater legibil-
ity of this drawing permits the possible identification of these shapes
as snakes. The occurrence of the snake is frequent in Pollock's early
drawings—a motif probably inspired by a variety of sources, including
classical representations of the Medusa, scenes in Orozco's murals,
and the graphic work of Paul Klee.[53] But despite the many possible
prototypes available to Pollock, for our interpretive purposes, the
question to ask is why Pollock connected snake imagery with the
human head?

Again, as in his depictions of women, Pollock's iconography points
to an imagery of a highly personal and private character. In another
early drawing of 1943, Pollock left a margin to the right of the
image, where he scribbled: "Thick/thin//Chinese/Am. Indian//s[illeg-
ible]/snake/woman/life//effort/reality//total//shoes/foot." Although

one cannot ascribe great importance to notes the artist may have made perhaps in a rapid, improvisational method of free association, the connection of "snake/woman/life" coincides with certain events in Pollock's biography. During birth, Pollock was choked by the umbilical cord, and, according to his mother, was born "as black as a stove."[54]

Pollock's problems with and ambivalent feelings toward his mother have been reported by those close to him. But could the recounting of this natal incident have still affected him psychologically as an adult? Could he have perceived it symbolically, as yet another manifestation of his dependence on his mother? Is it plausible to interpret Pollock's own connection "snake/woman/life" as a veiled reference to the circumstances of his birth (i.e., snake = cord, woman = mother, and life = birth)? And could these circumstances have generated specific aspects of his iconography (i.e., can the circular shapes around the heads in the Black Pourings be symbolically interpreted as snakes, and does the snake metaphorically stand for the umbilical cord)? Such interpretive hypotheses are essentially unverifiable of course. But the interpretive plausibility of such a suggestion could be made more convincing if the meaning of the heads, when they do not appear in isolation, could also be deciphered. Such examples are the *Portrait and a Dream* and *Number 27, 1951* [76]. These dual images are a direct result of Pollock's procedure when working on the Black Pourings. He often executed several works on a single sheet of canvas, only to divide them later. But Lee Krasner recalled that in some cases Pollock chose to combine two images in a final work, creating something akin to a diptych.[55]

In both of these examples Pollock juxtaposed a head on the right of the composition with a more abstract cluster on the left. The head in the right section of *Portrait and a Dream* [75], Pollock told his homeopath, Dr. Elizabeth Wright Hubbard, was a self-portrait.[56] Lee Krasner, in her 1969 interview with B. H. Friedman, confirmed this identification and added that Pollock spoke about "the upper-right hand corner of the left cluster as 'the dark side of the moon.' "[57] The presence of the self-portrait may strengthen the suggestion that the head motif in the Black Pourings is, if not always Pollock himself, at

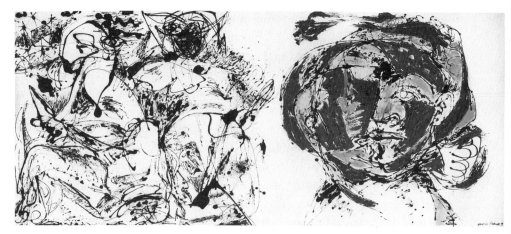

75. Jackson Pollock, *Portrait and a Dream* (1953). Dallas Museum of Fine Arts.

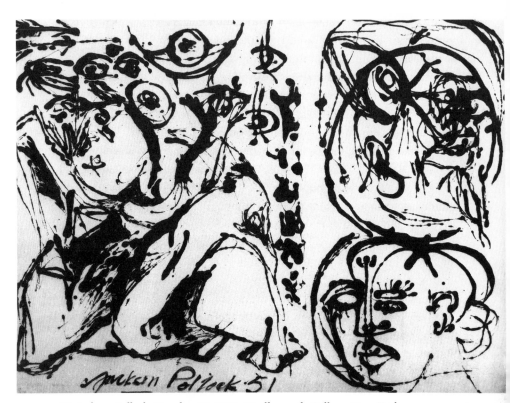

76. Jackson Pollock, *Number 27, 1951*. Marlborough Gallery, New York.

least a reference to something personal.[58] But what of the "dark side of the moon?" A crescent moon is indeed present where Lee Krasner has indicated it. The crescent seems, moreover, to intersect what may be interpreted as a human face, which, from the breastlike shapes underneath, could probably be identified as female. The specific association of the moon with the female element has several precedents in Pollock's work. During the 1940s, for example, he combined the two terms to title several of his works: *The Mad Moon Woman*, *The Moon Woman*, and *The Moon Woman Cuts the Circle* (CR1:84, 86, 90). Probably originating in American Indian myths, where the character of the Moon Woman appears,[59] the motif could also have been borrowed from illustrations in Esther Harding's *Woman's Mysteries*, which served as a source for several of Pollock's early drawings in the late 1930s and early 1940s[60] (see chap. 2).

Another obvious visual manifestation of this association in Pollock's work is an untitled drawing of around 1941–42 [77], where a female head is again intersected by a crescent moon. If the right side of *Portrait and a Dream* is Pollock's self-portrait, and the crescent moon suggests that the figure on the left side is female, Pollock may be reverting to his earlier 1942–43 images where he exploited the polarization of the sexes (e.g., *Male and Female*). This polarization of the male head and the female body is also anticipated in Pollock's early drawings. In an untitled pencil sketch of about 1944, Pollock depicts an ample, centrally placed woman surrounded by human heads [78]. The two on the right have the familiar Picassoesque combination of the frontal and profile face, but the spike-like forms emanating from them may be taken to represent a solar association. This suggests that if Pollock connected the moon with the female, he may have connected the sun with the male. He may therefore also have been familiar with the Jungian male/solar, female/lunar complementary principles.[61] Pollock's thematic preoccupation with the opposition of the sexes and association of the female with the moon by means of the lunar crescent—found in his earlier work—thus reappear in and later inform the iconography of the Black Pourings. And even if the particulars of Pollock's life history can only be loosely connected to these works (do they relate to specific relationships such

77. Jackson Pollock, *Untitled* (c. 1941–42). Location unknown.

as those with his mother or wife?), the presence of self-portraits in the
Black Pourings hints at their autobiographical character.

By returning to a figurative mode after the consistent use of
abstraction during 1947–50, Pollock made his iconography more spe-
cific and more private: the female figure and the portrait head (per-
haps symbolic of Pollock himself) appear either in isolation or in
combination. Instead of suggesting the connections between humanity
and the rhythms of nature, Pollock reverted to themes more personal
and psychological in nature. For this reason, the reemergence of ear-
lier themes and motifs he may have associated, either emotionally or
intellectually, with his psychoanalytic experience comes as no sur-
prise. Despite thematic connections to earlier paintings and drawings,
however, the Black Pourings should not be considered a simplistic
return to Pollock's pre-1947 work. First, the Black Pourings have a
reduced color scheme; second, the poured technique intervenes. To
stress too strong a continuity between the Black Pourings and Pol

78. Jackson Pollock, *Untitled* (c. 1944). Pollock/Krasner Foundation. Courtesy Jason McCoy Galleries, New York.

lock's previous work is reductive and overlooks their technical relation
to the 1947–50 poured paintings.

What the application of the poured technique to earlier images
does suggest, moreover, is that Pollock abandoned the intimate rela-
tion between form and content so evident in 1947–50. Reluctant to
repeat himself, he applied new methods to old problems. To modern-
ist critics like Greenberg and Fried, however, the return to figuration
was enough to condemn the Black Pourings as heralds of Pollock's
imminent artistic decline (this may account for the relatively little
critical attention these paintings have received compared with those
of 1947–50).[62] In their view, the development of modernist art is
progressive rather than regressive; it travels from figuration to ab-
straction, not vice versa. According to Fried, for example, some of
Pollock's works of 1951, *Number 3/Image of Man* [65], for instance,
"anticipate perhaps more closely than any other paintings by Pollock
what [Morris] Louis accomplished roughly two years later in his own
breakthrough."[63] For Fried this was achieved in the Black Pourings,
where "the thinned pigment has soaked into the raw canvas in such
a way as to have *assumed* its limits . . . rather than to have been
circumscribed *by* them. Pollock is said to have regarded *Number 3* as
one of the strongest of his pictures of this period."[64] But Fried contin-
ues by asking why Pollock "never pursued what are from our vantage
point its apparent implications. Perhaps it was because those implica-
tions were not apparent to him. There is, for example, an unmistak-
able allusion to the human figure in *Number 3*, and it is likely that
this . . . is mostly what Pollock saw in it."[65]

Thus, although Fried explains Pollock's influence on Louis (an
issue covered in greater depth in chap. 7), he is practically criticizing
Pollock for not pushing the possibilities implicit in the Black Pourings
to what he sees as their logical conclusions in Louis. With historical
distance, Fried arbitrarily constructs a preordained pattern for art to
follow. As if guided toward some predetermined goal, Fried's philoso-
phy of history is incremental; it relates component parts not only
chronologically but teleologically. Every work of art functions only
between other works of art, those which logically fit before or after it,
like links in a chain, according to a preconceived and prescriptive view

of history. Fried discusses the Black Pourings only in this context. The return to figuration and the nature of this figuration are not only inconsequential but even objectionable. This very concern for figuration, in fact, according to Fried, prevented Pollock from reaching the stylistic "breakthrough" achieved by Louis in the later 1950s.

But what is regressive for one ideology may be progressive for another. With even greater historical distance than Fried, who wrote his observations in the late 1960s, Pollock's "regression" may be interpreted completely differently. His return to figuration, like de Kooning's or Guston's, may be seen as an artist's affirmation of aesthetic freedom and intellectual independence from modernist ideas on the progressive nature of history. Indeed, Pollock and de Kooning have more recently been seen as anticipating the dominance of figuration and private iconography in much of the "Neo-Expressionist" painting associated with postmodernism.[66] Thus, what is arbitrarily considered retrogressive and is discarded by one philosophy of history is considered progressive and is picked up by another. In the new postmodern context, paradigm shifts may not only redress the relative inattention given the Black Pourings in previous Pollock scholarship, but, as a result, art historians may reconsider the arguments behind establishing historical paradigms based exclusively on a preordained idea of artistic progress.

Indeed, artists seldom follow the regular patterns prescribed by art historians. If Pollock did not explore the abstract formal possibilities inherent in the Black Pourings to what Fried would call their "logical" conclusions, he did not explore their figurative potential either. In fact, Pollock executed works similar to the 1947–50 poured paintings contemporaneously with the Black Pourings. Still others, like *Number 8, 1952* [79] and *Convergence* [80], appear to have been painted like most of the Black Pourings in their initial stages and then repainted with additional layers of orange, yellow, and blue. But the effect of both paintings is quite different. *Convergence* is closer to the 1947–50 poured paintings: the composition is allover, and the last layers of paint hide any figural reference that may have been present at the outset; whereas *Number 8, 1952* remains vaguely figural: a head is clearly visible at the lower left, but the configuration as a

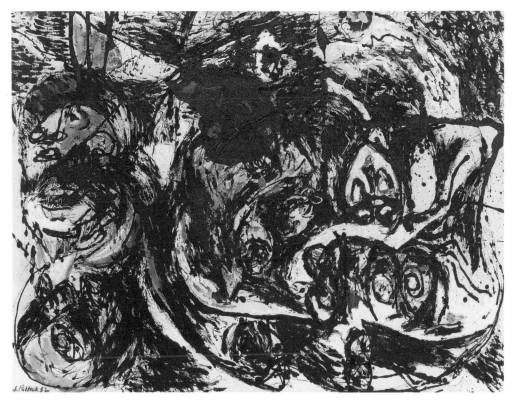

79. Jackson Pollock, *Number 8, 1952*. Wadsworth Atheneum, Hartford, Connecticut. Philip Goodwin collection.

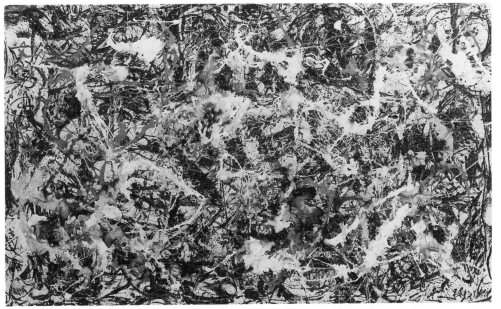

80. Jackson Pollock, *Convergence* (1952). Albright-Knox Art Gallery, Buffalo, New York. Gift of Seymour H. Knox, 1956.

whole is too obscure to interpret. What does distinguish *Number 8, 1952*, however, is the presence of marks that are clearly not poured but thickly applied with a brush. In an attempt not to repeat himself, Pollock seems to be juggling the formal components of his art: allover versus hierarchical composition, chromatic versus monochromatic color scheme, figuration versus abstraction, poured versus painted, and thick versus thin application of paint.

These paintings, along with *Portrait and a Dream* (which also includes passages applied with a brush), mark the end of the Black Pourings. Unlike many of the Abstract Expressionists who continuously, almost obsessively, pursued the representation of a specific motif, Pollock looked yet again for a new combination to reenergize his art. But in 1953–56, the last four years of his life, his artistic production dropped considerably. In those last four years, he painted only fifteen canvases.

Although these works neither approach the originality and sophistication of the 1947–50 poured paintings nor suggest a new direction for Pollock's art to take, they do mark a new combination of old elements. The veiling in *The Deep* [81], *Greyed Rainbow* [82], and *Ocean Greyness* (CR2:369), all of 1953, differs in kind from the veiling in Pollock's earlier work. All three paintings are partly painted and partly poured, and all three are partly figural (the titles refer to nature) and partly abstract. Eyes and facial configurations emerge out of *Ocean Greyness*, a reprise of the earlier *Eyes in the Heat;* bright colors dominate the lower half of an otherwise dark painting in *Greyed Rainbow;* and in *The Deep*, which Elizabeth Frank compares to a passage in Melville's *Moby-Dick*,[67] a dark ground is all but obscured by touches of white and yellow paint.

Pollock's new combination of formal elements is most evident in *The Deep*. The painting also reverses Pollock's tendency in the Black Pourings to apply dark colors to a light ground: here the underpainting is dark, the overpainting is light. The shape of the black form in the center of the work was, moreover, not created by the application of black paint but in effect by the uncovered negative space. Of course, whether this was Pollock's initial intention from the outset or whether the black layer itself obscures previously painted passages or even

figural imagery is impossible to ascertain without X rays.

Although the references to nature in titles such as *The Deep* or *Greyed Rainbow* may suggest a return to the iconography of the poured paintings, there are many distinctions to be made between the paintings of 1953 and those of 1947–50. As stated above, the later works are partly painted and partly poured; their effect hardly approaches that of the uninterrupted movement and energy of Pollock's line before 1951. The vague suggestions of imagery, moreover, negate the nonhierarchical effect of allover composition, and the brushwork, applied in addition to the poured lines, restricts the dynamic movements found in Pollock's previous work.

But, conversely, the figuration in these paintings is not of an ordinary sort. The titles suggest references to natural phenomena (the sea, the sky, the rainbow), but the works are neither as rigorously abstract as the 1947–50 paintings nor as obviously figural as the linear imagery of some of the Black Pourings. For example, the dark underpainting visible at the center of *The Deep* appears to suggest what is meant by the title. And although the paint strokes and colors can hardly be categorized as illustrative or descriptive of any kind of natural phenomena—they do not bound or create a form analogous to an object in the external world—the spectator nevertheless gets an impression of infinite depth. Pollock creates this effect by overlapping the white strokes on black, making the darker color recede. This may sound simple enough, but if one attempts to categorize the work as abstract (as in 1947–50) or figurative (as some of the 1951–53 paintings), a painting like *The Deep* is curiously neither. Since the black center "represents" the presence and sensation of depth, the painting cannot be called abstract; but since it does not quite correspond to visual phenomena, the painting cannot be called figurative. Pollock, then, has created yet another mode where his line can suggest a meaning without declaring itself abstract or figurative. The same can be said of *Greyed Rainbow* [82]. The forms are equally undescriptive, but Pollock's restriction of color to the lower half of the canvas and his overlapping strokes give the impression of a rainbow obscured by clouds. Pollock has paradoxically suggested a visual experience through abstract means.

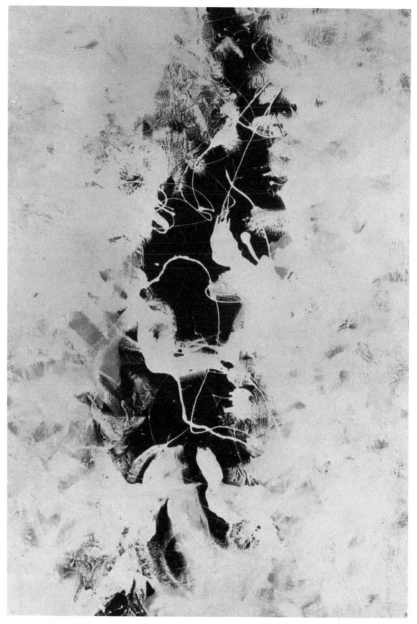

81. Jackson Pollock, *The Deep* (1953). Musée National d'Art Moderne, Centre Georges Pompidou, Paris.

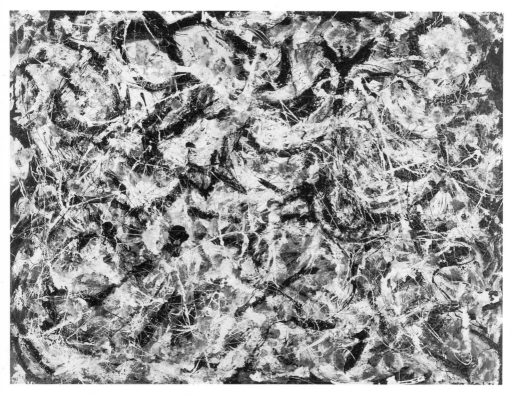

82. Jackson Pollock, *Greyed Rainbow* (1953). Art Institute of Chicago.

Afraid of repeating himself and attempting to break free of his own formulas, Pollock played with and recombined the stylistic elements at his disposal in an original way. Although he may not have arrived at a formal solution as daring and radical as the poured technique was in 1947, his mixture of pouring and painting and of abstraction and figural suggestion did create another potential artistic mode. As a draftsman, Pollock manipulated line to speak different languages. During 1947–50 Pollock's line was abstract. It moved at will, independent of any descriptive function and without visual reference to the external world. Although abstract, it successfully worked as a sign system, as a vehicle for meaning, simply by virtue of the artist's arbitrary association of a general meaning to his paintings (for the compatibility of meaning and abstraction, see chap. 3). In 1951, when Pollock returned to figuration, he reintroduced line's more suggestive role of outlining a figure. It transferred meaning as most figurative art does: by a visual reference to reality. But, as the previous discussion of the Black Pourings has revealed, Pollock's line was hardly conventional. Outlining heads or parts of the anatomy on one part of the canvas, it could suddenly change and, irrespective of description, become as abstract as its counterpart of 1947–50. In the Black Pourings, therefore, Pollock's line is not constant but alternates between, by passing through, a more traditional mode and an abstract mode. One could, incidentally, consider such an alternation between abstraction and figuration within a single painting to constitute a third and different mode altogether. Yet in attempting to determine where later works like *The Deep* or *Greyed Rainbow* would belong within this framework, it becomes evident that they fit none of the categories previously defined. These paintings are neither purely abstract nor purely figurative. Nor do they engage in an alternation of those two modes, as the Black Pourings do. It thus appears that they must be included in another, fourth mode, one that lies between or somehow combines the extreme poles of his art: figuration/abstraction, pouring/painting, veiling/revealing.

But the resolutions of such tensions, the combination of previously antithetical elements, did not prove either intellectually or artistically stimulating enough for Pollock. In the last three years of his life

(1954–56), Pollock's production declined even further: he finished only five paintings. His personal life was equally difficult, which may have contributed to his decreased productivity. Although Pollock had already reached a certain notoriety, if not fame, his financial situation was never stable. His problems with alcohol persisted, and his marriage to Lee Krasner deteriorated progressively. He began having an affair with a model, Ruth Kligman, who—when Lee Krasner took a trip to Europe—moved in with him in Springs. On August 11, 1956, while Lee Krasner was still in Europe, Pollock was killed in a car accident. Ruth Kligman was injured and recovered; Edith Metzger, a friend of Kligman's, also died. Pollock's acute mental depression during his last years has been recorded by Kligman herself:

> Jackson didn't work. Each day was similar to the next, talking about getting started and never getting to it. His conflict consumed his energy. One morning Jackson woke very early, went into the studio, and came right out again. He couldn't work. . . . At times when he was very sad he would cry and say, "it wasn't worth it, it wasn't worth the pain and the sacrifice, it's asking too much; I can't give that much anymore, I'm too miserable, and they never get the point anyway, they always change things around."[68]

Pollock's troubled state of mind in the period preceding his death has prompted speculation as to whether the car accident was not in fact suicide. Whether Pollock did commit suicide or whether, had he lived, his work would have culminated in a late style similar to Rothko's or de Kooning's is, of course, impossible to say.

Such conjecture, however, has rarely tempted Pollock scholars. Even if, at forty-four years of age, Pollock was relatively young when he died, his work divides itself so easily in early-middle-late categories that one often considers the oeuvre as complete rather than interrupted—a tendency reinforced by Pollock's inactivity in his last years. But such a reading is not entirely unjustified. Taken as a whole, his work does display a formative stage, a fully accomplished, mature style, and a more subjective, personal later phase. Yet despite such easy categorization, Pollock's work also betrays a certain unity and

consistency. Thematically, an interest in the natural dimension runs throughout his career: from the early landscapes to the poured paintings and late works like *The Deep* and *Greyed Rainbow;* and, visually, rhythmic compositions, dynamic manipulations of line, and an emphatic concern for the inherent physical properties of paint are consistent hallmarks of Pollock's pictorial style.

But whether Pollock's work emerges fragmented or unified, complete or interrupted, the development of the poured technique was his seminal contribution to gestural painting, and, by extension, to Abstract Expressionism as a whole. Not surprisingly, in its complexity and with historical distance, Pollock's achievement raises a number of issues, many of which could never have been foreseen by the artist himself. It is to those issues that we will now turn.

NOTES

1. De Kooning's statement "Pollock broke the ice" was made at a memorial service for Pollock on 30 November 1956. See D. Solomon, *Jackson Pollock: A Biography* (New York, 1987), 200. Although this statement is often quoted as a reference to the radical and revolutionary nature of Pollock's technique, it was actually meant as a tribute to Pollock's capacity to have brought advanced art to the attention of a wider public.

2. Lee Krasner quoted in *Pollock Painting,* n.p.

3. B. H. Friedman, *Jackson Pollock: Energy Made Visible,* xvi.

4. CR4, p. 261, D99.

5. L. Alloway, "Pollock's Black Paintings," *Arts Magazine* 43 (May 1969): 41.

6. E. Frank, *Jackson Pollock* (New York, 1983), 87.

7. F. V. O'Connor, *Jackson Pollock: The Black Pourings 1951–53* (Institute of Contemporary Art, Boston, 1980), 6.

8. C. Greenberg in *The Nation* (1 February 1947), quoted in F. V. O'Connor, *Jackson Pollock* (Museum of Modern Art, New York, 1967), 41.

9. E. A. Carmean, "Jackson Pollock: Classic Paintings of 1950," 133ff.

10. Krasner, in *Pollock Painting* n.p.: "The paint Jackson used for the black and whites was commercial too—mostly black industrial enamel, Duco or Davoe & Reynolds."

11. O'Connor, *The Black Pourings,* 7.

12. M. Fried, "Jackson Pollock," *Artforum* 4 (September 1965): 15.

13. E. H. Gombrich, *Art and Illusion* (Princeton, 1972), 217.

14. P. Leider, " 'The Properties of Materials': In the Shadow of Robert Morris," *New York Times,* 22 December 1968, D31.

15. For Pollock's relation to Post-Minimalism, see C. Robbins, *The Pluralist Era* (New York, 1984), 9ff., and R. Pincus-Witten, *Post-Minimalism* (New York, 1977), 150.

16. F. O'Hara, *Jackson Pollock* (New York, 1959), 26.

17. W. Rubin, "Jackson Pollock and the Modern Tradition," Part IV, 30.

18. B. Rose, *Jackson Pollock: Works on Paper* (New York, 1969), 9–10.

19. Alloway, op. cit., 41.

20. O'Connor, *The Black Pourings*, 8.

21. Ibid., 10.

22. CR4, p. 251.

23. See H. Gaugh, *Willem de Kooning* (New York, 1983), 41.

24. De Kooning interviewed by David Sylvester for the BBC, quoted in T. B. Hess, *Willem de Kooning* (Museum of Modern Art, New York, 1969), 148.

25. C. Greenberg, *Art and Culture*, 228.

26. M. Fried, *Three American Painters: Kenneth Noland, Jules Olitski, Frank Stella* (Fogg Art Museum, Cambridge, Mass., 1965), 15.

27. See, for example, I. Sandler, *The Triumph of American Painting* (New York, 1970).

28. O'Connor, *The Black Pourings*, 10.

29. This relationship between *Woman* and the Black Pourings has already been noted by O'Connor, ibid., 10–13.

30. See B. Brown, *The Art of the Cave Dweller*, 98, fig. 64; see also V. F. Gilardoni, *Naissance de l'art* (Paris, 1948), pl. 3. (See "Pollock's Library," CR4, p. 188). For the *Venus of Willendorf*, see Brown, 96; Gilardoni, pl. 2; and L. Adam, *Primitive Art* (London, 1949), 78, fig. 13.

31. That Pollock had no children and, according to the recollections of Tony Smith, was always inquisitive about the feelings involved in having children may suggest that a relationship exists between the motifs Pollock was borrowing and specific biographical events. See Tony Smith, in du Plessix and Gray, "Who Was Jackson Pollock?" 54.

32. J. J. Bachofen, "Das Mutterrecht," in *The Making of Man*, 157–67 (although the title is in German, the text is in English); and E. S. Hartlaud, "Motherright," in *The Making of Man*, 182–202.

33. O'Connor, for example, in the 1967 Museum of Modern Art Pollock catalog juxtaposed an illustration of *Woman* with a photograph of Pollock's family (19).

34. A. Ossorio, quoted in du Plessix and Gray, op. cit., 57, continues: "It was the classical Oedipal complex. Jackson had ambivalent feelings towards his mother. Once when his mother was due to arrive East—he was staying with his brother Sandy in New York—Jackson disappeared for three days."

35. Lee Krasner in du Plessix and Gray, op. cit., 50. In July 1941, moreover, Pollock's brother Sanford wrote to his brother Charles on Jackson's psychological problems: "Since part of his trouble (perhaps a large part) lies in his childhood relationships with his Mother [it is curious he would capitalize the word] in particular and family in general, it would be extremely trying and might be disastrous for him to see her at this time" (CR4, p. 226, D40).

36. Henderson quoted in C. L. Wysuph, *Jackson Pollock: Psychoanalytic Drawings*, 17.

37. The connection between Henderson's remarks and this specific drawing has been noted by Wysuph, op. cit., 17. Wysuph continues: "In this regard, Henderson suggests that the women so frequent in Pollock's iconography may represent his need for the 'all-giving mother.' Henderson is also convinced that Pollock's mother was central to his difficulties."

38. Frank, op. cit., 87.

39. K. Clark, *The Nude: A Study in Ideal Form* (New York, 1956), 25.

40. Ibid., 28.

41. Ibid., 29.

42. Betty Parsons in du Plessix and Gray, op. cit., 55.

43. W. De Kooning. Spoken narration during a film *De Kooning on de Kooning* (Cort Production, presented by Kera-TV, Dallas, 1982, CPI).

44. S. Rodman, *Conversations with Artists* (New York, 1961), 102. See also R. Rosenblum, "The Fatal Women of Picasso and De Kooning," *Art News*, October 1985, 98–103.

45. Rothko and Gottlieb, "Letter to the Editor," *New York Times*, 7 June 1943, quoted in M. D. MacNaughton, *Adolph Gottlieb: A Retrospective* (New York, 1981), 169.

46. Gaugh, op. cit., 52.

47. A. Kolodny, "Reply to Commentaries: Women Writers, Literary Historians and Martian Readers," *New Literary History* 11 (1980): 588.

48. J. Fetterly, *The Resisting Reader: A Feminist Approach to American Fiction* (Bloomington, Ind., 1978), xii.

49. Pollock owned a catalog of Dubuffet's work from the Pierre Matisse Gallery, 1951 (CR4, p. 190). He even mentioned Dubuffet several times in his correspondence. In 1951 he wrote his friends Ossorio and Ted Dragon: "The two Dubuffet books came this very moment—they are really very beautiful. There is a photograph of him in this issue of *Art News* [49 (January 1951): 26]—a surprise. We had no word from [Pierre] Matisse about borrowing the two D. [Dubuffet]" (CR4, p. 257, D93). The same year, Pollock wrote again to Ossorio saying, "I was really excited about Dubuffet's show" (CR4, p. 258, D94) and again in another letter (CR4, p. 258, D95).

50. See W. Rubin, "From Narrative to Iconic in Picasso: The Buried Allegory in *Bread and Fruit Dish on a Table* and the Role of *Les Demoiselles d'Avignon*," *Art Bulletin* 65 (December 1983): esp. 628ff.

51. Another example of a neutral depiction of a woman is *Number 9, 1951* (CR2:340); see O'Connor, *The Black Pourings*, 15. This image, according to O'Connor, appears to be the reworking of an earlier drawing of 1944 (CR3:717v).

52. Ibid., 21.

53. The late Professor Gert Schiff drew this relationship to my attention.

54. Mrs. Marvin Jay Pollock in conversation with F. V. O'Connor, 27 June 1973, CR4, p. 203. See also O'Connor, *The Black Pourings*, 13.

55. Krasner interviewed by B. H. Friedman in *Pollock Painting*, n.p.

56. O'Connor, *The Black Pourings*, 20: "Pollock himself confirmed that this large head, anatomically legible only to the right, depicted himself. He told his homeopath, Dr. Elizabeth Wright Hubbard, that it was a portrait of himself 'when I am not sober.' He also told her husband, 'That's a portrait of me, can't you see it?' " (Dr. Hubbard to Francis V. O'Connor, interview 22 February 1964 and letter of 14 May 1964.)

57. Krasner in *Pollock Painting*, n.p.

58. O'Connor, *The Black Pourings*, 20. This dual representation—of a self-portrait and another image—has a precedent in a drawing of the 1930s: the bottom right of CR3:410r found by O'Connor.

59. Rubin described the variety of Indian "Moon Woman" myths in "Jungian Illustrator," Part II, 90, note 7.

60. See P. Leider, "Surrealist and Not Surrealist in the Art of Jackson Pollock and His Contemporaries" in *The Interpretive Link: Abstract Surrealism into Abstract Expressionism* (Newport Harbor Art Museum, California, 1986), 43ff.

61. Lee Krasner, in conversation with Angelica Zander Rudenstine, admitted that Pollock associated the moon with the male and the sun with the female. See Rudenstine's *Peggy Guggenheim Collection, Venice* (New York, 1985), 633. The male/solar–female/lunar association is a frequent one in mythology and folklore; see E. Zolla, *The Androgyne: Reconciliation of Male and Female* (New York, 1981).

62. Essentially there have been only four Pollock scholars to devote themselves to the Black Pourings: O'Connor, Alloway, E. A. Carmean, and Ben Heller. Frank and Landau devote very few pages to them in their recent monographs.

63. M. Fried, *Morris Louis* (New York, 1970), 20.

64. Ibid.

65. Ibid., 21.

66. Tony Godffrey, for example, in his book *The New Image: Painting in the 1980s* (Oxford, 1986), sees the Black Pourings as precursors of or precedents for the new figurative painting that came into prominence in the 1980s (11, 118–19).

67. *Moby-Dick* was one of Pollock's favorite novels. From this book, Frank (op. cit., 97–102) quotes: "Hither, and thither, on high, glided the snow-white wings of small, unspeckled birds; these were the gentle thoughts of the feminine air; but to and fro in the deeps, far down in the bottomless blue, rushed mighty leviathans, sword-fish, and sharks; and these were the strong, troubled, murderous thinking of the masculine sea."

68. R. Kligman, *Love Affair: A Memoir of Jackson Pollock* (New York, 1974), 127–28.

PART TWO
SIGNIFICANCE

5
POLLOCK AND PRIMITIVISM*

In the second part of this inquiry into the work of Jackson Pollock—the part concerned mainly, though not exclusively, with significance—critical attention will focus primarily on issues raised by Pollock's work in relation to a broader context, sometimes beyond the known intentions of the artist. This is not to suggest that the artist's intentions are irrelevant to such investigations; on the contrary, most issues raised by Pollock's work originate with his intentions. But, although the realms of meaning and significance, as stated in the Introduction, often overlap, it should not be surprising if the long-term historical consequences and intellectual ramifications of Pollock's work were unknown even to him. The purpose of the following investigation is to determine, with the benefit of greater historical distance, how the initially restricted realm of the artist's intentions intersects other and larger currents in artistic and intellectual thinking, creating a broader and more general context.

One of the key issues in early Abstract Expressionism is that of primitivism.[1] At the outset of the 1940s, stylistic and thematic borrowings from non-Western cultures provided the younger generation of artists with specific means to circumvent what they saw as the time- and culture-bound character of American Scene painting and the declamatory, overdramatic, and sociopolitical work of the Mexican

*The word *primitivism* and the adjective *primitive* are used in this chapter not without consciousness of the problems involved in the use of such terms and their derogatory and ethnocentric associations. Because of the frequency of their usage, and the lack of equally comprehensible or appropriate alternatives, however, no other term(s) were found suitable.

Muralists. By providing an alternative to the art of the European moderns, it also encouraged American painters to avoid their dominance. Before an analysis of Pollock's particular brand of primitivism can be made, however, it may be useful to review the different typological manifestations of primitivism in the visual arts. As recent scholarship—particularly the polemics surrounding the 1984 exhibition at the Museum of Modern Art—has demonstrated, the definition of primitivism as the mere borrowing of certain stylistic characteristics from non-Western art on the part of modern artists is simply inadequate. William Rubin, in the introduction to the MoMA catalog of the 1984 show, posits a variety of possible relationships ranging from general interest in what were considered "primitive" works to direct stylistic influence (some visual, some conceptual) and affinities (where a visual correspondence between a modern and non-Western work is coincidental and cannot be explained by historical cause and effect).[2]

In attempting to define Pollock's visual and intellectual relationship to non-Western art, it quickly becomes evident that his brand of primitivism does not conform to any single category. Although his interest in native American folklore led him to loosely depict characters from Indian myth, such as the Moon Woman, a direct stylistic borrowing or influence in such paintings is difficult, if not impossible, to locate with any degree of precision. In other works, however, Pollock quotes almost literally: in a painting such as *Birth* [16], where Irving Sandler has discovered evidence of a direct borrowing from an Eskimo mask [15],[3] in the upper section of *Guardians of the Secret* (CR1:99), where Jackson Rushing discovered a specific reference to an Indian pottery bowl,[4] and in the poured paintings, where the use of handprints relates directly to prehistoric prototypes illustrated in books in Pollock's library.

But Pollock's involvement in the general phenomenon of primitivism does not end there. As also discussed in chapter 3, a technical rather than stylistic concordance exists between Pollock's poured canvases and Indian, particularly Navaho, sand paintings. There is no visual resemblance between the symmetrical articulation of geometrical forms in Indian sand paintings and the organic and irregular webs of Pollock's poured canvases. Yet, in painting on the floor and in using

the force of gravity in the creative process, Pollock developed a technique that on several occasions he himself called *"akin* to that of Indian sand painters of the West" (italics mine).[5] In effect, the technical influence is the affinity in reverse: instead of a visual similarity without cause and effect, there is cause and effect without visual similarity. An analogous example of technical influence is the use of mixed media in tribal art and the correspondent traditions of collage and assemblage in Western modern art.[6]

But when Pollock titled his works *Totem* or created hybrid mixtures of man and animal (see chap. 2), he was borrowing neither technical nor stylistic devices. Most likely influenced by books in his library, like Frazer's *Golden Bough* and Calverton's anthropological anthology *The Making of Man*, Pollock was generally referring to a system of tribal organization, to initiation rites, and to primal beliefs in humanity's communion with animals. Such manifestations of primitivism are neither one-to-one stylistic borrowings nor technical relationships; they reveal, rather, a more conceptual and cerebral kind of primitivism. So do the analogies between the visual effect of allover composition and Lévy-Bruhl's picture of the nondiscriminatory nature of the primitive mind, discussed in chapter 3.

Pollock's primitivism acts in varying degrees and on varying levels, simultaneously providing stylistic, thematic, and technical inspiration, as well as an operative model for what was then considered the inner workings of the primitive mind. To account for the complexity of meanings and plurality of forms associated with the primitive, the question to be addressed next is: What was Pollock's own conception of the idiom from which he was borrowing, the makers of this idiom, and to what degree was he reflecting intellectual currents of his time?

Since it may be assumed that Pollock's critical understanding of non-Western art and culture derived predominantly, if not exclusively, from the books in his library, they provide the primary source of investigation. In reading the texts Pollock owned on non-Western art, a definite and eventually predictable pattern begins to evolve. More often than not, although the utilitarian functions of the works discussed are mentioned, the authors of these books continuously stress that the objects are not simply ethnographic specimens but

works of art; and that their makers, fully aware of notions of beauty, are primarily engaged in making aesthetic decisions.

In Baldwin Brown's book *The Art of the Cave Dweller*, for example, the author acknowledges his own interest in the "artistic side of primitive cultures" and affirms that "there must have been art as art before there could be art as magic."[7] "The primary motive," he later interjects, "in the strict sense of the term, was certainly artistic."[8] In *Art of the South Seas*, moreover, Ralph Linton writes that "anthropologists have of course dealt with many of [Oceanic art's] regional and local manifestations but have treated them as a source of useful evidence in their studies and for other aspects of native life. Only a few artists and art lovers, most of them associated with advanced movements, have recognized its full aesthetic value."[9] Aldona Jonaitis, using Northwest Coast Indian art as an example, has remarked that the late 1930s and early 1940s was a period of intensive reinvestigation of non-Western art through an aesthetic lens. The various contemporary exhibitions devoted exclusively to alternative artistic traditions are cases in point. Holger Cahill, in the introduction to the 1933 exhibition catalog *American Sources of Modern Art* at the Museum of Modern Art, for example, wrote that although historians and archaeologists have studied pre-Columbian civilization for decades, the aesthetic appreciation of their works of art has been "a comparatively recent phenomenon."[10] It thus appears that the critical emphasis on the aesthetic properties of non-Western art found in the books in Pollock's library is no accident, but part of a broader intellectual current. To quote Jonaitis's evaluation of the critical literature on Eskimo art: "In less than a generation, the definition . . . of Northwest Coast pieces had changed from 'ethnographic specimen' to 'fine art.'"[11]

This change in the intellectual climate undoubtedly affected, if not conditioned, Pollock and the Abstract Expressionists' understanding and appreciation of what they themselves called the primitive. Barnett Newman, for example, one of the most outspoken and articulate of the group, often organized and wrote catalogs for exhibitions of non-Western art. In his essay accompanying the "Pre-Columbian Stone Sculpture" show at the Wakefield Gallery in New York, he

wrote, in concert with contemporary mentality, that the articles exhibited should be appreciated as art "rather than as works of history or ethnology."[12] This shift from specimen to art was to have important repercussions in the history of primitivism, particularly since the creation of art was often among the criteria used in judging whether a particular race or culture was worthy of respect. The recognition of objects produced by a non-Western culture as art, and the corresponding aesthetic appreciation of such objects, went hand in hand with a regard for this culture, for its traditional customs and social structure. The direct result is that the traditional distinctions between "modern" and "primitive," between industrial and tribal, begin to break down. Critical attention shifts, consequently, from the differences to the similarities, from the discontinuity to the continuity, between the modern and the "primitive," the Western and the non-Western.

It would therefore be no surprise if the books in Pollock's library, replete with claims to the aesthetic validity of non-Western art, would posit an equally tolerant view toward non-Western culture. Indeed, Leonard Adam, in his book *Primitive Art*, claims that "it is difficult, if not impossible, to give a satisfactory definition of 'primitive' man as distinct from 'civilized' man."[13] "A close examination of primitive cultures," he continues, "shows that . . . they differ from ours not in kind, but in degree. . . . there is no fundamental difference between the organization of a State as defined by constitutional law, and the organization of a tribe as defined by custom, and some primitive peoples have been able to establish states in the proper sense of the term."[14] This reevaluation of primitive art *and* culture contributed to the complexity of both Pollock's and Abstract Expressionist primitivism in general. Borrowings from non-Western works went beyond the appropriations of certain stylistic features; they implied a general appreciation of a particular culture and the way works of art function within that culture. As was mentioned in chapter 2, Rothko and Gottlieb believed that the significance of "primitive art" lay "not in formal arrangement, but in spiritual meaning underlying all archaic works."[15]

In this sense Abstract Expressionist primitivism differs from that of Picasso, a major initiator of modernist primitivism, who insisted that

all he needed to know about the African sculptures he was inspired by was in the visual properties of the objects themselves.[16] This is not to imply that Picasso's interest was purely formal; on the contrary, William Rubin has convincingly demonstrated the connection between African masks and the psychosexual content of the *Demoiselles d'Avignon*. But "beyond hazy assumptions (often incorrect) that tribal sculptures related to concerns such as fertility and death," he warns, "Picasso and his early twentieth-century colleagues knew nothing of their real context, function, or meaning. Their ignorance was an advantage insofar as it freed them to interpret the objects in manners suited to their personal concerns."[17] The Abstract Expressionists, on the other hand, were more interested in what one could call a spirit of communion with the primitive. For them, primitivism implied the crossing of cultural as well as aesthetic barriers. The appreciation of non-Western objects as art, according to Newman, was not only to "grasp their inner significance" (i.e., meaning in addition to form) but to transcend "time and place to participate in the spiritual life of a forgotten people."[18] But such participation is possible not simply because the modern and the primitive both engage in aesthetic activity, or because they have comparable social structures, but because a *psychological* link exists between them.

This continuity is best exemplified in the theory of recapitulation, a psychological hypothesis that modern individuals experience in their infancy the evolution of the human race at an accelerated pace. This would imply that the primitive is not radically different from the modern, but only at another level of psychical development. Marcelin Boule, in his essay "Fossil Men" included in the anthropological anthology in Pollock's possession, posits a similar idea: "Mankind as a whole has had to pass through the phases of intellectual and physical development which today characterize the development of each individual in the human mass. In the beginning the child is lulled by tales of song and marvel: poetry is his first instruction. Later his faculties of observation and reason awaken: truth compels him, and poetry is superseded by science."[19]

Pollock may also have been familiar with the theory of recapitulation through Wolfgang Paalen, editor of *Dyn* magazine (see chap. 2),

a publication Pollock read[20] and which included illustrations of his work.[21] In an article entitled "Totem Art," Paalen not only reiterated such ideas but outlined their logical ramifications: that the study of the primitive reveals the basic operations of the human mind. Paalen believed that totemic systems corresponded to a

> state of archaic mentality, the vestiges of which can be seen throughout mankind. For we can ascertain successive stages of consciousness: in order to pass from emotion to abstraction, man is obliged, in the maturation of each individual, to pass through the ancient stratifications of thought, analogously to the evolutionary stages of the species that must be traversed in the maternal womb. And that is why we can find in everyone's childhood an attitude toward the world which is similar to the totemic mind.[22]

Although modern individuals have outgrown this psychological state, access to "archaic mentality" is possible through the unconscious—what Pollock called the source of his art[23]—the nature of which, according to Jung, was collective. The theory of the collective unconscious, by explaining the striking similarities found among ancient myths, posited that humanity as a whole possessed the same psychological makeup. Thus, the intersection of the appreciation of primitive objects as art in aesthetics, the respect for tribal social organization in anthropology, and the idea of a collective unconscious in psychology—all intellectual currents Pollock was most likely exposed to—would lead to a very different kind of primitivism, at least conceptually, from, say, Picasso's.

In 1907, when exposed to tribal art in the Trocadéro, Picasso's reaction was one of shock.[24] His encounter, as well as that of his fellow artists upon seeing the *Demoiselles*, was a confrontation with an "other," with something alien to their realm of experience. But for Pollock, who was undoubtedly influenced by an intellectual climate that stressed the psychological continuity between the primitive and the modern, there was no shock. He was borrowing motifs not only from works he considered worthy of aesthetic admiration but from artists he must have considered not very different from himself. For

Pollock the primitive may not have been so much an "other" as a kin, a fellow participant in a more global, less circumscribed artistic venture. Indeed, providing an active dialogue with the unconscious, the emulation of non-Western art was the perfect way to transcend the particular (and the personal) and embrace the universal. The responsibility of art, moreover, if it was to have any profundity, was not to record the sociopolitical events of the day but to bring about a new consciousness, a new insight into the nature of humanity. According to Paalen, "This is the moment to integrate the enormous treasure of American Indian forms into the consciousness of modern art. . . . To a science already universal but by definition incapable of doing justice to our emotional needs, there must be added as its complement, a universal art: these two will help in the shaping of the new, the indispensable world-consciousness."[25]

Whether Pollock subscribed to such lofty ideas or not is difficult to say, but when he was interviewed several months after Paalen's article appeared, he reiterated some of Paalen's views on the universality of art and science. He called the idea of an isolated American painting as absurd as that of an isolated American mathematics or physics. And of American Indian art, he said, "Their vision has the basic universality of all real art."[26] If all "real" art had to be "universal"—and all non-Western art was already so—it is no surprise the Abstract Expressionists constantly drew parallels between the modern and the primitive. According to Newman, moreover, the modern artist was not only "emotionally tied to primitive art" but formed a "fraternity under a common fatherhood of aesthetic purpose."[27]

But beyond this rather pretentious rhetoric, what primitivism provided, on the simple level of style, was an intellectual justification for abstract art. For Abstract Expressionist artists, the fact that the prevalence of abstraction in non-Western art hardly suppressed its evocative power simply reinforced the stylistic experiments they themselves were making. The idea was that, at its most basic level, the artistic impulse was not a naturalistic or mimetic imitation of the external world but a more abstract concern for self-expression. Indeed, convinced that Northwest Coast Indian artists expressed their mythology by means of abstract symbols rather than figurative repre-

sentation, Newman found a weapon to defend abstract painting: "There is answer in these works to all those who assume that modern abstract art is the esoteric exercise of a snobbish elite, for among these simple peoples, abstract art was the normal, well-understood, dominant tradition."[28]

But it was not enough for Abstract Expressionist artists to justify abstraction through the example of non-Western art. For Newman the abstract shape in primitive art was not the arrangement of decorative patterning or an abstraction from nature. It was, rather, "directed by a ritualistic will towards metaphysical understanding."[29] It becomes obvious, therefore, that the young American artists used primitive art to justify not only the very experiments they themselves were making with abstraction but their interest in subject matter as well. Whether their interpretations of the primitive were anthropologically valid, however, or whether they were colored (if not conditioned) by their own ideas and intentions is a debatable point. The constant use of the word *terror* in the writings of Rothko and Gottlieb, for example, in reference to both the primitive's relationship to nature and as a dominant characteristic of primitive art, is now widely regarded as a typically Western misconception.[30] As William Rubin has observed, the visual distortions in some tribal sculptures were often interpreted by Expressionist artists as evidence of the angst of primitive people, an emotion they felt analogous to their own feelings of alienation.[31] Although such interpretations—also exemplified by Herbert Read's essay "Tribal Art and Modern Man"[32]—explain the appeal of non-Western art to a particular generation of modern artists, they also demonstrate how Westerners can manipulate the meaning of their sources to serve their own purposes. Thus, as a concept, primitivism does not imply a direct intellectual engagement with non-Western cultures as much as an intellectual transformation (or distortion) of these cultures into concepts malleable for Western appropriation.

This is not to imply that the Abstract Expressionists deliberately distorted the meaning of non-Western art for personal motives, but to demonstrate how, and to what degree, the intellectual climate of the time conditioned their ideas on the psychological proximity of the modern and primitive mind and on the integration of modern and

primitive art. Nor is this to applaud or condemn the Abstract Expressionists. Their point of view is significant not as a valid anthropological interpretation of non-Western cultures but only in so far as it paints an approximate picture of how they reflected the general intellectual climate of their time. But despite their high-minded ideas on the universality of art, and their belief in the proximity and integration of modernism and primitivism, the question to be addressed next is, How was this proximity to be made evident, and how was this integration to take visual form?

Stylistic analysis reveals that direct quotations from non-Western art are rare. When they do occur, as in the examples previously discussed in Pollock's work, they are so thoroughly digested and integrated within the modernist idiom as to be barely conspicuous. Indeed, the intellectual assumptions the Abstract Expressionists attached to their understanding of the primitive would inevitably lead to a more conceptual kind of primitivism. As a result, their interest in primitive mentality, in the birth of consciousness, and in the origins of things was to have two different but related manifestations.[33] The first, which was later to culminate in gestural painting, was a fascination with the primal sign, with traces of the artist's hand as images, and their relation to the beginnings of communication.

One finds a variety of forms visually analogous to calligraphic pictographs and petroglyphs in the work of Pollock [23], de Kooning, Gottlieb, Mark Tobey, B. W. Tomlin, David Smith, and Franz Kline. The quick, spontaneous movement of the hand, and the often improvisational quality of the marks, reveal an attempt to translate a physical gesture on canvas directly, without mediation, as if combining drawing and painting in a single style. The creation of primal signs ostensibly reconstructs the original state of creativity, when humanity was attempting to express messages with marks not yet systematically codified in a written alphabet. In this way the marks retain an autonomous quality as an expressive signature, rather than as a specific character functioning within a predetermined system of communication. This transitional stage, with its expressive yet indecipherable character, provided these artists with an intellectual model for the ancestry of artistic creation. "It is the poet and the artist," Newman

proclaimed, "who are concerned with the function of original man and who are trying to arrive at his creative state."[34] According to Newman, moreover, the creative precluded the practical: "Man's first speech was poetic before it was utilitarian. . . . Man's hand traced the stick through the mud to make a line before he learned to throw the stick as a javelin."[35]

The Abstract Expressionist artist thus attempts to tap the direct expressive possibilities of the primal sign—a mode of expression spontaneously produced and independent of inherited artistic conventions. In improvising such signs, Pollock and artists of his generation—like Klee before them—were attempting to re-create an elemental state of creativity from which both writing and art making would eventually evolve. John Wesley Powell, in an essay on American Indian pictographs published in the *Bureau of American Ethnology Reports* in Pollock's possession, wrote that "pictographs exhibit the beginning of written language and the beginning of pictorial art."[36] In early Abstract Expressionism the result is an unusual mixture of art and communication: writing through images and making images through writing.

The second mode in early Abstract Expressionism, in addition to the primal sign, is an interest in the dynamic and creative process of nature. Metaphors for or the suggestion of the birth of the world, or the creation of order out of chaos, are evident, for example, in Newman's *Genesis: The Break*. Other references to geological or biological evolution permeate the early work of Baziotes, Newman, Rothko, Still, and Stamos. But however connected to the natural environment, the physical evolution of nature was always tied to the psychological evolution of humanity. The interest expressed by these artists in totemic mentality was not only an attempt to comprehend the primitive mind but to enter into an analogous mode of thinking that eliminated the perennial barrier between the self and nature. On this point, discussing Stamos's painting *Sounds in the Rock*, Newman insisted that "the artist redefines the pastoral experience as one of participation with the inner life of the natural phenomena" and "is on the same fundamental ground as the primitive artist who never portrayed the phenomenon as an object of romance and sentiment, but always as an

expression of the noumenistic [sic] mystery in which rock and man are equal."[37]

This attempted fusion of the self and nature—further exemplified by Motherwell's previously quoted statement that, for the Abstract Expressionists, art was "one's effort to wed oneself with the universe"[38]—suggests that these artists often used the physical as a metaphor for the psychological, that the biological and geological birth of matter was symbolic of the birth of consciousness. This would explain the popularity of aquatic imagery, since physically water is the origin of life, and metaphorically, in the context of baptism or as symbolic of the unconscious, water implies the origin of thought.[39]

The type of primitivism the Abstract Expressionists were engaged in was thus not primarily based on the appropriation of stylistic forms particular to non-Western art. It was a more conceptual mode, based on intellectual ideas—how primitives think and participate in the realm of nature—rather than on the visual appearance of particular objects. The two distinct concerns discussed here, the interest in the primal sign and in the processes of nature, are inextricably combined in Pollock's poured paintings. Pollock fuses the very personal and unique trace of the artist's gesture on canvas, on the one hand, with a suggestion of the raw energy of nature's dynamic forces, on the other. On a stylistic level, this dichotomy is also made evident by the way the character of a Pollock painting changes depending on the spectator's vantage point. At close range the painted marks look disjunctive and dissonant; at a distance they fuse together in a harmonious, homogeneous image—as if, symbolically, the particular traces of the individual become subsumed in the greater dynamic rhythms of nature.

But if Pollock combined diverse issues central to Abstract Expressionist primitivism, he also differed from his contemporaries in his derivations from the primitive. First, his involvement with non-Western art was not restricted to his formative years; it can be traced throughout his artistic career. Second, not restricted to cerebral notions of the primitive mind, Pollock's primitivism included a method of painting physically akin to the primitive: the poured technique. It is essentially through this technique—so radical as to have been called

the destruction of painting—that Pollock's originality and major contribution to twentieth-century primitivism, and by extension to art history as a whole, made themselves manifest.

Yet it is ironic that although the understanding of the primitive, and the concept of primitivism, changed so radically from the turn of the century to 1950, Pollock's position at the outset of the second half of the twentieth century was strikingly similar to that of Picasso's at the outset of the first half. In his study of primitivism, William Rubin warned that its influence on the course of modern art in general, and on Picasso's art in particular, as important as it was, should not be overestimated. Contrary to popular belief, Picasso undoubtedly saw examples of African masks well before his now-legendary visit to the Trocadéro in 1907. But at that point African masks had no conspicuous impact on his artistic development. Thus far his work had not yet reached a stage where the stylistic absorption of this influence was morphologically possible. By 1907, however, when Picasso was working on the *Demoiselles*, he had already digested the influence of Iberian sculpture, and his work was already showing an increasing propensity toward angularization, fragmentation, and flattening of the picture space. African masks, therefore, not only could be visually absorbed within the pictorial fabric of his style but provided a surprisingly appropriate solution to the particular thematic problems he was facing at the time. What tribal art did for Picasso was to reinforce rather than change the direction his art was already taking; in effect, it is primarily in Cézanne rather than in tribal art that the roots of Cubism are to be found.[40]

The dialogue between the primitive and the modern, in effect, is more reflexive than reciprocal. Modernist artists co-opt a visual vocabulary from an alien tradition on their own terms and re-adapt it, out of context, within their own work to revolutionize their own tradition. For Picasso the impact of tribal art eventually led him to continue the aesthetic possibilities inherent in Cézanne rather than to a vital engagement with the primitive. His non-Western sources are detached from their original milieu and made to function differently in an altogether different pictorial and social idiom. Their function, therefore, is to reenergize latent potential within the modernist tradition.

This tendency to look at the primitive on modernist rather than primitive terms is somewhat analogous to an eighteenth-century literary didactic tradition that made, or pretended to make, moral statements on non-Western societies. In reality, however, the primitive was only an incidental subject of observation, a mere pretext for indirect commentary on Western society.[41] In this tendency, the West's relationship with the primitive is again reflexive rather than reciprocal.

In the same way, despite the greater knowledge available to him and the more tolerant attitude of his generation, Pollock looked to non-Western art for the solution of stylistic problems he was himself facing. Like Picasso, who registered the influence of African masks not when he first saw them but only when they could be absorbed within the stylistic parameters of his own visual vocabulary and when they corresponded to his needs, Pollock witnessed Indian sand painting demonstrations at the Museum of Modern Art as early as 1941. Although he was fascinated by and discussed this process with his psychoanalyst,[42] it was only in 1947 that its influence was fully felt. And just as William Rubin claims that Picasso's innovations in Cubism are far more indebted to Cézanne than to anything in tribal art, the real revelation Indian sand painting provided Pollock was a way to reenergize Surrealist automatism into a freer and more dynamic form of abstraction.

Even if they thought themselves different from Picasso, or from artists whose interests in non-Western art were purely formal, the Abstract Expressionists equally used and misinterpreted primitive art for their own purposes. For all their interest in a spirit of communion with the primitive, in the final analysis their mature styles can be explained almost exclusively within the stylistic and ideological parameters of modernism. This is not to belittle the influence of primitive art or to question the intellectual motives of the Abstract Expressionists but to better understand, in a wider context, why modern artists were drawn to the primitive: not so much to express the intellectual and artistic dynamics of another culture as to express themselves.

NOTES

1. See, for example, K. Varnedoe, "Abstract Expressionism," in W. Rubin, ed., *"Primitivism" in 20th Century Art*, vol. 2 (Museum of Modern Art, New York, 1984), 615–59 (hereinafter referred to as *Primitivism*); J. W. Rushing, "Ritual and Myth: Native American Culture and Abstract Expressionism," in *The Spiritual in Art: Abstract Painting 1890–1985* (Los Angeles County Museum of Art, 1986), 272–95.

2. W. Rubin, *Primitivism*, vol. 1, "Modernist Primitivism: An Introduction," 1–84.

3. I. Sandler, "Letter," *Art in America* (October 1980): 57–58.

4. Rushing, op. cit., 286–87.

5. See Pollock's statement from *Possibilities*, CR4, p. 241.

6. See Rubin, *Primitivism*, vol. 1, 64ff.

7. B. Brown, *Art of the Cave Dweller* (New York, 1931), 1.

8. Ibid., 2.

9. Linton, *Art of the South Seas* (New York, 1946), 7.

10. H. Cahill, *American Sources for Modern Art* (Museum of Modern Art, New York, 1933), 5.

11. A. Jonaitis, "Creation of Mystics and Philosophers: The White Man's Perception of Northwest Coast Indian Art from the 1930's to the Present," *American Indian Culture Journal* 5 (1981): 4.

12. B. Newman, *Pre-Columbian Stone Sculpture* (Wakefield Gallery, New York, 1944).

13. L. Adam, *Primitive Art* (London, 1949), 26.

14. Ibid.

15. Adolph Gottlieb and Mark Rothko, "The Portrait and the Modern Artist," typescript of a broadcast on "Art in New York," radio WNYC, 13 October 1943. Quoted in M. D. MacNaughton, "Adolph Gottlieb: His Life and Art," in *Adolph Gottlieb: A Retrospective* (New York, 1981), 42.

16. Rubin, *Primitivism*, vol. 1, 74, note 6.

17. Ibid., 258.

18. B. Newman, *Pre-Columbian Stone Sculpture* (Wakefield Gallery, New York, 1944).

19. M. Boule, "Fossil Men," in *The Making of Man*, 41.

20. Fritz Bultman, a painter and friend of Pollock, confirmed, in conversation with Jackson Rushing, that Pollock read *Dyn*. See Rushing, op. cit., 282.

21. *Moon Woman Cuts the Circle* was illustrated in *Dyn* 6 (1944): n.p.

22. W. Paalen, "Totem Art," *Dyn* 4–5 (December 1943): 18. Not all Abstract Expressionists agreed with Paalen on this issue. Barnett Newman did not agree with the equation of the primitive with the childlike. In the catalog to the pre-Columbian sculpture show at the Wakefield Gallery, Newman considered such equations "condescending." See also Sandler, *Triumph of American Painting*, 70, note 4.

23. Pollock quoted in Rodman, S. *Conversations with Artists* (New York, 1957), 82.

24. Rubin, "Picasso," in *Primitivism*, vol. 1, 255.

25. W. Paalen, "Editorial," *Dyn* 4–5 (December 1943): verso frontispiece.

26. CR4, p. 232.

27. B. Newman, "Art of the South Seas," *Studio International* (February 1970), reprinted from the original essay written in 1946.

28. B. Newman, *Northwest Coast Indian Painting* (Betty Parsons Gallery, New York, 1946), n.p.

29. B. Newman, *The Ideographic Picture* (Betty Parsons Gallery, New York, 1947), n.p.

30. See Newman, *Northwest Coast Indian Painting*, for the artist's view of the primitive as being in "terror before nature's meaning, the terror involved in a search for answers to nature's mysterious forces." And Adolph Gottlieb wrote: "If we profess kinship to the art of primitive man, it is because the feelings they express have a particular pertinence today. In times of violence, personal predilections for niceties of color and form seem irrelevant. All primitive expression reveals the constant awareness of powerful forces, the immediate presence of terror and fear, a recognition of the terror of the animal world as well as the eternal insecurities of life. That these feelings are being experienced by many people throughout the world today is an unfortunate fact and to us an art that glosses over or evades these feelings is superficial and meaningless." Quoted in McNaughton, op. cit., 42.

31. See Rubin, *Primitivism*, vol. 1, 35ff.

32. H. Read, "Tribal Art and Modern Man," in *The Tenth Muse: Essays in Criticism* (London, 1957).

33. See K. Varnedoe, "Abstract Expressionism," 627ff.

34. B. Newman, "The First Man Was an Artist," *The Tiger's Eye* (October 1947): 60.

35. Ibid., 59.

36. J. W. Powell, "On Limitations to Use of Some Anthropological Data," *Bureau of American Ethnology Report* 1 (1881): 375. See Rushing, op. cit., 284.

37. B. Newman, *Stamos* (Betty Parsons Gallery, 1947), New York, n.p.

38. R. Motherwell, quoted in F. O'Hara, *Robert Motherwell* (New York, 1965), 45.

39. For the prevalence of aquatic imagery in Abstract Expressionism and for some of its symbolic connotations, see S. Polcari, "The Intellectual Roots of Abstract Expressionism: Mark Rothko," *Arts Magazine* 54 (September 1979): 127ff.

40. See Rubin, *Primitivism*, vol. 1, 11, 13, 17.

41. Ibid., 6–7. See also a similar conclusion in A. Gopnik, "High and Low: Caricature, Primitivism, and the Cubist Portrait," *Art Journal* 43 (Winter 1983): 371–76.

42. See Rushing, op. cit., 282.

6
POLLOCK AND ABSTRACT EXPRESSIONISM

The conceptual primitivism of early Abstract Expressionism was short-lived. By the late 1940s and early 1950s the eclectic combination of Surrealism, primitivism, and mythic imagery gave way to a more elemental, "heroic"[1] form of abstraction. Although still stylistically indebted to the modernist tradition, the mature works of Jackson Pollock, Arshile Gorky, Willem de Kooning, Franz Kline, Mark Rothko, Adolph Gottlieb, Barnett Newman, Robert Motherwell, Hans Hofmann, Clyfford Still, William Baziotes, Ad Reinhardt, Mark Tobey, Lee Krasner, Jack Tworkov, and Bradley Walker Tomlin could no longer be considered a conspicuous, derivative emulation of European currents. Their artistic statements were original and significant enough to lead American art out of its provincialism and (as is now cliché to say) to shift the locus of the avant-garde from Paris to New York.[2] As a result, the tendency of art historians—particularly in the United States—is to treat Abstract Expressionism as a "breakthrough," as the "triumph" of American art.[3]

But despite its place traditionally awarded in history or its acknowledged importance in putting New York on the artistic map, the nature of Abstract Expressionism as a movement and the intentions of its members remain perplexingly unclear. Not surprisingly, this movement has been called one of the most complex in American art.[4] Part of the complexity, however, resides in the term *Abstract Expressionism*. Not coined by the artists themselves, it connotes a paradoxical combination of two concepts hitherto considered mutually exclusive: Abstraction and Expressionism.[5] Abstraction was generally associated

with an emotionally detached and intellectual concentration on form at the expense of content. Expressionism, conversely, was generally associated with an emotional and psychological concentration on content at the expense of form. The paradoxical combination implicit in the term *Abstract Expressionism* has remained, for this very reason, somewhat confusing.

The "New York School," another label used interchangeably with Abstract Expressionism, is similarly ambiguous. Although a geographic rather than stylistic term, New York School is misleading since the word *School* connotes a far greater stylistic congruity than is in fact the case. Painters as diverse as Rothko, Pollock, Newman, and Hofmann are considered central to Abstract Expressionism, but they neither worked together nor shared similar intentions nor addressed similar stylistic problems.

Objections by artists and critics notwithstanding,[6] both terms have endured, not simply because no acceptable alternatives have been found but because New York School points to the geographical origin of the movement and Abstract Expressionism to the artists' dual concern for abstraction and subject matter. It remains, however, that artists designated by both terms have developed widely divergent characteristic styles, which may often have little in common with one another. While it may be easy to connect the gestural paintings of de Kooning and Kline, the relation between, say, the dynamic energy of a Pollock and the classical regularity of a Newman is hardly as evident.

In the face of such stylistic diversity, how is Pollock's place in the context of Abstract Expressionism to be understood? Can a critical framework identify an artist's, or group of artists', distinguishing characteristics without losing sight of their place in the movement as a whole? If these artists do not share a common set of stylistic concerns, can stylistic subcategories be defined with any kind of precision? And, if so, to which does Pollock belong? Conversely, can categories founded on conceptual or thematic, rather than simply stylistic, concerns help clarify the pluralistic complexity of Abstract Expressionism?

The first and most important categorization found in Abstract Expressionist scholarship—a variation on the Wölfflinian distinction between the linear and the painterly—is the dichotomy between ges-

tural painting and color field.[7] Such a basic distinction, one of many possible approaches to stylistic analysis, is particularly appropriate for the painters of the New York School, since, moving toward an elemental form of abstraction, they often reduced their artistic vocabulary to a single principle. For example, the gestural painters (Pollock, de Kooning, Kline) are normally referred to as draftsmen.[8] Not that these artists are indifferent to color, but their pictures are organized by, and rely almost exclusively upon, the manipulation of line. The visual effects and formal relationships in a Pollock painting, for instance, are (relatively speaking) still effective in black and white reproductions, while those of the color field artists (Rothko, Newman, Still) are not.[9] Indeed, the color field paintings depend on large areas of unmodulated color and often avoid the dynamic and textural effects so characteristic of gestural painting. The use of Wölfflinian polarities are useful, partly because, as stated above, the Abstract Expressionists often reduced their visual vocabularies to exploiting the inherent possibilities of a single stylistic element, whether line or color.

But, however useful, such generalizations sometimes oversimplify a far more complex picture—often yielding as many exceptions to refute as examples to support them. The rigid separation of the draftsmen from the colorists may work for artists like Pollock and Rothko but would hardly indicate where to place Gottlieb, Motherwell, or Hofmann, since all three used devices common to both gestural painting and color field. Even a critical look at the artists normally thought to fit comfortably in a single category will only betray more exceptions and further inconsistencies. Rothko, Newman, and Still, for instance, have always been classified as color field. But the jagged edges in Clyfford Still's paintings rely on a variety of gestural effects; so do Rothko's late paintings—the Brown and Gray series in particular, where highly gestural marks remain visible on the canvas. Even Barnett Newman—whose use of masking tape and large areas of unmodulated color in his characteristic hard-edged striped paintings often eliminated any evidence of the artistic process—exploited the effects of gestural painting.

These examples do not deny that the predominant structural element in the paintings of Rothko, Newman, and Still is color, or that

the predominant one in Pollock, de Kooning, and Kline is line. What they do show, however, is that any rigid mode of stylistic analysis (like Wölfflin's) yields as many prescriptive generalizations as descriptive analyses. Because Abstract Expressionism in general appears to resist such overarching and reductive generalizations, the mode of stylistic analysis that will be suggested here should not be interpreted as an alternative but as a complement to the color versus line opposition.

However important the method of applying paint may be (painted versus poured, gestural versus nongestural, linear versus coloristic), it is no less important to distinguish how such applications were deliberately manipulated to produce particular effects. As discussed in chapter 3, Pollock's compositional strategy in his mature style was to distribute pictorial incidents in such a way as to create no center of attention: allover composition. As a pictorial device, it made Pollock's idea of a successful painting visible: "pure harmony, an easy give and take."[10] But Pollock was not the only artist of his generation to exploit such a nonhierarchical yet harmonious compositional format. Willem de Kooning [83], Bradley Walker Tomlin [84], Lee Krasner [85], Richard Pousette-Dart, Mark Tobey, and Ad Reinhardt, among others, also used allover composition. Although some of these artists are gestural painters like Pollock, some are not. Allover composition may thus apply not only to Pollock but to artists whose aims are considered diametrically opposed to his.

Tomlin and Reinhardt are cases in point. The more regular articulation of color and the geometric shapes in their works have little in common with the organic irregularity of the poured paintings. But although their morphology is different, the compositional format used by Pollock, Tomlin, and Reinhardt can be persuasively characterized as allover. In the same way allover composition cuts across the boundaries of gestural painting and color field, so does another type of compositional format used by New York School artists.

Unlike allover composition, this mode has received little critical attention from scholars.[11] And, unlike allover composition, its visual strategy is not the elimination but the accentuation of difference; its effect is not harmony but conflict. Among the practitioners of this mode—which can be considered the opposite of allover composition—

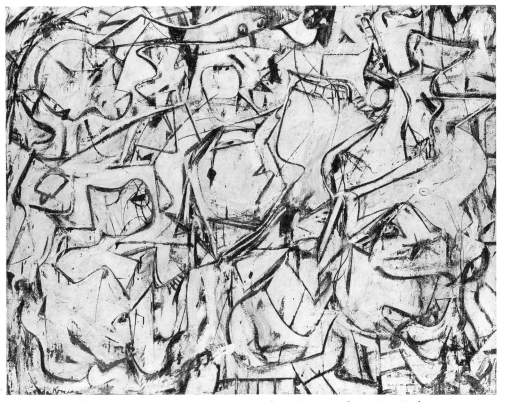

83. Willem de Kooning, *Attic* (1949). Metropolitan Museum of Art, New York.

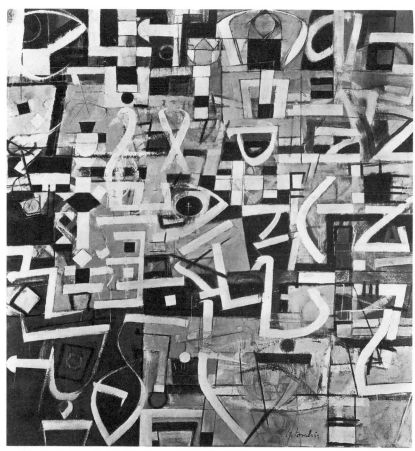

84. Bradley Walker Tomlin, *Number 29, 1949.* Museum of Modern Art, New York. Gift of Philip Johnson.

85. Lee Krasner, *Untitled* (1949). Museum of Modern Art, New York. Gift of Alfonso Ossorio.

are, most conspicuously, Motherwell [86], Gottlieb [87], Rothko [88], and Kline [89], with de Kooning and Hofmann working within both modes. Instead of constructing a unified, nonhierarchical field, the visual strategy of these artists is to generate oppositions.

In his *Elegy to the Spanish Republic* series, for example, Motherwell repeats, recombines, and deliberately contrasts a consistent and limited number of elements: straight versus ovoid, black versus white, figure versus ground. According to the artist, meaning was not in the elements themselves but "the product of the relations *between* elements."[12] The artist claimed that the opposition of black and white in the *Elegies* was a metaphor for the contrast between "life and death."[13] In Gottlieb's *Burst* series, the opposition of red versus black and of geometric versus irregular shapes suggests an analogous tension between order and chaos. Speaking on the effect of polarities in his work, Gottlieb stated: "There has to be some sort of conflict. If there is no conflict and the resolution of some sort of opposites, there's no tension and everything is rather meaningless."[14] Rothko, in his conversations with William Seitz, added that antitheses are neither synthesized nor neutralized in his work but held in momentary stasis.[15]

The formal strategies of Abstract Expressionist artists thus need to be categorized not only as either linear/gestural or color field painting. The methods by which these artists articulated forms and organized compositions reveal that they opted for either a holistic and harmonious allover image, on the one hand, or a discontinuous and fragmented image of conflict, on the other. Images structured by opposition, moreover, cross the boundaries of gestural painting and color field in the same way as allover composition. If artists as different as Pollock and Reinhardt used allover composition, artists as diverse as Rothko and Kline, Newman and de Kooning used the opposition mode. But, again, one should be careful not to overgeneralize. De Kooning, for instance, worked in a variety of styles: sometimes using allover composition [83], sometimes using the opposition mode [90]. The use of this polarity in investigating Abstract Expressionist compositional strategies should thus, as stated before, be considered not an alternative but a complement to the more traditional distinction between gestural painting and color field.

86. Robert Motherwell, *Elegy to the Spanish Republic* (1961). Metropolitan Museum of Art, New York.

87. Adolph Gottlieb, *Thrust* (1959). Metropolitan Museum of Art, New York.

88. Mark Rothko, *Black and Grey* (1970). Museum of Modern Art, New York. Gift of the Mark Rothko Foundation.

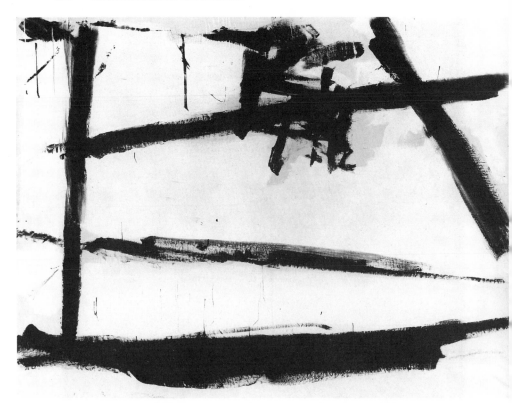

89. Franz Kline, *Painting Number 2* (1954). Museum of Modern Art, New York. Mr. and Mrs. Joseph H. Hazen and Mr. and Mrs. Francis F. Rosenbaum Funds.

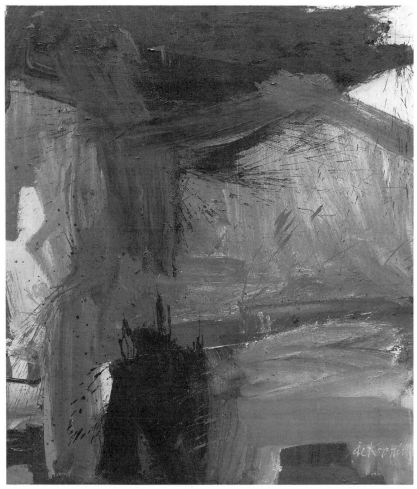

90. Willem de Kooning, *A Tree in Naples* (1960). Museum of Modern Art, New York. Sidney and Harriet Janis collection.

Although the origins of allover composition have been convincingly traced by art historians, the pedigree of images structured by oppositions has not. The history of the opposition mode nonetheless includes such important modernist images as the Suprematist compositions of Kazimir Malevich and the mature work of Piet Mondrian.[16] In the opposition of a black square on a white field, for example, Malevich tried to contrast "feeling" or "sensation" (the square) with "nothingness" (the field).[17] Likewise, Mondrian attempted in his mature paintings to distill the plurality and complexity of experience into two distinct and opposing forces: "Impressed by the vastness of nature, I was trying to express its expansion, rest, and unity. At the same time, I was fully aware that the viable expansion of nature is at the same time its limitation; vertical and horizontal lines are the expression of the two opposing forces; these exist everywhere and dominate everything; their reciprocal action constitutes 'life.' "[18]

Abstract artists (at least those concerned with issues of meaning) thus create their own metaphorical versions of reality by stressing either the distinctions (opposition mode) or the continuities (allover mode) between things. The oppositions in Malevich and Mondrian are analogous to the ones in Rothko, Gottlieb, and Motherwell, thereby explaining the latter's use of terms such as *tension, contrast,* or *antitheses.* It would thus be no surprise if, conversely, the statements of artists using allover composition would include opposite terms, such as *harmony* (Pollock's word), *unity,* or *wholeness.* Indeed, Mark Tobey claimed that his calligraphic white lines "symbolize a *unifying* idea which flows through the compartmented units of life" (italics mine).[19] Richard Pousette-Dart, after claiming that his definitions of art and religion were identical, defined the religious as "what dynamically realizes all within itself, it sees not in parts but *in wholes*" (italics mine).[20] Ad Reinhardt wrote that pure painting is "a creative completeness and total sensitivity related to personal *wholeness* and social order" (italics mine).[21]

Arguably, the distinction between allover composition and images structured by oppositions is as important as that between gestural painting and color field. It may also be argued that the strategy of the artists engaged in the second mode is to exploit visual tension and

conflict, whereas the strategy of those engaged in the first is to neutral-ize all tensions and conflicts into a more harmonious and coherent image. In retrospect, the most conspicuous formal tendencies in Ab-stract Expressionism are (1) a reduction of the visual vocabulary to essentials (either line or color) and (2) an arrangement of these essen-tials in either harmonious or conflicting images.

These artists ran a risk, however, by limiting themselves to a single element (like line or color) and to a compositional format that either eliminates or accentuates differences. Another visual quality had to be introduced to compensate for this apparent reduction of means and simplicity of composition: that quality was increased scale. The development of the large format was indeed central to the artistic maturation of the New York School; it not only provided sufficient space to receive the artist's gesture—Pollock said he felt more at ease in a large area[22]—but magnified the visual impact of an essentially limited pictorial vocabulary. Even if Pollock and Rothko shared a common economy of means, restricting themselves to line and color respectively, both artists understood that a large expanse of color would be more powerful than a small touch; a large gesture, more powerful than a single stroke. To the Abstract Expressionists, drafts-men and colorists alike, quality was directly proportional to quantity. The same could be said of allover composition and images structured by opposition. Tension increases as the conflicting elements are larger, and allover composition is more effective with greater scale (it is often remarked that Pollock's paintings threaten to expand beyond the physical boundaries of the canvas).

It is precisely this desire to directly affect the spectator that drew these artists to increased scale. The large format not only solved the practical problem of providing enough room for the gestural artist to operate but it created a space that would dominate the spectator's field of vision. This effect could be enhanced further if the artists exhibited their works in large numbers—a strategy often employed by the Abstract Expressionists. In his will, for example, Pollock wished his paintings to be left as "intact as possible,"[23] and Anna Chave related that Rothko "believed that group exhibitions caused his 'real and specific meaning' to be 'lost and distorted'; and after 1951 he was

reluctant to lend or sell his paintings to museums unless a group of them could be shown together."[24] This suggests that the Abstract Expressionists in general wanted to control the presentation of their work to the public,[25] an attitude best reflected in Newman, Rothko, and Gottlieb's letter to the art editor of the *New York Times*, Alden Jewel, where they wrote that it was "our function as artists to make the spectator see the work our way, not his way."[26]

This dual interest in large scale, on the one hand, and in a large number of works being exhibited together, on the other, suggests that Abstract Expressionist paintings were probably meant for public rather than private spaces. In his study of the issue of scale in modern painting, E. C. Goossen remarked that "the size of such pictures is not adjusted to the size of the kinds of rooms we currently live in. It is not adjusted, so to speak, to the market, as one may say seventeenth-century Dutch painting was, and as most easel painting has been for that matter."[27] As if anticipating a fusion of painting and architecture, the Abstract Expressionists continued to paint large pictures whether, in Pollock's words, it was "practical or not."[28] In his 1947 application for a Guggenheim Fellowship Pollock already spoke of his paintings as constituting "a half-way state" to "the wall picture or mural."[29] Most likely having himself and his contemporaries in mind, he added in 1950 that "the direction that painting seems to be taking . . . is away from the easel into some sort, some kind of wall—wall painting."[30]

But although the Abstract Expressionists painted large pictures, their works remained in the "half-way state" Pollock described— large movable paintings rather than murals in the strict sense of the term. Nonetheless, for artists as concerned with the presentation of their works to the public as the Abstract Expressionists, a marriage between painting and architecture could best provide the degree of control they so desired.

Pollock's interest in a possible architectural environment for his paintings came in 1947 when he met Peter Blake, an architect and then curator of architecture at the Museum of Modern Art. Blake's interest was such that he built a model of a museum explicitly de-signed to house Pollock's work. Pollock made miniature paintings and sculptures for the model, which was exhibited at Pollock's second 1949

show at the Betty Parsons Gallery and was published in Arthur Drexler's article "Unframed Space: A Museum for Jackson Pollock's Paintings." Blake's idea was to suspend the paintings in midair and amplify their visual propensity toward expansion by the use of mirrors. Drexler described it thus:

> The pictures [Pollock's] are heavily pigmented designs whose continuous rhythms often appear to end because there was no canvas left for more, and Mr. Blake feels that their distinguishing characteristics are best revealed by open space and by the absence of frames. The paintings seem as though they might very well be extended indefinitely, and it is precisely this quality that has been emphasized in the central unit of the plan. Here a painting 17′ long constitutes an entire wall. It is terminated on both ends not by a frame or solid partition, but by mirrors. The painting is thus extended into miles of reflected space, and leaves no doubt in the observer's mind as to this particular aspect of Pollock's work. . . . In its treatments of paintings as walls the design recalls an entirely different kind of pictorial art, that of the Renaissance fresco. The project suggests a reintegration of painting and architecture wherein painting *is* the architecture.[31]

Blake's model is now lost, and the project was never realized, but the idea of paintings as walls, and the use of mirrors to expand the already expansive effect of allover compositions, were strikingly original.

Another, equally effective, idea of combining painting and architecture also came to Pollock's mind, although in a rather unexpected manner. During his film of Pollock at work, Hans Namuth asked Pollock to paint on a sheet of glass suspended on a platform. In this way Namuth, lying on his back with the camera on his chest, could film Pollock from below, as if the painting were the earth upon which Pollock was working.[32] Since the painting was executed at Namuth's suggestion, specifically for the film he was completing, Pollock may not have immediately understood its implications. Namuth recalled, "Our prop for the film, the painting on glass stood outside for weeks. Rain fell on it, leaves collected on top of it, ocean winds weathered it. Then one day Jackson decided to take it inside. It is now in the National

Gallery in Ottawa, Canada, 'Number 29, 1950.' "[33] When he was later asked about the painting, Pollock replied: "Well, that's something new for me. That's the first thing I've done on glass and I find it very exciting. I think the possibilities of using glass in modern architecture—in modern construction—terrific."[34]

This idea may have come from his friend Tony Smith, also an architect, who had similar plans to create an architectural structure to house Pollock's works.[35] But although Betty Parsons recalled that Pollock loved and spoke frequently about architecture,[36] and that Lee Krasner confirmed his aspiration to include his works in architectural settings,[37] none of these projects ever materialized. This does not, of course, make Pollock's desire to integrate painting and architecture any less important, particularly since this desire was shared by many of his fellow artists. Indeed, Gottlieb, Motherwell, and Herbert Ferber worked on a synagogue in Milburn, New Jersey, in 1951;[38] Barnett Newman designed a synagogue of his own;[39] Clyfford Still donated a group of paintings to both the Albright-Knox Art Gallery in Buffalo and the San Francisco Museum of Art; and Mark Rothko was involved in a variety of architectural projects, the most successful being the Chapel for the Institute of Religion and Development in Houston, Texas, now called the Rothko Chapel.[40]

The Abstract Expressionists, it seems, collectively believed that their works would be more appropriately—and more effectively—shown in groups, in environments specifically designed for them, and where the artist could somehow control and manipulate their presentation to the public for optimum effect. The artists' combined ambition to, first, control exhibition spaces and, second, to amplify the scale of the paintings may appear tyrannical, as if they deliberately wanted to overwhelm the public and render the spectator insignificant. But, paradoxically, their intention was to induce greater physical—and thus psychological—proximity between the spectator and the work. Rather than creating a pompous statement in the grand manner, Rothko, for instance, attempted to generate a more intimate experience. To this end he also preferred to show his works in small rooms:

I paint very large pictures. I realize that historically the function

of painting large pictures is painting something very grandiose and pompous. The reason I paint them, however—I think it applies to other painters I know—is precisely because I want to be intimate and human. To paint a small picture is to place yourself outside your experience, to look upon your experience as a stereopticon view or with a reducing glass. However you paint the larger picture, you are in it. It isn't something you command.[41]

De Kooning reiterated the same idea when he declared, "I like a big painting to look small. I like to make it seem intimate through appearing smaller than it is."[42] And when Pollock admitted to feeling "more at ease . . . more at home in a big area,"[43] describing his technique of painting on the floor as allowing him to be "nearer . . . more part of the painting,"[44] it might be conjectured that this "feeling at home," this being "part of the painting," meant as much to the artist as the practical solution to a technical problem (having a painting large enough to admit the breadth of his gesture).

Indeed, there seems to be a strong feeling of identification between the artists and their work: a response the artist transfers to the public by creating paintings that encompass most, if not all, of the spectator's field of vision. By making the paintings appear close rather than remote, the artists encourage psychological proximity through physical proximity. Statements such as "feeling at home" and "being intimate and human" suggest sensations of calm, as if the artists desired the spectator to approach the work through quiet and introspective contemplation. On this point, it may be equally significant to mention that a large proportion of Abstract Expressionist architectural projects were for religious buildings, structures that encourage an engaging and meditative approach to works of art.

It may thus be argued that the different formal strategies discussed thus far—the manipulation of pictorial elements to create an effect of harmony (allover composition) or conflict (images structured by opposition), the use of large scale to produce intimacy, and the desire to create environments designed specifically for paintings—were meant to be collectively reinforcing. For the Abstract Expres-

sionists, art was something to be experienced, not a self-contained entity or an effect to be produced. The nature of this experience, however, or what is meant to be communicated by it is far from clear. In the literature on Abstract Expressionism, this problematic issue has yet to be resolved.

The artists themselves say surprisingly little on this point. They insisted that their works had meaning but were reluctant to explain the nature of this meaning with any degree of precision. In their view, the works should and could speak for themselves. Since no critical framework was established to clarify exactly how abstraction could generate meaning, many critics embraced a strictly formalist position—like Susan Sontag, who categorically and reductively claimed that abstraction has no meaning and therefore is in no need of interpretation. But even if Ferdinand de Saussure's idea that signification may function independently of imitation (see chap. 3) can invalidate Sontag's indiscriminate view of abstraction as pure form, certain questions regarding signification remain unanswered. Indeed, if Saussure's assumption explains how certain meanings may be attached to words, can it convincingly explain how meanings are attached to abstract art?

Although the Abstract Expressionists rarely discussed the meanings of their work, they occasionally divulged how those meanings came about. Indeed, during creation, Pollock admitted: "I'm not aware of what I'm doing. It is only after a sort of 'get acquainted' period," he continued, "that I see what I have been about." This statement reveals a polarity between the initial act of creation and the subsequent act of comprehension. Lest Pollock's divorce of making and meaning be considered an isolated phenomenon, other Abstract Expressionists described the process of signification in similar terms. A notable example is Motherwell's discovery of his characteristic *Elegy to the Spanish Republic* format. The first instance of an *Elegy* image was a drawing improvised, much like Surrealist automatism, to accompany a poem by Harold Rosenberg for the second issue of the avant-garde periodical *Possibilities*. Since the issue was never published, Motherwell put the drawing away and forgot about it, only to rediscover the drawing a year later as he was moving his studio. He was struck by the motif, made numerous variations of it, and called them *Elegies to the Spanish Republic*.[45]

The work of art may thus begin randomly, through improvisation, and, more important, *the artist may not necessarily be aware of its meaning during the act of creation.* Later, through reflection, the artist may perceive a meaning, which is then imposed on the work in a manner analogous to Saussure's concept of the arbitrary nature of the sign. By the time the artist creates later versions, however, the intention may be more precisely defined at the outset and integrated within a larger artistic program. This is precisely what happened to Barnett Newman. The artist finished a painting whose pattern, although it suggested no clear meaning to him, he later amplified into a series. After the execution of four canvases, Newman realized what he was after. He made twelve paintings in all and called them *Stations of the Cross.*[46] Newman's experience, again, suggests that the process of signification is *not generated by a visual relationship to the world, but by an arbitrary imposition of meaning on the part of the artist*—the same way Saussure described it in his *Course in General Linguistics.* Moreover, even if the artist was not aware of the meaning of the work at the time of creation, the work is not necessarily devoid of meaning. Paul Valéry described this very aspect of the artistic process when he wrote: "It is hard for a philosopher to understand that the artist passes almost without distinction from form to content and from content to form; that a form may occur to him before the meaning he will assign to it; or that the idea of a form means as much to him as the idea that asks to be given form."[47] Although the work may have no definite meaning during the course of creation, the meaning may then be assigned by the artist after the fact.

That the Abstract Expressionists themselves were convinced their works had meaning is reflected in the creation of a school in 1948 by Baziotes, Motherwell, Newman, Rothko, and Still titled "The Subjects of the Artist." Robert Motherwell recalled that the "title was Barney's [Newman] and I remember we all agreed it was right because it made the point that our works did have subjects."[48] Newman himself claimed that "the central issue of painting is the subject matter."[49] Pollock, although he did not officially participate in the school's activities, would nonetheless have sympathized with their claims. He himself spoke of modern artists "making statements" and of "deeper meanings in modern art."[50]

But although the artists' belief in the compatibility of meaning and abstraction is made unambiguously clear from their statements, how these meanings communicate themselves to the spectator remains a problematic issue. If the artist imposes a private or personal meaning onto an abstract image and is reluctant to explain it, how is this meaning to be decoded? However convincingly Saussure may describe one aspect of the process of signification, the problem remains that communication in art largely consists of the recognition of conventions shared by both artist and spectator. Without such conventions, the possibility of successful communication is severely, if not completely, inhibited. Yet, paradoxically enough, recognizable conventions were precisely what these artists avoided. Not altogether ignorant of this problem, Rothko confessed, "If I must put my trust somewhere I would invest it in the psyche of sensitive observers who are free of the conventions of understanding."[51]

From the artists' vantage point, then, when perceiving works of art, spectators are not meant to recognize something they already know—this would make aesthetic experience redundant. On the contrary, they are meant to experience something new. But problems inevitably arise when the audience is confronted with images it is likely to understand only by imposing familiar associations on unfamiliar art. For this reason, many of these artists stopped titling their works to "avoid," in Still's words, "introducing irrelevant associations or implications of illustration."[52] As previously quoted in chapter 3, the spectator, according to Pollock, "should not look for, but look passively—and try to receive what the painting has to offer and not bring a subject matter or preconceived idea of what they are to be looking for."[53]

In the absence of any common system of communication between artist and spectator, it is no surprise that the Abstract Expressionists would rely so heavily on the physical properties of their medium. This explains their concern with scale and their obsession with the public presentations of their work. It also explains their reduction of their visual vocabulary to a minimum number of elements. Motherwell stated that since "modern artists have no generally accepted subject matter, no inherited iconography," they were forced to "re-invent

painting, its subject matter and its means," only by reducing "it to a very simple concept."[54] To simplify and reduce the number of elements, however, is to give them added visual importance and, as a result, to magnify their expressive power.

Thus, the strategy of the artist is to manipulate the spectator to focus on certain elements combined in certain ways to generate certain meanings—meanings the spectator may reconstruct not through the recognition of conventions but through direct confrontation with the work. Information theory teaches that human beings are not cognitively static but intellectually dynamic. In other words, their repertory of understanding can expand. Even if there are no shared conventions between artist (sender) and spectator (recipient), spectators can eventually alter or modify their repertoire of experience to gradually absorb the signals sent by the artist. According to information theorist Abraham Moles, for example,

> Ideas can only be communicated in so far as both repertoires have elements in common. . . . But to the extent to which such a process takes place within systems equipped, like human intelligence, with memory and statistical perception, the observation of . . . similar signs gradually alters the recipient's repertoire and leads ultimately to a complete fusion with that of the sender. . . . Thus acts of communication, in their totality, assume a cumulative character through their continued influence on the repertory of the recipient.[55]

By continual observation and prolonged exposure, the audience may slowly alter its frame of reference and accept that generated by the work of art. This continual observation on the part of the spectator is encouraged by the unfamiliarity of the work of art. By refusing to exhibit easily recognizable symbols, the artist forces the spectator to focus on the work rather than on the passive recording of conventions. In effect, the artist relies, in the aesthetician Wolfgang Iser's words, on the spectator's "willingness to open himself up to an unfamiliar experience."[56] In such an instance, whether a meeting point (sometimes called the fusion of horizons) between sender and recipient can be reached is contingent not only on the spectator's willingness to

understand the work but on the strategies employed in the work to generate this understanding and motivate the spectator's engagement in the process of aesthetic experience.

What, for example, are the strategies employed in Pollock's 1947–50 paintings to affect the spectator? (How Pollock's poured paintings affect the spectator is, of course, too subjective a question, since every person is bound to be affected differently.) First is the expansion of scale so that the painting occupies the majority of the spectator's field of vision. Second is the different character Pollock's poured paintings display relative to the spectator's distance from the work. As mentioned previously, at close range the paintings appear fragmented and discontinuous; at a distance the holistic and harmonious effect of allover composition takes over. Although two different effects are at work in the same painting, the spectator cannot experience the discontinuity and harmony of a Pollock painting simultaneously. A distinction must be made, therefore, between the marks on the canvas and the effect they produce. This effect is analogous to an anecdote Kenneth Clark related about his observations of *Las Meninas* by Velázquez. Clark wanted to experience how the inanimate strokes of paint seen at close range would at a distance transform themselves into an illusion of reality. But however much he tried, moving forward and back, Clark could not see the strokes of paint and have an illusion at the same time.[57] And although there is no illusion in Pollock's mature paintings, the lack of congruity between the paintings at close range and the paintings seen at a distance is strikingly similar. The importance of Clark's observations for the subject at hand, though, is not the relations between Pollock and Velázquez but the impossibility of experiencing both effects simultaneously.

This multiplicity of effects encourages, according to Iser, a "process through which the aesthetic subject is constantly being structured and restructured [as in Clark's walking back and forth]. As there is no definite frame of reference to regulate this process, successful communication must ultimately depend on the reader's creative activity."[58] In Clark's case, it is in the spectator's mind that the strokes of paint assume a semblance of reality and that illusion is created. In Pollock's case, it is also in the spectator's mind, as he or she steps back, that an

effect of totality and unity is created from normally disparate and disjunctive elements. The result is an image in which the whole is indeed greater than the sum of the parts, an image where everything has its place and a perfect balance is struck between partiality and totality.

In the process just described, the spectator "experiences" and completes the work by participating in its cognition. The effects are created in the mind as much as on the canvas. The Abstract Expressionists thus recognized the beholder's share as central to artistic communication. Rothko wrote, "A painting lives by companionship, expanding and quickening in the eyes of the sensitive observer."[59] Richard Pousette-Dart added that "paintings cannot be explained, . . . they must be personally experienced."[60] Pollock himself, as quoted above, said the spectator should not look for, but look passively and receive what the painting has to offer. Since the Abstract Expressionists wanted the spectator to "experience" a painting rather than recognize codified symbols, it only follows that, to encourage communication, they would attempt to manipulate this experience as much as possible. Not only can the artist control exhibition space, but even the multiplicity of effects described above (close range versus distance) are the direct result of artistic manipulation.

Of course, the observation of works of art is naturally selective. Spectators scan the surface of the canvas and, unable to register all of the elements of the visual field at once, focus on what they consider important or particularly striking—a process likely to vary from spectator to spectator. To encourage, if not condition, a specific reaction, the Abstract Expressionist artist restricts the spectator's process of selection by either reducing the number or eliminating the importance of the visual elements in question. In allover composition, for example, not only is the part subordinated to the whole, but the parts are so equally distributed as to be virtually interchangeable. Which part the spectator decides to observe is therefore of no consequence, since no part is of greater visual importance than any other. Images structured by oppositions, by contrast, are rendered with such an economy of means—stark contrasts of color, shape, or gesture—that the spectator is given few unnecessary details to linger on. Motherwell's previously

quoted statement, that to generate meaning, the artist had to reduce his vocabulary to a simple concept, hereby becomes somewhat less ambiguous. Since the spectator does not know the code, the artist makes it simple: either all parts are the same and it is the whole that counts (allover composition) or parts are dissimilar and it is the contrasts that count (images structured by opposition).

In very subtle ways, the artist thus establishes strategies to manipulate the observer's response. Reducing the visual vocabulary to few elements, and placing them within a matrix of contrast, give them increased importance. Allover composition does the opposite. It decreases the importance of elements and emphasizes the painting as a totality. And whether the artist chooses allover composition or images structured by opposition, increased scale accentuates them both. The Abstract Expressionist rhetoric about the importance of scale and its relation to the spectator's experience is now becoming somewhat clearer.

What remains to be explained, however, is how specific meanings are to be communicated to the beholder. Even for scholars who disagree with Susan Sontag's opinion that abstraction is devoid of meaning, the question has been difficult to address. The two major tendencies have been either to seek figural elements in the abstractions—resulting in highly literal interpretations[61]—or to see the end product as negligible and the act of painting as the subject itself.[62]

These two positions neglect (1) the arbitrary nature of the sign suggesting the possible compatibility of meaning and abstraction and (2) the degree of anthropomorphism the Abstract Expressionists invested in their paintings. Pollock, for example, said that a painting "has a life of its own. I try to let it come through."[63] Still repudiated an interest in materials for their own sake: "I never wanted color to be color. I never wanted texture to be texture, or images to become shapes. I wanted them all to fuse into a living spirit."[64] And Rothko wrote that in his shapes, "one recognized the principles and passions of organisms."[65] How the spectator can perceive these anthropomorphic qualities can only be explained by the peculiar nature of an Abstract Expressionist painting as a sign system. Since the sign

is abstract, and by nature arbitrary, it reveals its meaning not by copying empirical experience but by creating a kind of *equivalent experience*—one with which the spectator may nonetheless identify.

If one takes Pollock's poured paintings as an example, their complexity is immediately apparent. Pollock's line is abstract and non-descriptive, his association of his works with the "rhythms of nature," purely arbitrary. But however abstract Pollock's line may be, it is caused by and directly related to the artist's physical movements in space. The slow or rapid nature of these movements in turn affect the character of the lines; and therein lies the key to communication. Frank O'Hara already remarked Pollock's ability "to quicken a line by thinning it, [and] to slow it down by flooding."[66] The perceptive nature of these remarks may indeed by confirmed by experience [50]. Similarly Harry Gaugh described de Kooning's gestures as activated by "a strong kinetic charge."[67] But however much O'Hara and Gaugh's comments ring true, painting is a static rather than kinetic idiom: lines on a painting cannot be faster or slower than other lines, they can only give the effect of being so.

That the paintings, or gestures on the paintings, give the effect of velocity is beyond question, but a painting should not be confused with its effect, what it is with what it does. If Pollock is not depicting a moving object (as a Futurist painter may have done), what, one may ask, produces the effect of movement? One may be tempted to attribute the effect of rapidity to a rapid gesture, but William Rubin has convincingly demonstrated that artists have learned to control the effects produced by their gestures. What often appears free and spontaneous can actually be carefully and deliberately calculated, and vice versa.[68] If a static idiom like painting makes thinner lines appear "faster" than thicker ones, the illusion of speed must be part of the spectator's response—as much in the mind of the beholder as on the surface of the painting. In front of the work, the spectator is (in a certain sense) tricked, encouraged to follow the painted lines and imagine the type of movements and gestures necessary to create them. Unaware that the artist is making subtle inflections to create different effects, the beholder assumes a thinner line was executed with greater haste than a thicker one. In this way, movement is experienced not by

the recognition of a codified symbol but through a kind of physical association.

But simply because the artist allows the spectator to "experience" rather than recognize movement, this does not imply that the artist is communicating meaning without assuming a basic level of experience from his audience. Although associating specific effects of velocity with the relative thickness and density of lines cannot be described as the recognition of conventions in the strict sense of the term, Pollock nonetheless depends on such associations for communication to be successful. Having experienced movement throughout their lives, spectators then call upon these stored sensations to reconstruct the "illusion" left by the artist. Without the most rudimentary knowledge of movement, it is doubtful whether a spectator could experience the effect of dynamism and energy so often felt before a Pollock painting—or, for that matter, before any gestural painting.

But in all fairness to Pollock, the artist probably did not conceive of physical associations as conventions in the strict sense of the term. By leaving traces of the process visible and encouraging the spectator to re-create the experience of making the painting in imagination, Pollock suggests the energy of nature without conventional systems of communication. Nor does communication depend on spectators' approaching the canvas with a "preconceived idea of what they are to be looking for." These artists apparently sought to evoke empathy between the spectator and the work of art. This clarifies many of the problematic issues often associated with Abstract Expressionism: the possibility of communication without fixed conventions, the desire for the spectator to experience rather than comprehend the work, and the degree of anthropomorphism the artists attached to their work. That art historians like O'Hara and Gaugh have been practicing their own kind of affective fallacy by attributing animate characteristics to the otherwise inanimate marks on an abstract canvas only reinforces abstraction's capacity to communicate.

But empathy begins with the medium of expression. Hans Hofmann wrote that "every medium of expression" can be set "into vibration and tension if we can spiritually master the nature of the medium. This demands above all a spiritual projection into the es-

sence of the medium of expression."[69] According to Hofmann, therefore, the medium is made expressive only by "spiritual projection." In effect, the spectator is to empathize with the medium and, depending on the strategies employed by the artists, is made to sense conflict in an image structured by opposition or, conversely, harmony and order in allover composition. But in the same way as the dialectic of horizontal and vertical was for Mondrian not purely formal but the expression of natural relationships, the visual tensions in Abstract Expressionism are not purely pictorial. Even Ad Reinhardt, the most dogmatically abstract of the group, said that "creative completeness" was "related to personal wholeness."[70] Indeed, the notion of an exclusively aesthetic realm—concerned only with questions proper to art and divorced from the external world—was alien to the Abstract Expressionists. During a discussion at an artists' session, Hans Hofmann proclaimed that art was "related to all of this world," and the sculptor Herbert Ferber concurred that although the means of art are important, he was really concerned with "an expression of a relationship with the world. Truth and validity cannot be determined by the shape of the elements in the picture." At the same discussion, Motherwell added: "It would be very difficult to formulate a position in which there were no external relations. I cannot imagine any structure being defined as though it has only internal meaning."[71]

If the Abstract Expressionists wanted to relate their creations to the outside world, they would do so not through appearances but through equivalences. Motherwell, who had studied French literature at Harvard, was struck by, and made many references to, the French poet Mallarmé's dictum "Paint not the thing, but the effect of the thing."[72] In the same way, Hofmann wrote, "The act of seeing is based upon the appearance, the emotional experience on the effect of the appearance."[73] And Pollock in a series of separate statements wrote, "Experience of our age in terms of painting—not an illustration of—(but the equivalent)."[74] These statements imply that formal relationships are not internal or purely stylistic, but offer, as they were for Mondrian, parallels, or equivalents, to real experience. If Pollock described his paintings (meant as metaphors for the rhythms of nature) as "pure harmony"[75] or as "states of order,"[76] it is because,

according to Lee Krasner, he thought that "man was part of nature, not separate from it."[77] Since allover composition permits no center of attention, the spectator gets a similar sensation of wholeness and unity. And because any spectator may perceive the changing velocity of lines, the audience gets the sensation of dynamic energy (Hofmann said, "Movement is the expression of life").[78] Thus, without depicting or illustrating a landscape but creating an analogous sensation of rhythm and movement, Pollock produces an "equivalent" experience.

It should be noted, parenthetically, that this is a perfect example of the mutual interdependence of form and meaning typical of Abstract Expressionist painting. If systems of communication common to both artist and spectator are abandoned, it is only through the expressive power of form that meaning may be communicated or, rather, experienced. This reliance on the expressive power of the medium is no less true of the color field artists than it is for the gesture painters. But since the former often do not leave evidence of the artistic process, aesthetic response is not the result of physical identification with the marks on the canvas but of the more subtle psychological effect of color and contrast. Like Kandinsky,[79] these artists were convinced that color was more significant than a mere problem of hue, value, and intensity. The effects of color were considered psychological. Hofmann wrote, "Color stimulates certain moods in us. It awakens joy or fear in accordance with its configuration."[80] But these artists also understood that, in and of itself, color could hardly elicit such responses. It was only through contrast that the full emotive impact of color could be felt. "A thing in itself," continued Hofmann, "never expresses anything. It is the relation between things that gives meaning to them."[81]

This is essentially the mode of thinking behind images structured by opposition. Motherwell, expressing a similar idea, stated that the juxtapositions of black and white in his paintings were symbolic of the contrast between life and death.[82] And Mark Rothko, while discussing a painting composed of a dark green rectangle hovering above a lighter red one, confessed that "The . . . tone of the lower section of the canvas could symbolize the normal, happier side of living, and in proportion the dark blue green rectangular measure above it could

stand for the black clouds that always hang over us."[83] Because of its lack of ambiguity and potential expressive force, the black and white opposition was frequently used by New York School artists.

At this point, however, it must be conceded that, regardless of how abstract Rothko's and Motherwell's paintings may be, the choice of light for positive and dark for negative can hardly be considered wholly arbitrary. Even physically, Motherwell noted, black is full of associations: "Ivory black, like bone black, is made from charred bones or horns, carbon black is the result of burnt gas. . . . Sometimes I wonder, laying in a great black stripe on a canvas, what animal's bones (or horns) are making the furrows of my picture."[84] Black is thus hardly an "abstract" color. And although it is true that the associations attached to black are somewhat culturally determined rather than inherent in the color, the Abstract Expressionists consciously exploited this to maximum effect (the same way a gestural artist depends on the spectator's previous experience of movement). These artists also understood that context determines meaning: however "tragic" black may be, its contrast to white is what generates this meaning. E. H. Gombrich's discussion of the choice of Theseus to have a white sail depict success and a black one to depict failure in his fight with the minotaur is precisely to the point:

> Here we have a case where a conventional code interacts with something felt to be "natural." Surely it was no accident that black rather than white was the sign agreed upon for failure. Black seems to us a more "natural" sign for grief, and white for a "brighter" mood: and even though we know that cultural conventions also play their part (and that black is not everywhere the colour of mourning), the correlation makes sense in terms of expressiveness. But clearly, black is infinitely more likely to be thus interpreted as an expression of gloom where we know, as we know in this case, that there is a choice between alternatives, one of which is to be taken as expressive of gloom. There are plenty of contexts where we are not aware of any possible alternatives and where black, therefore, is of no expressive significance: for instance, ordinary printer's ink ordinarily used.[85]

The process of communication is engaged by the recognition of the artist's selection from a set of possible alternatives. Black may be meaningless in isolation, but in contrast to white, it appears more tragic. It appears, hence, that the Abstract Expressionists do not necessarily reject all conventions but use them—as in the traditional Western association of white with positive and black with negative—in new and unexpected combinations.

Furthermore, the contrasts between paintings are just as important as the contrasts of elements within a single painting. Just as black is made more forceful by its contrast with white, a painting where black is the dominant hue is made more forceful by juxtaposition with one where it is not. Knowing the range of possibilities open to the artist—from the darkest possible painting (i.e., most tragic) to the lightest (i.e., least tragic)—the spectator can better situate an individual painting's expressive resonance within the available alternatives. Gombrich uses music to illustrate this point:

> What strikes us as a dissonance in Haydn might pass unnoticed in a post-Wagnerian context and even the *fortissimo* of a string quartet may have fewer decibels than the *pianissimo* of a large symphony orchestra. Our ability to interpret the emotional impact of one or the other depends on our understanding that this is the most dissonant or the loudest end of the scale within which the composer operated. . . . it is not the chord, but the choice of the chord within an organized medium to which we so respond.[86]

The Abstract Expressionists must have intuitively understood this principle. And, arguably, it was precisely this desire to help the spectator locate the emotional impact of a painting within their organized medium (their set of possibilities) that motivated them to exhibit their works in groups. The emotive resonance of a painting, although difficult to perceive at first, may be enhanced if the work is juxtaposed to another of opposite resonance. Franz Kline, for instance, said: "It is nice to paint a happy picture after a sad one. . . . the impending forms of something . . . have a brooding quality, whereas in other forms, they would be called or considered happier."[87] These artists were thus conscious of the expressive qualities in their work, and the

desire to "paint a happy picture after a sad one" reveals the effectiveness of juxtaposition as a means of accentuating emotive resonance.

The Abstract Expressionists sought the creation of a pictorial language with a restricted but infinitely variable vocabulary. Given only black and white, but with the possibility of going from one extreme to the other, and through the entire range of values in between, they could conceivably create a visual equivalent for any emotional or mental state imaginable. And this is without considering a whole variety of other factors at their disposal (e.g., shape, scale, texture, compositional arrangements). Such visual and emotive variety was necessary because their intentions were primarily focused on subjective self-expression. Indeed, William Baziotes said his paintings were his "mirrors. They tell me what I am like at the moment."[88] Gottlieb confided, "I love all paintings that look the way I feel."[89] Newman asserted, "The self, terrible and constant, is for me the subject matter of painting."[90] Still declared, "When I expose a painting I would have it say, 'Here I am: this is my presence, my feelings, myself.' "[91] And Pollock said, "Every good artist paints what he is."[92]

Thus, however filtered through the act of painting, or through the creation of images, this concern for self-expression is the leitmotif of Abstract Expressionism, the underlying Expressionist tendency of the movement. And although there have been several Expressionist tendencies in the history of modern art, the New York School was the first generally Expressionist movement devoted primarily to abstraction (the early work of Kandinsky being a possible exception). Combining such hitherto mutually exclusive tendencies as Abstraction and Expressionism, the artists developed a highly complex idiom in which all of the issues discussed thus far—the reduction of the visual vocabulary of means, the use of large scale, the different compositional strategies, the exhibition of paintings in groups—reinforce each other to communicate meanings.

Their concern with the spectator's participation, however—exemplified by Newman's claim that all formal elements were used to elicit the beholder's communion with the artist's thoughts[93] and Rothko's that the communication of emotions through his paintings

made spectators weep[94]—belongs to a context much larger than Expressionism. The Abstract Expressionists were hardly the first artists concerned with moving the spectator (they were perhaps, with Kandinsky, the first abstract artists to stress it so frequently). They belong, rather, to a long tradition within art and art theory dating back to Aristotle's concept of catharsis in the *Poetics*—a concept that the aesthetician Hans Robert Jauss defines as

> the enjoyment of affects as stirred by speech and poetry which can bring about both a change in belief and the liberation of his mind in the listener or spectator. This definition presupposes the dialectical interplay or self-enjoyment through the enjoyment of what is other and makes the recipient an active participant in the constitution of the imaginary, something which is denied him as long as aesthetic distance is understood according to traditional theory as one-directional, as a purely contemplative and disinterested relationship to an object at a certain remove.[95]

This idea of involving the spectator as a participant in the work of art was not unique to Greek tragedy. It was appropriated by different cultures who saw in art a powerful instrument of communication. According to Jauss, religious plays in the Middle Ages, which developed independently of Greek tragedy, nonetheless also relied on the cathartic experience. "More than a merely contemplative attitude of enjoyment," Jauss continues, "is expected from the spectator of a religious play: he is to be shaken and moved to tears by the biblical action being presented to him."[96]

This tradition is maintained throughout art history by artists religious (particularly in the Baroque of the Counter-Reformation) and secular, of whom Diderot in the eighteenth century demanded: "Move me, astonish me, break my heart, let me tremble, weep, stare, be enraged—you will delight my eyes afterwards if you can."[97] Emotive sympathy was also part of the aesthetic credo of the Romantics, Symbolists, and Expressionists, a tradition to which the artists of the New York School also belong. The Abstract Expressionists, however, had the unprecedented belief that abstraction could create as powerful an emotional impact as the great figural works of the past.[98]

But Abstract Expressionist concerns were not exclusively with the realm of the emotions. They could, on other occasions, draw striking parallels with intellectual currents in linguistics and anthropology. Robert Motherwell, for example, asserted that "one of the tasks that modern art set for itself was to find a language that would be closer to the structure of the human mind—a language that could adequately express the complex physical and metaphysical realities that modern science and philosophy made us aware of; that could more adequately reflect the nature of our understanding of how things really are."[99] Motherwell's assertion that modern art developed structures analogous to the human mind to reflect the nature of understanding is striking in light of a remarkable parallel offered by the two major Abstract Expressionist visual strategies, allover composition and images structured by opposition, and contemporary findings in anthropology. The parallel between allover composition and the ideas of Lévy-Bruhl have already been covered in chapter 3 (although it might be more than a parallel, since the Abstract Expressionists not only knew of but included his writings in their publications such as *Possibilities*). According to Lévy-Bruhl, the mind at its most primal level does not make distinctions but perceives the continuities between things and understands the world as a great totality.

Reacting against Lévy-Bruhl, however, Lévi-Strauss and the structuralists believed that, on the contrary, the mind operates and understands by discrimination. At its most basic level, human comprehension understands A as A only because A is different from B, and the relation of A to B is understood as equivalent to that of $-A$ to $-B$. According to Lévi-Strauss, the human mind makes sense of the complexity of phenomena by imposing an *a priori* system of oppositions on experience,[100] a system somewhat akin to Motherwell's opposition of black and white and ovoid and strictly vertical elements in the *Elegies to the Spanish Republic*.

It seems that the two major compositional devices used in Abstract Expressionism parallel the two dominant contemporary anthropological concepts of the human mind: either the mind perceives globally or it perceives categorically. But whether New York School artists chose allover composition or images structured by opposition, if

it was their task, as Motherwell claimed, to make analogies to the structure of the human mind and to reflect the nature of understanding, then they may be said to have succeeded. In addition, they succeeded in combining not only the mutually exclusive tendencies of Abstraction and Expressionism but the emotional and the intellectual. For this reason, the ambiguous term *Abstract Expressionism*, with its paradoxical combination of elements, is still the most appropriate label for the intricate and synthetic nature of this movement. It is a movement that raises a plurality of issues (stylistic, iconographical, etc.), intersects a variety of artistic and intellectual currents (Abstraction, Expressionism, concepts of the human mind), and whose place in history is ultimately more complex than New York's ostensible displacement of Paris on the world stage of the avant-garde.

NOTES

1. The term *heroic abstraction* has often been used to refer to mature Abstract Expressionism in the literature. An example is Sam Hunter's *American Art of the Twentieth Century* (New York, 1975), which calls the advent of Action painting "The Heroic Generation" (189).

2. The idea that New York had surpassed Paris as the art capital of the world is expressed in E. A. Carmean's introduction to the 1978 National Gallery catalog *American Art at Mid-Century* (16ff.) and is one of the major premises behind Guilbaut's *How New York Stole the Idea of Modern Art*.

3. This idea of a breakthrough is implicit in Irving Sandler's very title of his history of Abstract Expressionism: *The Triumph of American Painting*. In her introduction to *The New York School,* moreover, Dore Ashton speaks of "the ascendancy of modern American painting" (1). And Carmean, in the introduction to his National Gallery catalog, stated that "by mid-century . . . American painters, far from seeing themselves as missing the point of modern painting, had assumed its leadership" (15). It should be remarked that although the maturation of Abstract Expressionism occurred c. 1950, not all artists matured at the same time. Pollock was among the first to reach his mature style in 1947; Motherwell started his characteristic paintings of *Elegies to the Spanish Republic* in 1948–49; Newman began his stripe paintings in 1948; Rothko, his rectangular formats in 1949; Kline, his black and white abstractions in 1950; and Gottlieb, his *Burst* series in the mid-1950s.

4. The characterization of Abstract Expressionism as one of the most complex manifestations in American art was made by Carmean in the introduction to his National Gallery catalog, 15.

5. Sidney Janis quoted in I. Sandler, *The Triumph of American Painting*, 80.

The first combination of the terms *Abstract* and *Expressionism* was made by Alfred Barr in relation to the early abstract paintings of Kandinsky. See, for example, *Cubism and Abstract Art* (New York, 1974, reissue of the 1936 ed.), 64ff.

6. See M. Tuchman, *The New York School: The First Generation* (Los Angeles County Museum of Art, 1965), 37.

7. See, for example, Sandler, op. cit.

8. See Bernice Rose, *Jackson Pollock: Works on Paper* (New York, 1969).

9. Demonstration used by William Rubin in a seminar "Painting in New York: 1945–55" at the Institute of Fine Arts, New York University, Fall 1983.

10. J. Pollock, "My Painting," *Possibilities* 1 (Winter 1947–48), see CR4, p. 241.

11. See C. Cernuschi, "Mark Rothko's Mature Paintings: A Question of Content," *Arts Magazine* 60 (May 1986): 54–57.

12. Quoted in Carmean, op. cit., 103.

13. Ibid., 101.

14. J. Siegel, "Adolph Gottlieb: Two Views," *Arts Magazine* 52 (February 1968): 31.

15. W. Seitz, *Abstract Expressionist Painting in America* (Cambridge, Mass., 1982), 102.

16. See R. Krauss, "Contra Carmean: The Abstract Pollock," *Art in America* (Summer 1980): 130–31. Although Krauss's argument for an artistic mode structured by opposition (to which Malevich and Mondrian belong) is convincing, her inclusion of the mature Pollock in this category is not. As discussed in chapter 3, the plurality of effects evident in Pollock's work at close range is then neutralized at a distance by the nonhierarchical character of the allover style. The oppositions are thus reconciled in a unified and harmonious image.

17. K. Malevich, "Suprematism," in R. Herbert, ed., *Modern Artists on Art* (Englewood Cliffs, N.J., 1964), 96.

18. P. Mondrian, "Toward the True Vision of Reality," pamphlet published by the Valentine Gallery, New York, 1942.

19. Statement concerning the painting *Threading Light* in the files of the Willard Gallery, quoted in Seitz, op. cit., 40.

20. R. Pousette-Dart, "What Is the Relationship between Religion and Art?" Quoted in Tuchman, op. cit., 126.

21. A. Reinhardt, *Recent Paintings by Ad Reinhardt* (Betty Parsons Gallery, New York, 18 October–6 November 1948), 2. Quoted in Tuchman, op. cit., 131.

22. CR4, p. 251.

23. CR4, p. 262.

24. These are direct transcriptions from a letter written by Rothko dated 20 December 1952 in the artist's file, Whitney Museum of American Art, New York, quoted in A. Chave, *Mark Rothko's Subject Matter* (Ph.D. diss., Yale University, 1982), 1.

25. The Abstract Expressionists' concern with the exhibition of their works could be reflected in the number of paintings as well as the conditions under which paintings were exhibited. Rothko, for example, was notorious for wanting his works exhibited under dim lighting.

26. See M. D. MacNaughton, *Adolph Gottlieb: A Retrospective* (New York, 1981), 169.

27. E. C. Goossen, "The Big Canvas," in G. Battcock, ed., *The New Art* (New York, 1973), 62.

28. CR4, p. 251.

29. Ibid., p. 238.

30. Ibid., p. 251.

31. A. Drexler, "Unframed Space: A Museum for Jackson Pollock's Paintings," *Interiors* 109 (January 1950): 90–91.

32. Namuth in *Pollock Painting*, n.p.

33. Ibid.

34. CR4, p. 251.

35. See R. Krauss, "Contra Carmean: The Abstract Pollock," pp. 28–29, 126. In this article, Krauss is refuting an assumption made by E. A. Carmean in "The Church Project: Pollock's Passion Themes" that the Black Pourings are Pollock's attempt to formulate a specific Christian iconography for an architectural project designed by Tony Smith. Krauss disagrees not only with Carmean's identification of Christian themes in the Black Pourings but even with the suggestion that Pollock would have changed his style purely for such a reason.

36. Carmean, "The Church Project: Pollock's Passion Themes," 112.

37. Ibid.

38. J. Fitzsimmons. "Artists Put Faith in New Ecclesiastic Art," *Art Digest* (15 October, 1951): 15, 23.

39. See T. B. Hess, *Barnett Newman* (Museum of Modern Art, New York, 1971), 109ff.

40. See R. Rosenblum, *Modern Paintings and the Northern Romantic Tradition* (New York, 1975), 215ff., and D. Ashton, "The Rothko Chapel in Houston," *Studio* 181 (June 1971): 272–75.

41. From *Interiors* 110 (May 1951): 104.

42. H. Rosenberg, "Interview with Willem de Kooning," *Art News* 71 (September 1972): 56.

43. CR4, p. 251.

44. Ibid., p. 241.

45. See Carmean, *American Art at Mid-Century*, 95ff.

46. See Hess, op. cit., 95ff., esp. 97.

47. P. Valéry, *Collected Works*, Princeton, New Jersey, 1956–[75], vol. 8, 124.

48. Robert Motherwell in conversation with E. A. Carmean, 17 August 1977 (on file in the Department of Twentieth Century Art, National Gallery of Art, Washington, D.C.), quoted in Carmean's introduction to *American Art at Mid-Century*, 15.

49. D. Seckler, "Interview with Barnett Newman," *Art in America* 50 (Summer 1962): 83.

50. CR4, pp. 248–49.

51. Quoted in Chave, op. cit., 2.

52. Quoted in J. P. O'Neil, ed., *Clyfford Still* (Metropolitan Museum of Art, New York, 1979), 24.

53. CR4, p. 249.

54. Tuchman, op. cit., 34.

55. Quoted in W. Iser, *The Act of Reading: A Theory of Aesthetic Response* (Baltimore, 1980), 83.

56. Ibid., 85.

57. K. Clark, "Six Great Pictures, 3: 'Las Meninas' by Velasquez," *Sunday Times*, London, 2 June 1957, p. 9.

58. Iser, op. cit., 112.

59. Quoted in *Tiger's Eye* 1 (December 1947): 44.

60. Quoted in Tuchman, op. cit., 125.

61. The artists often objected strongly to literal interpretations of their work. But in the literature, many examples can be found. See for example Chave on Rothko, op. cit., and Harry Rand on Gorky. The only exception of an artist not objecting to attaching figural associations to his work is Kline, see Tuchman, op. cit., 92.

62. See D. Rubin, "A Case For Content: Jackson Pollock's Subject Was the Automatic Gesture," *Arts Magazine* 53 (March 1979): 103–9.

63. CR4, p. 241.

64. Quoted in O'Neil, ed., op. cit., 11.

65. Rothko quoted in Ashton, *The New York School*, 184.

66. O'Hara, op. cit., 26.

67. H. Gaugh, *Willem de Kooning* (New York, 1983), 71.

68. W. Rubin, "Jackson Pollock and the Modern Tradition," Part II, 31ff.

69. H. Hofmann, "Plastic Creation," in S. Hunter, *Hans Hofmann* (New York, 1964), 36.

70. See note 21.

71. R. Motherwell, A. Reinhardt, and B. Karpel, eds., *Modern Artists in America*, first series (New York, 1952), 19, 20.

72. In H. Mondor, ed., *Stéphane Mallarmé: Correspondance, 1862–71* (Paris, 1959), 137. For Motherwell's use of Mallarmé's quote, see R. Buck, ed., *Robert Motherwell* (New York, 1984), 19.

73. Hofmann, op. cit., 38.

74. CR4, p. 253.

75. Ibid., p. 241.

76. Ibid., p. 253.

77. Krasner, quoted in B. Rose, *Lee Krasner: A Retrospective* (Museum of Modern Art, New York, 1983), 134.

78. Hofmann, op. cit., 38.

79. See W. Kandinsky, *Concerning the Spiritual in Art* (New York, 1977).

80. H. Hofmann, "The Search for the Real in the Visual Arts," in S. Hunter, op. cit., 42.

81. Ibid., 39.

82. See note 12.

83. M. Philips, *Duncan Philips and His Collection* (Boston, 1970), 288.

84. R. Motherwell, "Catalogue Note," in *Black and White: Paintings by European and American Artists* (Kootz Gallery, New York, 1950).

85. E. H. Gombrich, "Expression and Communication," in *Meditations on a Hobby Horse* (Chicago, 1985), 61.

86. Ibid., 62.

87. Tuchman, op. cit., 92, 95.

88. Ibid., 39.

89. Ibid., 71.

90. J. O'Neill (ed.), *Barnett Newman: Selected Writings and Interviews* (New York, 1990), 187.

91. O'Neil, op. cit., 10.

92. S. Rodman, *Conversations with Artists* (New York, 1957), 82. See also CR4, p. 275. For another example in Newman, see Hess, op. cit., 80.

93. Newman wrote that "shapes and colors act as symbols to [elicit] sympathetic participation on the part of the beholder with the artist's thought" (Hess, op. cit., 38).

94. Rothko, in conversation with Rodman (op. cit., 93–94), said: "I'm not interested in relationships of color or form or anything else. . . . I'm interested only in expressing basic human emotions—tragedy, ecstasy, doom, and so on—and the fact that lots of people break down and cry when confronted with my pictures shows that I *communicate* these basic emotions. . . . The people who weep before my pictures are having the same religious experience I had when I painted them, and if you, as you say, are moved only by the color relationships, then you miss the point."

95. H. R. Jauss, *Aesthetic Experience and Literary Hermeneutics* (Minneapolis, 1982), 92.

96. Ibid., 101.

97. D. Diderot, "Salons of 1767," quoted in H. Honour, *Neo-Classicism* (New York, 1977), 144.

98. However unaware these artists may have been of findings in science or psychology, it is impossible not to see a certain relationship between the reliance on color in Rothko and Newman, on the one hand, and psychologists' belief in the emotive power of color, on the other, particularly when both artists and psychologists believe that the responses to color are emotional rather than intellectual. See D. Sharpe, *The Psychology of Color and Design* (Chicago, 1974).

99. Motherwell quoted in J. Flam, "With Robert Motherwell," in Buck, ed., op. cit., 25.

100. See C. Lévi-Strauss, *Structural Anthropology* (New York, 1963).

7
POLLOCK'S INFLUENCE

Pollock shared many characteristics with his con-
temporaries. On the formal level, he explored the
possibilities of large scale, allover composition, and gestural painting.
On a philosophical level, he believed in the compatibility of meaning
and abstraction and in abstract art's capacity to affect the spectator.
But although the Abstract Expressionists had much in common, they
never thought of themselves as a collective group. They worked inde-
pendently and practiced highly individual, characteristic styles. Even
among the color field artists one could not mistake a Rothko for a
Newman, and, among the gestural artists, a de Kooning for a Kline.
"This very diversity," according to E. A. Carmean, "denies any artist
the position of central figure."[1] Implicit in such a statement is the
assumption that—unlike previous movements in modern art where
the following of manifesto-like dictums (e.g., Futurism or Suprema-
tism) would allow the most powerful artistic personality to dominate
(e.g., Boccioni or Malevich)—the Abstract Expressionists, having no
artistic credo to follow, were free to explore any stylistic avenue
available. The result was a plurality of styles, none more important
than the next.[2]

But although Carmean claims no "central figure" emerges, are
not some inevitably considered more central than others? Even in the
exhibition Carmean's text accompanies, the artists included were
Gorky, Motherwell, Pollock, de Kooning, Newman, Rothko, and
David Smith. The choice could hardly be considered accidental. The
effect would have been somewhat different if the list had read: Wil-
liam Baziotes, Theodoros Stamos, Bradley Walker Tomlin, Richard
Pousette-Dart, Lee Krasner, David Hare, and Herbert Ferber. Al-

though hardly peripheral to Abstract Expressionism, these artists, as if by consensus, have been denied a central position in the literature—a tendency of exclusion Carmean not only conforms to but even propagates. However much one may want to deny it, distinctions of major and minor are always made, implicitly or explicitly.

But what then accounts for distinctions like "major" and "minor"? What makes artists "central" or "peripheral"? By what criteria do art historians include or exclude, privilege or discard, particular artists from their investigations? And ultimately, how are those criteria open to question? There are no simple answers to these questions. Only a multiplicity, and a different combination, of factors can explain an artist's place in history. Some factors are completely subjective. Take fashion, for instance. An artist may unpredictably rise to prominence, be awarded great public acclaim, and, just as unpredictably, be relegated to the dustbin of history. Quality, another criterion often invoked to justify the validation of one artist over another, is equally volatile. Although it may be tempting to think of the quality of a work of art as absolute, fixed, or consistent, quality is often contingent on fashion—as the recent controversy over the Sistine Chapel cleaning attests. However subjective qualitative judgments may be, they play a powerful, if sometimes clandestine, role in art history. Invocations of quality are often deciding factors in questions of authenticity, which in turn reinforce preconceived questions of quality by validating or invalidating works in terms of authorship. Hardly irrelevant to art historical investigation, qualitative judgments may themselves simultaneously condition and be conditioned by what is or is not considered important, what is or is not considered fashionable.

But in and of themselves, even qualitative judgments cannot guarantee an artist's place in history. Many avowedly technically proficient, if not "superior," pieces are dismissed as "derivative" if they lack yet another valued ingredient: originality. Marcel Duchamp's place in art history, for example, ostensibly rests largely on the development of the readymade, not on the creation of qualitatively superior works. Indeed, Duchamp did not create but selected objects without recourse to good or bad taste, out of what he called

"aesthetic anesthesia."[3] In fact, he may not have considered the readymade a work of art at all.[4] But subjective questions of quality aside, Duchamp's idea was original (and, hence, important) enough to play a major role in the Dada movement and subsequently in modern art as a whole. Originality may thus not only determine the place an artist is awarded in history, but its very role is easier to assess critically than those of either fashion or quality; indeed, art historians often follow the general assumption that any innovation may be considered original if it chronologically precedes all examples or manifestations of its type. This may sound simple enough, but originality is also a relative term. If an artist's work is too original or, more accurately, too unrelated to the general concerns of its time, it can easily be overlooked or even considered irrelevant.

Obviously no single or consistent formula can explain an artist's place in history. Often, complex and unpredictable factors interact. Art historians may study taste, quality, and originality, but inevitably their own taste and their own ideas on quality or originality interfere. The criteria used to evaluate an artist's importance are inseparable from, and inevitably contaminated by, our own conceptions of what constitutes importance. Another such criterion—one paramount in determining an artist's importance—is influence. Picasso's place in history, for example, rests not only on the perceived quality of his works and the originality of his innovations (Cubism, collage, construction) but on the sheer magnitude of his influence. To concentrate on this issue, however, is not to imply that other factors are unimportant or that influence is less susceptible to manipulation from subjective factors. On the contrary, although its effects may be traced and documented from artist to artist, influence is subject, as will be discussed below, to a variety of external—and specifically ideological—manipulations. The issue of influence may in effect even subsume factors such as originality, quality, and fashionability; indeed, in Pollock's case, the different manifestations of his influence specifically betray what other artists considered original, successful, or even fashionable in his work. And unlike the pervasive consensus found in the literature as to the quality of Pollock's canvases and the originality of the poured technique,[5] no cohesive account of Pollock's influence exists.[6] It remains,

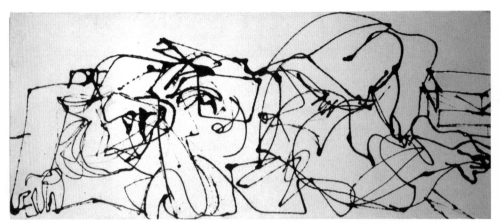

91. David Smith, *Untitled* (1964). Courtesy Knoedler Galleries, New York.

therefore, the most significant yet unexplored factor in determining Pollock's place in history.

As a further introduction to the subject at hand, the term *influence*, or the different manifestations thereof, should be precisely defined at the outset. Pollock's poured technique, for instance, was influential in a number of ways. First, it was considered so radical that its very invention broadened the possibilities of painting. According to Jane Freilicher, for instance, it provided a sense of unlimited freedom. Pollock's achievement, she wrote, "brought a glamor and authority to American painting which inspired younger painters. . . . If you could bring it off, 'make it work,' it might be possible to do anything."[7]

The second manifestation of influence is the stylistic borrowing. But since Abstract Expressionist paintings display no quotable motifs, such borrowings are, not surprisingly, mostly of a technical kind; indeed, many artists, like David Smith [91] and Larry Rivers [92], chose to experiment with the poured technique. But as these examples show, Pollock's method was so singular, so idiosyncratic, that, as Irving Sandler put it, it could not "be followed without yielding counterfeit Pollocks."[8] Indeed, Rivers destroyed the majority of such examples—most likely because he considered them too derivative.[9] Thus,

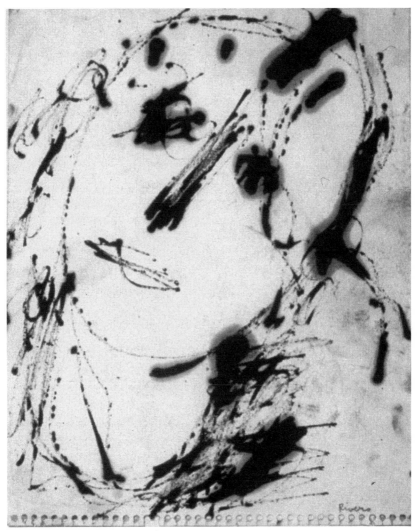

92. Larry Rivers, *Girl with Sad Eyes* (1951). Artist's collection.

paradoxically, if Pollock's technique communicated a feeling of artistic freedom, a feeling that anything was possible, on a practical level, however, it resisted any kind of borrowing. Hence the perplexing question remains, What then remained to be imitated in Pollock outside the inimitable character of his technique?

What made Pollock influential—and herein lies the importance and magnitude of his influence—was in changing not the *appearance* but the *direction* of contemporary art. What that direction would be, of course, would depend on one's understanding of Pollock. Not surprisingly, this understanding was strongly marked, if not conditioned, by the critical reaction to his work. It may even be argued that younger artists did not respond to Pollock as much as to critics' reactions to Pollock. Indeed, had it not been for the emergence of such highly defined critical reactions, Pollock's influence may have taken a completely different turn.

Pollock's first and foremost critic was, of course, Clement Greenberg. While de Kooning credits John Graham for "discovering" Pollock,[10] it was Greenberg who wrote about and drew critical and public attention to Pollock's work. In his first review, as early as 1943, Greenberg already called *Conflict* and *Wounded Animal* "among the strongest abstract paintings I have ever yet seen by an American."[11] In another review the following year, Greenberg asserted that "the future of American painting depends on what he [Motherwell], Baziotes, and Pollock, and only a comparatively few others do from now on."[12] As a critic, notions of quality were paramount for Greenberg. As early as 1939, he had made a distinction, or, rather, an opposition between high culture and popular culture, between "avant-garde" and "kitsch." "It is among the hopeful signs in the midst of the decay of our present society," Greenberg wrote, "that we—some of us—have been unwilling to accept this as the last phase of our own culture. . . . a part of Western bourgeois society has produced something unheard of heretofore: avant-garde culture."[13] Later in the same essay, Greenberg affirms that the function of the avant-garde is to "find a path along which it would be possible to keep culture *moving.* . . . Retiring from the public altogether, the avant-garde poet or artist sought to maintain the high level of his art."[14]

According to Greenberg, the task of the avant-garde is to segregate art from the corrupting influence of popular taste and ensure high standards of quality. But it was not only his sensitivity to quality—however finely tuned this sensitivity was—that made Greenberg single out Pollock and others of the future Abstract Expressionist generation as those who will "keep culture moving." And it was not merely the power of his writing or the strength of his rhetoric that made Greenberg such an influential critic. Crucial to Greenberg's writing was the critical framework behind the critic's aesthetic judgments—a framework that, when formulated, would become one of the most important ideologies of twentieth-century art. While rejecting the concerns of society at large, the artist, according to Greenberg, abandons the world of appearances. " 'Art for art's sake' and 'pure poetry' appear, and subject matter or content becomes something to be avoided like the plague."[15] Thus, the aim of art is not to engage something external but to enter an internal dialectic with itself. "In turning away from subject matter of common experience," Greenberg continues, "the poet or artist turns in upon the medium of his own craft."[16] This preoccupation with the properties of the medium, he claims, is true of all important modern artists: "Picasso, Braque, Mondrian, Miró, Kandinsky, Brancusi, even Klee, Matisse and Cézanne derive their chief inspiration from the medium they work in. The excitement of their art seems to lie most of all in its pure preoccupation with the invention and arrangement of spaces, surfaces, shapes, colors, etc., to the exclusion of whatever is not necessarily implicated in these factors."[17] Not surprisingly, Greenberg violently attacked any notion of the artist's responsibility to social issues. And attempting to reverse the concomitant prejudice of equating artistic excellence with fidelity to nature, he made a case for the superiority of abstraction. "That a picture gives us something to identify," he writes, "as well as a complex of shapes and colors to behold, does not mean it gives us more art."[18]

Thus, not only is figuration irrelevant to art but, for Greenberg, it may even be detrimental. In his view subject matter thwarts the natural evolution of form by imposing religious, literary, social, and political demands from *outside* the realm of painting. The point of

abstract art is to willfully distort and separate itself from the external world. Its aim is to "make strange,"[19] to defamiliarize and dislocate the relationship between itself and nature and, consequently, to draw attention to itself. Its development is autonomous and practically self-regulating, understandable only in terms of its own laws. Meaning, if it exists at all, is expressed only through, and is inseparable from, form: "Content," Greenberg concludes, "is to be dissolved so completely into form that the work of art or literature cannot be reduced in whole or in part to anything not itself."[20]

Despite the powerful rhetoric and somewhat arrogant and elitist tone,[21] Greenberg at this point makes no original contribution to the formalist theory of art. His distinction between pure and illustrative art, and between high culture (avant-garde) and popular culture (kitsch), is highly indebted to the writings of other formalists, most notably Roger Fry: "Literalism and illustration have throughout all these centuries been pressing dangers to art—dangers which it has been the harder to resist in that they allow of an appeal to the vast public to whom the language of form is meaningless."[22]

By 1940, however, in his "Towards a Newer Laocoon," Greenberg is less concerned with aesthetic distinctions than with explaining the superiority of abstract art. This superiority depends quite heavily on the concept of purity:

> Discussion as to purity in art and, bound up with it, the attempts to establish the differences between the arts are not idle. There has been, is, and will be, such a thing as a confusion of the arts. From the point of view of the artist engrossed in the problems of his medium and indifferent to the efforts of theorists to explain abstract art completely, purism is the terminus of a salutory reaction against the mistakes of painting and sculpture in the past several centuries which were due to such a confusion.[23]

Purity is an attempt toward an uncompromising distinction between one art form (e.g., painting) from another (e.g., sculpture), a quality that, as early as the nineteenth century, Schopenhauer, Nietzsche,[24] and Walter Pater[25] associated with music, an art form inherently devoid of references to the external world, and, for that matter, to the other arts. This notion of "all arts aspire to the condition of music," or,

in other words, all arts aspire to the condition of purity, inspired Greenberg's idea of a strict process—which he later codified as "Modernism"[26]—of redefining one medium by excluding references to other mediums. Hence, modernist painting abandons narrative meaning and illusions of three-dimensionality, properties of literature and sculpture respectively, and embraces flatness, a property exclusive to painting.

This concept of modernism (a qualitative term as opposed to the chronological term *modern*) is the backbone of Greenberg's criticism. Although the critic makes aesthetic judgments—say, calling Pollock, as early as 1947, the "most powerful painter in contemporary America"[27]—such judgments are nonetheless an extension of the critical framework described above. Thus: "Pollock's strength lies in the emphatic surfaces of his pictures, which it is his concern to maintain and intensify in all that thick and fuliginous flatness which began—but only began—to be the strong point of late Cubism."[28] Pollock is hence yet another step in the modernist evolution toward aesthetic purity initiated by Manet and the Impressionists and continued in Cézanne and Picasso. Since purity is achieved by emphasizing the flat nature of the picture plane, Greenberg saw this tendency at work in Pollock's paintings in two ways. First was the already discussed principle of allover composition—a term coined by Greenberg. By treating every square inch of canvas with equal emphasis and eliminating a pictorial center of attention, an allover painting gives the impression of expanding laterally rather than in depth, destroying any vestige of three-dimensional illusionism.

Second was Pollock's dilution of the pigment. By thinning the paint and staining his canvases, as Pollock often did (especially during 1951–53), the pigment was absorbed into rather than sitting upon the canvas surface. Identified with the support, the paint lost any tactile associations and became, in Greenberg's and later Michael Fried's, terminology "optical."[29] The articulation of these two strategies (allover composition and the dilution of the pigment) makes Pollock a modernist. Greenberg's observations and qualitative judgments reinforce and justify his theories, and in turn his theories reinforce and justify his qualitative judgments.

But in the process, not only are many issues deemphasized and

overlooked, but characteristics that contradict his position are overtly criticized. For example, Greenberg occasionally noticed a certain "Gothic quality"[30] in Pollock. But this quality does not enhance Pollock's art; on the contrary, for Greenberg, "its paranoia, and resentment narrow it."[31] What Greenberg wanted instead was a "large, balanced, Apollonian art,"[32] and the task of culture in America, he believed, was to create an environment "that will produce such an art . . . and free us (at last!) from the obsession with extreme situations and states of mind. We have had enough of the wild artist—he has by now been converted into one of the standard self-protective myths of our society: if art is wild it must be irrelevant."[33]

Downplaying the "Gothic" and emphasizing the "Apollonian" side, Greenberg saw what he wanted to see in Pollock's paintings. He understood them as "art for art's sake," as painting's self-referential celebration of its own medium; in short, as the essence of modernism as he himself defined it. Although these characteristics are not absent from the paintings he describes, his descriptions are selective. What does not conform to modernist issues—literary sources, social context, biography of the artist, and so on—are deemed irrelevant. And, most important, the question of the compatibility of meaning and abstraction, one of the central issues of Abstract Expressionism, is essentially overlooked. Greenberg in effect leaned on the Abstract rather than Expressionist side of Abstract Expressionism.

But Greenberg's was not the only interpretation of Pollock. In the December 1952 issue of *Art News*, Harold Rosenberg published an essay titled "The American Action Painters," where he formulated his own interpretation of Abstract Expressionism—an interpretation diametrically opposed to Greenberg's. "At a certain moment," he wrote

> the canvas began to appear to one American painter after another as an arena in which to act—rather than as a space in which to reproduce, redesign, analyze, or "express" an object, actual or imagined. What was going to go on the canvas was not a picture but an event.
>
> The painter no longer approached his easel with an image in mind; he went up to it with material in his hands to do something

to that other piece of material in front of him. The image would be the result of this encounter.[34]

In other words, gestural painting is an unpremeditated and essentially unpredictable record of a strictly individual and unrepeatable interaction between artist and canvas. This very interaction, this "act" of painting *is* the subject. Figuration is rejected not because it stifles problems of pure form but because it stifles the spontaneous act of creation.

But for Rosenberg questions of form become irrelevant altogether since critical attention shifts away from the final product to what is revealed in the "event." "The aesthetic," Rosenberg writes, "has been subordinated. Form, color, composition, drawing, are auxiliaries, any one of which . . . can be dispensed with. What matters is the revelation contained in the act."[35] If the act of creation is more important than the end product, then the standards of quality so important to Greenberg no longer apply. "An action," Rosenberg insists, "is not a matter of taste."[36] An action "is of the same metaphysical substance as the artist's existence. The new painting has broken down every distinction between art and life."[37] The very "states of mind" so distasteful to Greenberg have become the essence of Rosenberg's criticism. Rosenberg, then, leaned on the Expressionist rather than the Abstract side of Abstract Expressionism. If Greenberg was playing Apollo, Rosenberg was playing Dionysus. In his view, Abstract Expressionism was the cult of the subjective; not a solution of formal problems but the expression of the artist's most private mental states. Never an end in itself, a Pollock painting is an "action," an activity of signature, where every stroke reveals the inner psychology of its creator.

Rosenberg not only disputes Greenberg's ideas of art based on quality and rationality but challenges the very framework of his criticism: the notion of modernist purity. Instead of a specifically delineated, hermetically sealed realm of art, self-defining and devoid of references to the external world, Rosenberg's "action" cannot, by virtue of its very impermanence, be divorced from the world at large. If Greenberg's definition is exclusive, Rosenberg's is inclusive. "It

follows," he writes, "that anything is relevant to it [art]. Anything that has to do with action—psychology, philosophy, mythology, hero worship. Anything but art criticism."[38] Rosenberg suggests that if artists are no longer making paintings in the traditional sense of the term, then the terminology and methodology of (traditional) art criticism is beside the point. Probably having Greenberg in mind, he continues: "The critic who goes on judging it [action painting] in terms of schools, styles, form, as if the painter were still concerned with producing a certain kind of object (the work of art), instead of living on the canvas, is bound to be a stranger. . . . Its value must be found apart from art."[39]

For Greenberg, Pollock is the exponent of a modernist tradition of high art—mostly French high art, and Cubism in particular. For Rosenberg, conversely, the precursors of Abstract Expressionism are not the practitioners but the iconoclasts of high art. It is no surprise, therefore, that Rosenberg found the sources of action painting in Dada. In an interview with Max Kozloff, Robert Motherwell recalled that Rosenberg derived the concept of action

> from a piece by Huelsenbeck. . . . At that time I was editing "Dada" proofs of Huelsenbeck which ultimately appeared in the Dada anthology as "En Avant Dada." It was a brilliant piece. . . . Harold came across the passage in proofs in which Huelsenbeck violently attacks literary aesthetes, and says that literature should be action, should be made with the gun in the hand, etc. Harold fell in love with this section, which we then printed in the single issue that appeared of *Possibilities*. Harold's notion of "action" derives directly from that piece.[40]

In the passage included in *Possibilities*, Huelsenbeck wrote that "one is entitled to have ideas only if one can transform them into life," that the possibility of achieving knowledge was "only through action," and that action was a product of "impulse."[41]

Thus Rosenberg applies Dadaist principles to Abstract Expressionism. It is not in Cézanne and Picasso that he looks for precedents but in artists who act impulsively, make gestures, neglect art, and whose work is theatrical and ephemeral. In the same way that Marcel

Duchamp claimed to be an "anartist, meaning no artist at all,"[42] Rosenberg affirmed that the artist "gets away from Art through his act of painting."[43] Yet, curiously enough, Abstract Expressionist paintings—or their making—are not theatrical events in the strict sense of the term. After all, as is often stated by Rosenberg's critics, "it is impossible to hang an event on a wall."[44] In the final analysis, Pollock's paintings, as physical entities, are paintings in the conventional sense of the term; Rosenberg's application of the term *action* from Dadaist performance in fact may not have been inspired by the direct observation of Pollock's paintings at all. Indeed, Barbara Rose convincingly argues that in his formulation of "action painting"

> Rosenberg was not talking about painting at all; he was describing Namuth's photographs of Pollock. All the metaphors are decipherable from the photographs: Pollock attacking his canvas spread out on the floor in front of him like a boxing ring or bull fighting arena, with paint brush extended aggressively. . . . Pollock pictured alone, isolated from any frame of reference save his own creation which obviously dwarfed him and engulfed him— what images could more poignantly conjure up a literary vision of the existential hero?[45]

Namuth's photographs of Pollock, isolated in his studio, provided inspiration for Rosenberg's term *arena*, which, in fact, had also been Pollock's own way of referring to his studio.[46] The physical movement of the artist in space, as recorded by the camera, underscored the temporal nature of Pollock's technique. This led to Rosenberg's concept of action, of painting as a moment—a temporary, unpremeditated, Dionysian release of energy rather than the creation of a permanent, precalculated art object.

Rosenberg's emphasis on the creator at the expense of the creation also parallels the photographs' concentration on the man rather than the work. And the highly concentrated, sometimes pained, expression on Pollock's features may have reinforced Rosenberg's idea of art as an existential activity, inseparable from, if not identical to, the artist's life. But paintings and photographs of painters at work are not interchangeable.[47] However much the Abstract Expressionists were

concerned with process (leaving traces of it throughout their paint-
ings), as well as with questions of self-expression and meaning, they
never adopted an attitude as extreme as Rosenberg's. There is no
evidence in their statements of an anti-aesthetic attitude. On the
contrary, their devotion to art, in the Greenbergian sense, was as
fervent as that of any previous generation—their obsession with exhi-
bition environments attests to this (see chap. 6). Pollock, moreover,
was conscious of and had great respect for the modern tradition, the
evolution of which, he recognized, generated the work he himself and
his contemporaries were doing.[48]

Perhaps not perceiving Pollock's relationship to this tradition, or
not understanding how meaning could be expressed through abstrac-
tion, Rosenberg relied on the photographs rather than the paintings.
They were easier to read, more susceptible to interpretation than the
hermetic and cryptic poured paintings. Rosenberg deflected attention
from the art to the artist, from the issues raised by the paintings to the
more subjective ones of the artist's personality, which, ostensibly,
were revealed through the act of painting.[49] How and in what way
they were revealed Rosenberg never defined with any kind of preci-
sion. Had he looked at the paintings more closely, he would have
noticed that, despite their look of impulsive spontaneity, Abstract
Expressionist paintings have a conspicuous degree of regularity. So
much so that each artist developed a highly individual and singular
style: "Pollocks always come out Pollocks and Klines always come out
Klines."[50] This adherence to a recognizable style, whose characteris-
tics reappear consistently, contradicts Rosenberg's idea of the act of
painting as pure, unpremeditated improvisation.

Pollock spent long hours studying the bare canvas and the work
in progress,[51] revealing his capacity to store decisions and later use
them in the artistic process.[52] Not only is Pollock's style consistently
recognizable—indicating the artist's development and variation of a
set idea—but the very nature of allover composition requires a care-
ful, even distribution of parts so as to create no center of attention.
The holistic character of Pollock's poured paintings could only be the
product of an artistic intelligence whose intentions, although mani-
fested *through* the act of painting, must have been clear at the outset.

Indeed, when asked whether he had a preconceived image as he worked, Pollock answered, "Well, not exactly—no—because it hasn't been created," but, he added, *"I do have a general notion of what I'm about and what the results will be"* (italics mine).[53]

Greenberg's and Rosenberg's ideas of Abstract Expressionism are so diametrically opposed that it is often difficult to remember they were inspired by and meant to refer to the same paintings. Yet these two opposing poles, of a modernist and antimodernist tradition, paradoxically were to guide the course of Pollock's influence. Greenberg's and Rosenberg's writings were not passive art criticism. Their statements were buttressed by preconceived theories and ideological stances concerning the progression of modern art. For one, that progression was toward a strictly exclusive definition of art through the purity of the medium, and for the other, it was an all-inclusive and expansive breakdown of the barriers between art and life. However incompatible and mutually exclusive these ideas were, they provided a powerful example for younger artists to follow. In effect, Greenberg's and Rosenberg's statements were directed at Pollock but pointed to the future; their criticism became as much prescriptive as descriptive, and, ironically, in both cases, Pollock was part of the prescription.

To younger artists interested in the modernist side of Pollock, the two strategies emphasized by Greenberg, the dilution of the pigment and the nonhierarchical lateral expansion of allover composition, proved most significant. One of the first artists to transform Pollock's influence into an original statement was Helen Frankenthaler. After experimenting with Synthetic Cubism and Surrealism, she began, at Greenberg's suggestion, to look to Abstract Expressionism for inspiration. Although she was initially attracted to de Kooning, Pollock's influence proved more powerful. In 1951 her reaction to the Black Pourings was immediate: "It was as if I suddenly went to a foreign country, but didn't know the language, but had read enough and had a passionate interest, and was eager to live there . . . and master the language."[54] "Language" here is probably Frankenthaler's metaphor for technique, the mastery of which, however, came after she visited Pollock's studio. She learned his practice of painting on the floor and

of pouring paint directly onto the canvas surface. But Frankenthaler (most likely under the influence of Greenberg) pushed the modernist possibilities inherent in Pollock even further.

The painting *Mountains and Sea* [93], painted late in 1952, marks the beginning of Frankenthaler's mature style. Like Pollock, she poured paint on unsized and unprimed canvas. But although Pollock had already diluted the viscosity of his paint by the time of the Black Pourings, Frankenthaler thinned her pigment even further. "My paint," she said, "was becoming thinner and more fluid and cried out to be soaked."[55] As a result, the pigment stained the canvas, thus not only achieving a kind of co-identity with it but destroying any kind of linear armature. If Pollock was a draftsman, relying essentially on line to structure his canvases, Frankenthaler, perhaps again at Greenberg's suggestion, was relying increasingly on color. Greenberg realized that the linear art of, say, Picasso, Pollock, and de Kooning still depended on contrasts of light and dark, which in his opinion still harbored vestiges of modeling and therefore suggestions of the three-dimensional. Large areas of color, on the other hand, particularly when soaked and absorbed into the canvas, had no such suggestions. Color is more optical than tactile, and for these reasons Greenberg started to pay more attention to the color field offshoots of Matisse—in Rothko, Newman, and Still—as the more radical wing of Abstract Expressionism.[56] Not surprisingly, when Greenberg saw Frankenthaler's increasing shift toward color in *Mountains and Sea*, Frankenthaler recalled, he "encouraged me to make more."[57] Thus, although her inspiration was kindled by Pollock, Frankenthaler's more radical dilution of the pigment and increasing reliance on color rather than line led her progressively down the modernist path prescribed by Greenberg.

At this time Greenberg also befriended Morris Louis and Kenneth Noland, two Washington artists particularly interested in Pollock. Greenberg, however, led them to Frankenthaler. "We were interested in Pollock," Noland remembered, "but could get no lead from him. He was too personal. But Frankenthaler showed us a way—a way to think about and use color." According to Louis, Frankenthaler was "a bridge between Pollock and what was possible."[58]

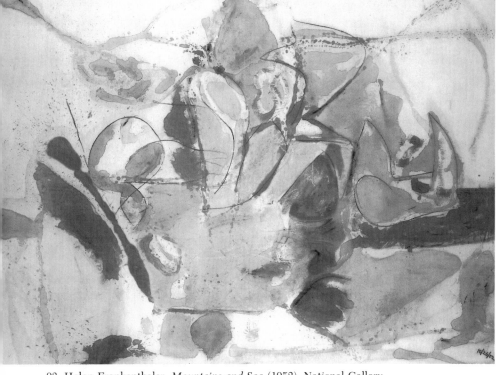

93. Helen Frankenthaler, *Mountains and Sea* (1952). National Gallery, Washington, D.C.

Greenberg not only introduced Louis and Noland to advanced artists in New York, he encouraged their efforts, included them in exhibitions, and wrote about their works; his influence must have been significant enough to guide the course of their art. In a 1960 article on both Louis and Noland, Greenberg discussed them in purely formalistic terms. He wrote of Louis that, after experimenting with Cubism, "his first sight of the middle period Pollocks and a large extraordinary painting done in 1952 by Helen Frankenthaler, called 'Mountains and Sea,' led Louis to change his direction abruptly."[59] Like Frankenthaler, Louis diluted the pigment and shifted his artistic vocabulary from line to color. "The crucial revelation he got from Pollock and Frankenthaler," Greenberg continues,

> had to do with facture as much as anything else. The more closely colour could be identified with its ground, the freer would it be from the interference of tactile associations; the way to achieve this closer identification was by adapting water colour technique to oil and using the paint on an absorbent surface. Louis spills his paint on unsized and unprimed cotton duck canvas leaving the pigment almost everywhere thin enough, no matter how many different veils of it are superimposed, for the eye to sense the threadedness and wovenness of the fabric underneath. But "underneath" is the wrong word. The fabric, being soaked in paint rather than being covered by it, becomes paint itself, like dyed cloth: the threadedness and wovenness are in the colour.[60]

This of course reinforces the purely optical rather than tactile quality of the color and eliminates suggestions of the three-dimensional.

When discussing Noland's work, Greenberg reiterates the now-familiar modernist arguments:

> Thanks to their centeredness and their symmetry, the disks, the diamonds . . . create a revolving movement that spins out over unpainted surfaces and beyond the four sides of the picture to evoke, once again, limitless space, weightlessness, air. But just as in Louis's case—and the middle period Pollocks—the picture succeeds . . . by re-affirming in the end (like any other picture that

succeeds) the limitedness of pictorial space as such, with all its rectangularity and flatness and opacity. The insistence on the purely visual and denial of the tactile and ponderable remain in tradition—and would not result in convincing art did they not.[61]

In discussing Pollock's influence on Frankenthaler and in turn her influence on Noland and Louis, Greenberg describes them as the natural course of events. As if to distance himself from the movement he helped create, his own role is never mentioned. Greenberg pretends to respond innocently to events he himself brought about. Yet his bias is clear; his observations and qualitative judgments are the mere extension of his concept of modernism—a concept that in his eyes increasingly appears as the ultimate goal of artistic practice. This is not to claim that stained and color field painting would never have occurred without Greenberg's participation—if interference is too strong a word. After all, color provided a fresh avenue for artists to explore. But it would be too naive to consider, as Greenberg would have his readers believe, that the Pollock-Frankenthaler-Louis connection is the result of the inevitable forward momentum of history.

Although the principles of his art criticism did not change from the 1940s to the 1950s—the time of the emergence of Abstract Expressionism—in the 1960s, Stephen Foster remarks, "Greenberg, partly by historical accident, found himself applying his criticism to a style where it appeared to fit better than it had ever fit the Abstract Expressionists."[62] However correct this statement may be, that Greenberg's criticism was more applicable to color field painting than to Abstract Expressionism was no accident. It was the powerful character of his writings and the convincing articulation of his ideas that made Greenberg so influential. And influential he was. Not only were color field paintings flatter than any produced by the Abstract Expressionists, but gone, too, were the subjective suggestions of self-expression so often associated with that movement. In their discussions, Louis and Noland dismissed any suggestions of content. On the contrary, they asserted the absence of "anything symbolic."[63] This reaction against the more personal and emotionally charged aspects of Abstract Expressionism was to be symptomatic of a more intellectual and emotionally de-

tached generation of artists, who matured in the later 1950s and 1960s. Attention was predominantly given to questions of form, a tendency that also coincides with the general tenor of Greenbergian criticism.

Another example is the work of Frank Stella. As a young artist, Stella remembered being

> badly affected by what could be called the romance of Abstract Expressionism, . . . the idea of the artist as a terrifically sensitive ever-changing, ever-ambitious person—particularly in magazines like *Art News* and *Arts*, which I read religiously. It began to be kind of obvious . . . terrible, and you began to see through it. . . . I began to feel very strongly about finding a way that wasn't so wrapped up in the hullabaloo, or a way of working that you couldn't write about . . . something that wasn't constantly a record of your sensitivity, a record of flux.[64]

But Stella is an important figure for another reason. He not only exemplifies the new, more cerebral attitude of the 1960s, but he demonstrates how another of Pollock's formal characteristics emphasized by Greenberg became influential to a younger generation of artists.

As discussed in chapter 6, Pollock and his contemporaries frequently used allover composition. But it was Stella and another younger generation of artists who would extend Pollock's language into a more austere and rigorous form of abstraction. Indeed, although the near-mechanical repetition of Stella's Black Paintings [94] is generally interpreted as a reaction against the spontaneous brushwork of gestural painting, their visual organization is strikingly similar to the mature Pollocks. Halfway through the Black Paintings, Stella recalled, "it was literally staring me in the face . . . [I began] to see the importance of Pollock . . . I tried for something which, if it is like Pollock, is a kind of negative Pollockism. I tried for an evenness, a kind of alloverness, where the intensity, saturation, and density remained regular over the entire surface."[65]

Of course, there are more differences than similarities between Stella and Pollock: Stella's technique is more calculated, the format of

94. Frank Stella, *Marriage of Reason and Squalor* (1959). Museum of Modern Art, New York. Larry Aldrich Foundation Fund.

his design more preconceived, and, more important, the strict repetition of a single element, the stripe, from one edge of the canvas to the other eliminates the variety of effects typical of the Pollockian web. In this respect Stella's paintings are far closer to being absolutely allover than Pollock's. And, unlike Pollock's, Stella's visual articulation does not stop short of the edge, as many of the poured paintings do, but expands to touch the border of the frame. For Stella, allover composition achieved two things. First, it eliminated what he called "relational painting" (i.e., "the balancing of various parts with and against each other");[66] and, second, it reinforced the integrity of the picture plane. According to Stella, the way to destroy relational painting was "symmetry—make it the same allover."[67] "The solution I arrived at," he continues, "and there are probably quite a few, although I know of only one other, color density—forces illusionistic space out of the painting at a constant rate by using a regulated pattern."[68] The tone of Stella's rhetoric is obviously Greenbergian: density of color and allover composition are the most effective ways of destroying illusionism.

Stella in effect took Pollock even farther down the modernist path. He made allover composition flatter and the result of a regulated pattern. "Spanning the entire surface," he wrote, "produces an effect of change of scale—the painting is more on the surface, there is less depth. And the picture seems bigger because it doesn't recede in certain ways or fade at the edge."[69] To achieve this sense of scale, Stella established a modular unit, the two-and-a-half-inch width of the stripes, which is incrementally repeated from edge to edge, regardless of compositional design. But compositional may be the wrong word, for once conceived in the artist's mind, the piece practically paints itself. Thus, Stella not only eliminated the balance of parts, he seems to have eliminated composition altogether.

This use of modular repetition became very popular in the 1960s, particularly among Minimalist sculptors such as Carl Andre [95], Donald Judd, and Robert Morris. Like Stella, they generated works through the repetition of identical and interchangeable elements. The result, according to Andre, was "essentially the simplest I can arrive at. . . . a kind of symmetry in which any one part can replace any other

95. Carl Andre, *Mönchengladbach Square* (1968). Blum Helman Gallery, New York.

part."[70] Hence, as with the development of color field painting, Greenberg's statements in the 1940s again appear prophetic: with historical distance, his definition of Pollock's allover manner of composition as "a surface knit together of identical or closely similar elements which repeat themselves without marked variation from one edge of the painting to the other,"[71] is, ironically but not accidentally, even more appropriate to the art of the 1960s than it ever was to Pollock.

Also in keeping with Greenbergian criticism is the elimination of all external associations from the work of art. Applied to an exclusively geometrical visual vocabulary, moreover, modular repetition produces works of art undeniably abstract, emotionally detached, and having the look of the machine-made. Not only are all traces of the working process excluded, so are any anthropomorphic, or, for that matter, any other kind of, associations. According to Andre, "The art of association is when the image is associated with things other than the work itself is. . . . My work is the exact opposite of the art of association."[72]

Likewise, Donald Judd affirmed that he eliminated "all extraneous meanings—connections that didn't mean anything to the art."[73] And Frank Stella added: "I always get into arguments with people who want to retain the "old values" in painting—the "humanistic" values that they always find on the canvas. If you pin them down, they always end up asserting that there is something there besides the paint on the canvas. My painting is based on the fact that you can see the whole idea without any confusion. . . . What you see is what you see."[74] It would be no surprise, therefore, if, comparing himself and his colleagues with the Abstract Expressionist generation, Stella confessed to having a "somewhat more neutral attitude, a more neutral way of addressing ourselves to painting."[75]

Thus, although Stella acknowledged Pollock's influence on nonrelational painting and sculpture, he and the Minimalists eliminated not only the effects of gestural painting but all the existentialist associations normally attached to Abstract Expressionism. What Stella rejected, moreover, are all the qualities Greenberg could have found objectionable in Pollock. In fact, Minimalism could easily be construed as the fulfillment of Greenberg's theory of modernism. It would indeed be difficult to find better examples of the purity of the medium than a Minimalist work of art. But, paradoxically, Greenberg was highly critical of Minimalism, particularly Minimalist sculpture. In rejecting all extraneous associations from the art object, and in respecting rather than altering the inherent textural properties of the materials used,[76] the Minimalist sculptor created works whose most conspicuous visual quality was literalness. By eliminating all references to the external world, however, art paradoxically became indistinguishable from the external world. Indeed, Minimalist sculpture, being three-dimensional and existing in the same realm as non-art objects, was so literal as to be confused with non-art—a quality Michael Fried would call its "objecthood."[77]

For Greenberg, Minimalist pieces acted in the realm of the real world rather than in the realm of art. He begins his critique by stating that "the borderline between art and non-art had to be sought in the three-dimensional, where sculpture was, and where everything material that was not art also was. Painting had lost the lead because it was

so ineluctably art."[78] The Minimalists, he argued, "commit them-
selves to the third dimension because it is, among other things, a
coordinate that art has to share with non-art."[79] Although there is
nothing in their statements to suggest the Minimalists attempted a
non-artistic condition, the nonassociative and literal character of their
works made Greenberg think otherwise. Even the "machine look," in
his estimation, appears "arty by comparison"[80] to Minimalism. In
fact, "a kind of art nearer to the condition of non-art," Greenberg
continues, "could not be envisaged or ideated at the moment. That
precisely is the trouble."[81] The trouble is that Minimalism has gone
too far. It has become the victim of what Greenberg himself has
termed "dialectical conversion."[82] A concept borrowed from Hegel
and later adapted by Marx, dialectical conversion simply means that
pushing a tendency to its extreme eventually results in its opposite.
Greenberg used this mainly to illustrate the fluctuations he perceived
between representation and abstraction, and illusion and flatness. In
his discussion of Courbet, for example, he wrote, "We see once again
that driving a tendency to its farthest extreme—in this case the illusion
of the third dimension—one finds oneself abruptly going in the oppo-
site direction."[83] But dialectical conversion would haunt Greenberg's
own writings as well.

While responding to the innovations in Pollock's paintings,
Greenberg not only initiated a type of criticism that anticipated and
encouraged strategies later employed by artists to "purify" or flatten
their works but unknowingly predicted that this tendency, pushed to
its extreme, would eventually yield its opposite. In separating itself
from the external world, modernist art became pure; in becoming
pure, it became literal; in becoming literal, it lost its status as art. For
this reason Greenberg concluded that "Minimalist [art] follows too
much where Pop, Op, Assemblage, and the rest have led,"[84]—all
artistic manifestations that have exploited a strategy disdained by
Greenberg: the collision of high culture and popular culture, the con-
flation of art and life.

This very impossibility of the modernist ideal to fulfill itself—to
achieve a pure realm of art distinct from other realms and to produce
an art free of external associations—became for some artists an inspi-

96. Roy Lichtenstein, *Composition III* (1965). Mr. and Mrs. S. I. Newhouse collection.

ration in itself. For the Pop artists, the pictorial devices of modernism became the subject of satire. Andy Warhol, for example, pointed to the impossibility of achieving pure art devoid of association in his *Brillo Boxes*, where the devices of Minimalism—strict geometry and repetition of identical, interchangeable parts—is applied to a deliberately banal, non-artistic subject matter. However remote modernist visual language would be from the real world, the Pop artist would always counter with the possibility of association—and an association of a disrespectful kind. Roy Lichtenstein was yet another Pop artist who, with wit and humor, cultivated the approximation of modernist vocabulary to the banal and commonplace. His *Composition* III [96] is a pun on Pollock's allover poured paintings.[85] Some of Lichtenstein's comic strips mimic Morris Louis's effects of diluted paint [97], with, appropriately, a fighter pilot exclaiming, "OK Hot Shot, I'm Pouring!"

Thus, if Greenberg's modernist interpretation of Pollock prophesied and in fact conditioned the increasing dilution of paint in color field and stained painting, as well as the allover nonrelational and nonassociative character of much of Minimalism, his concept of dialectical conversion also unwittingly anticipated an artistic tendency whose philosophy of art was diametrically opposed to his own. A philosophy whose results he would consistently disapprove of. Its strategy was not to restrict but to expand the definition of art and not to separate but to conflate the hitherto distinct realms of art and life.

This tendency, however, coincides exactly with Rosenberg's interpretation of Pollock. And as a critic, Rosenberg was no less influential than Greenberg. His critical shift of emphasis toward the process of creation struck a chord in artists who began to react against the confining geometric austerity of Minimalism. Among the initiators of this tendency—sometimes referred to as Post-Minimalism or, more commonly, as Process art—was Robert Morris. Morris turned his back on his Minimalist past to reconsider and reemphasize the process of making art and the inherent properties of materials. In an article titled "Antiform," Morris explained how Pollock encouraged his change of direction:

> The process of making itself has hardly been examined. . . . Of the Abstract Expressionists only Pollock was able to recover process

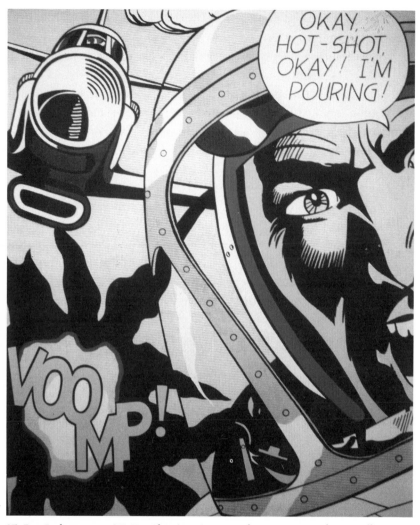

97. Roy Lichtenstein, *OK Hot Shot* (1963). Mr. and Mrs. S. I. Newhouse collection.

and hold on to it as part of the end form of the work. Pollock's recovery of process involved a profound re-thinking of the role of both materials and tools in making. The stick which drips paint is a tool which acknowledges the nature of the fluidity of paint. Like any other tool, it is still one that controls and transforms matter. But unlike the brush, it is far in greater sympathy with the matter because it acknowledges the inherent tendencies and properties of that matter.[86]

Minimalist sculptures never betrayed the process of their making. Often executed by craftsmen and engineers at the artist's specifications, these works were the result of intellectual systems conceived *a priori*. Reacting against the pristine purity of the Minimalist surface, the Post-Minimalists returned to the expressionistic painterly and irregular effects of the 1950s and applied them not only to painting but to sculpture.[87] And although the Minimalists never disguised the textural properties of their materials—this, after all, was what made them so literal—they manipulated these materials into predetermined shapes or forms. The Post-Minimalists, on the other hand, decided to let the materials themselves assume the shape or form they would naturally, as they would, for example, under the laws of gravity. Thus, materials chosen were no longer solid and firm but soft and malleable, revealing their inherent properties with a minimum of external manipulation. Robert Morris and Barry Le Va used felt, Eva Hesse used rope, fabric, and latex, and Richard Serra used rubber and, highly reminiscent of Pollock's technique, threw molten lead on gallery walls and floors [98].

In discussing the Minimalist style he previously practiced, Robert Morris stated that the "constructions of rectilinear objects involves a split between mental and physical activity and a simultaneous underlining of the contrast;"[88] but the Process artists "don't build, [they] . . . drop, hang, lean, in short act. . . . for the static noun 'form' is substituted the dynamic verb 'to act' in the priority of making."[89] The drawing of critical attention away from conception to the "act" of creation is decidedly Rosenbergian in tone. And like Rosenberg, Morris attributed a central role to Dada: "Here is the issue stated long ago

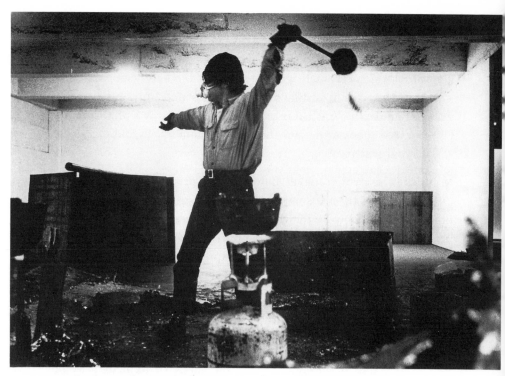

98. Richard Serra throwing lead (1969), Castelli Warehouse, New York.
Photographed by Gianfranco Gorgoni.

by Duchamp: art making has to be based on other terms than the arbitrary, formalistic, tasteful arrangements of static forms. This was a plea as well to break the hermeticism of 'fine art' and to let in the world on other terms than image depiction."[90] Hence, not only is Morris embracing an antimodernist attitude, but the emphasis on process, the stated irrelevance of taste, the search for precedents in Dada, and the breaking down of the barriers between art and life are all strikingly similar to Rosenberg's response to the photographs of Pollock at work.

This is probably no coincidence. Morris not only recognizes Pollock's importance to Process art, but—although artists like Eva Hesse had been working in this mode since the mid-1960s—Morris's own shift from Minimalism to Post-Minimalism in 1967, as well as Serra's,[91] coincides with the Pollock retrospective at the Museum of Modern Art of that year. In addition to the paintings, moreover, Namuth's photographs of Pollock at work were also enlarged and exhibited. Morris's rethinking of the role of process and reconsideration of the general importance of Pollock (but through Rosenberg's rather than Greenberg's interpretation) may very well have been stimulated by the MoMA show.

But although Morris's interpretation of Pollock is indebted to Rosenberg's, it has far less of the existentialist rhetoric. The equation of art making with the artist's inner life is a little too extreme for Morris. But a concern with process does not preclude, first, an interest in psychology and, second, an analysis of how art relates to the world. "I believe," Morris wrote, "that there are 'forms' to be found within the activity of making as much as within the end products."[92] And these in turn become "forms of behavior aimed at testing the limits and possibilities involved in that particular interaction between one's actions and the materials of the environment."[93] In other words, the manipulation of materials produces physical activity. This activity in turn varies according to the materials and procedures used and, according to Morris, produces different modes of behavior. Bodily potential is different, he points out, in a two- or three-dimensional environment. Therefore, previous categorical distinctions based exclusively on medium (e.g., painting or sculpture) should in his view

be replaced with activities that "interact with surfaces, some with objects, some with objects and a temporal dimension, etc."[94]

This idea of a temporal interaction with material also echoes Rosenberg's definition of action painting as an event: "The painter no longer approached his easel with an image in mind; he went up to it with material in his hand to do something to that other piece of material in front of him. The image would be the result of this encounter." But what mattered, according to Rosenberg, was the revelation contained in the act. And although Rosenberg did not define this concept with any degree of precision, Morris went further. He understood Pollock's work as a mode of behavior, as an interplay between the artist's potential bodily movements in space and the way paint behaves under the law of gravity: "In seeing such works as 'human behavior' several coordinates are involved: nature of materials, the restraints of gravity, the limited mobility of the body interacting with both. The work turned back to the natural world through accident and gravity and moved the activity of making into a direct engagement with natural conditions."[95] Morris's explanation of the breakdown of the distinctions between art and life is thus more precise than Rosenberg's. Pollock and the Process artists reflect how the activity of humanity (art) interacts with the natural conditions of the environment (properties of materials, gravity) or, as Morris put it, of how the arbitrary interacts with the nonarbitrary.

This type of binary opposition, he continues, was found to be the basic operating mode of language by structuralist linguists like Saussure and behind the structure of myths by anthropologists like Lévi-Strauss. But Morris understood that Saussure and Lévi-Strauss believed they were describing more than the structure of language or myth. Structuralist linguistics and anthropology revealed humanity's alleged capacity to order by discrimination, to impose on experience a predetermined set of oppositions—a tendency unique to and characteristic of the human mind. Its effects were ostensibly ubiquitous, so that, although "language is not plastic art," Morris states, echoing the structuralists, "both are forms of behavior and the structures of one could be compared to the structures of the other. That there should be some incipient general patterning modality to both should not be

surprising."[96] Thus, art, or rather the "making of art," according to Morris, "approaches the polar situation of arbitrary/non-arbitrary."[97] Morris suggests that however irregular, Process art always reveals the logical order of its making. "The current art with which I am dealing," he adds, "represents the least amount of formalistic order, with an even greater order of the making behavior being implied."[98]

The evidence of process, moreover, engages the spectator to re-enact this process in imagination, thus creating a rapprochement between the artist's procedure and the public's response—an effect somewhat akin to the feeling of empathy generated by Abstract Expressionist works (see chap. 6). But whether Process art, as Morris suggests, reveals the inner workings of the human mind from a scientific point of view is, of course, a matter of debate. His ideas on art making as behavior, however, and his attempt to understand the forces that condition this behavior, are nonetheless more precise than Rosenberg's all-too-subjective interpretation. His view of Pollock's abstractions as an interaction between materials and process is a sound explanation of the variables at work in the poured technique. No less, and perhaps more, important is his remark that "allowing gravity to shape and complete some of the work . . . the artist has stepped aside for more of the world to enter the art."[99] And, as Rosenberg seems to have predicted, Morris sees the art of his time as expanding beyond the museum and the gallery space, as his own would eventually do, to engage the environment more directly.

Many of these innovations, however, were already under way. A central figure in this development—an artist who was greatly influenced by Pollock or, more precisely, Rosenberg's view of Pollock—was Allan Kaprow. In 1958, just two years after Pollock's death, Kaprow wrote an article titled "The Legacy of Jackson Pollock,"[100] where he outlined the importance of Pollock for his own art. Like Rosenberg, Kaprow uses the term *act* when referring to Pollock's work, whose seemingly "chaotic" quality has, in his opinion, "a tenuous connection to 'paintings.' "[101] Kaprow notices Pollock's use of allover composition; but, unlike Greenberg, who interprets the lateral expansion of the canvas as a reaffirmation of the integrity of the picture plane, Kaprow sees this quality as expanding *"beyond the*

literal dimensions of any work."[102] The most meaningful way to experience Pollock's work, he argues, is in a medium-size room whose walls are completely covered by paintings: the spectator should be surrounded by, if not literally inside (as Pollock himself claimed to be), the works themselves. In this way, according to Kaprow, the paintings cease "to become paintings and become *environments*."[103] They point to the expansion of painting beyond the confines of the two-dimensional canvas. Indeed, Kaprow asserts that this creates "a type of art which tends to lose itself out of bounds, tends to fill our world with itself, an art which, in meaning, looks, impulse, seems to break sharply with the traditions of painters back to at least the Greeks. Pollock's near destruction of this tradition may well be a return to the point where art was more actively involved with ritual, magic and life than we have known it in our recent past."[104] Kaprow's pronouncements are not only obviously Rosenbergian but decidedly anti-Greenbergian as well. He even coined the term *impurity* (in which he includes Pollock), as if to counteract Greenberg's "purity" of the medium. He seems to advocate a dematerialization of the art object—a Rosenbergian destruction of the barriers that distinguish art from non-art.

Artists after Pollock, he argues, are left with two alternatives: either continue in Pollock's vein or "give up the making of paintings entirely, I mean the single, flat rectangle or oval as we know it. It has been seen how Pollock came pretty close to doing so himself."[105] Pollock is thus the precursor of Kaprow's Happening. If action painting, according to Rosenberg, breaks "down every distinction between art and life," Kaprow's Happenings dispense with painting altogether and tilt the scale completely in the realm of action—or, as it is often called, performance. And, again, as happened to Greenberg, Rosenberg's description of Pollock's paintings is more appropriate to a younger generation of artists than to Pollock himself.

In March of 1966, in an article titled "The Happenings Are Dead . . . Long Live the Happenings," Kaprow described his own works in quasi-Rosenbergian terms. The piece reads like a manifesto enumerating the artistic rules to be followed, a number of which are near-literal transcriptions from "The American Action Painters." The first, quite predictably, is "The line between the happening and daily

life should be kept as fluid and perhaps as indistinct as possible."[106] This echoes Rosenberg's pronouncements quoted above. "The themes, materials, actions and the associations that the happenings evoke," Kaprow's second rule states, "are to be gotten from anywhere except the Arts, their derivatives and their milieu."[107] This echoes Rosenberg's pronouncement that everything is relevant to action painting except art criticism.

The fourth rule is "Whatever is to happen should do so in its natural time, in contrast to . . . arbitrarily slowing down or accelerating occurrences in keeping with a structural scheme."[108] This echoes Rosenberg's pronouncement that action painting is an event. The fifth rule is a variation on the first two: "The composition of all materials, actions, images, and their times and places should be taken in as artless . . . a way as possible."[109] The sixth is that unlike regular theater, "Happenings should be unrehearsed."[110] This echoes Rosenberg's statement that while painting, the artist approached the canvas without preconceived images in mind. And Rosenberg's lament that the "vanguard artist has an audience of nobody. An interested individual here and there, but no audience."[111] has been transformed in Kaprow's seventh, and last, rule that "there should not be (and usually cannot be) an audience or audiences to watch a happening."[112]

Thus Kaprow appears to have made explicit, and in actual works, what was implicit in Rosenberg's criticism. Indeed, according to Rosenberg, art cannot be defined at the outset; it has, rather, the potential to redefine itself, to reinvent its own parameters and rules. It was precisely this view of Pollock that appealed to artists like Morris and Kaprow: action painting suggested the possible amplification of painting from two to three dimensions (which partly explains why the artists influenced by Rosenberg—Morris, Serra, Kaprow—were primarily sculptors, and those by Greenberg—Frankenthaler, Louis, Stella—were primarily painters). This expansion in the realm of the three-dimensional encouraged the possible collision between the work and the environment, between art and life. And intruding upon the environment, art could not be circumscribed or explained by its own internal laws, unique and peculiar to itself, as Greenberg intended to do. The works of Morris emphasize how certain materials interact

with natural laws such as gravity, while those of Kaprow function within the framework of natural space and time. Art raises new issues, and, accordingly, art criticism and art history must follow suit.

Another inspiration for the amplification of artistic activity from the two-dimensional to the three-dimensional was Pollock's practice of painting on the floor. Although this characteristic was seminal to Kaprow's Rosenbergian view of Pollock's works as rituals within an environment, it was undoubtedly of equal importance to the Post-Minimalists, particularly Serra and Le Va. Yet if one combines the concerns of the Happening (fusion of art and life, ephemeral nature of the work, use of natural time) with those of the Post-Minimalists (using inherent properties of materials and having them interact with natural laws such as gravity) with using the floor as the dimension in which to work, then these concerns—which were extrapolated from Rosenberg's idea of action painting—almost coincide with those of another artistic manifestation that emerged in the late 1960s and early 1970s: environmental art or Earthworks.

Again the photographs and film of Pollock at work proved to be seminal influences. By showing the artist pouring paint directly onto the canvas surface, Namuth's photographs brought to light the way the natural properties of paint, the force of gravity, and the energetic movements of the artist in space were all brought into play on the horizontality of the floor. Pollock's method is inseparable from and a function of the general orientation of the canvas horizontally on the ground. But instead of pouring the pigment on a canvas, so Robert Smithson must have thought, why not pour it directly on the earth? Smithson did precisely this in Rome, Italy, with a 1969 piece titled *Asphalt Rundown*. The work consisted of a truck dumping asphalt on a dirt quarry. The issues raised by this work are directly related to the movements discussed above. The manipulation of non-art materials according to the laws of gravity and an awareness of the floor are characteristic of Post-Minimalism, while making an essentially ephemeral work conform to natural time, and making it somewhat identical to a non-art situation, are characteristic of Happenings.

Robert Hobbs, however, a Smithson scholar, has remarked the similarity between this work, and others like *Glue Pour* [99], and Pollock's poured paintings,[113] which, incidentally, Smithson greatly

admired. Particularly striking is the similarity between the photographs of Smithson's works and those of Pollock's cans of paint [100]—the tools of painting, either abandoned after or being prepared for the act of creation, but without the presence of the artist's guiding hand. Indeed, in the photographs of Smithson's works, the materials and force of gravity ostensibly take over, acting, as it were, independently of and without interference from the artist's physical or intellectual manipulation. In such works, tools have themselves become obsolete. The tools are the materials; and the materials, the tools. In an article titled "A Sedimentation of the Mind: Earth Projects," Smithson outlines this idea as it was filtered through Robert Morris's interpretation of Pollock: "At the low levels of consciousness the artist experiences undifferentiated or unbounded methods of procedure that break with the focused limits of rational technique. Here tools are undifferentiated from the materials they operate on, and they seem to sink back into their primordial condition. Robert Morris (*Artforum*, April 1968 ['Anti-form']) sees the paint brush vanish into Pollock's 'stick,' and the stick dissolve into 'poured paint.'"[114]

From these remarks on materials, it would be no surprise if Smithson would find Kaprow's term *impurity* appropriate for his own work. Indeed, "My work is impure," Smithson asserts, "it is clogged with matter. I'm for a weighty, ponderous art."[115] But not only is the matter decidedly non-artistic, it is culled from and identified with the environment from which it comes. By working in the land, as in the *Spiral Jetty*, probably Smithson's most famous work, the strict distinction between the work and the environment, between art and non-art, is no longer clear. In addition, the traditional modernist distinction between the arts becomes, according to Smithson, totally irrelevant. He believes, for example, that "the categorization of art into painting, architecture, and sculpture . . . was one of the most unfortunate things that took place."[116] Again, his works are meant not to conform to any preconceived idea of what constitutes artistic creation but to expand the parameters of art:

> The strata of the Earth is a jumbled museum. Embedded in the sediment is a text that contains limits and boundaries which evade the rational order, and social structures which confine art.

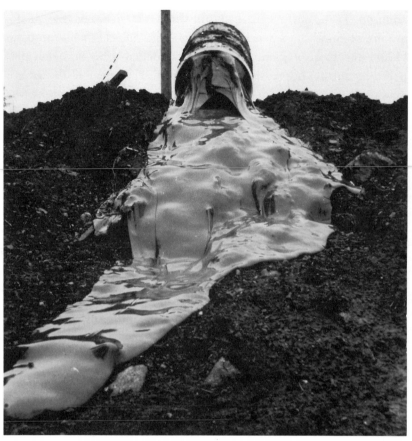

99. Robert Smithson, *Glue Pour* (1969). Vancouver, British Columbia. Photographed by Nancy Holt.

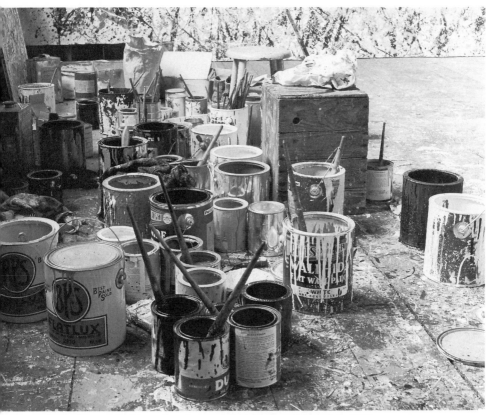

100. Jackson Pollock's studio, photographed by Hans Namuth in 1951.

In order to read the rocks we must be conscious of geological time, and the layers of prehistoric material that is entombed in the Earth's crust. When one scans the ruined sites of prehistory one sees a heap of wrecked maps that upsets our present art historical limits.[117]

The concern, then, is with nature, and nature works outside the confines of art historical definitions. The shape of the work, as in the *Spiral Jetty*, is not conceived *a priori* but determined by the form, appearance, and material of the environment where the work will take shape. Even the form of the spiral was chosen according to the molecular structure of the crystals found at the site. Smithson writes that "while the entire mass echoes the irregular horizons . . . each cubic salt crystal echoes the Spiral Jetty in terms of the crystal's molecular lattice. Growth in a crystal advances around a dislocation point, in the manner of a screw. The spiral layer could be considered one layer within the spiraling crystal lattice, magnified trillions of times."[118] The structure defines the form, and the form defines the structure. Art not only mirrors nature, it *is* nature; it creates and is destroyed by its own laws. Hence Smithson's interest in entropy, in nature's capacity to destroy as well as to create.[119] The works are themselves left at the mercy of the elements: rain, wind, erosion. The very temporal nature of the work itself echoes the rhythms of nature.

Although the sheer scale and character of such an environmental project seem far beyond what was intended in Pollock's poured paintings, Smithson's concern with nature coincides with the iconography of the 1947–50 paintings. What comes to mind are not only Pollock's comments about the "rhythms of nature" but those of Tony Smith, who remarked that Pollock painted on the floor not for its large area, or because the pourings would not run, but because of his bond with the elements (see chap. 3). Perhaps because Smithson was himself interested in natural forms, he perceptively saw Pollock's paintings as a metaphor for the dynamic rhythms of nature:

Jackson Pollock's art tends toward a torrential sense of *material* that makes his paintings stand like splashes of marine sediments.

Deposits of paint cause layers and crusts that suggest nothing "formal" but rather a physical metaphor without realism or naturalism. *Full Fathom Five* becomes a Sargasso Sea, a dense lagoon of pigment, a logical state of an oceanic mind. Pollock's introduction of pebbles into his private topographies suggests an interest in geological artifices. The rational idea of "painting" begins to disintegrate and decompose into so many sedimentary concepts.[120]

What Pollock achieves metaphorically, in the realm of iconography, Smithson achieves physically, in the realm of fact: "the confusion of man and nature."[121] And it is precisely the distinction between these two realms—the realm of metaphor and the realm of fact—that distinguishes these two artists. Smithson's use of materials was, in his own words, "essentially abstract and devoid of any mythological content." And when asked if there were any figural overtones to his work, he replied: "No, I had completely gotten rid of that problem. I felt that Jackson Pollock never really understood that and although I admire him still, I still think that was something that was always eating him up inside."[122] Smithson felt that there was still an "anthropomorphism" or "iconic imagery"[123] buried underneath the poured skeins of Pollock's web. Indeed, however abstract his paintings may be, Pollock still used paint as a sign system: as traces of the artist's movements in space, as a metaphor for the rhythms of nature.

In this respect, Pollock still works within the traditional method of using his material (paint) as a means to suggest something other than itself. Smithson does not. His use of material is purely literal rather than metaphorical (although the form, that of the spiral in the *Spiral Jetty*, may be an exception). And although Pollock's use of foreign matter and materials according to their inherent properties may have influenced Post-Minimalism and Earthworks, the latter manifestations are far more radical in their fusion of art and the environment.

It may be worth mentioning, if only parenthetically, that Pollock's thematic interest in nature as a subject may also be due to his having grown up in the West or to his sudden change of environment from

New York City to Long Island in 1946. The example of Albert Pynk-ham Ryder, the only American artist Pollock admitted being inter-ested in, must also have been particularly influential. The same con-cern for nature [5], for its dynamic rhythms, and for its untamable character seems common to both artists. One could, in fact, trace a lineage from contemporary Earthworks and environmental art through Pollock back to American nineteenth-century landscape painting. Humanity's relationship to nature has always been an im-portant part of the American experience; and the same way Pollock found an antecedent in Ryder, Smithson was interested in the work of Thomas Cole.[124] Although he may not have been interested in Cole's use of allegory—as in *The Course of Empire*, a five-painting cycle tracing the course of civilization from the savage state to the arcadian state, from the consummation of Empire to its destruction[125]—Cole's general interest in the issue of time may have been more appealing. Time reinforces the permanent power of nature and the transitory nature of human life: landscape painting becomes another reflection of the brevity of life, a memento mori. But instead of painting nature's propensity toward destruction and decay, as was the case in nine-teenth-century painting, Smithson incorporates these properties in his sculptures directly. In addition to their susceptibility to decay, the very scale of some environmental art dwarfs the spectator. Smithson was not oblivious to such connotations; when he flew above the *Spiral Jetty* to make a film, he recalled: "All existence seemed tentative and stagnant. . . . Was I but a shadow in a plastic bubble hovering in a place outside mind and body? *Et in Utah ego.* I was slipping out of myself again, dissolving into a unicellular beginning."[126]

Thus, although nineteenth-century landscape painting, Abstract Expressionism, and Earthworks are three distinct manifestations in the development of American art, they nonetheless embody concerns central to the American experience. Barbara Novak stated that "American artists guarded the unbroken integrity of the objects or things of this world," which "became, very often, vessels or carriers of metaphysical meaning."[127] This may indeed be seen in the record-ing of the specifics and particulars of empirical experience in nine-teenth-century landscape painting and can be expanded to include the

emphasis on the material properties of paint in Abstract Expression-
ism and in the use of materials proper in Earthworks. For Smithson,
however, the importance of the temporal dimension was more than
the destruction of artistic "timelessness" in favor of real time, or the
vanitas associations of decay and death. Because of the physical mag-
nitude of many Earthworks, a spectator requires time to experience
them in their entirety. This inevitably raises the question, What is the
best vantage point or points from which to view a work like *Spiral
Jetty*? The traditional ways of looking at a work of art, either walking
before a painting or around a sculpture, suddenly become hopelessly
inadequate. The work has no fixed appearance; it constantly changes
according to the spectator's relative position either inside or outside
the work.

It is perhaps for this reason that when Smithson decided to film
the *Spiral Jetty*, he did it from the air.[128] A crucial inspiration for this
idea, and in fact for his work as a whole, was Smithson's employment
as an art consultant for an engineering firm submitting new designs for
the Dallas–Fort Worth Regional Airport.[129] Working on this project
stimulated Smithson's idea of what he called Aerial Art, which he later
defined as a type of art "that could be seen from aircraft on takeoff and
landing, or not be seen at all."[130] Smithson wanted to encourage a new
mode of perception—one perhaps particularly suited to the modern
age. "Simply looking at eye level," he asserted, "is no solution."[131]
Although aerial views had influenced previous artists and photogra-
phers—like Malevich, Moholy-Nagy, and Rodchenko—Smithson
wanted an art to be seen predominantly from the air. Such vantage
points "bring into view the surface features of this shifting world of
perspectives" and require an art of "total engagement with the build-
ing process from the ground up and from the sky down."[132] The work
then must be built on the ground in view of how it will appear from
the air.

What is particularly striking—and pertinent to the subject at
hand—about this desire for shifting perspectives, for looking from the
ground up and the sky down, is its similarity to the problems faced by
Hans Namuth when he photographed Pollock at work. Pollock worked
on the floor (horizontally), but his paintings are exhibited on walls

(vertically). To record both artist and work in progress, Namuth often photographed Pollock from above [43]. When Namuth was filming, as opposed to taking still photographs, he was faced with another problem. "I wanted more; somehow a main ingredient was missing," he recalled. "I realized that I wanted to show the artist at work with his face in full view, becoming part of the canvas, inside the canvas, so to speak—coming at the viewer—through the painting itself. How could this be done? One evening it came to me: the painting would have to be on *glass* and I would film from underneath."[133] For Namuth a compelling portrayal of Pollock at work—suggesting the dynamic nature of his technique and his amplification of the space involved in creation—required shifts in perspective. By placing the camera beneath the artist, Namuth assumed a position physically impossible for the spectator but highly revealing for his purposes (a situation somewhat akin to Smithson's need of the airplane to see and film his work in its entirety).

Through the medium of film, Namuth and Smithson transformed a static medium (painting and sculpture) into a kinetic one. Something inherent in both the creation of Pollock's poured paintings and the observation of a work of the magnitude of *Spiral Jetty* is susceptible to and therefore encourages the intervention of the medium of film: "Aerial art," Smithson thought, "can therefore not only give limits to 'space,' but also the hidden dimension of 'time.' "[134] That Pollock's creative process and Smithson's work elicit the engagement of another medium, like film, seems to reinforce the Rosenbergian premise that postwar art is not confined to a predetermined set of problems but constantly increases its sphere of activity and, accordingly, raises newer and broader issues. Whether Smithson drew a parallel between his film and Namuth's is impossible to say, but the connection may not have been lost to Smithson. While filming the *Spiral Jetty*, with the sun reflecting in the water, Smithson recalled: "My eyes were like combustion chambers churning orbs of blood blazing in the light of the sun. All was enveloped in a flaming chromosphere; I thought of Jackson Pollock's *Eyes in the Heat*."[135]

The idea of shifting perspectives seems the most suitable place to end a section on Pollock's influence, since it was itself subject to

shifting perspectives—namely, Greenberg's and Rosenberg's. On the one hand, the idea of a modernist Pollock influenced a variety of artists who held fast to the problems inherent in and particular to the medium of painting. On the other, the idea of Pollock as an action painter influenced those who rejected imposed conventions by rethinking and expanding the definition of art. Although Pollock emerges as an extremely influential artist, the nature of his influence did not comprise the simple borrowing of motifs or experimentation with the poured technique (although abundant examples could be found in the formative works of postwar artists). Had it remained on this level, Pollock's place in history would be restricted to that of the first artist to fully exploit the visual potential of the poured technique, but whose influence was minimal compared with, say, de Kooning's or Newman's. But to consider Pollock as a major Abstract Expressionist—a painter who, as is now cliché to say, helped shift the avant-garde center from Paris to New York—is equally insufficient. Pollock's influence on the second half of the twentieth century is a crucial element in determining his place in history, a place that was conditioned by the critical reception and understanding of his work.

In interpreting Pollock, Greenberg and Rosenberg not only diagnosed the direction art was taking in their own time, but they, so to speak, caught developments in midstream. The powerful and influential character of their writings changed the course of contemporary art. Greenberg's and Rosenberg's writings became prescriptive rather than descriptive. They provided the equivalent of what Thomas Kuhn calls "paradigms" in the history of science: "universally recognized scientific achievements that for a time provide model problems and solutions to a community of practitioners."[136] Rather than tackling new problems, scientific inquiry is conditioned by, and often sets out only to confirm, the paradigm. Similarly, to formulate their ideas, Greenberg and Rosenberg rearranged history by selecting artists (or qualities within an artist's work) that fit their theories and rejecting those that did not. But although it may be the historian's or art historian's task to "find a pattern in, or impose a pattern upon, a multitude of individual facts,"[137] Karl Popper warns:

It is possible, for example, to interpret "history" as the history of class struggle, or of the struggle of races for supremacy, or as the history of religious ideas, or as the history of the struggle between the "open" and the "closed" society, or as the history of scientific and industrial progress. All these are more or less interesting points of view, and *as such* perfectly unobjectionable. But historicists do not present them as such; they do not see that there is necessarily a plurality of interpretations which are fundamentally on the same level of both suggestiveness and arbitrariness. . . . Instead, they present them as doctrines or theories, asserting that "all history is the history of class struggle," etc. And if they actually find that their point of view is fertile, and that many facts can be ordered and interpreted in its light, then they mistake this for a confirmation, or even proof, of their doctrine.[138]

Greenberg and Rosenberg are obviously guilty of this. Pollock himself did not consider their interpretations accurate. He believed that Rosenberg's theory of action painting grossly misrepresented his work and that Greenberg neglected the issue of meaning.[139] In the final analysis, the very plurality of issues raised by Pollock's work resists the methodological imposition of a fixed and intractable paradigm.

But although Popper's critique of historicism is an important reminder of the flaws inherent in practicing too inflexible a methodology, Greenberg and Rosenberg proved so influential that the critical issue shifts from the accuracy of their interpretations to their historical impact. Whether their views of Pollock were extreme or accurate no longer is the issue: what was written about history became history. Indeed, the fluctuations between Greenberg's and Rosenberg's paradigms reenact the central preoccupations of modern painting. As William Rubin noted in the late 1960s:

The history of modern art, from its inception with the generation of Manet and the Impressionists, has moved in the direction opposite to the *Gesamtkunstwerk;* it was only with Dada that theater influenced it. Clement Greenberg has observed that the informing dialectic of modern painting, indeed, of all the modern arts, has been the search for those qualities that are both indis-

pensable and peculiar to them. It is no accident that Dada, react-
ing to the implied autonomy of painting at the very moment that
it was going over into total abstraction, should have wanted "to
dissolve the rigid frontiers" of the various arts. . . . Nor does it
seem to be an accident that the reaffirmation of abstract painting
by the "first generation" of post–World War II artists should in
turn have engendered a reaction in the form of Environments,
Happenings, and other mixtures of the arts which are still under
way.[140]

Pollock's influence, and the role of criticism in guiding this influence,
thus intersect an even broader context. Greenberg and Rosenberg
aligned themselves to, and Pollock was associated with, the two fluctu-
ating but central poles in the development of modern art: one toward
the segregation of the arts and the other toward their confusion.

However opposed these two tendencies might be, as well as the
theories behind them, both clearly have an element in common.
Whether Greenberg and Rosenberg see art progressing toward mod-
ernist purity or toward a gradual destruction of the ideological walls
dividing art and life, whether they see Pollock as midway between
Picasso and Stella or midway between Duchamp and Kaprow—both
Greenberg and Rosenberg generated *progressive* philosophies of his-
tory. For both critics, the development of history is incremental, teleo-
logical, as if art were moving toward some predetermined goal.

In the 1980s, however, with the return of painting as a dominant
idiom and the reemergence of an Expressionist mode, one finds yet
another attitude, one neither modernist nor antimodernist but post-
modernist. This attitude, which although difficult to define with preci-
sion,[141] has been categorized as "an aesthetic liberated from all tradi-
tions including the tradition of the new."[142] Art becomes eclectic and
pluralistic and, above all, independent of any idea of aesthetic prog-
ress. To some, the emphasis on painting is itself regressive.[143] But
regression is typical of the antiprogressive postmodern attitude. In
such an artistic climate, Pollock's influence again bifurcates. On the
one hand, attention turns toward Pollock's abrupt return to figuration
in the 1951–53 Black Pourings, a period relatively neglected in com-

parison with the 1947–50 abstractions. Indeed, Pollock's deliberate (but by modernist standards regressive) shift is, in Tony Godfrey's book *The New Image: Painting in the 1980's,* considered a precedent for contemporary postmodern developments.[144] On the other hand, although Pollock's technique may have resisted borrowing when artists were conditioned by the idea of originality and by a progressive philosophy of history, in the postmodern age—where the ideas of originality and linear progression are being called into question—what was considered derivative is now permissible, and quotations from Pollock's poured paintings are now fair game. Indeed, imitation of Pollockian effects can be found in the works of artists like Julian Schnabel, and Pollock paintings have even been copied whole by Mike Bidlo.

Pollock did not, of course, influence all artistic manifestations after him. (Photorealism, for example, is conspicuously absent from the movements discussed, although the fascination with the photograph as an intermediary between the artist and experience and the impact of Namuth's photographs may be part of the same phenomenon.) But although it is often said that younger artists could not imitate Pollock without copying him, his work, in addition to having considerable influence, holds a pivotal place in the art of the postwar era. Equally clear is that Pollock's influence was contingent on, and implied the validation of, a specific artistic ideology and a philosophy of history, either modernist, antimodernist, or now postmodernist. What remains puzzling—something that must be credited to the richness of his work—is how Pollock could serve the purposes of such diametrically opposed artistic ideologies equally successfully. But only by looking at his work through various perspectives, rather than favoring one or the other, can one understand not only the role of criticism in shaping Pollock's influence but Pollock's place in history and his importance for the art of our time.

NOTES

1. E. A. Carmean, "Introduction," in *American Art at Mid-Century*, 15.

2. Carmean, ibid., however, proposes Dada and Surrealism as possible parallels to Abstract Expressionism (40, note 2).

3. See A. Schwarz, *The Complete Works of Marcel Duchamp* (London, 1969), 39.

4. Duchamp considered himself to be an "anartist, meaning no artist at all" (ibid., 33).

5. References to the high quality of Pollock's work can be found particularly in Michael Fried's "Jackson Pollock" article in *Artforum*, while references to Pollock's originality permeate the literature. See, for example, William Rubin's cycle of articles "Jackson Pollock and the Modern Tradition."

6. A possible exception are Rubin's articles cited above, Michael Auping's essay "Beyond the Sublime" in *Abstract Expressionism: The Critical Developments* (Albright-Knox Art Gallery, Buffalo, N.Y., 1987), 146ff., and Ellen Landau's conclusion to her book *Jackson Pollock* (New York, 1990).

7. Quoted in "Jackson Pollock: An Artist's Symposium, Part 2," *Art News* 66 (May 1967): 72, also quoted in B. H. Friedman, *Jackson Pollock: Energy Made Visible*, xix.

8. I. Sandler, *The Triumph of American Painting*, 15.

9. L. Rivers, with C. Brightman, *Drawings and Digressions* (New York, 1979), 39.

10. De Kooning's famous quote that Graham discovered Pollock was previously mentioned in chapter 2, note 63.

11. C. Greenberg, "Review of Exhibitions of Marc Chagall, Lyonel Feininger, and Jackson Pollock," in J. O'Brian, ed., *Clement Greenberg: The Collected Essays and Criticism*, vol. 1 (Chicago, 1986), 164. (Hereinafter referred to as CGCEC)

12. Ibid., 241.

13. *Art and Culture*, 4.

14. Ibid., 5.

15. Ibid.

16. Ibid., 6.

17. Ibid., 7.

18. Ibid.

19. The terminology is borrowed from the Russian Formalists; see V. Erlich, *Russian Formalism* (New Haven, 1981), 76.

20. *Art and Culture*, 6.

21. Ibid., 16.

22. R. Fry, *Vision and Design* (New York, 1981), 129.

23. CGCEC, 23.

24. See *The Birth of Tragedy*, passages previously quoted in chapter 3.

25. See W. Pater, "The School of Giorgione," in H. Bloom, ed., *Selected Writings of Walter Pater* (New York, 1974), 57.

26. "Modernist Painting," in G. Battcock, ed., *The New Art* (New York, 1973), 66–77.

27. CGCEC, 166.

28. Ibid.

29. For allover composition, see "The Crisis of the Easel Picture," in *Art and Culture*, 154ff., and for the absorption of the paint into the canvas surface, see "Louis and Noland," *Art International* 4 (25 May 1960): 28.

30. CGCEC, 166.

31. Ibid.

32. Ibid., 167.

33. Ibid., 168.

34. H. Rosenberg, "The American Action Painters," *Art News* 51 (December 1952), reprinted in H. Geldzahler, *New York Painting and Sculpture 1940–1970* (Metropolitan Museum of Art, New York, 1969), 342.

35. Ibid., 343.

36. Ibid., 349.

37. Ibid., 343.

38. Ibid.

39. Ibid.

40. M. Kozloff, "An Interview with Robert Motherwell," *Artforum* 4 (September 1965): 37.

41. R. Huelsenbeck, "En Avant Dada," *Possibilities* 1 (Winter 1947–48): 42–43.

42. See note 4.

43. Rosenberg, op. cit., 343.

44. M. McCarthy, quoted by Rosenberg in *The Tradition of the New* (New York, 1959), 5. A possible exception, however, could be Georges Matthieu's demonstrations in the streets of Paris.

45. B. Rose, "Hans Namuth's Photographs and the Jackson Pollock Myth, Part I: Media Impact and the Failure of Criticism," in *Pollock Painting*, n.p. Rose argues that the importance of the photographs as a dispersion of the Pollock image, the Pollock "myth," is explainable by criticism's failure to interpret his work convincingly.

46. See Lee Krasner interviewed by B. H. Friedman in *Pollock Painting*, n.p.

47. Pollock said, "Technique is just a means at arriving at a statement" (CR4, p. 251).

48. See CR4, p. 250, for Pollock's statement: "It [modern art] didn't drop out of the blue; its part of a long tradition dating back with Cézanne, up through the cubists, the post-cubists, to the painting being done today."

49. Rose, in *Pollock Painting*.

50. J. Tworkov, "A Cahier Leaf: Journal," *It Is* (Spring 1958): 25: "To approach a canvas without any pre-conceptions is in a sense impossible. Many painters approach their canvas without any preliminary drawing, or any preliminary image. Yet they each end up with a characteristic work that cannot be mistaken for anyone else's, because they are, however freely they approach their work, already committed to certain forms, to certain colors, to certain materials,

and to certain manners of manipulation. Klines always come out Klines, and Pollocks always come out Pollocks."

51. Pollock's long hours studying the work in progress has been related by Lee Krasner to Carmean, see *American Art at Mid-Century*, 133–34.

52. See W. Rubin, "Jackson Pollock and the Modern Tradition," Part I, 15.

53. CR4, 251.

54. B. Rose, *Helen Frankenthaler* (New York, 1971), 29.

55. G. Baro, "The Achievement of Helen Frankenthaler," *Art International* 20 (September 1967): 36.

56. " 'American-Type Painting' " in *Art and Culture*, 221ff.

57. G. Baro, op. cit., 36. See also "After Abstract Expressionism," in Geldzahler, op. cit., 360–71.

58. Quoted in J. Elderfield, *Morris Louis* (Museum of Modern Art, New York, 1986), 13.

59. C. Greenberg, "Louis and Noland," *Art International* 4 (25 May 1960): 28.

60. Ibid.

61. Ibid.

62. S. Foster, *The Critics of Abstract Expressionism* (Ann Arbor, Mich., 1980), 88.

63. K. Moffet, *Kenneth Noland* (New York, 1977), 39.

64. Taped interviews in 1966, for a series entitled "U.S.A. Artists." Quoted in W. Rubin, *Frank Stella* (Museum of Modern Art, New York, 1970), 13.

65. Quoted in Rubin, *Frank Stella*, 28, 29.

66. Ibid., 22.

67. Ibid.

68. Ibid.

69. Ibid., 39.

70. P. Tuchman, "An Interview with Carl Andre," *Artforum* 8 (June 1970): 57.

71. *Art and Culture*, 155.

72. E. Develing, *Carl Andre* (The Hague, 1974), 5.

73. J. Coplans, "An Interview with Donald Judd," *Artforum* 9 (June 1971): 44.

74. B. Glaser, "Questions to Stella and Judd," in G. Battcock, ed., *Minimal Art* (New York, 1968), 157–58.

75. Quoted in Rubin, *Frank Stella*, 41.

76. The Minimalists' truth to materials can be seen in several of their statements. Carl Andre often used ordinary, standard, mass-produced parts untouched or altered by the artist's hand. "Things have qualities," he said, "perceive the qualities" (B. Buchloh, ed., *Carl Andre/Hollis Frampton: Twelve Dialogues 1962–63* [New York, 1981], 15). In a similar way, Morris said, "I like the idea that I'm not doing anything to the material. I'm just using it my way . . . and I like the materials pretty much the way they are" (E. C. Goossen, "The Artist Speaks: Robert Morris," *Art in America* 58 [May 1970]: 110). Donald Judd expressed a similar appreciation for the qualities of untransformed material: "The reason for

using galvanized iron was that it didn't have to be painted" (Coplans, op. cit., 44).

77. M. Fried, "Art and Objecthood," in Battcock, *Minimal Art*, 116ff.

78. C. Greenberg, "Recentness of Sculpture," in Battcock, *Minimal Art*, 182.

79. Ibid., 183.

80. Ibid.

81. Ibid.

82. For Hegel's influence on Greenberg, see Foster, op. cit., 20.

83. C. Greenberg, "Art" (Gustave Courbet), *The Nation* 169 (8 January 1949): 51. For more on Greenberg and the concept of dialectical conversion, see D. B. Kuspit, *Clement Greenberg: Art Critic*, esp. 20–29.

84. Greenberg, "Recentness of Sculpture," 186.

85. C. Stuckey, "Another Side of Jackson Pollock," *Art in America* 65 (November–December 1977): 81.

86. R. Morris, "Antiform," *Artforum* (April 1968): 34–35.

87. See R. Pincus-Witten, *Post-Minimalism* (New York, 1977) 16ff.

88. R. Morris, "Some Notes on the Phenomenology of Making: The Search for the Motivated," in A. B. Sandback, *Looking Critically: Twenty-One Years of Artforum Magazine* (Ann Arbor, Mich., 1984), 92.

89. Ibid.

90. Ibid., 91.

91. See C. Robbins, *The Pluralist Era*, 8ff. On this point Serra said: "If my origins as a painter culminated in anything, they culminated in Pollock. Then I felt a need to move into literal space" (*Skyline* [April 1983]: 16).

92. Morris, "Some Notes on the Phenomenology of Making," 88.

93. Ibid.

94. Ibid.

95. Ibid., 89.

96. Ibid., 90.

97. Ibid.

98. Ibid., 90–91.

99. Ibid., 91.

100. *Art News* 57 (October 1958): 24–26, 55–57.

101. Ibid., 26.

102. Ibid.

103. Ibid., 56.

104. Ibid.

105. Ibid. It should be stated that in the same way Greenberg disapproved of Minimalism—what could be construed as the outcome of his own theories—Rosenberg disapproved of Happenings. In *Artworks and Packages* (Chicago, 1969), 156, Rosenberg stated: "To dissolve 'the barriers that separate art from life' is an impossible ideal—the dream of a world in which actions are intended to be forgotten at their moment of fulfillment. In such a world, ruled entirely by the Now, museums, of course, have ceased to exist."

106. A. Kaprow, "The Happenings Are Dead . . . Long Live the Happenings," *Artforum* 4 (March 1966), reprinted in Sandback, op. cit., 34.

107. Ibid.

108. Ibid.

109. Ibid.

110. Ibid., 36.

111. Rosenberg in Geldzahler, op. cit., 349.

112. Kaprow, "The Happenings Are Dead," 36.

113. R. Hobbs, ed., *Robert Smithson: Sculpture* (Ithaca, N.Y., 1981), 176: "The free flowing movement of this piece has an antecedent in the art of Jackson .Pollock. Long an admirer of Pollock's work, Smithson with *Asphalt Rundown* takes the drip beyond the canvas and monumentalizes it in a slow ooze. The large scale of American art, often discussed in reference to Pollock's canvases is realized in this outdoor 'action painting.' Directing the action into asphalt, Smithson seems to be commenting on the act of action itself." See also Hobbs, 74.

114. R. Smithson, "A Sedimentation of the Mind: Earth Projects," in N. Holt, ed., *The Writings of Robert Smithson* (New York, 1979), 84.

115. Quoted in L. Lippard, "Breaking Circles: The Politics of Prehistory," in Hobbs, ed., op. cit., 32.

116. Quoted in "What Is a Museum? A Dialogue between Allan Kaprow and Robert Smithson," in Holt, ed., op. cit., 64.

117. "Sedimentation of the Mind," 89.

118. Quoted in "The Spiral Jetty," in Holt, ed., op. cit., 112.

119. See L. Alloway, "Robert Smithson's Development," in A. Sonfist, ed., *Art in the Land: A Critical Anthology of Environmental Art* (New York, 1983), 125ff., esp. 127.

120. "Sedimentation of the Mind," 89.

121. Quoted in Lippard, op. cit., 31.

122. "Smithson Interviewed by Paul Cummings" (1972), in Holt, ed., op. cit., 147.

123. Ibid., 146, 148.

124. R. Hobbs, "Smithson's Unresolvable Dialectics," in Hobbs, ed., op. cit., 27ff.

125. The five paintings are in the New-York Historical Society. See B. Novak, *American Painting in the Nineteenth Century* (New York, 1979), 67ff.

126. "The Spiral Jetty," in Holt, ed., op. cit., 113.

127. Novak, op. cit., 262.

128. "The Spiral Jetty," 113.

129. See Hobbs, ed., 74ff.

130. "Aerial Art," in Holt, ed., op. cit., 92.

131. Ibid.

132. Ibid.

133. H. Namuth, in *Pollock Painting*, n.p.

134. "Aerial Art," 92.

135. "Spiral Jetty," 113.

136. T. S. Kuhn, *The Structure of Scientific Revolutions* (Chicago, 1970), viii.

137. J. R. Strayer, *The Interpretation of History* (New York, 1950), 7.

138. K. Popper, *The Poverty of Historicism* (New York, 1964), 151.

139. For Pollock's statement about Greenberg, see J. Potter, *To a Violent Grave: An Oral Biography of Jackson Pollock*, 183: "A few of us were talking at dinner about criticism, about art in general, and I [Nicholas Carone] asked Jackson, 'Who the hell do you know who understands your picture? People understand the *painting*—talk about the technique, the dripping, the splattering, the automatism, and all that, but who really knows the picture, the content?'

"He was a little defensive, because I'd been griping about critics and artists riding one another's career. I waited, then said, 'Well, who? Greenberg?' I knew what Greenberg meant to him and I knew how one has to be very careful with a man who's supporting you internationally. . . . I waited, then again, 'So tell me—*does* Greenberg know what your picture is about?' Finally he says, 'No. He doesn't know what it is about. There's only one man who really knows what it's about, John Graham.'"

For Pollock on Rosenberg, see D. Solomon, *Jackson Pollock: A Biography*, 237: "Pollock was appalled by Rosenberg's famous essay on 'action painting.' Even though the article did not mention any contemporary painters by name, Pollock felt sure that the piece was about him. It had to be, for it even included a comment he had once made to Rosenberg. The previous summer, a time when he was having difficulty getting down to work, he had casually referred to his canvas as an 'arena.' . . . The last thing he had meant to imply was that he considered the canvas 'an arena in which to act,' but there was his word, completely out of context, with Rosenberg building a theory around it and caricaturing him as a Promethean paint-flinger who cared more about the act of hurling paint than making good paintings."

140. W. Rubin, *Dada, Surrealism, and Their Heritage* (Museum of Modern Art, New York, 1968), 60.

141. See H. West, ed., *The Idea of the Post-Modern: Who Is Teaching It?* (Henry Art Gallery, Seattle, 1986).

142. Quoted in D. B. Kuspit, "Postmodernism, Plurality and the Urgency of the Given," in West, op. cit., 16.

143. G. Gerken, "Figurative Painting after 1960," in *German Art in the Twentieth Century* (London and Munich, 1985), 473.

144. T. Godfrey, *The New Image: Painting in the 1980's* (New York, 1986), 11.

CONCLUSION

The methodological application of E. D. Hirsch's categories of meaning and significance may not be appropriate for all art historical monographs. In Pollock's case, however, this distinction proves particularly fruitful. The meaning and significance format allows the art historian to focus on unresolved stylistic and thematic problems in Pollock's career and to locate his work within a broader historical and intellectual context. Rather than portraying Pollock as a pure abstractionist or a cowboy existentialist, this approach reveals a multifaceted artist interested in a plurality of issues from style and technique to iconography and cultural ideas in psychology and anthropology.

During 1947–50, for instance, his early rhythmic studies with Benton, the experiments in the Siqueiros workshop, and his experience of Surrealist automatism—enhanced by his move to Long Island and his feeling for nature—fused together with Indian sand painting to create his own personal, idiosyncratic, and inimitable style. This rather singular capacity for synthesis cannot be explained exclusively in terms of style, technique, composition, meaning, biographical events, social context, and so on. Only through a multiplicity of perspectives may the complexity of ideas, influences, and intentions behind Pollock's potent and original form of abstraction be persuasively evaluated. Not abstraction as pure form, but abstraction suggesting the rhythms of nature and how humanity fits into the order of things.

From the meaning and significance approach Pollock also emerges as a powerfully influential artist. Rather than seeing Pollock as insular, as an artist whose achievement could not be emulated without counterfeit, it may be more accurate to view Pollock as Amei

Wallach does: as the Picasso of the second half of the twentieth century.[1] Although his career was cut short at the age of forty-four, and his importance rests predominantly on his achievement in the few years between 1947 and 1950 (although this attitude may be changing), his works, like Picasso's, influenced artists working in different modes and in varied directions. The same way Picasso influenced artists as diverse as Gris, Boccioni, Mondrian, Malevich, Tatlin, and Pollock himself—all of whom explored stylistic possibilities implicit, but never made explicit, in Picasso's style—Pollock's progeny includes artists as different as Frankenthaler, Louis, Stella, Morris, Kaprow, Smithson, and Schnabel. Pollock and Picasso were, so to say, creatively misinterpreted; their influence, and by implication their importance, lay beyond the sphere of their own intentions. Providing more than stylistic motifs to be borrowed, they suggested new possibilities and paved new paths for twentieth-century art. Therein lies both the magnitude of their influence and the importance of their position in history.

But conclusions about Pollock's achievement, the originality and synthetic nature of his style, the compatibility of meaning and abstraction, as well as an evaluation of his influence and place in history have been offered in the preceding chapters. Returning to the issue of theory, what does the meaning and significance format itself reveal? What may be concluded from an investigation, not simply of this or that side of Pollock, but of the totality of the meaning *and* significance of his work? Again, Hirsch's comments are particularly helpful. In the conclusion of *The Aims of Interpretation*, he states:

> The reader will have noticed that the two concepts which have presided over these chapters—meaning and significance—bear a close resemblance to the concepts knowledge and value. Meaning is the stable object of knowledge in interpretation, without which wider humanistic knowledge would be impossible. The chief interest of significance, on the other hand, is the unstable realm of value. The significance of meaning in a particular context determines its value in that context. For, significance names the relationships of textual meaning, and value is a relationship, not a substance. Value is value-for-people.[2]

Although meaning does not change, significance does. Indeed, particularly striking in Pollock's case is not so much the difference between meaning and significance but their almost total lack of correspondence.

That Pollock's poured paintings were a metaphor for the rhythms of nature had little, if anything, to do with the influence these paintings exercised (the only possible exception being Pollock's influence on Smithson, as described in chapter 7). The significance of an artist's work, its value to future generations—or even to his or her own—may be totally unrelated to the artist's original intentions. In the dichotomy between meaning and significance, the meaning of meaning is different from the meaning of significance. What Pollock meant to express in his paintings may not change, but what another generation chooses to value in them may. It is impossible to predict what another generation may value in Pollock's work or whether this value may increase or decrease; in another place and time, this value may cease to exist altogether. Although it is tempting to think that the search for knowledge is undertaken for its own sake, independent of practical value, the reason Pollock is studied today is precisely for his value to the art of our time and his relevance to the major artistic movements of the later twentieth century.

The importance accorded to meaning is thus directly related to and inseparable from significance. In fact, meaning is studied *because* of significance. If an artist's importance is tangential to major historical currents, critics may not take the trouble to recover his or her intentions. If, on the other hand, that artist's place is central to the prevalent issues of the day, an otherwise minor biographical detail may generate a disproportionately large amount of critical attention. It is Pollock's very centrality to the development of modern painting, the importance and influential character of his achievement, that make the nature of his intentions the object of historical and critical inquiry. Many artists may have suggested the rhythms of nature, but few in quite the same way as Pollock, and still fewer will be accorded Pollock's place in the history of modern art.

NOTES

1. A. Wallach, "An Oversimplified Portrait of Jackson Pollock" [review of Deborah Solomon's *Jackson Pollock: A Biography, Newsday,* 16 August 1987, pp. 13, 16].

2. E. D. Hirsch, *The Aims of Interpretation* (Chicago, 1976), 146.

SELECTED
BIBLIOGRAPHY

*This bibliography contains only material directly related to Pollock.
For additional references pertaining to other artists or to theoretical
issues, please consult chapter notes.*

GENERAL BOOKS

Allentuck, M., ed. *John Graham's System and Dialectics of Art*. Baltimore, 1971.

Ashton, D. *The New York School*. New York, 1972.

Auping, M., ed. *Abstract Expressionism: The Critical Developments*. Albright-Knox Art Gallery, Buffalo, N.Y., 1987.

Buettner, S. *American Art Theory: 1945–1970*. Ann Arbor, Mich., 1981.

Carmean, E. A., and E. Rathbone. *American Art at Mid-Century: The Subjects of the Artists*. National Gallery of Art, Washington, D.C., 1978.

Champa, K., ed. *Flying Tigers: Painting and Sculpture in New York: 1939–1946*. Providence, R.I., 1985.

Cox, A. *Art as Politics: The Abstract Expressionist Avant-Garde and Society*. Ann Arbor, Mich., 1982.

Foster, S. *The Critics of Abstract Expressionism*, Ann Arbor, Mich., 1980.

Frascina, F., ed. *Pollock and After: The Critical Debate*. New York, 1985. Contains essays by Clement Greenberg, T. J. Clark, Michael Fried, Max Kozloff, Serge Guilbaut, and others.

Geldzahler, H., ed. *New York Painting and Sculpture: 1940–1970*. Metropolitan Museum of Art, New York, 1969.

Greenberg, C. *Art and Culture*. Boston, 1965.

Guggenheim, P. *Out of This Century: Confessions of an Art Addict*. New York, 1980.

Guilbaut, S. *How New York Stole the Idea of Modern Art: Abstract Expressionism, Freedom, and the Cold War*. Chicago, 1983.

Hobbs, R. C., and G. Levin. *Abstract Expressionism: The Formative Years*. Ithaca, N.Y., 1981.

Kuspit, D. B. *Clement Greenberg: Art Critic*. Madison, Wis., 1979.

Mackie, A. *Art/Talk: Theory and Practice in Abstract Expressionism*. New York, 1989.

McShine, K. *The Natural Paradise: Painting in America 1800–1950*. MoMA, New York, 1976. Contains essays by Robert Rosenblum, John Wilmerding, and others.

Meewis, W. *Iconologie van de Action Painting*. Brussels, 1983.

O'Brian, J., ed. *Clement Greenberg: The Collected Essays and Criticism.* 2 vols. Chicago, 1986.

Roeder, G. *Forum of Uncertainty: Confrontations with Modern Painting in Twentieth-Century Thought.* Ann Arbor, Mich., 1980.

Rosenberg, H. *The Anxious Object.* Chicago, 1964.

———. *Artworks and Packages.* Chicago, 1969.

Rudenstine, A. Z. *Peggy Guggenheim Collection, Venice.* New York, 1985.

Sandler, I. *The Triumph of American Painting: A History of Abstract Expressionism.* New York, 1970.

Seitz, W. *Abstract Expressionist Painting in America.* Cambridge, Mass., 1983.

Tuchman, M. *The New York School: The First Generation.* Los Angeles County Museum of Art, Los Angeles, 1965.

GENERAL ARTICLES

Alloway, L. "The Biomorphic Forties." *Artforum* 4 (September 1965): 18–22.

———. "Residual Sign Systems in Abstract Expressionism." *Artforum* 12 (November 1973): 36–42.

Arnheim, R. "Accident and the Necessity of Art." In *Toward a Psychology of Art.* Berkeley and Los Angeles, 1966, 162–80.

Baker, K. "Reckoning with Notation: The Drawings of Pollock, Newman, and Louis." *Artforum* 18 (Summer 1980): 32–36.

Bannard, W. D. "Touch and Scale: Cubism, Pollock, Newman, and Still." *Artforum* 9 (June 1971): 58–66.

Cavaliere, B., and R. Hobbs. "Against a Newer Laocoon." *Arts Magazine* 51 (April 1977): 110–16.

Firestone, E. R. "Herman Melville's 'Moby-Dick' and the Abstract Expressionists." *Arts Magazine* 54 (March 1980): 120–24.

———. "James Joyce and the First Generation New York School." *Arts Magazine* 56 (June 1982): 116–21.

Harrison, C. "Abstract Expressionism." *Studio* 185 (January 1973): 9–18.

Kagan, A. "Paul Klee's Influence on American Painting: New York School." *Arts Magazine* 49 (June 1975): 54–59.

Kuspit, D. B. "Abstract Expressionism: The Social Contract." *Arts Magazine* 54 (March 1980): 116–19.

Leider, P. "New York School: The First Generation." *Artforum* 4 (September 1965): 3–13.

Levine, E. "Abstract Expressionism: The Mystical Experience." *Art Journal* 31 (Fall 1967): 22ff.

Linker, K. "Abstraction: Form as Meaning." In *Individuals: A Selected History of Contemporary Art.* New York, 1986, 30–59.

McEvilley, T. "Heads It's Form, Tails It's Not Content." In *Looking Critically: Twenty-one Years of Artforum Magazine.* Ann Arbor, Mich., 1984, 256–63; originally published in *Artforum* 21 (November 1982).

Rand, H. "The Modes and Recent Art." *Arts Magazine* 55 (December 1980): 76–92.

Rosenblum, R. "The Abstract Sublime." *Art News* 59 (February 1961): 38–41.

Rushing, J. "Ritual and Myth: Native American Culture and Abstract Expressionism." In *The Spiritual in Art: Abstract Painting 1890–1985.* Los Angeles County Museum of Art, 1986, 272–95.

Varnedoe, K. "Abstract Expressionism." in W. Rubin, ed., *"Primitivism" in 20th Century Art*, vol. 2. Museum of Modern Art, New York, 1984, 614–59.

INTERVIEWS, STATEMENTS, WRITINGS

Pollock, Jackson. "Statement." In S. Janis, *Abstract and Surrealist Art in America.* New York, 1944, 112.

———. "Responses to a Questionnaire." *Arts and Architecture* 61 (February 1944): 14.

———. "My Painting." *Possibilities* 1 (Winter 1947–48): 78–83.

———. "Unframed Space." *New Yorker* 26 (5 August 1950): 16.

———. Interviewed by William Wright on radio station WERI in Westerly, R.I., 1950.

———. Narration for the film *Jackson Pollock* by Hans Namuth and Paul Falkenberg, 1951.

———. "Statement." In S. Rodman, *Conversations with Artists.* New York, 1957, 76–87.

MONOGRAPHS AND
SOLO EXHIBITION CATALOGS

Alloway, L. *Jackson Pollock: Paintings, Drawings, and Watercolors from the Collection of Lee Krasner Pollock.* Marlborough, London, 1961.

———. *Jackson Pollock.* Marlborough, Rome, 1962.

Bozo, D., ed. *Jackson Pollock.* Centre Pompidou, Paris, 1982.

Busignani, A. *Jackson Pollock.* Florence, 1970.

Crispolti, E. *Pollock: Un saggio critico.* Milan, 1958.

Davis, W. N. M. *Jackson Pollock.* Art of This Century, New York, 1947.

Fifteen Years of Jackson Pollock. Sidney Janis Gallery, New York, 1955.

Frank, E. *Jackson Pollock.* New York, 1983.

Friedman, B. H. *Jackson Pollock: Energy Made Visible.* New York, 1972.

Gagnon, F., ed. *Jackson Pollock: Questions.* Musée d'art Contemporain, Montreal, 1979.

Guggenheim, P. *Jackson Pollock.* Museo Correr, Venice, 1950.

Heller, B. *Jackson Pollock: Black Enamel Paintings.* Gagosian Gallery, New York, 1990.

Hulten, K. G. *Jackson Pollock.* Moderna Museet, Stockholm, 1963.

Hunter, S. *Jackson Pollock.* MoMA, New York, 1956.

Jackson Pollock. Sidney Janis Gallery, New York, 1958.

Kambartel, W. *Jackson Pollock 'Number 32, 1950.'* Stuttgart, 1970.

Landau, E. *Jackson Pollock.* New York, 1989.

Lieberman, W. S. *Jackson Pollock: Black and White.* Marlborough-Gerson, New York, 1969.

———. *Jackson Pollock: The Last Sketchbook.* New York, 1982.

Naifeh, S., and G. W. Smith. *Jackson Pollock: An American Saga.* New York, 1989.

Namuth, H. *L'Atelier de Jackson Pollock.* Paris, 1978. Translated as B. Rose, ed., *Pollock Painting.* New York, 1980.

O'Connor, F. V. "The Genesis of Jackson Pollock: 1912 to 1943." Ph.D. diss., Johns Hopkins University, 1965.

———. *Jackson Pollock.* MoMA, New York, 1967.

O'Connor, F. V., and E. V. Thaw. *Jackson Pollock: A Catalogue Raisonné of Paintings, Drawings, and Other Works.* New Haven, 1978.

———. *Jackson Pollock: New Found Works.* ICP, Boston, 1980.

———. *Jackson Pollock: The Black Pourings.* Institute of Contemporary Art, Boston, 1980.

O'Hara, F. *Jackson Pollock.* New York, 1959.

Ossorio, A. *Jackson Pollock.* Betty Parsons Gallery, New York, 1951.

Potter, J. *To a Violent Grave: An Oral Biography of Jackson Pollock.* New York, 1985.

Putz, E. *Jackson Pollock: Theorie und Bild.* Hildesheim, West Germany, 1975.

Robertson, B. *Jackson Pollock.* New York, 1960.

———. *Jackson Pollock.* Marlborough-Gerson Gallery, New York, 1964.

Rose, Barbara. *Krasner/Pollock: A Working Relationship.* Grey Art Gallery, New York, 1981.

Rose, Bernice. *Jackson Pollock: Works on Paper.* New York, 1969.

———. *Jackson Pollock: Drawing into Painting.* MoMA, New York, 1980.

Solomon, D. *Jackson Pollock: A Biography.* New York, 1987.

Sweeney, J. J. *Jackson Pollock.* Art of This Century, New York, 1943.

Tapié, M. *Jackson Pollock.* Studio Facchetti, Paris, 1952.

Tomassoni, I. *Pollock.* Florence, 1968.

Wysuph, C. L. *Jackson Pollock: Psychoanalytic Drawings.* New York, 1970.

ARTICLES

Allara, P. "Veiled Images." *Art News* 79 (September 1980): 218–21.

Alloway, L. "Notes on Pollock." *Art International* 5 (May 1961): 38, 41, 90.

———. "Pollock's Black Paintings: The Recent Exhibition at Marlborough-Gerson." *Arts Magazine* 43 (May 1969): 40–43.

Ashbery, J. "Black Pollock." *Art News* 68 (March 1969): 28.

Ashton, D. "Pollock: Le Nouvel Espace." *XXe Siècle* 17 (December 1961): 75–80.

———. "Pollock at Marlborough-Gerson." *Studio* 177 (May 1969): 243–45.

———. "Jackson Pollock's Arabesque." *Arts Magazine* 53 (March 1979): 142–43.

"Beyond the Pasteboard Mask." *Time* 83 (17 January 1964): 66–69.

Blistène, B. "Centre Pompidou: Jackson Pollock." *Flash Art* 16 (Summer 1982): 72–73.

Bloch, S. "Review: Jackson Pollock: A Catalogue Raisonné of Paintings, Draw-

ings, and Other Works, 1978." *Art Journal* 39 (Fall 1979): 55–56.

Brach, P. "Tandem Paint: Krasner/Pollock." *Art in America* 70 (March 1982): 92–95.

Canaday, J. "Art: Pollock's Searching for a Symbol." *New York Times*, 14 January 1964, p. 29.

Carmean, E. A. "Jackson Pollock's Classic Paintings of 1950." In *American Art at Mid-Century: The Subjects of the Artists*, National Gallery of Art, Washington, D.C., 1978, 127–53.

———. "The Pollock Puzzle." *Washington Post*, 21 March 1982, sec. 1, pp. 1, 4.

———. "The Church Project: Pollock's Passion Themes." *Art in America* (Summer 1982): 110–22.

Carter, B. "Jackson Pollock's Drawings under Analysis." *Art News* 76 (February 1977): 58–60.

"Chaos, Damn It." *Time* 56 (20 November 1950): 70–71. Response by Pollock in "Letters to the Editor" (December 11, 1950): 10.

Cox, A. "The Aura of the Primitive: The Photographs of Jackson Pollock." In *Art and Politics: The Abstract Expressionist Avant-Garde and Society*. Ann Arbor, Mich., 1977, 83–104.

du Plessix, F., and C. Gray. "Who Was Jackson Pollock?" *Art in America* 55 (May–June 1967): 48–59.

Fichner-Rathus, L. "Pollock at Atelier 17." *The Print Collector's Newsletter* 13 (November/December 1982): 162–65.

Finkelstein, L. "Gotham News." *Art News Annual* 34 (1968): 114–23.

Fitzsimmons, J. "Jackson Pollock." *Art Digest* 26 (15 December 1951): 19.

Foster, S. "Turning Points in Pollock's Early Imagery." *University of Iowa Museum of Art Bulletin* 1 (Spring 1976): 34.

Frankenstein, A. "Laying the Pollock Case to Rest." *Art News* 76 (October 1977): 94–95.

Freke, D. "Jackson Pollock: A Symbolic Self-Portrait." *Studio International* 184 (December 1972): 217–21.

Fried, M. "Jackson Pollock." *Artforum* 4 (September 1965): 14–17.

Friedman, B. H. "Profile: Jackson Pollock." *Art in America* 43 (December 1955): 49, 58–59.

———. "A Reasoned Catalogue Is Almost a Life." *Arts Magazine* 53 (March 1979): 100–102.

Friedman, S. P. "Loopholes in 'Blue Poles.' " *New York* 6 (October 29, 1973): 48–51.

Glaser, B. "Jackson Pollock: An Interview with Lee Krasner." *Arts Magazine* 41 (April 1967): 36–39.

Glueck, G. "Scenes from a Marriage: Krasner and Pollock." *Art News* 80 (December 1981): 57–61.

Glynn, E. "Books in Review: Jackson Pollock: Psychoanalytic Drawings." *The Print Collector's Newsletter* 1 (November/December 1970): 112–13.

Goodnough, R. "Pollock Paints a Picture." *Art News* 50 (May 1951): 38–41, 60–61.

Gordon, D. E. "Department of Jungian Amplification, One: Pollock's 'Bird,' or

How Jung Did Not Offer Much Help in Myth-Making." *Art in America* 68 (October 1980): 43–53.

Greenberg, C. "The Jackson Pollock Market Soars." *New York Times Magazine,* 16 April 1961, pp. 42, 132–35. "Letters to the Editor," 30 April 1961.

———. "Jackson Pollock: Inspiration, Vision, Intuitive Decision." *Vogue* 149 (1 April 1967): 160–61.

Hess, T. B. "Jackson Pollock 1912–1956." *Art News* 55 (September 1956): 44–45, 57.

———. "Jackson Pollock: The Art of a Myth." *Art News* 62 (January 1964): 39–41, 62–65.

———. "Editorial: Artists' Symposium on Jackson Pollock." *Art News* 62 (April 1967): 27. Reply by William Rubin in "Editor's Letters," May 1967, 6.

Horn, A. "Jackson Pollock: The Hollow and the Bump." *Carleton Miscellany* 7 (Summer 1966): 80–87.

Hunter, S. "Jackson Pollock Catalogue Raisonné: A Vast Impressive Panoply." *Art News* 77 (November 1978): 24, 27.

"Jackson Pollock: An Artists' Symposium. Part One." *Art News* 66 (April 1967): 28–33, 59–67. "Part Two," May 1967, 27–29, 69–71. Discussion in the Summer issue, p. 6.

"Jackson Pollock: Is He the Greatest Painter in the United States?" *Life* 27 (8 August 1949): 42–44.

Johnson, E. "Jackson Pollock and Nature." *Studio* 185 (June 1973): 257–62.

Judd, D. "Jackson Pollock." *Arts Magazine* 41 (April 1967): 32–35.

Junkers, H. "Jackson Pollock/Robert Smithson: The Myth/The Mythologist." *Arts Magazine* 52 (May 1978): 130–31.

Kagan, A. "Improvisations: Notes on Jackson Pollock and the Black Contribution to American High Culture." *Arts Magazine* 53 (March 1979): 96–99.

Kaprow, A. "The Legacy of Jackson Pollock." *Art News* 57 (October 1958): 24–26, 55–57. Reply by Irving Sandler in "Editor's Letters," December 1958, 6. Rejoinder by Kaprow, February 1959, 6.

———. "Impurity." *Art News* 61 (January 1963): 30–55.

Karp, I. "In Memoriam: The Ecstasy and Tragedy of Jackson Pollock, Artist." *Village Voice,* 26 September 1956.

Kramer, H. "Jackson Pollock and Nicolas de Stael: Two Painters and Their Myths." *Arts Yearbook* 3 (1959): 52–60.

———. "The Inflation of Jackson Pollock." *New York Times,* 9 April 1967, sec. D, p. 25.

———. "Jackson Pollock: Energy Made Visible." *New York Times Magazine,* 8 October 1972, pp. 7–8, 34.

———. "The Jackson Pollock Myth." In *The Age of the Avant-Garde.* New York, 1973, 335–41.

———. "Art: Jackson Pollock and Barnett Newman." *New York Times,* 15 February 1980, sec. C, p. 19.

Krauss, R. "Jackson Pollock's Drawings." *Artforum* 9 (January 1971): 58–61.

———. "Contra Carmean: The Abstract Pollock." *Art in America* 70 (Summer 1982): 123–31, 155.

Kristeva, J. "La Voie Lactée de Jackson Pollock." *Art Press* 55 (1982): 4–7, 9.

Kroll, J. "A Magic Life." *Newsweek* 69 (17 April 1967): 96–98.

Kuspit, D. B. "To Interpret or Not to Interpret Jackson Pollock." *Arts Magazine* 53 (March 1979): 125–27.

Langhorne, E. "Jackson Pollock's 'The Moon Woman Cuts the Circle.' " *Arts Magazine* 53 (March 1979): 128–37.

Levine, E. "Mythical Overtones in the Work of Jackson Pollock." *Art Journal* 26 (Summer 1967): 366–68.

Lowengrund, M. "Pollock Hieroglyphics." *Art Digest* 23 (1 February 1949): 19–20.

Mai, E. "Paris—Musée National d'Art Moderne Centre Georges Pompidou Ausstellung: Jackson Pollock." *Pantheon* 40 (April/June 1982): 150–52.

Mandeles, C. "Jackson Pollock and Jazz: Structural Parallels." *Arts Magazine* 56 (October 1981): 139–41.

Marchesseau, D. "Jackson Pollock." *Oeil* 288/89 (October 1979): 56–60.

O'Connor, F. V. "The Genesis of Jackson Pollock: 1912 to 1943." *Artforum* 5 (May 1967): 16–23.

―――. "Hans Namuth's Photographs of Jackson Pollock as Art Historical Documentation." *Art Journal* 39 (Fall 1979): 48–49.

O'Doherty, B. "Jackson Pollock's Myth." In *American Masters: The Voice and the Myth*. New York, 1973, 80–111.

O'Hara, F. "Jackson Pollock." In *Art Chronicles 1954–1966*. New York, 1975, 12–39.

O'Rorke, R. "Malevich and Pollock." *Art and Artists* 6 (April 1971): 58–61.

Peppiatt, M. "Jackson Pollock: L'Action reconsiderée." *Connaissance des Arts* 25 (February 1982): 28–35.

Pierre, J. "Surrealism, Jackson Pollock and Lyric-Abstraction." In *Surrealist Intrusion in the Enchanters' Domain*. D'Arcy Galleries, New York, 1960, 30–35.

Polcari, S. "Jackson Pollock and Thomas Hart Benton." *Arts Magazine* 53 (March 1979): 120–24.

Quick, D. "Jackson Pollock." In *Meaning in the Art of Barnett Newman and Three of His Contemporaries*. Ph.D. diss., University of Iowa, 1978.

Raynor, V. "Jackson Pollock in Retrospect—'He Broke the Ice.' " *New York Times Magazine*, 2 April 1967, pp. 50–76.

Robbins, D., and H. Zerner. "A Propos de la rétrospective Jackson Pollock." *Revue de l'art* 3 (1969): 93–95.

Rose, Barbara. "Hans Namuth's Photographs and the Jackson Pollock Myth: Part One: Media Impact and the Failure of Criticism." *Arts Magazine* 53 (March 1979): 112–16; "Part Two: 'Number 29, 1950,' " 117–19. Reply by Clement Greenberg and rejoinder by Barbara Rose in "Letter to the Editor," *Arts Magazine* 53 (April 1979): 24.

Rosenberg, H. "The Mythic Act." *New Yorker* 43 (6 May 1967): 162–71.

Roskill, M. "Jackson Pollock, Thomas Hart Benton, and Cubism: A Note." *Arts Magazine* 53 (March 1979): 144.

Rubin, D. "A Case for Content: Jackson Pollock's Subject Was the Automatic Gesture." *Arts Magazine* 53 (March 1979): 103–9.

Rubin, W. "Notes on Masson and Pollock." *Arts Magazine* 34 (November 1959): 36–43.

———. "Jackson Pollock and the Modern Tradition: Part One." *Artforum* 5 (February 1967): 14–22; "Part Two," March 1967, 28–37; "Part Three," April 1967, 18–31; "Part Four," May 1967, 28–33. Reply by Harold Rosenberg in "Letters," April 1967, 6–7, and rejoinder by Rubin, May 1967, 4.

———. "Pollock Was No Accident." *New York Times Magazine*, 27 January 1974, pp. 35–48.

———. "Pollock as Jungian Illustrator: The Limits of Psychological Criticism." *Art in America* 67 (November 1979): 104–23; December 1979, 72–91.

Sandler, I. "The Influence of Impressionism on Jackson Pollock and His Contemporaries." *Arts Magazine* 53 (March 1979): 110–11.

Sandler, I., D. Rubin, E. Langhorne, and W. Rubin. "Department of Jungian Amplification, Part Two: More on Rubin and Pollock." *Art in America* 68 (October 1980): 57–67.

Schjeldahl, P. "Anxieties of Eminence." *Art in America* 68 (September 1980): 106–15.

Steinberg, L. "Month in Review." *Arts Magazine* 30 (December 1955): 43–44, 46.

Stevens, M. "Quests in Paint." *Newsweek* 92 (23 October 1978): 138–39.

Stuckey, C. "Another Side of Jackson Pollock." *Art in America* 65 (November–December 1977): 80–91.

Temin, C. "MFA Offered Forty-three Pollock Works." *The Boston Globe*, 19 September 1985, p. 77.

Tillim, S. "Jackson Pollock: A Critical Evaluation." *College Art Journal* 16 (Spring 1957): 242–43.

Tyler, P. "Jackson Pollock: The Infinite Labyrinth." *Magazine of Art* 43 (March 1950): 92–93.

———. "Hopper/Pollock: The Loneliness of the Crowd and the Loneliness of the Universe: An Antiphonal." *Art News Annual* 26 (1957): 86–107.

Valliere, J. T. "The El Greco Influence on Jackson Pollock's Early Works." *Art Journal* 24 (Fall 1964): 6–9.

———. "De Kooning on Pollock." *Partisan Review* 34 (Fall 1967): 603–5.

Welch, J. "Jackson Pollock's 'The White Angel' and the Origins of Alchemy." *Arts Magazine* 53 (March 1979): 138–41.

Wolf, B. "Non-Objectives by Pollock." *Art Digest* 21 (15 January 1947): 21.

Wolfe, J. "Jungian Aspects of Jackson Pollock's Imagery." *Artforum* 11 (November 1972): 65–73.

Wysuph, C. L. "Behind the Veil." *Art News* 69 (October 1970): 52–55, 80.

FILMS

Jackson Pollock. Produced by Hans Namuth and Paul Falkenberg. Narration by Jackson Pollock. 1951. 16mm.

Jackson Pollock: Portrait. Written and directed by A. C. Pope. Produced by K. Lindsay. 1984.

Index